ART & PHYSICS

Clifton
N. Druid Hills
La Vista
Houston M. Tiffany

Sigma Xau

404. 417 - 0194

desman
dekter

Greatest hits

ART & PHYSICS

PARALLEL VISIONS IN SPACE, TIME, AND LIGHT

LEONARD SHLAIN

Quill
William Morrow
New York

Library of Congress Cataloging-in-Publication Data

Shlain, Leonard.
 Art & physics : parallel visions in space, time, and light /
Leonard Shlain.
 p. cm.
 Originally published: New York : Morrow, c1991.
 Includes bibliographical references and index.
 ISBN 0-688-12305-8
 1. Art—Philosophy. 2. Physics—Influence. I. Title.
II. Title: Art and physics.
N70.S48 1993
701—dc20
 92-24714
 CIP

Printed in the United States of America

13 14 15 16 17 18 19 20

ƆK DESIGN BY MN'O PRODUCTION SERVICE

To Cynthia, who was there at the first scratchings on foolscap; to my children, Kimberly, Jordan, and Tiffany; and to my parents

PREFACE

In 1979 I took my twelve-year-old daughter to visit the Museum of Modern Art in New York City. I was somewhat concerned that her California upbringing might have deprived her of Western civilization's rich cultural legacy, and wanted her to see some outstanding examples that existed on the East Coast.

Commencing with MOMA's French Impressionist exhibits, I tried to inspire in her the reverence and excitement I felt for great painting. As we ventured deeper into the labyrinth, however, the artwork became increasingly modern. In the manner that is so disconcerting to adults, my daughter pressed me for explanations as to why one painting after another constituted "great art." If, as I had told her, this building was our culture's treasure trove, then surely I could explain in simple English what made each work unique and precious. Increasingly, I became discomfited by my inability to answer her straightforward questions.

Later, munching hot dogs in the sunshine, we discussed what we had seen. With the penetrating innocence of a child, she announced her view that for much of the art, the Emperor had no clothes! I recognized that though I knew the intellectual context of each modern movement, I too didn't really "get it." I felt annoyed with the artists who made comprehension so difficult for us; who refused, as it were, to let us in on some important secret.

Over the next several days in other museums, I was forced repeatedly to confront this uncomfortable dilemma. How could the meaning of my century's artistic expressions elude a responsive, alert member of the culture such as I?

On this trip I was also reading a popular book about the new physics and I grappled with the subject's radical concepts. My lifelong curiosity about such matters had not been satisfied in college physics because we studied neither Einstein's relativity theory nor quantum mechanics. Our dense and dry professor dismissed them, saying that he had run out of

time. When, in the ensuing years, I began to probe the new physics on my own, I was struck by the sheer abstruseness of many of its basic ideas; a thought that was to recur to me while on my museum excursion in New York. Several days later while distractedly standing before a huge abstract painting in the Whitney, I wondered how a system of thinking about the world (because that is essentially what physics really is) could stand beyond the grasp of most intelligent members of society.

It was then I had the epiphany that inspired this book—and my work for the next decade. Perhaps, I mused, there was a connection between the inscrutability of modern art and the impenetrability of the new physics.

I am by profession neither a physicist nor an art critic, but a surgeon, so I brought to both art and physics a relatively unbiased eye and a beginner's mind. Though my innocence demanded that I do far more research than an expert might have had to do to understand the nuances of my subject, it also had distinct advantages. Because I do not rely on either field for my living, for instance, I can be somewhat freer in my speculations than professionals who have something at stake to lose. I approach physics as if I were an artist trying to explain its principles to other artists. Similarly, by using a scientific interpretation, I hope to demystify art.

I have often been asked how a surgeon could hold forth on two such weighty and diverse subjects. Surprisingly, my surgery has uniquely prepared me for the task, for a surgeon is both artist and scientist. The craft demands a finely honed sense of aesthetics: A maxim of the profession is if an operation does not "look" beautiful it most likely will not function beautifully. Thus, surgeons rely heavily on their intuitive visual-spatial right-hemispheric mode. At the same time, our training is obviously scientific. Left-brained logic, reason, and abstract thinking are the stepping-stones leading to the vast scientific literature's arcane tenets. The need in my profession to shuttle back and forth constantly between these two complementary functions of the human psyche has served me well for this project.

My intention has been to reach artistically inclined readers who want to know more about the new physics and scientists who would like to have a framework to appreciate art. Because the language of physics is so precise in contrast to the evocative language of art, I have had to build many bridges using the vocabulary common to both fields. To accomplish this I have had sometimes to broaden the meanings of scientific words, and occasionally to stretch them into poetic metaphors. At the same time I have had to be very concrete about the interpretation of specific artworks which may make it appear as though I believe mine is the only interpre-

tation. On the contrary, I know that mine is but one among many, which I hope will enrich the others. Bearing the above in mind, I would ask for a degree of forbearance from the specialists in both fields. In the words of William Blake, "Forgive what you do not approve & love me for this energetic exertion of my talent."

As I write these last few sentences which ironically appear first, it is hard to believe this engrossing project is completed. I hope you enjoy reading this book nearly as much as I have enjoyed writing it.

<div style="text-align: right">Leonard Shlain
Mill Valley, California</div>

ACKNOWLEDGMENTS

In writing this book I have been fortunate to have had input from a large range of readers. The manuscript has been through the sieve of their individual intellects, each one culling out some dross. Many readers have clarified concepts or relationships for me. Others have helped untangle my prose from the tetherings of my syntax. Still others, through their enthusiasm, have encouraged me to persist in this project. Last, but not least, are the many writers both past and present who, although I've never met them, informed and inspired me in the quiet hours.

I want to thank the following people without whose help this book could not have been written: Heinz Pagels, Fritjof Capra, Brian Swimme, Rollo May, Piero Mancini, Nick Herbert, Harrison Sheppard, Bernard Millman, Kenneth Baker, Hazel Henderson, Donald Palmer, Larry Garlington, Ann Nadel, Harriet Hirsh, Ann Reynolds, Robert Geering, Robin Reitzes, Sheldon Levin, Judy Frankel, Irving Weiman, Douglas Powers, Ronald Grossman, Josh Burton, Suzanne Boettger, Bill Keepin, Jerry Lowenstein, Erik Guttman, Mark Von Proyen, Barbara Hassid, Stephen Goldstine, June Richards, Weldon Smith, Shirlee Byrd, Toshi Oi, Jerome Kirk, Jean Paul Sirag, and Elizabeth Rauscher. William Henkin was the principal editor for this work before it reached the publisher and he is a wordsmith *extraordinaire*. Maria Watts, Trish MacMahon, Shoshanna Tembeck, Forbes Norris, and Dawn Farber all made many needed editorial corrections. To these people I extend a special thanks. To Cynthia Stern, thanks for taking me seriously as well as for your many perceptive suggestions along the way. To Robert Stricker, my agent, who skillfully shepherded this book over strange terrain, heartfelt thanks for your attention and advice. To Judy Snyder who typed the manuscript and has been a steadfast, reliable friend, my deepest gratitude. To Randy Ladenheim-Gil and James Landis at William Morrow, thanks for believing in me. To Elisa Petrini, my editor at Morrow, thank you for your careful help and many suggestions which strengthened this

book. To my copy editor at Morrow, I am appreciative for the incredible attention to detail. And to my children, Kimberly, Jordan, and Tiffany, who tiptoed quietly around while I took over the house with my books, papers, and computer printouts, thanks for your help, editorial comments, and patience; and finally to Ina Gyemant, for your steadfast support.

CONTENTS

- The purpose of art is to lay bare the questions which have been hidden by the answers.

 James Baldwin

Physics is a form of insight and as such it's a form of art.

 David Bohm

CHAPTER 1

ILLUSION / REALITY

Art and physics are a strange coupling. Of the many human disciplines, could there be two that seem more divergent? The artist employs image and metaphor; the physicist uses number and equation. Art encompasses an imaginative realm of aesthetic qualities; physics exists in a world of crisply circumscribed mathematical relationships between quantifiable properties. Traditionally, art has created illusions meant to elicit emotion; physics has been an exact science that made sense. Even the stereotypical proponents of each endeavor are polar opposites. In college, the hip avant-garde art students generally do not mingle with their more conventional counterparts in the physics department. By casual juxtaposition, these two fields seem to have little in common: There are few if any references to art in any standard textbook of physics; art historians rarely interpret an artist's work in light of the conceptual framework of physics.

Yet despite what appear to be irreconcilable differences, there is one

fundamental feature that solidly connects these disciplines. Revolutionary art and visionary physics are both investigations into the nature of reality. Roy Lichtenstein, the pop artist of the 1960s, declared, "Organized perception is what art is all about."[1] Sir Isaac Newton might have said as much for physics; he, too, was concerned with organizing perceptions. While their methods differ radically, artists and physicists share the desire to investigate the ways the interlocking pieces of reality fit together. This is the common ground upon which they meet.

Paul Gauguin once said, "There are only two kinds of artists—revolutionaries and plagiarists."[2] The art discussed in this book will be that created primarily by revolutionaries, because theirs is the work that heralds a major change in a civilization's worldview. And in parallel fashion, although the development of physics has always depended upon the incremental contributions of many original and dedicated workers, on a few occasions in history one physicist has had an insight of such import that it led to a revision in his whole society's concept of reality. The poet Rainer Maria Rilke referred to this sort of transcendent insight as a "conflagration of clarity,"[3] allowing certain artists and physicists to see what none before them had ever imagined, and it is they—the revolutionary artist and the visionary physicist—who will be paired in the coming pages.

Émile Zola's definition of art, "Nature as seen through a temperament,"[4] invokes physics, which is likewise involved with nature. The Greek word *physis* means "nature." Beginning with this common ground as a point of departure, I will describe the connections and differences between these two seemingly disparate ways our perceptions of nature are organized.

The physicist, like any scientist, sets out to break "nature" down into its component parts to analyze the relationship of those parts. This process is principally one of reduction. The artist, on the other hand, often juxtaposes different features of reality and synthesizes them, so that upon completion, the whole work is greater than the sum of its parts. There is considerable crossover in the techniques used by both. The novelist Vladimir Nabokov wrote, "There is no science without fancy and no art without facts."[5]

Insofar as science is the subject, I shall concentrate in this book on physics as it has developed during the last several hundred years. Nevertheless, the reader should keep in mind that present-day physicists wear a mantle that has been passed down through the ages. Physicists are the modern representatives of a distinguished tradition that winds its way back through the first scientists, Christian theologians, natural philosophers, pagan priests, and Paleolithic shamans, the exceptional of whom have

contributed pieces to fill in the infinite jigsaw puzzle of nature. The first physicist was probably the one who discovered how to make a fire.

I single out physics in particular because in this century all the other "hard" sciences have learned that they are anchored to this rock. Chemistry had its beginning in the attempt to identify and separate the elements, and it came to be fused to the laws that govern atomic events. Astronomy began as a fascination with heavenly movements and advanced to an inquiry into the arrangement of the solar system. Today, in studying the galaxies, astrophysicists address the laws that govern forces and matter. From its origins in Aristotelian taxonomy, biology has evolved to the study of the physical interaction of atoms in molecular biology. Physics, formerly one branch among many, has in this century become enthroned as the King of the Sciences.

In the case of the visual arts, in addition to illuminating, imitating, and interpreting reality, a few artists create a language of symbols for things for which there are yet to be words. Just as Sigmund Freud in his *Civilization and Its Discontents* compared the progress of a civilization's entire people to the development of a single individual, I propose that the radical innovations of art embody the preverbal stages of new concepts that will eventually change a civilization. Whether for an infant or a society on the verge of change, a new way to think about reality begins with the assimilation of unfamiliar images. This collation leads to abstract ideas that only later give rise to a descriptive language.

For example, observe any infant as it masters its environment. Long before speech occurs, a baby develops an association between the image of a bottle and a feeling of satisfaction. Gradually the baby accumulates a variety of images of bottles. This is an astounding feat considering that a bottle viewed from different angles changes shape dramatically: from a cylinder to an ellipse to a circle. Synthesizing these images, the child's emerging conceptual faculties invent an abstract image that encompasses the idea of an entire group of objects she or he will henceforth recognize as bottles. This step in abstraction allows the infant to understand the idea of "bottleness." Still without language, the baby can now signal desire by pointing.

Then at a certain moment, in that part of the brain called Broca's area, the connections between synapses attain a critical number, tripping the switch that suddenly lights up the magical power of language. This word factory, noisily chugging away, generates sounds that will replace and even eclipse the earlier images. As soon as the baby connects the bottle's image with the word "bottle," this word begins to blot out the image, so much

so that as adults we are rarely aware that when we engage in abstract thinking, we are not thinking in images. Concepts such as "justice," "freedom," or "economics" can be turned over in the mind without ever resorting to mental pictures. While there is never final resolution between word and image, we are a species dependent on the abstractions of language, and in the main, the word eventually supplants the image.

When we reflect, ruminate, reminisce, muse, and imagine, generally we revert to the visual mode. But in order to perform the brain's highest function, abstract thinking, we abandon the use of images and are able to carry on without resorting to them. It is with great precision that we call this type of thinking "abstract." This is the majesty and the tyranny of language. To affix a name to something is the beginning of control over it. After God created Adam, the very first task He instructed Adam to perform was the naming of all the animals. God informed Adam that by accomplishing this feat he would gain dominion over all the beasts and fowl. Note that God didn't teach Adam anything as practical as how to make a fire or fashion a spear. Instead, He taught him to name. Words, more than strength or speed, became the weapons that humans have used to subdue nature.

Because the erosion of images by words occurs at such an early age, we forget that in order to learn something radically new, we need first to imagine it. "Imagine" literally means to "make an image." Witness the expressions we use when struggling with a new idea: "I can't picture it," "Let me make a mental model," and "I am trying to envision it." If, as I propose, this function of imagination, so crucial to the development of an infant, is also present in the civilization at large, who then creates the new images that precede abstract ideas and descriptive language? It is the artist. In the following pages, I shall demonstrate how revolutionary art can be understood as the preverbal stage of a civilization first contending with a major change in its perception of the world. In order to elaborate this thesis, I shall examine art, not only as an aesthetic that can be pleasing to the eye, but as a Distant Early Warning system of the collective thinking of a society. Visionary art alerts the other members that a conceptual shift is about to occur in the thought system used to perceive the world. John Russell, the art critic, observed: "There is in art a clairvoyance for which we have not yet found a name, and still less an explanation."[6]

Despite each discipline's similar charge, there is in the artist's vision a peculiar prescience that precedes the physicist's equations. Artists have mysteriously incorporated into their works features of a physical description of the world that science later discovers.

The artist, with little or no awareness of what is going on in the field of physics, manages to conjure up images and metaphors that are strikingly appropriate when superimposed upon the conceptual framework of the physicist's later revisions of our ideas about physical reality. Repeatedly throughout history, the artist introduces symbols and icons that in retrospect prove to have been an avant-garde for the thought patterns of a scientific age not yet born. Few art historians have discussed this enigmatic function of art in depth. Robert Hughes, another art critic, explains why it is so often overlooked:

> The essence of the *avant-garde* myth is that the artist is a precursor; the truly significant work of art is the one that prepares the future. The transitional focus of culture, on the other hand, tends to treat the present (the living artist) as the culmination of the past.[7]

All too often, when reading about the work of exceptional artists, we are told about the past styles that influenced their work. Their pedigrees are traced backward to former artists, and rarely is their work explained in terms of how they anticipated the future.

A large segment of present society, unable to comprehend art's vision, dismisses the importance of art. Marshall McLuhan, in his seminal work, *Understanding Media*, asks:

> If men were able to be convinced that art is precise advance knowledge of how to cope with the psychic and social consequences of the next technology, would they all become artists? Or would they begin a careful translation of new art forms into social navigation charts? I am curious to know what would happen if art were suddenly seen for what it is, namely, exact information of how to rearrange one's psyche in order to anticipate the next blow from our own extended faculties . . .[8]

Revolutionary art in all times has served this function of preparing the future.

Both art and physics are unique forms of language. Each has a specialized lexicon of symbols that is used in a distinctive syntax. Their very different and specific contexts obscure their connection to everyday language as well as to each other. Nevertheless, it is noteworthy just how often the terms of one can be applied to the concepts of the other. "Volume," "space,"

"mass," "force," "light," "color," "tension," "relationship," and "density" are descriptive words that are heard repeatedly if you trail along with a museum docent. They also appear on the blackboards of freshman college physics lectures. The proponents of these two diverse endeavors wax passionate about elegance, symmetry, beauty, and aesthetics. The equal sign in the formulas of the physicist is a basic metaphor used by many artists. While physicists demonstrate that A equals B or that X is the same as Y, artists often choose signs, symbols, and allegories to equate a painterly image with a feature of experience. Both of these techniques reveal previously hidden relationships.

Niels Bohr, a founder of quantum physics, was intrigued by the relationship between physics and language and observed:

> It is one of the basic presuppositions of science that we speak of measurements in a language that has basically the same structure as the one in which we speak of everyday experience. We have learned that this language is an inadequate means of communication and orientation, but it is nevertheless the presupposition of all science. . . . For if we want to say anything at all about nature—and what else does science try to do?—we must somehow pass from mathematical to everyday language.[9]

Vincent van Gogh addressed the same concern when in frustration he wrote to his brother Theo about his inability to articulate his feelings in words, "Really, we can speak only through our paintings."[10]

Revolutionary art and visionary physics attempt to speak about matters that do not yet have words. That is why their languages are so poorly understood by people outside their fields. Because they both speak of what is certainly to come, however, it is incumbent upon us to learn to understand them.

fields and the Tower of Babel

In the parable of the Tower of Babel, early humankind attempted in a grand collaborative effort to build a tower to reach the heavens. Yahweh, looking down from the clouds, became so incensed that ordinary mortals should think they were capable of such a godlike feat that He summarily garbled the speech of every worker and so brought the construction to a halt.

History has been the record of our agonizingly slow resumption of work on this mythic public monument to knowledge. Gradually, the parochial suspicions that had been abetted by large numbers of local dialects have given way to the more universal outlook of modern humankind. Currently

this work in progress is the creation of a global commonwealth. The world-wide community of artists and scientists is and has been in the forefront of this coalescence, offering perceptions of reality that erase linguistic and national boundaries. Reconciliation of the apparent differences between these two unique human languages, art and physics, is the next important step in developing our unifying Tower.

To better understand the connection between art and physics, we must first ask, "How do we know the world?" Plato, in his famous cave analogy, proposed that we are all like prisoners chained to a low wall in a cave, unable to turn around and witness firsthand the activities of real people conducting their lives before a large fire on the ledge behind. Instead, because of the constraints imposed by our manacles, we can see only our own shadows mingled with the ghostly shadows these free people cast onto the opposite wall that we as prisoners must face. Our perceptual apparatus condemns us to believe these flickering images of things and people are the "real" things, and it is only from this secondhand information that we can deduce the nature of reality.

Two thousand years after Plato, René Descartes reiterated this distinction between the inner eye of imagination and the external world of things. He split the purely mental "in here" of our consciousness *(res cogitans)* from the objective world of "out there" *(res extensa)* and declared these two realms inviolably separate. In the eighteenth century, Immanuel Kant rein-forced the views of Plato and Descartes in his *Critique of Pure Reason*. Kant sadly declared that we can know the nature of things only by what filters through our senses and is processed by our mind, but we can never directly experience the *Ding an sich*: the *thing in itself*. By thus banishing us to the impenetrable tower of our thought, Kant asserted that we must all peer out at reality through the chinks of our senses. Our exasperating inability to know the world directly is one of the central existential dilemmas he perceived in the human condition. In his monumental work entitled *The World as Will and Idea*, Arthur Schopenhauer summed up this phil-osophical point of view in his trenchant opening sentence, "The world is my idea."

The faculty we use to grasp the nature of the "out there" is our imag-ination. Somewhere within the matrix of our brain we construct a separate reality created by a disembodied, thinking consciousness. This inner reality is unconnected to external space and exists outside the stream of linear time. When reminiscing about a day at the beach, we knit together elements of that day that no longer "actually" exist. We can run the events forward and backward with ease, and amend with alternate possibilities what we

believe happened. It is the bane and the balm of individual perception that "objective" reality is seen through the filter of each person's temperament: In the classic Japanese tale *Rashomon*, each person is convinced of the truth of his or her own version. Consciousness, resembling nothing so much as long columns of ants at work, must laboriously transfer the outside world piece by piece through the tunnels of the senses, then reconstruct it indoors. This inner spectral vision amounts to a mental "opinion" unique to each individual of how the world works.

When a critical mass of people agrees on one viewpoint we call that agreement a "consensus." Group consensus within the context of society leads us to form political parties, religious sects, and economic systems. Each model is based upon an accepted belief system. When an entire civilization reaches a consensus about how the world works, the belief system is elevated to the supreme status of a "paradigm," whose premises appear to be so obviously certain no one has to prove them anymore. No longer even questioned, the assumptions upon which the paradigm rests become a priori postulates. Two plus two will always be four and all right angles are equal. For believers, these assumptions constitute bedrock "truths."

"Truth," as defined by Alfred North Whitehead, "is the conformation of Appearance to Reality."[11] What makes any set of bedrock truths slippery is that every age and every culture defines this confirmation in its own way. When the time comes to change a paradigm—to renounce one bedrock truth and adopt another—the artist and physicist are most likely to be in the forefront.

Some people might object to pairing art and physics, since the artist is concerned not only with external reality but with the inner realm of emotions, myths, dreams, and the spirit as well. While art is thought to be relatively subjective, physics, until this century, scrupulously avoided any mention of the inner thoughts that related to the outer world. Physics concerned itself instead with the objective arena of motion, things, and forces. This stark difference between art and physics blurs in light of the startling revelations put forth by the quantum physicists that emerged from the fusion of the contradictory aspects of light.

In 1905 Albert Einstein proposed that light could exist in the form of a *particle*, that is, a small piece of something called a photon. For over two hundred years light had been experimentally proven to be a *wave*. Einstein's proposal implied that light had two distinct and seemingly opposing natures: a *wave*like aspect and a *particle*like aspect. At the turn of the century, what was to be a surprising feature of quantum reality amounted to a Zen

koan. This mind-knot seemed insoluble because the rules of conventional logic could not be applied.

In a bold move Niels Bohr synthesized these antithetical aspects of light in his 1926 theory of complementarity. Stating it simply, Bohr said that light was not *either* a wave *or* a particle, but was *both* a wave *and* a particle. Knowledge of both these very different aspects was necessary for a complete description of light; either one without the other was inadequate.

As it turned out, light would reveal only one aspect of its nature at a time, resembling an odd carnival peep show. Whenever a scientist set up an experiment to measure the wavelike aspect of light, the subjective act of deciding which measuring device to use in some mysterious way affected the outcome, and light responded by acting as a wave. The same phenomenon occurred whenever a scientist set out to measure the particlelike aspect of light. Thus "subjectivity," the anathema of all science (and the creative wellspring of all art) had to be admitted into the carefully defended citadel of classical physics. Werner Heisenberg, Bohr's close associate, said in support of this bizarre notion, "The common division of the world into subject and object, inner world and outer world, body and soul, is no longer adequate. . . ."[12] Natural science does not simply describe and explain nature; it is part of the interplay between nature and ourselves."[13] According to the new physics, observer and observed are somehow connected, and the inner domain of subjective thought turns out to be intimately conjoined to the external sphere of objective facts.

John Wheeler, one of Bohr's students, subsequently expanded Bohr's duality, proposing that Mind and Universe, like wave and particle, constitute another complementary pair. Wheeler's theory proposes a connection between the inner realm of consciousness (Mind) and its reciprocal, the external world of the senses (Universe). According to Wheeler, Mind and Universe are inextricably integrated. The Talmud expresses this subtle relationship in an apocryphal story of a dialogue between God and Abraham. God begins by chiding Abraham, "If it wasn't for Me, you wouldn't exist." After a moment of thoughtful reflection, Abraham respectfully replies, "Yes, Lord, and for that I am very appreciative and grateful. However, if it wasn't for me, You wouldn't be known." Somehow, in one of the great mysteries of the cosmos, human consciousness is able to ask questions of nature and the answers that come back are actually comprehensible. Perhaps, as Wheeler suggests, the two, Mind and Universe, are simply aspects of a binary system. Art and physics, then, may be seen as two pincers of a claw the Mind can use to grasp the nature of Wheeler's complementary image, the Universe.

At the same time that quantum physicists began to wrestle with Bohr's theory of complementarity, which is not classically scientific and seems to border on the spiritual, the Swiss psychologist Carl Jung promulgated his theory of synchronicity, the internal corollary in human experience of this external quantum idea. Like Bohr, Jung repudiated the conventional doctrine of causality. He proposed that all human events interweave on a plane to which we are not consciously privy, so that in addition to prosaic cause and effect, human events are joined in a higher dimension by meaning. The principles of synchronicity and complementarity, bridging as they do the very separate domains of the psyche and the physical world, apply as well to the connection between art and physics. The German language encapsulates this idea in the word *zeitgeist*, which unfortunately has no single-word equivalent in English, but means "the spirit of the times." When discoveries in unrelated fields begin to appear at the same time, as if they are connected, but the thread that connects them is clearly not causal, then commentators resort to proclaiming the presence of a *zeitgeist*.

Originally using the theory of complementarity to unite the opposite and paradoxical aspects of light, Bohr went on to extend his philosophical device to include other pairs of opposites. This book is about the complementarity of art and physics and the ways these two fields intimately entwine to form a lattice upon which we all can climb a little higher in order to construct our view of reality. Understanding this connection should enhance our appreciation for the vitality of art and deepen our sense of awe before the ideas of modern physics. Art and physics, like wave and particle, are an integrated duality: They are simply two different but complementary facets of a single description of the world. Integrating art and physics will kindle a more synthesized awareness which begins in wonder and ends with wisdom.

The connections between the art of one period and the physics of a later one become more apparent when examined retrospectively, looking all the way back to classical Greece. Sometimes the lag period is several hundred years; at other times it can be decades. In this century, an auspicious conjunction between art and physics occurred in its first decade with both fields exploding into many new directions.

Art generally anticipates scientific revisions of reality. Even after these revisions have been expressed in scholarly physics journals, artists continue to create images that are consonant with these insights. Yet a biographical search of the artists' letters, comments, and conversations reveals that they were *almost never aware* of how their works could be interpreted in the light of new scientific insights into the nature of reality. In these cases to

be discussed, artists have continued to work in splendid isolation, bringing forth symbols that have helped the rest of us grasp the meaning of the new concepts even they, the artists, may not have formulated intellectually.

The same principle holds true in reverse. Upon making his discovery, the physicist is usually unaware of the artist's anticipatory images. Rarely has a physicist, discussing a new breakthrough in his science, acknowledged an influential artist who preceded him. Despite many deep friendships throughout history between artists and scientists, revolutionaries in art and visionaries in physics seem peculiarly separate. Picasso and Einstein, who I shall demonstrate shared a common vision, never even met or evinced interest in each other's work.

Since the visual arts do not exist independently of music, drama, poetry, literature, philosophy, and architecture, I will weave these fibers into the fabric of this thesis where appropriate. However, the principal thread of this book is the visual arts of Western civilization against the backdrop of physics. This skein can be followed through ancient Mesopotamia, Egypt, Greece, and then on to Rome. The thread seems to have been broken during the disruption of the Dark Ages, but in that nocturnal period it still spun on virtually unobserved into Europe, reemerging in the Middle Ages until, like a phoenix rising, it reappeared resplendent in the Renaissance. The culture we call Western tradition then spread its net ever wider until it has encompassed all of Europe and the Americas.

In order to create a context in which to discuss the individual works of the artist and how they relate to the theories of the physicist, we need to start with ancient Greece, where many of the premises of our present-day value and thought systems originate. Not unlike the great founders of the major religions of the world, the early Greek thinkers began their inquiry by assuming that the variegated manifest universe arose from a cosmic unitary principle. Each of them attempted to trace all experience back to one primordial element. Around 580 B.C., Thales of Miletus, the first philosopher, declared that it was water. Heraclitus almost immediately disagreed, announcing that the original element was fire. Soon other voices cast their votes for air or earth. In one of the first great syntheses of science (and, I might add, one of the first known compromises), Empedocles proposed that perhaps there was not just one primordial element but rather four. If at the root of reality there were four different essences, then all of existence could be explained as some combination of the basic building blocks of water, fire, earth, and air. This idea "felt" right to the college of early philosophers perhaps because the number four universally evokes a sense of foundation. Whether it is the four points on a compass, the four

corners of a square, or the four legs to a table, there is in this cardinal number an expectation of fundamental completeness.

One hundred years after Empedocles, however, Aristotle was not quite satisfied with this scheme. He observed that all things here on earth are in varying states of flux and argued that something was missing. Influenced by Plato's concept of an eternal ideal, Aristotle posited that, in addition to the tetrad proposed by Empedocles, there must be a fifth essence, a *quintessence*, that is constant and immutable and somehow connects the other four. Since the celestial constellations seemed unchanging in their unwavering courses across the sky, he proposed that the quintessence was composed of the stuff of stars.

Although we have discarded the early Greeks' quaint notions in the latter half of the twentieth century, this ancient scheme retains an uncanny familiarity. In our present paradigm we still acknowledge four basic constructs of reality: space, time, energy, and matter. Space and time constitute the gridwork within which we conduct our lives, while inside their frame, energy, matter, and various combinations thereof create our world of appearance. These four elemental constructs form a mandala of totality. All perceptions created in the dream room of our minds are constructed from these four building blocks.

In looking to the light from the stars, Aristotle's speculation was close to the reality of twentieth-century physics. The quintessence, we have learned, is not the stars, but rather light itself. This, too, is fitting. Elusive and enigmatic, this fifth essence has engendered wonder and reverence throughout history. Whether it was the miracle of fire or the life-giving rays from the sun, light in and of itself has always been the most mysterious element. It has been accorded a prominent place in all religions of the world, and discoveries in modern physics revealed that it was the unique nature of light that held the key to unlocking the secrets of the other four. Both the fields of quantum mechanics and relativity arose out of two unresolved questions about the nature of light. Further, Einstein discovered that the speed of light was an invariant and immutable number. In some strange way light is the link connecting space, time, energy, and matter. The symbol for the speed of light in physics, c, plays a prominent role in the key equations connecting the other four.

In the coming chapters we shall principally explore the interrelationships of space, time, and light. The reason for coning down to these three elements is to narrow the focus for a more manageable discussion. A book about art by itself contains many currents and characters. Similarly, the history of physics shares this diversity. When trying to integrate one in

terms of the other the thesis is in danger of sinking into a morass of names, dates, and movements. Space, time, and light were the three constructs revised by Albert Einstein in his 1905 special theory of relativity. They will be the key characters in the synthesis ahead. However, quantum mechanical conceptions, mass-energy equivalence and field theories, the other equally important physics revolutions, will be touched upon whenever it is pertinent.

Parallel straight lines do not meet one another in either direction.

Euclid

Everything either is or is not.

Aristotle

CHAPTER 2

CLASSICAL ART / IDEAL PHILOSOPHY

Space, time, and light are of profound interest to both the physicist and the artist. Since the time of classical Greece, natural philosophers have made repeated attempts to sort out the relationships among these three. Painters and sculptors, too, have dedicated themselves to understanding the interplay among them.

Yet, despite a historical record that contains immense diversity among civilizations, there have been only a few different models of space, time, and light. Although there are striking differences among such diverse thought systems as those of the ancient Egyptians, Hindus, and aborigines, in general, they share the conviction that there is no sharp line dividing the "in here" space of imagination or "subjective" reality and the "out there" space of "objective" reality. In fact, admixing the inner space of dream, trance, and myth with the events of everyday existence characterized every belief system worldwide before the Greeks. In addition, time had not yet been put on a spindle to be unwound at a uniform rate in any of these

28

religious cultures. Instead, time meandered back and forth between reality and myth.

The introduction of rational doubt by the ancient Greek philosophers sharply separated their system from others based upon religious beliefs. The classical Greeks began to investigate the nature of reality with their newly refined tool called "reason," a faculty that was to become the underpinning of an entirely novel conception of space and time. Rationalism was a stunning system because it swept away convoluted magical and mystical explanations and, in effect, replaced them with only one lodestone—logic. Why this particular system of thought arose in Greece twenty-five hundred years ago and not in some other time and place merits some speculation.

The people who lived on those Hellenic isles were the recipients of a powerful, rich Indo-Aryan language washed down from the north by invasions and immigrations. They fused its prolific and varied lexicon with an innovative technology called the alphabet, which they had learned from Phoenician traders in the south. Alphabets had been in use for some time by many Semitic peoples, but they were cumbersome because they lacked the vital element of vowels.*

The Greeks' simple invention was letters to stand for vowels. When added to the Phoenician consonants, they produced an easy-to-use system of written communication, whose basics have remained unchanged to this day.

Any time a new means of communication is introduced into the world, a giant step occurs in the historical record.[1] The Greek alphabet was not only new; it was an extremely efficient means of processing information, as revolutionary in its time as computer technology is today. The alphabet's lettering system was "user friendly" because, instead of the thousands of images that made up a system of hieroglyphics or ideographs, there were only twenty-four symbols. When beaded together on a horizontal line in a particular sequence these symbols became a decipherable code and made commonplace the ability to record and transfer information with relative ease.

On another level, the alphabet was civilization's first abstract art form. As the actual shape of each letter became divorced from any connection to the image of the thing it might once have represented, the abstract quality of alphabets most likely subliminally reinforced the ability of those

*In terms of significance for Western civilization's subsequent development, the Ten Commandments' moral weight received by Moses from God on Mount Sinai was equaled by the curious fact that they were written, not in Moses' native language—hieroglyphics, but rather in alphabetic form.

who used them to think abstractly. An ideogram or hieroglyph is basically a picture that may contain multiple concepts all superimposed upon one another. The alphabet, on the other hand, strings out these concepts so that they become words in a sentence whose meaning depends on their linear sequence. Untangling the multiple ideas coiled within one ideographic image and converting them into a linear code reinforces the belief that one thing follows another, and thus ever so surreptitiously alphabets impose causality upon the thinking processes of those who use them.

 Marshall McLuhan pointed out the critical importance of a new communications technology when he coined his famous aphorism, "the medium is the message."[2] In *The Gutenberg Galaxy*, he proposed that the *content* of information exchanged in a particular medium such as oral speech or the alphabetic written word is profoundly affected by the *process* used to transmit that information. The process, more than the original quality of the information, ultimately has a greater effect on the civilization's art, philosophy, science, and religion. The repeated use of alphabets by a large number of ancient Greeks over a long period of time reinforced three aspects of comprehension: *abstraction, linearity,* and *continuity*. These three ideas were also the foundation for the new conception of space, time, and light that would emerge centuries later, following a wide acceptance of the Greeks' new lettering system.[3]

It is no accident that the first science of space emerged in the civilization that developed the first streamlined alphabet. The Greek mathematician Euclid, who taught at the Museum of Alexandria around 300 B.C. (museums were schools dedicated to the Muses), codified space into a field of knowledge called geometry. The Egyptians, Babylonians, Hindus, and others had discovered bits and pieces of geometrical truths, but it was Euclid who gathered all these proofs together and, in one grand rational scheme, laid the foundation for a whole new science. Euclid translated abstract thought into diagrams that formed a coherent system. He began by defining his terms and then proposed axioms that to him were so obvious they needed no proof. From these he formulated his five postulates. The more familiar ones—that parallel lines will never cross; that all right angles are equal to one another—have been held up for over two thousand years as the very nexus of truth.

From the basic five postulates, Euclid went on to deduce theorems and propositions. The proof of the inherent truth of his system stemmed from the fact that his definitions and axioms could be used to prove the theorems. But Euclid made some other assumptions that he did not state in the *Elements*. For example, he organized space as if its points could be con-

nected by an imaginary web of straight lines *that in fact do not exist in nature*. Geometry was an entire system based on a mental abstraction. Felicitously, when it was superimposed upon external reality, nature obligingly corroborated this fabrication of the mind. Using Euclid's notion of space, the third-century B.C. philosopher-engineer Archimedes declared the self-evident axiom that the shortest distance between two points is a straight line. This rule, without actually saying so, implied that Euclid's space was uniform, continuous, and homogeneous. There were no potholes, bumps, or curves, and everywhere space was presumed to be the same. If the straight line happened to be a ruler, and if one used his or her imagination, then space could be cut into slices and its sides sequentially numbered making Euclid's space measurable.

Another assumption implicit in Euclid's space but not explicitly stated is that space is totally empty. Since space for Euclid had no substance, one could put objects, forms, and figures in it and move them around without affecting either the space or the objects. Space could not interact with mass or form because it is essentially nothing. It was the empty container in which the Greeks could arrange the things of their reality.

The triumph of Greek notions of space was so complete that Plato had engraved above the gate to his academy a sign that read "Let no one enter here who is not schooled in geometry." Earlier Zeno, a mischievous philosopher, in the fifth century B.C. constructed a series of paradoxes demonstrating some inconsistencies in Greek ideas about space. (One paradox is that of the footrace between Achilles and a tortoise. The tortoise, who has a head start, wins because Achilles always covers one half the distance to the tortoise but, while ever gaining, can never overtake the slower turtle as the half distance remaining keeps getting ever smaller but never disappears.) Zeno's paradoxes were never taken seriously or addressed completely. Aristotle, a hundred years later, peremptorily dismissed Zeno as a crank. He accused him of that worst of Greek philosophical sins, sophistry. More to our point, however, today "sophistry" is a derogatory term philosophers ascribe to arguments that cannot be explained within a system.

If linearity laid the basis for a new conception of space, it had an equally profound effect on the notion of time. In all civilizations of that ancient era, time was cyclic. All the evidence available to the observer spoke of resurrection and repeatability. The rising and falling of the Nile, the return of the seasons, and the periodicity of the heavens reinforced this belief in cyclical time. One event, however, dramatically did not. Personal death and its irreversibility harshly pointed to a linear, inexorable direction of time. Though the Egyptians and Hebrews had begun to develop the idea of linear,

nonrepeatable time, it existed within a religious context. Until the Greeks, the proper time line of mortals was entangled in the more serpentine mythical time of the gods. Therefore, the clear idea of an abstract, sequential, linear time so necessary for rational thinking could not emerge. The Greeks began the task of pounding this crooked, curved essence into an arrow-straight line. And the man who did for time what Euclid did for space was Aristotle.

Like a smith in a foundry, Aristotle straightened out the arabesque shape of time, but to do so he first had to demythologize the three Daughters of Necessity. These three Fates were Lachesis, who guarded what had been, Clotho, who guarded what is, and Atropos, who oversaw what is yet to come. By excluding the possibility that mythical time had anything to do with everyday time, Aristotle transformed the three Fates into the past, the present, and the future. Once he had, in a sense, created linear time, the rules of rational thinking could develop into a powerful problem-solving technique. Armed with abstract, linear, and continuous time and space, he went on to formulate the rules of logic, codifying a special kind of thinking used by earlier Greek philosophers into a standardized system.

The basic unit of logic is the syllogism, which depends upon the proposition "if-then." "If-then" became the simple tool that Aristotle claimed was all that was necessary to reveal truth without the help of oracles, sacrifices, or prophets. Although logic itself is timeless, the process of logic depends heavily upon time. Logic proceeds one step after another.[4]

Aristotle's writings suggest that he himself did not fully recognize that his formulation of logic's rules would generate certain inevitable conclusions about time. He personally believed that time was recurring, and that its cycles, which he called eras, were so far apart that one could dismiss consideration of previous eras because they were outside his newly invented linear time. It is not uncommon for someone as farsighted as Aristotle to fail to grasp the full significance of his own visionary insight. Galileo, Newton, and Einstein, too, held on to beliefs that were antithetical to their respective discoveries. Aristotle's willingness, however, to tackle the problem of time is all the more extraordinary, since his mentor, Plato, dismissed the whole notion of time as nothing more than an illusion that interfered with the motionless ideal. Plato referred to time as "the moving image of this changeless eternity."

Sequence became the key to time, and each duration followed in a progressive nonreturning flow. The Greeks' novel ideas about space also depended upon order and linearity, as did other facets of their civilization. In John White's *The Birth and Rebirth of Pictorial Space*, he points out

the most striking feature of both Greek narrative and art: "All the forms lie in a single plane. All the movement is in one direction."[5] From temple friezes to vase paintings this linear convention was rarely violated.

Once time was wrested from the clutches of mythology, it occurred to the Greeks that history was possible. If proper time was linear, then it would be possible to chronicle events in a sequential order, and so Herodotus in the fifth century B.C., freeing himself from mythical considerations, became civilization's first historian. The concept that an accurate catalogue of the events of the distant past could be written down by one person who was living in the present was a profoundly new idea. It could have taken place only in a civilization that adhered to linear time. The Greeks' acknowledgment of the absolute uniqueness of historical events is one of history's unique events.[6]

Euclidean space and Aristotelian time have formed the basis of a paradigm that has been remarkably enduring. This worldview has survived virtually unchanged since it was first proposed nearly twenty-five hundred years ago. Almost without exception everyone in Western society uses this ancient system. Euclid's *Elements* is probably the second most widely read book in the history of the world. It is nearly impossible to grow up without being inculcated with Euclid's ideas at a very early age. Likewise, a tacit knowledge of Aristotle's logic is a prerequisite for every professional, technological, and literate position in sophisticated society. To be profoundly *irrational* is to be considered insane.

Everyone learns this system of thinking so early and it works so well that it is very difficult to see its deficiencies. But, if truth is the correspondence between appearance and reality, then there are some glaring inconsistencies in this system. Straight lines are strikingly absent in nature. If you take a walk in the woods, it is apparent that there is virtually nothing that is ruler-straight. Instead, all naturally occurring forms are curved and arabesque. Rocks, bushes, mountains, rivers, gullies, branches, and leaves all follow an organic outline that does not contain a single perfect straight line. Only tree trunks and the perpendicular alignment of the human form standing upright upon the earth offer a commonly seen vertical that approximates a plumb line. Despite this direct evidence of our senses, we continue to connect everything with straight lines. The nineteenth-century Romantic artist Eugène Delacroix once speculated, "It would be worthy to investigate whether straight lines exist only in our brains."[7]

The Western adherence to the illusion that the link between objects in space and events in time is a straight line is similar to belief in a religious dogma. Just as all the major religions of the world begin with the as-

sumption that beneath the flux of our sensations there lies a unifying principle, so science had discovered in Euclid's rectilinear system its corollary. While there are an infinite variety of curved lines, there is, after all, only one straight line. The rectitude of this revelation became integrated into the Pythagorean mystical cult. Pythagoras, who was midwife to the birth of science from its mother, religion, believed that only through number and pure geometrical forms could humankind grasp the nature of the universe. In Euclid's famous book on optics, he begins by informing the reader that the lines of vision, or visual rays, are straight.

To say, however, that nature does not contain any perfect obvious straight lines is not entirely correct. To most people's vision, there is one: the uncluttered meeting of sea and sky—the horizon as seen upon the water. The horizon is the central orienting line in our experience. Pilots and sailors who are lost in a fog and cannot see the horizon frequently report a strange disorientation regarding up, down, front, back, right, and left. This naturally occurring straight line is so important that I speculate its ready visibility had a powerful effect on seacoast civilizations. Perhaps the reason that linear alphabets, linear logic, and linear space have been championed principally by the seafaring empires of classical Greece, Imperial Rome, Renaissance Venice, and Elizabethan England is that their inhabitants continually had nature's straightest line in plain sight. This sharp crease was missing from everyday experience in the land-based civilizations of ancient Egypt, Asia Minor, and China. Perhaps its absence is the reason these empires failed to develop a widely used alphabet, or to organize space and time in a linear fashion.

Having invented a new way to conceptualize space and time, the Greek philosophers tried to understand the nature of light. The preclassical Greeks did not distinguish between "eye" and "light": either word could be used to describe something beloved or admired.[8] Eyes seemed to emanate light and sources of light appeared as large eyes. The sun could be called an eye and one's eye was referred to as a light. The later Greeks began to separate light as the vehicle of information from the sense organ that received it. Aristotle called the eye "the gate of the intellect," after Alcmaeon in the sixth century B.C. discovered that the optic nerve connected the eye with the brain. At the beginning of his *Metaphysics*, Aristotle remarks how we value sight above all. "The reason is that this, more than any other sense, makes us know and reveals to us many differences between things."[9] Our word for imagination derives from the Greek *phantasia*, which itself is derived from *phaos* ("light") because it is not possible to see without light.[10]

Hampered by their lack of scientific instruments with which to begin

the study, the Greeks nevertheless began to understand that light had properties. Since space was empty, light had to be something that traveled through this nothingness. Plato proposed that light emanated from within our minds. In Plato's theory, light rays shot forth from our eyes and enveloped those objects we could see. Aristotle conjectured the exact opposite. He thought light originated from the sun and after bouncing off the objects in the external realm, ricocheted into our eyes. The debate they began continues into the present.

Implicit in both Plato's and Aristotle's ideas of light was that it was a "thing." They assumed it traveled from here to there through space, though they weren't sure if light performed this mysterious feat in a certain allotted time or whether its transfer was instantaneous. The Greeks' stabs in the dark about the nature of light and their proud accomplishments regarding the definition of space and time were the beginning of a twenty-five-hundred-year-old misconception that space and time were absolute constructs of reality and that light was a go-between bouncing off the walls of this grid work.

The Greek artist and architect had been aware of the advantages of uniform, measurable space long before the strict formalism of Euclid and Aristotle. The Greek artists increasingly positioned their figures in a linear orientation that depended upon the horizon, and the Greek architects had used the principles later elaborated by Euclid as a new aesthetic ideal to calculate the visual effects of their buildings. These refinements even included making the outer column of their temples thicker than the inner ones so as to prevent them from being optically "eaten" away by the surrounding light.

A century before Euclid had popularized the proportions of an isosceles triangle, Greek sculptors had accurately estimated the proportions of the human face and figure. The fifth-century B.C. sculptor Polyclitus wrote a book entitled the *Kanon (Rule)*, which established the measured relationships of the different parts of the human body. He recommended these values as the basis of an entire aesthetic. He then sculpted his *Doryphoros* (Spear bearer) to illustrate these principles.

In the century before Plato's search for the ideal forms that lie hidden in nature, artists created the forms that today we refer to as "classical." In their striving for perfection, Greek artists achieved the essence of Plato's ideal. The derivation of the word "rational," which has under its aegis the subsidiary terms "reason," "logic," and "causality," can be traced back to the Latin word *ratio* which means "proportion." Both art and natural philosophy were engaged in a quest to strip away the outer veils of ap-

pearance in order to discover the ideal proportional forms that lay hidden underneath this covering.

In classical architecture the ideal proportion for a rectangle is one whose sides are in the ratio of five to eight. Greek temples were laid out using this formula, and this model of perfection became known as the "golden rectangle." This has its roots in the artistic aesthetics of the Greek ideal of the perfect human face. When divided into eighths, the physiognomic features are all in the lower five eighths, and the distance from eyebrow to crown is the remaining three eighths.

This Greek idea continued to influence subsequent artists. Marcus Vitruvius, a first-century B.C. Roman architect and writer, began his *De architectura* with the recommendation that temples, in order to be magnificent, should be constructed on the analogy of the well-shaped human body, in which there is a perfect harmony among all parts. Socrates, Plato, and Aristotle all proposed that the essence of beauty was order, proportion, and limit. Despite all these "rules," Greek art was the first "free" art—free in the sense that its purpose was more aesthetic than religious or political.

The Greek constructs of space and time similarly affected all facets of the Greek culture. Since we are the children of their classical traditions, their ancient beginnings are freighted with consequence for us. There was another legacy of the Greeks' system of thought that, as we shall see, took centuries to overcome—the idea of the essential duality of reality. Democritus, in the fifth century B.C., had declared that all the world was composed of only two elements: atoms and the void. This reduction of the myriad number of forms to only two was the ultimate in dualistic reasoning. Christianity adopted dualism when it created the strict divisions between good and evil and heaven and hell. Dualism is evident in the Cartesian philosophy of "in here/out there," and science's division of the world into observer and observed. While this notion of duality was a vital rung on the ladder of thought enabling us to reach the next higher plateau, for a very long time it has impeded our climb.

The conquering Romans embraced the Greek worldview and modeled their culture after it. The classical world lasted approximately eight hundred years (400 B.C. to A.D. 400). The Romans, a practical people, accepted the Greek conventions concerning space, time, and light along with almost every other facet of Greek culture. Given the duration and scope of it, the wonder of the Pax Romana is how very little innovative thinking concerning these ideas actually took place. Perhaps it was this dearth of originality and slavish devotion to the classical ideals of the earlier Greek culture that

caused this paradigm to lose its vitality. But lose it, it indeed did. Christianity, which became ascendant by A.D. 400, eclipsed the rational system conceived by Euclid, Plato, and Aristotle. Christian conceptions of the world proposed notions of space, time, and light that were radically at odds with those of classical Greece.

All curiosity is at an end after Jesus, all research after the
Gospel. Let us have Faith and wish for nothing more.
Tertullian, a third-century Roman convert to Christianity

CHAPTER 3

SACRED / PROFANE

Early Christianity rested upon the belief that the Bible, which pur-
ported to contain the Word of God, was infallible. Since all answers
to all questions were to be found between its covers, the laws of
logic were essentially dismissed from A.D. 400 to A.D. 1250. St. Augustine,
the most influential architect of the medieval mind, invalidated the hard-
won truths of classical antiquity when in his *City of God* (A.D. 415) he
proclaimed:

> When . . . the question is asked what we are to believe in regard
> to religion, it is not necessary to probe into the nature of things,
> as was done by those whom the Greeks call *physici*; . . . It is
> enough for the Christians to believe that the only cause of all
> created things . . . whether heavenly or earthly . . . is the good-
> ness of the Creator, the one true God.[1]

Euclid's smooth space cracked and splintered under the weight of the
authoritative New and Old Testaments. In this theological topography,

space became fragmented. It lost its homogeneity and could no longer be measured. Heaven was up and hell was down, but neither was connected to the space of everyday occurrence. As the anthropologist Mircea Eliade writes in *The Sacred and the Profane*: "For religious man, space is not homogeneous; he experiences interruptions, breaks in it."[2] This ubiquitous acceptance of disconnected "regions" of space led to its further conceptual fragmentation. The place into which sailors disappeared when they fell off the end of the earth was qualitatively different from the familiar kind of space back home. Even heaven was subdivided: The outermost region was the purest and was called the *seventh heaven*.

The picture that prevailed in medieval Christendom was that of a flat table of earth that lay beneath a huge vault, the ceiling of which was the heavens. No one was sure what was above the ceiling or, for that matter, below the table. These regions were spiritual spaces, and so beyond the reach of human abstraction—not chartable by Euclid's straight lines or by the postulates of his plane geometry.

As space fractured, knowledge of the alphabet slid silently into its cracks. Illiteracy became the norm. In Europe of A.D. 800; for the preceding five centuries no layperson, from kings and emperors downward, could read or write.[3] Those in monasteries who still could were remanded to distinguish between carnal and spiritual divisions. Within a relatively short span of years, vows of silence replaced the voices of disputation.

During the early Christian era, time, too, lost the smooth sequential linearity that marked it in the classical period. Like space, it splintered into jagged slivers. According to St. Augustine, nothing occurred before Genesis. Time began with God's creation of the universe in 5000 B.C. and would end on Judgment Day. At that moment, the future would disappear and be replaced by eternity, which was a qualitatively different kind of time.

Eternity differs from the future in that the rules of causality govern the latter but are absent from the former. In eternity nothing ever "happens." There can be no history in heaven because there are no "events" to record. Birth, death, falling in love, learning, working, having children, none of these crucial milestones that mark earth's time can ever occur in heaven. The very place where eternity occurs is not connected to the human arena. As St. Augustine pointed out, time was a feature of the world that God had created. Since He Himself had invented time, therefore, it would be a fallacy to believe that God existed in it. (Where was God standing before He created both time and space? Augustine would ask.) Divine time could not be synchronized with earthly time because they were fundamentally different.

Jesus' life was so crucial to early Christianity that its central circumstances dominated calendars, thought, and research. Worldly time slowed and became mired in past events as the focus of Christian attention became what *had* happened during the life of Jesus. Past, present, and future retained a semblance of sequence but became frayed and disjointed just as space had become tattered and disconnected. Contemporary art critic José Argüelles, acknowledging the sharp shift in the notion of time, wrote:

> The source of this misunderstanding is to be found in the orthodox Christian doctrine of the uniqueness of the event of Christ, which alone gives meaning to all other events. From the Christ-event to the Second Coming, in the Christian view, all human activity takes place in unrepeatable units, redemption being possible only by relation to the unique Christ-event. This doctrine is absolutist and terrifyingly single-minded. It breaks from the traditional view, common to most world cultures, that time is cyclic and that the meaning of human existence is related to certain recurring cosmic patterns.[4]

● The great Western tradition of classical art and physics was demolished and then ground into dust. Besides extensive book burnings, the zealous Church Fathers set out to obliterate every work of art that remained from classical antiquity. In the sixteenth century, Vasari, the first art historian after the medieval period, looked back upon these fogs and bogs of the human condition and lamented this incredible slaughter of the innocents. In his book *Lives of the Artists*, Vasari (deeply moved by his own bias) described this aesthetic holocaust:

> But what inflicted incomparably greater damage and loss on the arts than the things we have mentioned was the fervent enthusiasm of the new Christian religion. After long and bloody combat, Christianity, aided by a host of miracles and the burning sincerity of its adherents, defeated and wiped out the old faith of the pagans. Then with great fervour and diligence it strove to cast out and utterly destroy every last possible occasion of sin; and in doing so it ruined or demolished all the marvellous statues, besides the other sculptures, the pictures, mosaics and ornaments representing the false pagan gods; and as well as this it destroyed countless memorials and inscriptions left in honour

of illustrious persons who had been commemorated by the genius of the ancient world in statues and other public adornments. Moreover, in order to construct churches for their own services the Christians destroyed the sacred temples of the pagan idols. To embellish and heighten the original magnificence of St Peter's they despoiled of its stone columns the mausoleum of Hadrian (today called Castel Sant'Angelo) and they treated in the same way many buildings whose ruins still exist. These things were done by the Christians not out of hatred for the arts but in order to humiliate and overthrow the pagan gods. Nevertheless, their tremendous zeal was responsible for inflicting severe damage on the practice of the arts, which then fell into total confusion.

As if these disasters were not enough, Rome then suffered the anger of Totila: the walls of the city were destroyed, its finest and most noble buildings were razed to the ground with fire and sword, and then it was burned from one end to the other, left bereft of every living creature and abandoned to the ravages of the conflagration. For the space of eighteen days not a living thing moved; Totila tore down and destroyed the city's marvellous statues, its pictures, mosaics, and stuccoes. As a result, Rome lost, I will not say its majesty but rather, its identity and its very life . . . In the end there was left not the slightest trace of good art.[5]

The result of the destruction of Greco-Roman art and thought led to the long night of the Dark Ages. Antirational mists enshrouded these early centuries of the medieval period so that the artists emerging in the middle- and late-medieval period had no traditions on which to base their work. They were forced to invent new forms. Their fresh start would contain an accurate reflection of the larger culture's thinking about space, time, and light.

Early churches contained wide expanses of empty walls. Since literacy was lost, it became necessary to revert to simple images in order to tell the story of Christ. High on the walls of the churches and frequently filling their domes, a new art form emerged that was the perfect metaphor for the early Christian conceptions of space: the mosaic, a large composition pieced laboriously together out of small square chips of colored glass and tile (Figure 3.1). The glittery expanse of reflecting *tesserae* ("squares")

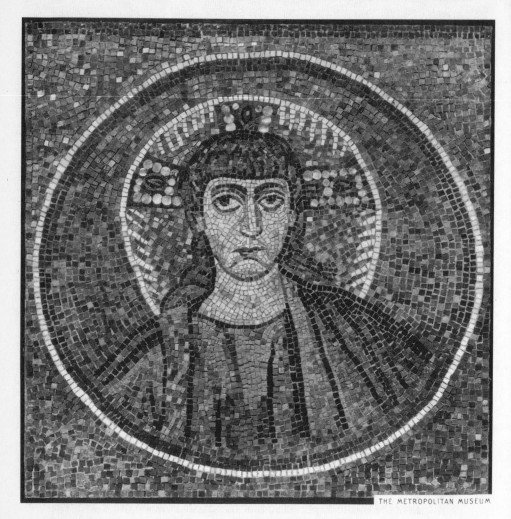

THE METROPOLITAN MUSEUM

Figure 3.1. Portrait of Christ, *Byzantine mosaic (late fifth century–early sixth century), Archbishop's Palace, Ravenna* THE METROPOLITAN MUSEUM OF ART, JOHNSTON FUND, 1924 (24.144.6)

dissolved the substantiality of matter into an immaterial image that underscored the principal message of the Gospels.

Although the Greeks and Romans used mosaics in their tiled floors, this art form did not reach its full development until the early Christian era. A mosaic breaks up space into sharply distinctive pieces—and yet produces a coherent image.

In both the mosaic and in early Christian theology, space was discontinuous. Regions were connected, however, on a grander spiritual level.

This higher order reunited the separate individuals of Christendom and the fragmented medieval spaces into a seamless continuum. Each piece of a mosaic is a small part; the sum of the parts makes up a whole that is greater than the totality of the individual pieces. Mosaics and theological theory had as their premise the same belief about space and life. Discontinuous space came also to characterize frescoes, paintings, and, later, stained-glass windows.

The subtle message contained within the form of the mosaic permeated every aspect of the early Christians' conception of space. The feudal system, which represented the cracked remains of the centralized bureaucracy of Imperial Rome, created a jigsaw puzzle mosaic of the entire map of Europe. The smooth, reassuring universality of Latin tattered into thousands of local dialects and vernaculars. Early Gothic script was crabbed and difficult to read: A page resembled nothing so much as a wall mosaic, more perhaps to be looked at than read. The word "text" derives from the Teutonic *textura*, which really meant "tapestry." Each Gothic letter in this tapestry was like a glittering glass piece of a wall mosaic.

Books themselves contained the writings of numerous people, juxtaposed haphazardly without regard for authorship. Each early manuscript was in itself a mosaic of the thoughts of diverse thinkers and commentators. Early fresco painters, working anonymously, did not treat space in any strict coherent geometrical manner. Rather, these unknown craftsmen used space to arrange a jumble of disconnected images knit together on a symbolic level.

At its inception, Christian art also reflected an alternative conception of time. By effectively effacing the rules of causality, prophecy gained dominion over reason and mysticism shared the stage with ignorance and superstition. As early Christian artists disregarded conventions of linear causality and sequence, so important to the earlier Greek paradigm, so time frames within their art assumed a similar nonlinear elasticity.

Artist Gyorgy Kepes points out in his book *The Language of Vision*:

> Early medieval painters often repeated the main figure many times in the same picture. Their purpose was to represent all possible relationships that affected him and they recognized this could be done only by a simultaneous description of various actions.[6]

The representation of the same figure occupying more than one location and in more than one posture is a flagrant violation of logic and sequence.

According to Euclidean geometry, a point cannot occupy more than one locus. Further, when a single figure performs more than one action in one canvas, different moments converge simultaneously and violate the tenets of causality. The medieval artists splintered time just as they had fractured space. Contemporary literary critic Georges Poulet in his *Studies in Human Time* writes:

> For the man of the Middle Ages, then, there was not one duration only. There were *durations*, ranked one above another, and not only in the universality of the exterior world but within himself, in his own nature, in his own human existence.[7]

Time was no longer perceived as a straight geometrical arrow. Instead it meandered into different zones, profane and divine. Consequently, the incisive edge of analytic logic became blunted, and reason could no longer be relied upon to sort out events in their proper order. If events did not have a correct sequence, logic was useless.

Just as the notions of space and time that prevailed in the medieval mind were different from the Greek ones, light in early Christian thinking ceased to belong to the external world alone. According to these religious beliefs, light did not travel from a source through space and time. It was instead an ectoplasmic manifestation of the Spirit; a bridge between this world and another. Light originated from within the soul and its rays were the vehicle a soul could use to get from one space to another, as well as from one kind of time to another. The artist depicted light as a spiritual essence: either as a luminous halo or as inner radiance.

It was divine light that shone through the letters in the words of the Bible. Origen, an early-third-century Greek Church Father, exalted this concept:

> Blessed are the eyes which see divine spirit through the letter's veil.[8]

The dual meaning of the word "gloss" reveals the idea of a spiritual luminosity backlighting the letters of the words in the Bible. Originally derived from the Latin word for "tongue," "gloss" took on a new meaning. Something that had a gloss began to shine. This shine was the Word of

God coming through the letters. The *gloss* released the light from within the text. Books were "illuminated" so that light could come *through* rather than flow *on* the page. Thus, both our present English words "glossary" and "glossy" derive from this earlier confusion regarding the true meaning of the white background upon which words are written.

The idea that light was an essence that could pierce substance was a fundamental belief of the age of faith. Light not only connected souls and backlit the message of the Bible, it could also pass through solid matter. In his book, *The Gothic Cathedral*, Otto von Simson describes this unique property of medieval light:

> In a Romanesque church, light is something distinct from and contrasting with the heavy, somber, tactile substance of the walls. The Gothic wall seems to be porous: light filters through it, permeating it, merging with it, transfiguring it. . . . Light, which is ordinarily concealed by matter, appears as the active principle; and matter is aesthetically real only insofar as it partakes of, and is defined by, the luminous quality of light. . . . In this decisive aspect, then, the Gothic may be described as transparent, diaphanous architecture.[9]

Though light had a mysterious quality that allowed it to shine through matter, the rediscovery of glass by medieval craftsmen did not principally lead to the construction of windows that worshipers could see *through*. No windows were placed for a congregation anywhere near eye level. Rather, craftsmen placed colored-glass windows high in the walls of cathedrals, permitting only light from above to enter. The effect of rippling chromatic rays playing upon the thin interior pillars enhanced the idea that matter was insubstantial and of no real concern. Light was of the Spirit. A church was not a place where ordinary mortals needed to be reminded of or distracted by the mundane and severe existence of a "real" world outside.

The Christian worldview of space, time, and light dominated Western thought for a thousand years. In this time of faith, science was replaced by an original, complex, theological system of belief. The artist, beginning from near ignorance, produced the metaphors to express the spirit of this era. The mosaic spoke directly to a new conception of space,

time, and light as well as to other facets of this disjointed age. During this millennial period this radical reaction to the classical worldview pulled the string so taut in the opposite direction that when the rebound did occur it would carry Western civilization far past the mark set by the ancient Greeks.

There is nothing which Giotto could not have portrayed in such a manner as to deceive the sense of sight.

Boccaccio

In questions of science the authority of a thousand is not worth the humble reasoning of a single individual.

Galileo

CHAPTER 4

STATIONARY PERSPECTIVE / ABSOLUTE REST

During the late medieval period, curiosity, jolted by the prod of literacy, stirred from its slumber of a thousand years. Words, once again, became the tools of thought rather than objects of worship. Beginning in the Renaissance, stimulated by a voracious hunger for the knowledge of the ancients, virtually every classical truth that could be exhumed was embraced. Johann Gutenberg's invention of movable type in 1455 reinforced the primacy of the written word. The concept of space organized along Euclidean axioms quickly reestablished itself. Time, too, fell into line, and once again was characterized by sequence. The multiple religious time frames of the medieval age were superseded by a temporality that was more in keeping with the strict linearity of typeset.

The book, placed in the hands of the individual, allowed any person to

drift away from the crowd in church and be alone. Individuality reasserted itself in this solitude and began to dominate the art and thought of Western civilization as it would continue to do far into the future. It was the diffusion of books that split the landmass of the Church into an archipelago of individual thinkers.

The early years of the fourteenth century were a gestational period in human history. An intense interest in craft during the previous century had quickened the rate of technological innovations that pulsed through the late medieval period. Like the spreading roots of a tuber, the cultural impact of the development of craft was almost invisible. But the flower of the Renaissance that blossomed from it was an outgrowth of its inventive and practical applications.

One person who uplifted the human intellect and spirit in those years was the artist Giotto di Bondone (1276–1337). Vasari praised Giotto thus:

> In my opinion painters owe to Giotto, the Florentine painter, exactly the same debt they owe to nature. . . . It was, indeed, a great miracle that in so gross and incompetent an age Giotto could be inspired to such good purpose that by his work he completely restored the art of design, of which his contemporaries knew little or nothing.[1]

Vasari, writing several hundred years after the fact, recounts the legend of Giotto's childhood. As a precocious peasant child, Giotto when tending sheep whiled away his time by drawing figures in the dust with his shepherd's staff. The famous Italian artist Cimabue heard of this prodigy and stopped along the road to ask the young Giotto to draw some figures for him. Impressed by the results, Cimabue offered Giotto's parents an apprenticeship for their son, and took him back to his studio in Florence.

As the years passed, Giotto's skills at representation surpassed those of his mentor. Giotto was the first artist of record to understand intuitively the benefits of painting a scene as if it were viewed from a stationary point of view that was organized about a horizontal and vertical axis. Without ever expressing it in so many geometrical axioms, Giotto returned Euclid's conception of space back into the picture plane of art. As a result, the flat picture writing that had been the style for a thousand years suddenly acquired the third dimension of depth. An example of Giotto's mature style is his *Encounter at the Golden Gate* (1306) (Figure 4.1). Giotto's "proto-perspective" places the central focus of the viewer outside and in front of the canvas. Within a generation almost every artist who saw his work could

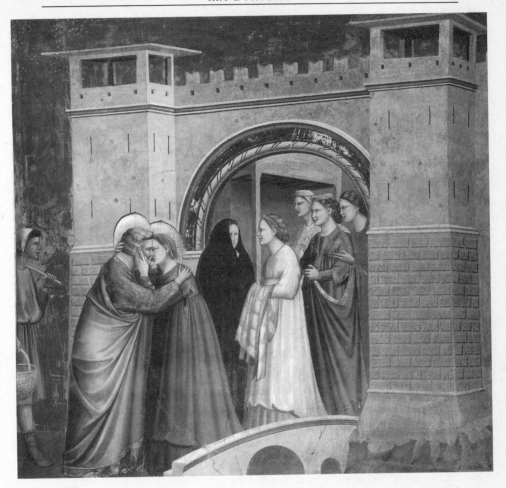

Figure 4.1. *Giotto,* Encounter at the Golden Gate *(1306), Scrovegni Chapel, Padua* ALINARI-ART REFERENCE BUREAU

appreciate the advantages of painting or drawing so that all lines of sight coming off the painting converged to form an invisible inverted pyramid, the apex of which was the eye of the viewer (Figure 4.2).

Word of the wonder of Giotto's representational skills soon spread to Rome. Vasari tells a charming story of the pope's first encounter with Giotto:

> Giotto won such a reputation in Pisa and beyond that Pope Benedict IX, who was intending to have some paintings commissioned for St Peter's, sent one of his courtiers from Trevisi to Tuscany to find out what sort of man Giotto was and what

Figure 4.2. *In perspective, all lines of sight converge on the viewer's eye which is positioned in a stationary privileged location. This creates the illusion of recession to a nexal vanishing point.*

his work was like. On his way to see Giotto and to find out whether there were other masters in Florence who could do skilful work in painting and mosaic, this courtier spoke to many artists in Siena. He took some of their drawings and then went on to Florence itself, where one day he arrived at Giotto's workshop to find the artist at work. The courtier told Giotto what the Pope had in mind and the way in which he wanted to make use of his services, and, finally, he asked Giotto for a drawing which he could send to his holiness. At this Giotto, who was a very courteous man, took a sheet of paper and a brush dipped in red, closed his arm to his side, so as to make a sort of compass of it, and then with a twist of his hand drew such a perfect circle that it was a marvel to see. Then, with a smile, he said to the courtier: "There's your drawing."

As if he were being ridiculed, the courtier replied:

"Is this the only drawing I'm to have?"

"It's more than enough," answered Giotto. "Send it along with the others and you'll see whether it's understood or not."

The Pope's messenger, seeing that that was all he was going to get, went away very dissatisfied, convinced he had been made a fool of. All the same when he sent the Pope the other drawings

and the names of those who had done them, he also sent the one by Giotto, explaining the way Giotto had drawn the circle without moving his arm and without the help of a compass. This showed the Pope and a number of knowledgeable courtiers how much Giotto surpassed all the other painters of that time. And when the story became generally known, it gave rise to the saying which is still used to describe stupid people: "You are more simple than Giotto's O." This is a splendid witticism, not only because of the circumstances which gave rise to it but also because of the pun it contains, the Tuscan word *tondo* meaning both a perfect circle and also a slow-witted simpleton.[2]

Besides infusing Euclidean space back into art, Giotto also redefined the artist's framework of time. He treated each instant of visual experience like a fluttering butterfly that he captured and pinned to his canvas. From Giotto until the modern era, this convention became the standard with each painting representing only one frozen instant viewed as if it were on a lighted, three-dimensional stage. Gone were the simultaneous representations of different temporal events in one work of art. This device, evident in the Bayeux Tapestry (A.D. 1073), among others, all but disappeared from Renaissance art. Not only did Giotto single-handedly create a new way to envision and organize space, he also isolated for art the frame of stopped time.

Light still presented problems that Giotto could not solve as evidenced in his fresco *The Pentecost* (1305) (Figure 4.3). Torn between representing the halos of the saints in the correct perspective, or according to the older medieval concept of light, Giotto tried to blend features of both systems. He depicted the Pentecostal feast as it would be drawn if seen in perspective. The Apostles in the forefront are facing Christ so that their backs are to the viewer. Christ and the other Apostles are seated across the table facing the viewer. Giotto placed the halos about the heads of Christ and those seated adjacent to him in their traditional renderings behind the head.

For the Apostles who faced Christ, however, Giotto could not determine where to place their halos. If he positioned them where they ought to be, that is, closer to the viewer, on top of the diners' necks would be only round yellow circles. Since this was unacceptable, he compromised and placed the halos as they were painted in earlier medieval works, on the distant side of the head, that is, away from the viewer. The ludicrous result was that the saints facing Christ were forced to eat the Pentecostal feast

Figure 4.3. *Giotto,* The Pentecost *(1305)* MUSEO CIVICO, PADUA

through rings of light! Despite the delicious folly of it, Giotto, innovator that he was, could not resolve the problem because he stood at the interface between one paradigm and another.

An extraordinary congruency between art and physics occurred a few years after Giotto reorganized pictorial space. In the 1360s Nichole d'Oresme, a medieval schoolman, introduced a graphic means to plot scientific functions.[3] The graph, an indispensable tool of science, gave to thinkers the means to express visually the concepts of motion, time, or space on a piece of paper intersected by a horizontal abscissa and vertical ordinate. The ability to make abstract concepts visual was an absolute prerequisite for the scientific discoveries that followed. It is hard to imagine

any of the sciences progressing as they have without graphs. The key geometrical principle underlying art's perspective and science's graphs is essentially the same.

In 1435, a century after Giotto's death, Leon Battista Alberti published a formal treatise on perspective in which he seized upon the crucial importance of a single "vanishing point" that lay at the intersections of horizontal and vertical perpendiculars. Alberti made extensive use of Euclidean principles in order to instruct subsequent artists in this new technique. The Renaissance painters who followed increasingly were able to represent the world with precise accuracy. Implicit in their art lay a totally new paradigm regarding space, time, and light, which replaced the one that reigned supreme in the Christian era.

The beginning development of perspective by Giotto and its elaboration by Alberti and other artists was a revolutionary milestone in the history of art. By painting a scene from one stationary point of view, an artist could now arrange three axes of the geometry of space in their proper relationships. Perspective, which literally means "clear-seeing," made possible a new, third dimension of depth. Using perspective to project a scene upon a two-dimensional surface made the flat canvas become a window that opened upon an illusory world of stereovision. Literally and compositionally, art came down to earth as the horizon line became, for the Renaissance artist as for the seaman exploring the globe, the most crucial orienting straight line.

In his incisive book *Art and Geometry* William Ivins explains the difference between perspective and what had preceded its discovery:

> Perspective is something quite different from foreshortening. Technically, it is the central projection of a three-dimensional space upon a plane. Untechnically, it is the way of making a picture on a flat surface in such a manner that the various objects represented in it appear to have the same sizes, shapes, positions, *relatively to each other*, that the actual objects as located in actual space would have if seen by the beholder from a single determined point of view. I have discovered nothing to justify the belief that the Greeks had any idea, either in practice or theory, at any time, of the conception contained in the italicized words in the preceding sentence. . . . It is an idea that was unknown to the Greeks, and it was discovered at a time so ignorant of geometry that Alberti thought it necessary to explain the words diameter and perpendicular.[4]

John Russell summed up the importance of this discovery:

> By taking as its first premise a single point of vision, perspective
> had stabilized visual experience. It had bestowed order on chaos;
> it allowed elaborate and systematized cross-referencing, and
> quite soon it had become a touchstone of coherence and even-
> mindedness. To "lose all sense of perspective" is to this day a
> synonym for mental collapse.[5]

For some critics, the shift from sacred symbolism to realistic art had a
price. Argüelles deplored the acceptance of perspective:

> In the mechanical, rigidly perspectival visual system of the post-
> Renaissance West, the center is in the individual ego outside of
> the window frame, and not within the work of art itself; this
> amounts to saying that there is no longer any sacred center, for
> visual art no longer functions as a divine symbol but simply as
> the picture of an imaginary world.[6]

But for most people, perspective was a surprising and delightful technical
advance, embraced as enthusiastically as computer technology is today.
Renaissance parents urged their children to become professional perspec-
tivists because this skill was much in demand. Someone who knew the
rules of perspective could easily find employment in the military calculating
the trajectories of missiles hurled at the enemy. More pacific occupations
such as cartography, navigation, architecture, drafting, and engineering
all soon demanded apprentices grounded in the principles of perspective.

Coincident with Alberti's treatise, a contemporary Florentine artist Piero
della Francesca introduced the shadow into art, and with it a great truth
about the nature of light. Before Piero, painters generally depicted objects
in cartoon fashion, without shadows. If shadows were included in a painting,
they were for the most part inconsistent and confusing because the painters
did not understand the organizing benefits of perspectivist space. Piero's
shadows fell consistently on the side opposite the light source. Ernst Gom-
brich describes this Italian master's innovation:

> Piero had mastered the art of perspective completely. . . . But
> to these geometrical devices of suggesting the space of the stage
> he has added a new one of equal importance: the treatment of
> light. Medieval artists had taken hardly any notice of light. Their

flat figures cast no shadows. Masaccio had also been a pioneer in this respect . . . the round and solid figures of his paintings were forcefully modeled in light and shade. But no one had seen the immense new possibilities of this means as clearly as Piero della Francesca . . . light not only helps to model the forms of the figures, but is equal in importance to perspective in creating the illusion of depth.[7]

From the vantage of the late twentieth century, we are so accustomed to this feature of shadow that we are perplexed as to why such an obvious characteristic of reality was not noted at a much earlier date.

Piero could make his discovery about shadows only after the artist's space had reverted to Euclidean and time once again had became sequential. Once space conformed to all the postulates of classic geometry, Piero could propose that light also traveled in a straight line in the three-dimensional scene depicted within the still frame of a painting. His experiments concerning the nature of light preceded by two hundred years investigations by physicists such as Newton and Leibniz into light's nature. Shadow, the absence of light, became one of the unique hallmarks of light in Renaissance art. From the fifteenth century onward, with few exceptions, light was something that flowed *on* rather than an essence that pierced *through*.

Beside giving shape to the third dimension of depth, Piero's refinement of shadow had another profound effect on art. Since the early days of human civilization, shadows have been used to tell time. The very first clocks were sundials that divided the time of day based solely upon the shadow cast. The slant of the sun supplies critical clues about the time of day, and its angle of declination can be used to figure out the season of year as well. Although early Byzantine painters had been familiar with the use of shading, it had taken the genius of Piero della Francesca to introduce the shadow, the most important signifier of time, and with it a time sense absent from early Christian art.

Eratosthenes had connected shadow and time in the third century B.C. to demonstrate that the earth was round and to calculate its circumference. Without the use of a single scientific instrument, using his powers of observation alone, he noted that the sun shone directly upon the deep surface of a well at noon on the summer solstice in Syrene, Egypt. Learning that the sun's zenith cast a slight shadow of 7°30′ at that same moment, five hundred miles north at Alexandria, Eratosthenes deduced the spherical nature of the earth and calculated its approximate circumference to within three thousand miles. This fantastic achievement regarding the shape of

space was possible because Eratosthenes understood how shadows reveal time. Piero della Francesca's painterly innovation has much in common with the intellectual triumph of a Greek scientist fifteen hundred years earlier.

Having acknowledged the importance of shadow, Renaissance painters refined the technique of shading and introduced new terms into art to define light and shade. Chiaroscuro, which literally means "clear-dark" in Italian, referred to the abrupt change from light to shadow that occurs whenever an object or a person stands in strong light. Caravaggio, a sixteenth-century Baroque master, is famous for his powerful use of chiaroscuro.

Leonardo da Vinci (1452–1519) refined another feature of shadows—sfumato, which is the opposite of chiaroscuro. The word literally means "turned to vapor." Leonardo noted that shadows of objects seen off in the distance are not as sharp as those viewed close up, and that distant objects are not as crisp in outline as those nearer the eye. He recommended that artists make allowances for these subtle atmospheric conditions so as to render more accurately the landscape of nature.

The painter's invention of perspective was coexistent with a new scientific perspective of the world. Modern science was born in the Renaissance. For the first time fledgling scientists began to compare ancient Greek philosophical speculations with actual observations from nature. When logic merged with experimental data, the scientific method was born. Observation by means of measurement and number became the crux of the new science. Perspective had already required careful measurement and direct observation of nature before the major scientific discoveries of the sixteenth century.

Beginning in the Dark Ages, people believed for a thousand years that only God could change the world. People in the fifteenth century discovered that they too could make a difference. Emboldened by the advances in art and science, the citizen of these times began to feel that his or her unique point of view could have validity. One of the pivotal works of the Renaissance was the *David* of Michelangelo (1501). His monumental freestanding sculpture is notable in that, for the first time in centuries, the principal subject was not invested with the spirit of God. As David was a young mortal armed only with courage and a slingshot, so a victory against great odds became the metaphor of this creative period. The members of medieval society had lived in a mosaic. Personal opinions had little value. Medieval communities prized self-effacing team effort so much that individual names are rarely attached to medieval works of art. Painters and sculptors devoted their

energy to depicting God and the Holy Family paying little heed to the
vicissitudes of ordinary mortals. In the Renaissance, by contrast, man
emerged as the hero: not Zeus, not Wotan, not God, but the industrious,
creative citizen of the new age. Michelangelo's *David* signaled that the
collaborative efforts required to construct a Gothic cathedral were largely
over: Michelangelo had helpers, but he did not have a partner. The science
and art of this age were expected to be the creation of one person working
alone. The age of the solitary hero had begun.

The Renaissance gave new meaning to the axiom of the ancient Greek
philosopher Protagoras: "Man is the measure of all things that he is and
that he is not." The belief in people's ability to judge for themselves en-
gendered a new self-confidence and enthusiasm for the integrity of each
person's singular ideas which coalesced into a philosophy called Humanism.
In the spirit of the age, Leonardo created a symbol of this confidence in
his image of a nude man with outstretched arms circumscribing both a
square and a circle *(Proportions of the Human Figure)* (1501) (Figure 4.4).
The new self-respect is evident in Alberti's exhortation to his fellow Hu-
manists.

> To you is given a body more graceful than other animals, to
> you powers of apt and various movements, to you most sharp
> and delicate senses, to you wit, reason, memory like an immortal
> god.[8]

As Humanism encouraged each individual to develop his own unique point
of view, man became both the measure and the measurer of all things.

Once the third dimension of space appeared in art beginning in the
fourteenth century, someone soon had to notice that the third dimension
in the real world was relatively lackluster and undeveloped. The expiring
medieval paradigm had posited a flat disk of Earth situated at the center
of the cosmos, and a vaulted, enclosed heaven full of unchanging celestial
bodies wheeling in stately, predictable movements overhead for all to see.
Every twenty-four hours the sun arose in the east and set in the west. The
moon and stars traveled the same, well-plowed paths; the commonsense
consensus was that the Earth was in the center and everything revolved
about it. Furthermore, the scholars of the Church declared that statements
in the Bible emphatically confirmed this arrangement.

Nicholas Copernicus (1473–1543), a Polish cleric and amateur astron-
omer, had doubts about the Church's authorized version of the world. He
puzzled over the strange orbits of the planets, which, unlike the other

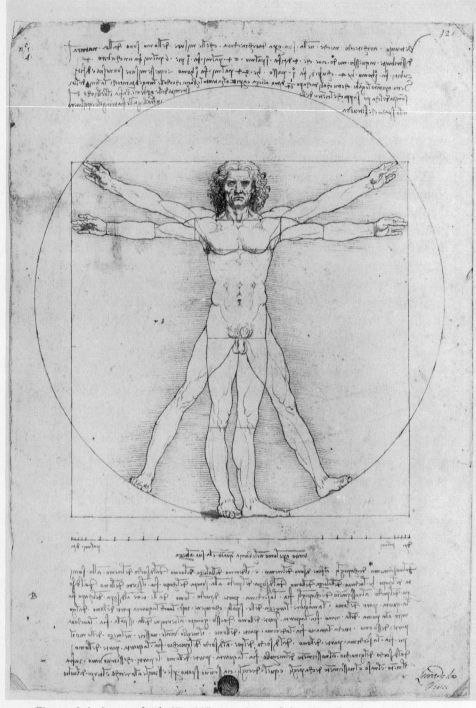

Figure 4.4. *Leonardo da Vinci,* Proportions of the Human Figure *(1501)*
GALLERIE DELL'ACCADEMIA, VENICE

heavenly bodies, did not participate in the regular east-west procession. Mars, for example, after traveling east to west as expected, seems to be arrested in its motion for several nights and then mysteriously begins to travel backward from west to east, going against heavenly traffic. Several nights later, after its enigmatic peregrination, Mars once again resumes its expected orbit traveling east to west. The question troubling astronomers since antiquity was: Why does the planet make this strange loop in its course?

In recognition of their unique place in the heavens, the very word "planet" is derived from the Latin word for wanderer. Before Copernicus's time, many ingenious, convoluted explanations had been offered for these few troubling trajectories. Ptolemy, a Greek astronomer of the second century A.D., who made many other significant contributions, unfortunately is remembered as the perpetrator of the false assessment that the universe was geocentric. Subsequent thinkers, including Church authorities, accepted Ptolemy's design for over a thousand years. His scheme was so complicated, however, that when King Alfonse of Castile was first briefed on its details, he suggested that if this were truly a creation of Divine inspiration, perhaps he, Alfonse, could have given God some better advice.[9]

Copernicus introduced a radical solution to the age-old mystery of the planets, which derived from what is essentially an artist's perspectivist question. He asked himself, "How would the orbits of the planets appear if viewed from the vantage of the sun instead of from the earth?" In his flash of insight, belief in the previous system was doomed. The hub of the solar system *was* the sun, he realized. Copernicus, stepping outside the existing model of the solar system and looking back on it from an imaginary outside perspectivist point of view, was able to rearrange the planets and the sun in an entirely new way. His revolution achieved for the space of science what Giotto's perspective had done for the territory of art. The "underdimensional" medieval worldview was expanded to encompass a larger richer third dimension of depth. Copernicus was a cautious man, however. Knowing that his theory would produce a major controversy, he waited until the end of his life before publishing a book about it. The first copy off the press was handed to him on his deathbed in 1543.[10]

Had Copernicus proposed his theory in ancient Greece, detractors and supporters would have sat about in the groves of academe to debate its merits and weaknesses.* In the Humanist Renaissance, however, scientists understood that they had to check it against the raw facts.

*In the third century B.C., when Aristrachus of Samos proposed the heliocentric model of the solar system, his opponents accused him of impiety.

The most famous of this new breed of scientists was Galileo Galilei (1564–1642). As a young man, Galileo learned about an astounding new invention developed by the Dutch. A hollow tube with a ground-glass lens affixed to each end enabled its user to see distant things as if they were closer. The military and commercial implications of such a device were enormous, especially for such rival seagoing states as the Netherlands and the city-states of Italy. Instead of training his new telescope upon the Earthbound horizon, however, Galileo raised its sights to the heavens and began the first investigation of celestial movements with the aid of this new invention.

When he discovered that Jupiter had four moons that orbited about it, he happily concluded that Copernicus was right. Many intellectuals had scoffed at Copernicus's scheme because the moon obviously circled the earth. If the sun was at the center of the solar system, why then, they would ask, does the moon singularly continue to circle the earth instead of joining all the other planets in their turn about the sun? If other planets could have satellites circling about them, then the objection about the earth's satellite was answered. But when Galileo tried to show the school-men of Padua the moons of Jupiter through his telescope, they steadfastly refused to believe the evidence of their senses and claimed that there were merely too many specks of dust within Galileo's contrivance.

In the years following the publication of the Copernican theory, many serious objections continued to be raised. His critics asked, if the earth hurtled through space, rotating every twenty-four hours, then why wasn't everyone and everything flung off its surface? Further, they persisted, why didn't everyone fall off when, because of the earth's rotation, they stood upside down with the solid earth above and empty space below?

Galileo said no one would fly off the earth for the same reason that a passenger aboard a ship moving at a uniform speed is not flung off its decks. If the passenger goes below and stands still with all the portholes closed as the ship (like the earth) moves at a constant speed, the passenger could not detect any movement unless he could see out the porthole. Thus only by comparing his position with a second frame of reference could the passenger say with assurance that he was in motion. Like the passengers on the deck of a ship, people, cows, and horses traveled with the earth, and, therefore, did not fly off. Galileo's ingenious conception of an *inertial frame of reference* was a key feature of what would later be known as the theory of Galilean relativity.

When Galileo displaced a static earth as the center of the universe and sent it whirling and twirling about the sun, he replaced the idea of a

stationary planet with a more universal concept that would become known as _absolute rest_.* Later, the Galilean (or inertial) frames of reference would be applied to _any_ system that contained a series of objects that all moved at constant speeds _relative_ to one another. The ship in Galileo's example, or the earth in the academics' objections, is each an inertial frame of reference for any movements _within each frame_. As far as a scientist is concerned, each inertial frame of reference is at absolute rest relative to all the many different motions going on within it. For the purposes of measurement, each inertial frame's motion relative to another _outside_ inertial frame need not be taken into account when measuring motions of things _inside_. For example, for the passenger measuring something in his cabin on a ship moving at a uniform speed or a scientist measuring something here on earth, both the passenger and the investigator are at _absolute rest_ within their respective inertial frames of reference.

In order to calibrate the essential new instruments of observation that enabled scientists to observe the solar system, such as the astrolabe, sextant, and the telescope, it was first necessary to locate a stationary locus in space: a universal Ground Zero, if you will, that did not move, and that would remain exactly the same for all the motions of the planets. In effect, it was this ideal place to stand that Galileo had invented.

The concept of absolute rest, a subtle idea at the heart of the new science of mechanics, was precisely the same principle that had enabled Alberti to formulate perspectivist rules nearly two centuries earlier. The viewer has to be at absolute rest, standing in a frame of reference that is favored over all the others, in order to view a perspectivist painting! The idea that one privileged place to stand might exist, differing fundamentally from every other place because this one vantage point was at absolute rest, elevated it to a position of superiority. These profound parallel discoveries in both art and physics affected the entire mind-set of Western thought for centuries to come.

No thoughtful Renaissance intellectual found Galileo's theory of relativity difficult to accept—indeed the new science embraced his notion of absolute rest so completely it became new a priori knowledge, so self-evident that it need not be proven. Although the concept of absolute rest would later support an entire erroneous edifice of scientific thinking, as we shall see, at the turn of the seventeenth century Galileo's radical ideas improved scientific accuracy enormously.

*Aristotle, too, had proposed the idea of absolute rest, but his was within an erroneous system of mechanics.

In a way, the notion of absolute rest is similar to the idea of the straight line. Just as there are an infinite variety of curved lines but only one straight line, so, too, are there an infinite variety of motions but only one non-motion: absolute rest. On this point, science does not differ from religion: It, too, seeks the unitary principle that hides behind the varieties of experience. The question—whether such a thing as a straight line or a platform at absolute rest really exists—was beyond asking in Galileo's time.

Galileo, at the age of seventeen, also discovered the laws of the pendulum. Elaborating these laws allowed Renaissance craftsmen to build better clocks. Once time could be chopped into separate pieces, like Euclidean space before it, time became mechanized, reduced to repeatable units between events. Harnessing time further led Galileo to investigate the concept of speed—that is, distance traveled in space in a certain amount of elapsed time—which had been discovered in the fourteenth century by philosophers at Merton College, Oxford. After Galileo the concept of speed became a routine part of science. The ability to measure both time and space accurately allowed a growing number of people to understand more fully what it meant to live on a spherical globe orbiting about the sun.

In the sixteenth century, cartography became a science and Gerardus Mercator squashed the image of a spherical earth so that it could be laid out on a flat piece of paper crisscrossed by ruler-straight lines. This grid of horizontal and vertical could then be integrated with the new divisions of time so that sixteenth-century mariners could fix their ships' location in space by correlating their ships' time. Eventually, all mariners agreed on a planetary standard: Greenwich time. The sextant, an instrument to measure space, could accurately synchronize time. Latitude and longitude, the language of space, are measured in minutes and seconds, the language of time. The beginning integration of these two coordinates became indispensable for Renaissance explorers as they learned to orient themselves in the here and now of a newly conceived world. The resurrection of Euclid's principles of plane geometry to map the round planet according to Mercator's ideas, and the new feeling of mastery over nature, were evident when Shakespeare in the early seventeenth century has King Lear pronounce upon the unrolling of a map, "Strike flat the thick rotundity o' the world."

Despite his many significant contributions, Galileo died beset upon and saddened. Threatened with the rack by the Inquisition, he was forced to recant his belief in the Copernican theory in an infamous trial at the Vatican and lived out his remaining years under house arrest. In an ironic twist of fate, partly as a result of staring at the sun through a telescope, the man

who studied the light of the heavens lost his sight in his old age. Writing to a friend, Galileo lamented:

> This universe, that I have extended a thousand times . . . has now shrunk to the narrow confines of my own body. Thus God likes it; so I too must like it.[11]

In his epic poem *Paradise Lost*, John Milton, who was also blind, covertly refers to Galileo when he describes the biblical Samson as "Eyeless in Gaza at the Mill with slaves." Samson, too, had been struck blind by his tormentors. Yet even in his captivity and infirmity, he was able to bring down the pillars of the temple. Galileo, though old and blind, destroyed an entire paradigm that had been built upon the Rock of Ages.

The Humanists, armed with ancient wisdom and new science, faced the future with confidence. The artist and the physicist, Giotto and Galileo, played leading roles in bringing about that feeling of mastery. In 1642, the same year that Galileo died in Italy, Isaac Newton was born in England. Before presenting the story of this giant's contribution to physics, we must consider the insights of Galileo's contemporary Johannes Kepler and his relationship to the art of an earlier period.

To make clear my exposition in writing this brief commentary on painting, I will take first from the mathematicians those things with which my subject is concerned.

<div align="right">Leon Battista Alberti</div>

I have the answer, the orbit of the planet is a perfect ellipse.

<div align="right">Johannes Kepler</div>

CHAPTER 5

CONIC SECTIONS / ELLIPTICAL ORBITS

Copernicus's heliocentric theory produced a hubbub of arguments in universities and taverns all across Europe. In formulating his theory of relativity, Galileo had done much to silence the Copernican detractors, but there remained another significant problem. Master mathematician that he was, Copernicus still had to introduce numerous artificial convoluted constructions in order to force the planets' observed orbits to conform to his heliocentric theory. The last and most serious objection to Copernicus's heliocentric theory was that it seemed too complicated to be a divine creation. After all, the critics pointed out, Copernicus had to *increase* the number of rococo epicycles over Ptolemy's in order to match his theory with the observed positions of the planets. In this regard, his system was not an improvement on Ptolemy's generally accepted scheme.

The idea that the cosmos is made of celestial bodies that display perfect circular forms both in shape as well as orbit was an echo of earlier Greek concepts about classic forms. Copernicus was an advanced thinker, but he was still bewitched by the Platonic belief that the solar system must consist of perfect geometrical spheres traveling in true circular orbits. It was inconceivable to him—or to anyone else at that time—that a divine creator would have designed the universe using anything other than the purest geometrical forms. A brief digression to these Hellenic concepts of geometry is in order now so that Kepler's insight may be more fully appreciated.

Pythagoras, in the sixth century B.C., was one of the first thinkers to ask questions of nature rather than of the gods. He was profoundly moved when the answers nature returned were couched in mathematical and geometrical terms that in and of themselves expressed an inner symmetry and elegance. His discovery of the numerical ratios that underlie the aesthetic experience of musical harmony, and his theorem that applies to all right triangles anywhere in space and time, reinforced subsequent philosophers' worship of the beauty inherent in perfect form. Their great passion for symmetry became a magnificent obsession. Rational numbers became the objects of adoration. When the Pythagoreans discovered irrational numbers, they considered them "ugly" because they were not perfect. They made it a condition of their cult that no acolyte would reveal to anyone outside this mathematical quasi-religious sect that irrational numbers even existed.

Plato greatly admired Pythagoras. He is the one philosopher who most clearly embraced Pythagoras's concept of the cosmos, and he urged all others to do the same. He promoted the idea that a few basic ideal shapes underlay all the myriad number of shapes of the visible world. At the core of his philosophy was a set of true circles, perfect spheres, symmetrical cubes, and equilateral pyramids. The Platonic ideal of perfect forms, and the elaboration of a coherent scheme to organize space using Euclid's axioms, advanced the notion that the cosmos consisted of these ideal forms that represented Truth, Good, and Equality. The beauty and harmony of these ideal forms reinforced this system of spatial orientation and increased the hypnotic hold that perfect forms had upon the early Greek mentality.

Aristotle agreed with Plato that purity of form is the basis of the universe, even though he was more practical than his mentor in other matters. When Aristotle cast his glance at the heavens, what he observed were perfectly round spheres. Since the sun and the moon were evocative of the Platonic ideal, Aristotle extrapolated his theories from these obvious features and,

in an explanation of how motion entered the world, proposed a complex system of rotating perfect spheres within spheres, each describing a perfect circle.

These four thinkers—Pythagoras, Plato, Aristotle, and Euclid—had an overarching influence on all subsequent thought in the Western world. Most philosophies begin by quoting either Plato or Aristotle. Euclid's geometry is still taught unchanged from the original. Pythagorean mathematics remains one of the linchpins of modern education.

Profound as these early thinkers were, their fascination with the universal symmetry of geometrical forms led them to make stepchildren of the ellipse, parabola, and hyperbola: shapes that belong to a branch of geometry that has to do with conic sections. Euclid did write a book on the subject of conic sections, but it was lost and all we know of it is through quotations in the work of Archimedes. We do know that it was not as widely read or well known as his *Elements of Geometry*.

Even though there are more ellipses, parabolas, and hyperbolas in ordinary visual experience than there are spheres, cubes, or pyramids, the subject of conic sections lay dormant for fifteen hundred years. Giotto was the first person to rekindle an interest in this arcane field of geometry. He intuited that it would be necessary to draw conic sections through cylindrical and circular forms in order to render accurately objects seen in perspective. When viewed from an angle of vision that is not perpendicular to the center, a circle appears as an ellipse to the eyes of the beholder. Giotto distorted Plato's perfect forms in the service of art and made a stunning contribution to the science of visual perception.

Other artists began to imitate Giotto's rudimentary method of three-dimensional projection, but they were less skilled than the Italian master: They needed guidelines to help them solve complex perspectivist problems. Alberti's 1435 treatise on the subject was as much about geometry as it was about art. The next authoritative book on perspective was published seventy years later in 1505 by Pelerin of Toul, better known as Viator. Albrecht Dürer published a comprehensive book on the subject in 1525. The seminal realization of all these artist/writers was that the picture plane of the artist's canvas was but a cross section of the cone of vision that funnels into the pupil of the eye.

Two and a half centuries after Giotto's insight about conic sections, the Danish astronomer Tycho Brahe carefully mapped the precise locations of the planets in their vagabond courses across the nocturnal canopy. Brahe, a colorful character, had a golden nose. He lost his own tip in a youthful dueling accident and had a goldsmith fashion him a prosthetic one made

out of the only substance fitting for the nobility. Besides his shiny nose, Brahe was endowed with an acute sense of vision and a dogged and patient temperament. He spent most of the nights of his life sitting in an observatory. When he died he passed on his observations to his astronomer-in-residence, Johannes Kepler (1571–1630).

Kepler instinctively believed in Copernicus's heliocentric theory, but could not explain why it did not fit Tycho Brahe's careful observations of planetary positions. After many years of trying alternative explanations, Kepler finally abandoned the dogmatic belief that God would have designed His cosmos using only circular and spherical geometric forms. Like Copernicus before him, Kepler used the artist's technique of perspective. He imagined himself on Mars and tried to reconstruct the earth's motion from that vantage. This effort consumed nine hundred pages of calculations. Finally Kepler figured it out. He wrote his astonishing proposal to a friend and fellow astronomer: The orbits of the planets were ellipses. His friend wrote back that such a proposition was "absurd" and Kepler apologized for introducing the inexplicably eccentric ellipse into God's perfect creation. Nonetheless, he wrote of his insight as "one more cart-load of dung as the price for ridding the system of a vaster amount of dung."[1] Undaunted, Kepler realized that God also respected parabolas and hyperbolas. By immersing himself in the study of conic sections he gained the knowledge to solve the problem, and in an ironic twist of history, the scientist had to refer to books on the subject that had been written by artists!

Kepler's insight, known as his three laws of planetary motion, exploded upon the world of science like a thunderclap. When his laws were superimposed upon the orbits of the planets, all the complex Ptolemaic retrogressions and filigreed epicycles disappeared. What remained were clean, clear elliptical orbits around the sun for each planet. Each had two foci that cause the path of the planets to be not only elliptical but eccentric as well. Kepler had unlocked the mighty secret of the heavens. With Kepler's laws and Galileo's theories, Copernican advocates swept away all remaining objections to the heliocentric theory. In exultation, Kepler wrote:

> I care not whether my works be read now or by posterity. I can afford to wait a century for readers when God Himself has waited six thousand years for an observer. I triumph. I have stolen the golden secret of the Egyptians. I will divulge my sacred fury.[2]

Kepler published all his laws by 1618, three hundred years after Giotto intuited that the key to the accurate rendering of nature was the conic

section, and almost two hundred years after Alberti had introduced the geometric details of perspective, including the rudiments of conic sections. In a curious testimony to the existence of a *zeitgeist*, the French mathematician Gérard Desargues discovered a theorem in 1639 that once and for all revealed the intricacies of projective geometry. In this new geometry, which allowed for the precise depiction of perspective, two parallel lines do meet at a point. The key to his discovery was the theorem that bears his name, and that clarifies the mathematics of conic sections.

Before Desargues's discovery, the early Renaissance artists had mutely called into question the truth of Euclid's troublesome fifth postulate. More complex than the other four, it implied that parallel lines will never meet however far they are extended. To the Renaissance artist it was apparent that two parallel lines in three-dimensional space when projected onto a two-dimensional plane (such as a canvas) are not parallel but meet at a point on the horizon called the vanishing point. While this observation seems obvious and trivial to twentieth-century readers, to artists of the fifteenth century it was recognized as a critical feature of a painted landscape. It also contained the embryo of an idea that had bedeviled Greco-Roman thinkers—the concept of infinity, which would later become an essential building block in the edifice of science.

The artists' interest in infinity and the vanishing point preceded by several hundred years the proposal by Descartes that space is infinite. Artists anticipated scientists in recognizing the importance of the stationary observer at absolute rest; in perceiving the importance of conic sections; and in discerning the vanishing point of infinity. In the Middle Ages and the Renaissance, as before, the precognition of the intuitive artist foreshadowed the discoveries of the analytical scientist.

✦ Art is the Queen of all sciences communicating knowledge
to all the generations of the world.

<div align="right">Leonardo da Vinci</div>

We are to admit no more causes of natural things than
such as are both true and sufficient to explain their ap-
pearances.

<div align="right">Isaac Newton</div>

<div align="center">CHAPTER 6</div>

ARTIST - SCIENTIST / MYSTIC - PHYSICIST

If Giotto loomed great upon the threshold of the Renaissance,
Newton was the giant who closed the door upon this era. Imperious
and brilliant, he was endowed with a mind as incisive as cut glass.
He made sweeping discoveries about gravity, motion, and light. Gathering
up the beams and struts of his and earlier scientific discoveries, he con-
structed a seemingly impregnable citadel of thought. What began in the
early Renaissance as a quickening in the understanding of nature culmi-
nated in 1687, when Newton published his all-encompassing *Principia
Mathematica*, the Bible of the new scientific paradigm. Newton, continuing
a theme begun by Descartes and Galileo, demoted God to the role of Grand
Designer. In the scientific determinism that grew out of Newton's insights
there could be no room for miracles. God ceased to be an active participant

<div align="center">69</div>

in the daily affairs of His subjects and became a passive observer of the creation He had set into motion.

Newton began with the Pythagorean assumption that nature can be reduced to mathematical relationships. He was so taken with Euclid's organization of the *Elements of Geometry* that he used a similar format, starting with definitions and proceeding to formulate his laws upon them. In doing so, he scaffolded upon Aristotelian logic. He then added Galileo's experimental method, always checking theory with observed facts, and concluded with his own revelations concerning mechanics, gravitation, and the infinitesimal calculus. Newton presented his insights in the language of mathematics. Crisp equations and numbers translated the mighty wheelings of the heavens, crowding them onto thin pages of paper. This system of thought, a thorough and practical method for investigating and describing the physical phenomena of the world, became known as Newton's classical mechanics. It worked magnificently. His intellectual feat so astonished his countrymen that he was compared to Moses come down from Mount Sinai. Alexander Pope summed up the feeling of the age when he wrote:

> Nature and Nature's laws lay hid in Night
> God said, Let Newton be, and all was Light.[1]

Classical mechanics addressed objective reality. Space and time were a tight intersecting grid where the events of science took place. The investigator (like God) usually sat motionless and observed the external world. During the rise of Newton's system, Western European art had also been concerned with the concrete objects of the external world. Perspective distinctly separated the "I" from the "it." Just as perspective was a framework that allowed painters to carry out what the nineteenth-century English painter John Constable later called "experiments on nature," so Newton's system was to be a map that made possible an exploration to the edge and beyond. Art and physics each concurred with common sense, which further enhanced their popular acceptance.

The laws of physics enabled the knowledgeable user to draw diagrams of trajectories of missiles and orbits of planets. These diagrams connected individual objects with imaginary lines that could not be seen in nature. In art, beneath the paint of the canvas, there also lay hidden the *pentimenti* of the invisible lines the artist had drawn while planning the painting. The dominant perspectivist convention ruled over art from the 1300s to the 1860s. Classical physics reigned from approximately 1500 to 1900. During

these centuries, the parallel principles of perspective and Newtonian physics permeated every aspect of European civilization.

Despite the many brilliant accomplishments of this genius, Newton put into place a series of flawed notions regarding the essence and relationships among space, time, and light. Galileo's idea of rest within an inertial frame of reference became the starting point of Newton's system. In Hypothesis 1 of his *The System of the World*, Newton states: "The center of the system of the world is unmovable. This is acknowledged by all, while some contend that the earth, others that the sun, is fixed in that centre."[2] Newton accepted Galileo's theory of relativity and at first sought a point in space near the sun that would be at absolute rest. He tried to calculate its position by taking into account the gravitational fields of all the planets, moons, and sun.

What would subsequently influence Newton's ideas on the subject of absolute rest were two related discoveries. In 1676 Ole Christensen Roemer, a Danish astronomer, demonstrated that light traveled across space at a finite speed. When apprised of this information, Newton, like other scientists, asked an obvious question: What yardstick can the speed of light be measured against if according to Galileo every object in the sky is in motion relative to all the other objects? The second was Christian Huygens's 1678 proposal that light traveled through space as a wave transmitted by an invisible substance called the *luminiferous ether*. Although Newton disagreed with this assessment (he believed light was corpuscular, made up of tiny particles that shot through space in straight, single-file rays), he accepted the idea of an invisible insensate ether because he could conveniently use the ether to convey his newly discovered gravitation as well as answer the question raised by Roemer's calculation of the speed of light.

The momentous mistake that Newton made regarding the ether was to assign to it the property of absolute rest. He believed that while the fixed stars, sun, planets, and moon executed the choreographic steps in their stately ballet, the ether provided *the* platform that was superior to all other viewing platforms. A stationary observer parked anywhere in the ether had a privileged vantage point that remained at all times at absolute rest. From this followed Newton's conception of space and time.

Newton carved in stone the absolute immutability of both. His words, rolling off the mountaintop in sonorous tones, were spoken with the stentorian authority of a scientific god:

Absolute, True, and Mathematical Time, of itself, and from its own nature flows equably without regard to any thing external.[3]

Space followed suit:

> Absolute Space, in its own nature, without regard to any thing
> external, remains always similar and immovable.[4]

Although other scientists contemporary with Newton, notably Leibniz and
Hooke, disagreed with this assessment, his enormous prestige eventually
endowed his ideas with the rigidity of dogma—despite the fact that these
ideas were wrong. The medieval misconception that the earth was at rest
and at the center of the world was replaced with an equally problematic
misconception regarding the absolute nature of space, time, and rest.

Newton's disagreement with Huygens concerning the nature of light
was the beginning of the wave/particle dilemma alluded to in Chapter 1.
Newton's belief in corpuscular light stood in sharp contrast to Huygens's
light waves undulating through the ether as water waves break upon a
shore. Although publicly adhering to his published position, Newton pri-
vately was troubled by light's seemingly dual nature.

The issue appeared to be resolved a century later in 1801 when Thomas
Young argued conclusively that light behaved as a wave. Young's incon-
trovertible evidence was his demonstration of the interference pattern of
light. Targets and alternating bands of light and dark are interference
patterns and are the signature of waves. After initial resistance to the work
that refuted the indisputable Newton, other scientists hailed Young's light-
as-a-wave as the major scientific discovery it was.

Newton, Huygens, and Young are featured prominently in any discus-
sions of optics; however, science historians usually skip over the discovery
of Francesco Grimaldi. This post-Renaissance painter noted in 1665 that
in the shadows surrounding an opaque object, there lies a thin layer of
interference fringes. Disagreeing with the positions of Galileo and Newton,
Grimaldi proposed that light was not a stream of particles, but was rather
a fluidlike substance that could flow around objects. He surmised the fringes
he observed were the ripples from the flow. While he did not formulate
his findings in the tight mathematical language of science, this artist did,
nevertheless, propose that light behaved like a wave thirteen years before
Huygens's 1678 wave theory.

Newton's mistakes pale before his accomplishments and he emerges as
a colossal figure who instituted a new way to think about the world. His
Principia controverted the authority of the Bible. By the early 1700s, the
Majestic Clockwork replaced the image of a white-bearded God on a heav-
enly throne. Philosophers and theologians influenced by physicists such as

Newton compared the universe to a huge, mechanized ticking clock, set in motion by the deity. After God made His timepiece and the laws that governed its functions, He retreated to observe His creation unconcernedly. Time, according to this scheme, flowed inexorably at a constant rate through a uniform and homogeneous space. Light was a mysterious essence that traveled from here to there like a speedy errand boy. The success of this metaphor led thinkers to exalt the strung beads of causality, which were conveniently linked by the Great Chain of Being, another dominant metaphor extolling the virtues of determinism later in the eighteenth century.

In the preceding chapters, the physical descriptions of the world put forth by physicists were paired with an antecedent artist's visions. In these comparisons, we have seen that the artist presented society with a new way to *see* the world before a scientist discovered a new way to *think* about the world.

But what artist's sensibility could possibly have anticipated the towering, solitary genius of Isaac Newton? Only one in all of Western civilization: Leonardo da Vinci. Although Leonardo was the outstanding figure of the fifteenth century and Newton's genius illuminated the seventeenth, there are many close parallels in the lives, thoughts, natures, beliefs, and accomplishments of these men.

Newton was born a few months after his illiterate farmer father's death. When his mother soon remarried, Newton was sent away to be raised by his grandmother. As a child, he had to compete with a stepfather for his mother's affection.

Leonardo was the illegitimate child of an illiterate peasant woman. Like Newton, he was initially raised by his mother without a father; then, before the age of five, he was also separated from his mother and brought into the household of his father, a Florentine lawyer of means who apparently didn't care much for the young Leonardo.

Both Newton and Leonardo had few friends during childhood and both developed highly sensitive, dreamy natures. Each enjoyed his solitude and treasured his books above friendship. When Newton later in life was pressed by Edmund Halley to publish his discovery of the calculus, he felt concerned that publication would bring fame that might erode his privacy. He wrote in a letter:

> I see not what there is desirable in public esteem, were I able to acquire and maintain it. It would perhaps increase my acquaintance, the thing which I chiefly study to decline.[5]

Two hundred years earlier, Leonardo, echoing a similar sentiment, had written:

> If you are alone you belong entirely to yourself. . . . If you are accompanied by even one companion you belong only half to yourself, or even less, in proportion to the thoughtlessness of his conduct; and if you have more than one companion you will fall more deeply into the same plight.[6]

As young men, both Newton and Leonardo had a penchant for exotic practical jokes. Young Newton alarmed the Lincolnshire populace one summer night by launching a hot-air flying saucer that he constructed by attaching candles to a wooden frame beneath a wax paper canopy. Leonardo, using a connecting tube, once attached some bellows to the shriveled dried intestines of a bull and placed the guts in one room while he stood with the bellows in another. When people arrived in the room they barely noticed the prunelike coils, but were soon discomfited and then stupefied as a huge balloon suddenly started to fill the available space, crowding them against the opposite wall.

Both Leonardo and Newton had fecund imaginations from which poured forth a stream of discoveries, gadgets, engineering marvels, and farsighted contrivances. Newton invented the reflecting telescope, Leonardo, the helicopter; Newton, the binomial theorem, Leonardo, the parachute, submarine, and tank. Newton's discoveries were expressed in equations, Leonardo's in drawings. Leonardo made many contributions to science, both in theory and application, but he is principally featured in art history classes. Newton wrote lengthy exegeses on alchemy, the mysteries of the Trinity, and the authority of the Bible, yet he is considered history's premier physicist.

Both believed in pure mathematics as the highest expression of the human mind. Leonardo stated, "There is no certainty where one can neither apply any of the mathematical sciences nor any of those which are based upon mathematical sciences."[7] Newton, in the introduction to his *Principia*, wrote: "I offer this work as the mathematical principles of philosophy, for the whole burden of philosophy seems to consist in this . . ."[8]

Both rejected the trinitarian dogma of Christian theology, believing instead in one God, and neither could express his true beliefs because in their repressive times men and women were still hanged upon the gallows or burned at the stake for harboring such heresies.

Each man transformed the science of his day from one that held an

essentially static view of the universe into one that included motion. The subject of motion consumed them both and their greatest contributions to humankind grew out of an intense curiosity about it. Newton's ambitious desire to explain celestial movements resulted in the formulation of his three famous laws of motion and his discovery of the inverse square law of gravitation. Leonardo's compelling studies of the muscular movements of men and horses, exemplified in his cartoons for his *Battle of Anghiari*, are the most detailed anatomical descriptions of men and animals in motion that have ever been produced. He published a book that still remains the definitive study of equine anatomy. His interest in the principles of movement carried him far into the field of anatomy so that his contributions to this field of knowledge changed forever the way future students of this subject would be taught. The first modern medical textbook, Andreas Vesalius's *De humani corporis fabrica*, published in 1543, owes an enormous debt to Leonardo's earlier anatomical studies.

Leonardo also attempted to understand the concept of inertia and came astonishingly close to the central clue that allowed Newton to elaborate his laws of motion two centuries later. Leonardo wrote, "Nothing whatever can be moved by itself, but its motion is effected through another. There is no other force." Elsewhere he proposes:

> All movement tends to maintenance, or rather all moved bodies
> continue to move as long as the impression of the force of their
> motors (original impetus) remains in them.[9]

Newton's great First Law of Motion states:

> Every body continues in its state of rest, or of uniform motion
> in a straight line, unless it is compelled to change that state by
> forces impressed upon it.[10]

A comparison of these two statements explains why the principle of inertia was called the *Principle of Leonardo* until Newton published his *Principia*. Thereafter, Newton was routinely granted credit for this discovery, which overturned a system of mechanics founded by Aristotle two thousand years earlier. (I have found very few references in scientific history books that acknowledge Leonardo's crucial observation two centuries before Newton.) To Leonardo, "mechanics is the paradise of the mathematical science because by means of it, one comes to the fruits of mathematics."[11]

Both Leonardo and Newton developed a code of laws to explain the

physical universe, Leonardo through *seeing* the world, Newton through *thinking* about it. Leonardo, the artist, analyzed the visual world with a scientist's eye.

In a sampling of his precepts one finds:

> When you have to draw from nature, stand three times as far away as the size of the object that you are drawing. . . . Every opaque object that is devoid of color partakes of the color of that which is opposite to it, as happens with a white wall. . . . The shadows cast by trees on which the sun is shining are as dark as that of the center of the tree. . . . The sun will appear greater in moving water or when the surface is broken into waves than it does in still water.[12]

Newton, the scientist, reduced the visual world to mathematical relationships and yet was not satisfied with his formulations until he could make an easily visualizable geometrical model he could see. He expressed this feeling when he wrote that "it is the glory of geometry that from those few principles, brought from without, it is able to produce so many things. Therefore geometry is founded in mechanical practice . . ."[13]

Both men were pioneers in the study of light, and both revealed revolutionary insights about its nature. Leonardo understood that images were reversed upon the retina. He is generally credited with the invention of the camera obscura, upon which the principle of modern photography rests. He studied optical illusions and his explanations for them are still applied today. He sketched an instrument to record the intensity of light that differed little from the one developed by Benjamin Thompson, an American, three centuries later. Leonardo was also fascinated by shadows and worked out the geometrical details of the umbra and penumbra that are still in use by present-day astronomers. He was familiar with eyeglasses and suggested in the fifteenth century the possibility of contact lenses. He investigated the phenomenon of the iridescence of peacock feathers and oil on water. He was the first person in the historical record to make the all-important surmise that light traveled through space and time as a wave. Extrapolating from water waves and sound waves, he wrote: "Just as a stone thrown into water becomes the center and cause of various circles, sound spreads in circles in the air. Thus every body placed in the luminous air spreads out in circles and fills the surrounding space with infinite likenesses of itself and appears all in all and all in every part."[14]

Leonardo, the most visual of scientists, waxed poetic when describing the sense of sight by which we perceive light:

> The eye, which is the window of the soul, is the chief organ whereby the understanding can have the most complete and magnificent view of the infinite works of nature.
>
> Now do you not see that the eye embraces the beauty of the whole world? . . . It counsels and corrects all the arts of mankind. . . . It is the prince of mathematics, and the sciences founded on it are absolutely certain. It has measured the distances and sizes of the stars; it has discovered the elements and their location. . . . It has given birth to architecture and to perspective and the divine art of painting.
>
> Oh, excellent thing, superior to all others created by God! What praises can do justice to your nobility? What peoples, what tongues will fully describe your function? The eye is the window of the human body through which it feels its way and enjoys the beauty of the world. Owing to the eye *the soul is content to stay in its bodily prison, for without it such bodily prison is torture.*
>
> O marvelous, O stupendous necessity, thou with supreme reason compellest all effects to be the direct result of their causes; and by a supreme and irrevocable law every natural action obeys thee by the shortest process possible. Who would believe that so small a space could contain all the images of the universe. . . .[15]

His most enduring contributions to our knowledge of light were not written in words, however, but rather they can be seen in his paintings. Leonardo was able to coax out of brush and paint a rare quality of light. No artist before or since has achieved the mysterious opalescence of the distant atmosphere. His ineffable vistas of faraway mountains, the wordless interplay of ethereal light upon a woman's smile, the rippling fasciculations of a horse in motion, all are bathed in a light that at once is representative of the visual world and at the same time contains a sfumato that gives his works an almost other-worldly quality.

Newton, on the other hand, wrote the definitive treatise on light when he published in 1704 his *Opticks*. Typically, he was not as interested in seeing the effects of light as he was in understanding its nature. By passing

sunlight through a series of prisms in a darkened room, he made discoveries that built upon the scientific inquiries that began with Leonardo. Newton went much further and explained how white sunlight can be broken down into different colors by refraction. Before Leonardo and Newton, alchemy had been the repository of European knowledge about optics. However, alchemists always resorted to spiritual terms to explain the prism's rainbow phenomenon. Newton repeatedly worked out with mathematical precision what Leonardo had expressed in concise drawings.

Despite Newton's inventiveness, Leonardo was the more fecund of the two. I suspect his technical innovations and scientific discoveries are not appropriately acknowledged by science historians because Leonardo was so ahead of his time. His imagination so far outstripped the technology of the fifteenth century that many of his most brilliant inventions and theories could not even be tested.

Nonetheless, Newton and Leonardo both traveled in the rarefied atmosphere of the brain's highest function, abstraction. Newton's invention of the calculus demanded the most difficult level of abstract thinking from those who attempted to follow him. Leonardo was similarly interested in abstract designs. In his *Treatise on Painting* (not published until 1651), he spoke of a method "of quickening the spirit of invention." He advised artists:

> You should look at certain walls stained with damp, or at stones of uneven colour. If you have to invent some backgrounds you will be able to see in these the likeness of divine landscapes, adorned with mountains, ruins, rocks, woods, great plains, hills and valleys in great variety; and expressions of faces and clothes and an infinity of things which you will be able to reduce to their complete and proper forms. In such walls the same thing happens as in the sound of bells, in whose stroke you may find every named word which you can imagine.[16]

Leonardo's interest in images without things led him to be the first European artist to draw a landscape. In so doing, he took the important step away from concrete and symbolic representation toward abstraction. Pure landscapes were utterly unimaginable to Greek, Roman, or Christian artists because they do not include the usual hierarchy of man-made things or people; instead they are the beginning of a recognition of patterns rather than objects. His interest in abstract pattern intensified until Leonardo became preoccupied with pure geometrical designs. His notebooks are filled

with pictures that have finally no identifiable image. Later in Leonardo's life, he did many drawings for his *Eruption of the Deluge* (1514), that second coming of the flood, purifying with water the sins of humankind. In these drawings, the complex shapes of massive walls of falling water achieve a level of art-without-an-image that anticipated by four hundred years the abstract works of Wassily Kandinsky, Kazimir Malevich, and Piet Mondrian.

Both men were prolific writers who wrote about many subjects, though neither published the bulk of his writing during his lifetime. John Maynard Keynes, whose fame as an economist eclipsed his lifelong study of Newton, purchased at auction the remains of a trunk into which Newton had stuffed his writings on matters nonscientific. Keynes estimates that "upwards of 1,000,000 words—in handwriting still survive" and goes on to classify the material:

> All his unpublished works on esoteric and theological matters are marked by careful learning, accurate method, and extreme sobriety of statement. They are just as *sane* as the *Principia*, if their whole matter and purpose were not magical. They were nearly all composed during the same twenty-five years of his mathematical studies. They fall into several groups.
>
> Very early in life Newton abandoned orthodox belief in the Trinity. . . . He arrived at this conclusion not on so-to-speak rational or skeptical grounds, but entirely on the interpretation of ancient authority. He was persuaded that the revealed documents give no support to the Trinitarian doctrines which were due to late falsifications. The revealed God was one God. . . .
>
> Another large section is concerned with all branches of apocalyptic writings from which he sought to deduce the secret truths of the Universe—the measurements of Solomon's Temple, the Book of David, the Book of Revelations, an enormous volume of work of which some part was published in his later days. . . .
>
> A large section, judging by the handwriting amongst the earliest, relates to alchemy, transmutation, the philosopher's stone, the elixir of life. The scope and character of these papers have been hushed up, or at least minimized, by nearly all those who have inspected them. . . .
>
> Newton was clearly an unbridled addict. . . . It is utterly impossible to deny that it is wholly magical and wholly devoid of

scientific value; and also impossible not to admit that Newton devoted years of work to it.[17]

Although Leonardo never published a single book, his writings were as extensive. The scattered and uncollated pages of notes he left behind have been indexed somewhat haphazardly over the ensuing centuries, resulting in the *Codex Atlanticus*, which contains 1,222 pages bundled together, evidently not in the order Leonardo wrote them. In these pages are some of the astonishing revelations of the Renaissance's most incisive mind. In one line Leonardo states with conviction, "The sun does not move,"[18] thereby anticipating both Copernicus and Galileo. The many pages of notes include an astonishing array of drawings of aerial maps, swirling water, plants, grand irrigation schemes, anatomical studies, and the ever-present profiles of faces of every physiognomic variation.

In addition to their other parallels, as an interesting aside, both of these titanic figures had to contend with rivals of almost equal stature. In the case of Newton, it was the German mathematician Gottfried Wilhelm von Leibniz; for Leonardo it was Michelangelo. The living presence of intellects that could challenge Newton's and Leonardo's led, as one would expect, to confrontations with their respective foils.

Leibniz had had a chance to see Newton's notes concerning the calculus by means of a third party in 1676. Using Newton's equations, he claimed to have invented the calculus independently and when he published his method the German intellectuals were quite proud that one of their own had made such a significant contribution to human thought. Edmund Halley, an Englishman, was aware that Newton had discovered his "flux-ions" (which is what Newton called his calculus) twenty years earlier but had failed to share them with anyone else because of his secretive nature. Concerned about the claim of primacy, Halley made a patriotic appeal to Newton and urged him to come forward to receive this honor. Newton detested Leibniz and did finally unveil his calculus by publishing it in the proceedings of the Royal Society.

He then wrote letters to the society under assumed names impugning Leibniz's honor and advancing his own claim of primacy for the discovery of the calculus. Newton hid behind another scientist, John Keill, surrep-titiously instructing him how to question Liebniz's integrity. On one oc-casion, Newton suggested to Keill which exact phrases to use and then added, "Compare them with your own sentiments & then draw up such an Answer as you think proper. You need not set your name to it."[19] Thus, by character assassination and subterfuge, Newton persisted until the Royal

Society properly accorded him the official honor of discovering this much-valued mathematical tool even though Leibniz published first.

Leonardo's confrontation with Michelangelo is equally revealing about how different Leonardo's character was from Newton's. According to Vasari, Leonardo and Michelangelo strongly disliked each other. Leonardo, who enjoyed dressing immaculately and wearing the latest fashions, had frequently made snide comments about the coarse and peasant-like appearance Michelangelo presented in his sculptor's working clothes and his ever-present pale patina of marble dust. Michelangelo had heard of Leonardo's remarks and they did not endear the painter to him. When Michelangelo learned that the Duke of Sforza, the ruler of Milan, had commissioned Leonardo to cast an equestrian statue, he sneered contemptuously, believing that the dilettante painter could never bring such a project to completion.

Leonardo, of course, was up to the task. There had been many man-on-a-horse monuments and Leonardo was determined to create something the likes of which the world had never seen. He set out to create an object not only of great beauty, but also the largest, most daring equestrian statue ever conceived.

When Leonardo finished making a model in plaster, it was so magnificent the townspeople urged him to place it outside in the piazza for all to behold in the sunshine. Meanwhile the artist busied himself with the engineering details of the proposed casting and informed his patron, Sforza, he would need two hundred thousand pounds of bronze. Sforza dutifully began to accumulate such a staggering quantity of the expensive metal, but not without a nagging doubt about the wisdom of commissioning such a large and expensive statue. Shortly thereafter Sforza found himself pressed by the armies of the French at his gate. He diverted the bronze he had put aside for Leonardo's statue and directed that it be cast into cannons instead. Depressed, Leonardo prudently departed for Florence.

The horse suffered the fate of the martyrdom of St. Sebastian. When the French mercenaries forced the gates, they were confronted by a piazza deserted save for a towering clay horse, which must have appeared to them as a Trojan horse in reverse. In the victory celebration that followed, drunken soldiers began shooting arrows at the vulnerable *cavallo*, and continued to do so into the night. In the morning, the arrows were removed and the mortally wounded horse was exposed to the elements. Rainwater seeped into the arrow tracks, and within a few months the erosive effect caused the horse to disintegrate.

One day soon after in Florence, Leonardo passed a group of young men

in the piazza who were discussing Dante's *Inferno*. They asked Leonardo for his interpretation just as Michelangelo, who was also living in Florence, deep in thought, rounded the corner. Michelangelo was known to have studied Dante zealously. Leonardo, in a gentlemanly fashion, said, "Here is Michelangelo; let us ask him as he will know." Michelangelo, however, misunderstood and thought Leonardo was making fun of him. Michelangelo exploded:

> Explain them yourselves! You made a design for a horse to be cast in bronze, and, unable to cast it, you have in your shame abandoned it. And to think that those Milanese capons believed you![20]

Leonardo flushed deeply but made no reply, turned on his heels and strode away. These two titans never spoke to each other again, but Leonardo, as best we know, never disparaged or wrote ill of Michelangelo. Newton, on the other hand, continued to malign Leibniz even after his enemy had died.

In the voluminous writings of both men, personal statements are curiously absent. Upon learning of his father's death, for example, Leonardo made the following dispassionate entry in his journal:

> On the ninth of July 1504, Wednesday at seven o'clock, died Sen Piero da Vinci, notary at the palace of the Podesta, my father, at seven o'clock. He was 80 years old, left ten sons and two daughters.[21]

Newton likewise tells us almost nothing about the seething passions that might lie beneath his granitelike exterior. His quarrels with Hooke, Flamsteed, and Leibniz provide indirect insights into his nature, but of his own thoughts, he offers very little.

These solitary geniuses shared a penchant for secrecy and loved to decode and write in cryptograms. In correspondence with Leibniz, Newton enshrouded his calculus in a cryptogram. During the time that he formulated the laws that guide our understanding of celestial mechanics, he was immersed in trying to decipher the cryptic verses of ancient alchemists. Leonardo, whose handwriting was barely decipherable, also engaged in writing in code and enjoyed trying to decipher occult messages from the past.

In some ways, of course, Leonardo and Newton were entirely unalike. On the one hand, Newton was a caricature of a one-sided, scientific genius. Aldous Huxley wrote that "as a man he was a failure, as a monster he was

superb." Later in his life when Newton became head of the Mint, he seemed to take an inordinate pleasure in interrogating counterfeiters and attended their hangings with a ghoulish, avid interest. His attitudes toward the leavening aspects of life were bleak. Timothy Ferris writes that "Newton turned a deaf ear to music, dismissed great works of sculpture as 'stone dolls' and viewed poetry as 'kind of ingenious nonsense.' "[22]

Leonardo, on the other hand, was the exemplary Renaissance man. By reputation, he was gentle and generous, and although he was a solitary man, he was an accomplished musician and a pleasant, witty conversationalist. Leonardo developed a philosophy akin to that of St. Francis of Assisi. He had a reverence for all living things and frequently bought caged birds just so he could set them free. He became a vegetarian because he did not believe one should ever kill a living creature.

It is a paradox without parallel in Newton's life that Leonardo, who was reputed to be unable to harm a fly, developed a peculiar detachment toward his engines of war. In the course of his career, he invented the most gruesome devices to grind and rend the flesh of enemy soldiers. Without the faintest moral compunction, he solicited employment from the infamous Cesare Borgia and left his post as Borgia's military engineer only when he discovered that a fellow worker of his, also in Borgia's employ, had been strangled to death for some unknown reason by their mutual patron.

It is probable that historians have failed to pair these two geniuses because we learn history as a record of accomplishment. Newton's legacy completely altered the way Western civilization thought about the world, while Leonardo has been called a genius who did not leave to posterity any idea that changed the way we think. But that sort of criticism misses the point. Using both brush and pen, Leonardo changed the way we *see* the world and this subtle shift in mind-set prepared people to be receptive when Newton introduced a new way to *think* about the world. Once again, the artist's revelation preceded the physicist's. In one of Newton's most famous statements he deferred to the scientists who preceded him: "If I have seen further than other men, it is because I stood on the shoulders of giants."[23] Traditionally, these other giants were thought to be Copernicus, Descartes, Galileo, and Kepler. To this illustrious group I would add Leonardo.

Although all knowledge begins with experience, it does not necessarily all spring from experience.

Immanuel Kant

Art degraded, Imagination denied.

William Blake

CHAPTER 7

RATIONALITY / IRRATIONALITY

During the late eighteenth century, Europeans expressed a general optimism about the human mission. Their confidence derived from advances taking place all around them in technology and science. Building upon Newton's authoritative work, scientists proposed theories that subversively supplanted religious notions of how the world worked, and by about 1725, science had replaced religion as the dominant social force in Western culture. Julien de La Mettrie, exulting in this triumph, declared in his 1747 essay *L'Homme machine* that all mental activities were capable in principle of being explained mechanically.

The term "soul" is therefore an empty one, to which nobody attaches any conception, and which an enlightened man should employ solely to refer to those parts of our bodies which do the thinking. Given only a source of motion, animated bodies will possess all they require in order to move, feel, think, repent—

84

in brief, in order to *behave*, alike in the physical realm and in the moral realm which depends on it. . . . Let us then conclude boldly that man is a machine, and that the whole universe consists only of a single substance [matter] subjected to different modifications.[1]

Painting during the Age of Reason was extraordinarily realistic. Perspective had reduced the format of art to geometry, to the extent that measurements and theorems were more esteemed than intuition by many artists. Artists organized space mathematically, like physicists, and "neoclassicism," the term used to describe the works of Jean Auguste Ingres, Jacques Louis David, and others of this period, affirmed the rectitude of rectilinear space and of clear, precise logic. Earlier, André Félibien, theorist of the French artistic academy, proclaimed, "Perspective is so vital that one may go so far as to say it is the very essence of painting . . ."[2] Painters presented social realism, the obvious message in neoclassical works, allegorically. Social realism was based on the optimistic belief that art, like science, could shape and change society. Constable, the English landscape painter of this era, wrote: "Painting is a science and should be pursued as an inquiry into the laws of nature. Why, then, may not landscape painting be considered as a branch of natural philosophy, of which pictures are but the experiments."[3]

Realism, the zenith of perspective in art, ruled when reason held the reins of thought. Formal gardens, such as those at Versailles, were laid out in paeans of homage to Euclid's postulates and the strict mathematics of Newton's *Principia*. Neoclassical realism and Newton's classical mechanics became the only comprehensible ways to see and think, and no one seriously challenged the basic rules of their respective canons.

Realism, the depiction of real objects as viewed in perspective, and determinism, the doctrine that every effect had an antecedent cause, divided the European psyche from the mysticism and intuition that had until recently maintained it. As we have seen, Leonardo and Newton, the preeminent representatives of art and physics, complemented each other in many regards, sharing a profound respect for reason and mathematics. In this chapter two other figures will be juxtaposed to illustrate how science and art were beginning to diverge. Immanuel Kant and William Blake epitomized the schizoid condition resulting from the hypertrophy of just the rational side of the European psyche. Kant, the philosopher-critic, using words instead of equations, did for philosophy what Newton accomplished for science, elevating reason to a position coequal with Newton's mathe-

matics. Kant and Newton created instruments of Western thought that set it apart from other world cultures. William Blake, on the other hand, was a mystic-artist, much denigrated by his contemporaries as he tried to awaken the West from the trance cast by linear perspective in the arts and determinist logic in the sciences. As background to their stories, a brief review of both European philosophy and poetry is in order.

In the early sixteenth century, reason resuscitated philosophy from the moribund state into which it had fallen during the early- and mid-medieval period. Envying scientists' certainty, philosophers strove to bring equivalent organization to their own field. They confronted a special problem, however. Whereas Newton's world consisted of only five essences: space, time, motion, matter, and light, philosophers had to contend with a sixth: the entity called mind. When Newton stated, "I frame no hypotheses,"[4] he meant that his science dealt only with matters susceptible to proof by reason and experimental evidence. Mind, the entity that reasoned and evaluated the evidence, was of no concern to him. It could not, however, be ignored by the post-Renaissance philosophers.

Rational discourse, unlike religious dogma, allows its practitioners to doubt. René Descartes (1596–1650) took doubt to its logical extreme. Emerging at the hinge point between the fall of the Vatican's hegemony and the rise of European philosophy, the young Descartes systematically began to doubt every one of his beliefs. He said, "In order to reach the Truth, it is necessary, once in one's life, to put everything in doubt—so far as possible."[5] When he asked himself what was the absolute bedrock truth he could be certain of, he concluded that since he was doubting, he was thinking, and since he was thinking, he must exist. In 1637 he declared, "Cogito ergo sum" ("I think, therefore I am").

By doubting everything except doubting, Descartes believed he had discovered the starting point for a new philosophy. He went on to divide the world into the mental operations of the mind versus the material stuff of the body and said that each was separate and distinct. He introduced a strict dualism between mind and matter that was conducive to scientific advances in the short run, but bedeviling to Western thinkers for the next three hundred years. He was deterministic, believing there had to be reasons for everything. His philosophy depended upon a mechanistic cog and gear, and described a universe of cause and effect. He saw the body as a machine; scientists still examine it "to see what makes it tick."

Descartes's system of thought certainly diminished the role for an interventionist God. Nonetheless, Descartes was a prudent fellow. When apprised of Galileo's run-in with the Inquisition, Descartes wrote in his private

journal, "I now ascend the stage of the world of which previously I have been a spectator but I come forward wearing a mask."[6] In his writings, Descartes rendered unto God what was God's for the benefit of the Vatican censors; but with his cleverly crafted arguments he subversively edged God away from the central role He had played in the previous historical period. Descartes granted the theologians an inviolable realm immune to the encroachment of science, but in exchange demanded that they no longer interfere with the workings of the world, which henceforth would be the sole domain of science.

Among his many contributions to philosophy and science, the most enduring was his discovery of analytic geometry. He proved the isomorphism between the two maths, algebra and geometry. Analytic geometry translates the purest abstract mental functioning (algebra) into a concrete visual mode (geometry). In discovering this connection, Descartes bridged pure thought *(res cogitans)* and visual space *(res extensa)*. This has proved vital for the subsequent progress of science. This gift came, paradoxically, from the one philosopher who more than anyone else decisively split mind from matter.

Voltaire and Diderot were other advocates of the Enlightenment, exalting the power of reason over the excesses of blind faith. The apotheosis of this adulation occurred in 1789, when, at the climax of the French Revolution, fervent citizens paraded a float through the streets of Paris on which stood the "Goddess of Reason" (who happened to be a prostitute dressed up in a toga for the occasion).[7]

John Locke (1632–1704) was another post-Renaissance philosopher who ardently addressed the issue of mind. Locke wanted to know exactly who was doing the reasoning. He proposed that all knowledge about the world came from experience, and that mind arose phantasmagorically from the fevered emanations of matter. In describing the basis for his philosophy, which favored materialism, he wrote:

> . . . all our knowledge comes from experience and through our senses . . . there is nothing in the mind except what was first in the senses. The mind is at birth a clean sheet, a *tabula rasa*; and sense-experience writes upon it in a thousand ways, until sensation begets memory and memory begets ideas.[8]

According to Locke, *sensations* were the primitive stuff of thought, and since sensations were excited by matter from the outside world, matter was therefore the raw material for the mind's completed thoughts. Locke

said the mind is like a dark room into which our senses let in pictures of the outside world. Using this line of reasoning, Locke hoped to connect mind and matter and thus create a solid scientific footing for philosophy. His ultimate ambition was to affix his philosophical conception upon the rock-solid equations of Newtonian science.

Bishop George Berkeley (1685–1753), in an ironic twist of Lockean analysis, derived an opposite conclusion from Locke's premises. Berkeley said, in essence: Locke has told us that all knowledge is derived from sensation; therefore all knowledge is only sensation. If a tree falls in the forest and there is no sentient being to hear it, then it cannot make a sound. Since trees and the manifest world cannot exist anywhere but inside our minds, the bishop concluded, therefore, sensations occur only in our minds, and "All those bodies which compose the mighty frame of the world have no subsistence without a mind."[9]

Confronted by the problem of trees popping in and out of existence depending solely upon the presence of a thinking mind, Berkeley, not unexpectedly, used this apparent contradiction in his arguments to prove the existence of God. He was, after all, a bishop. Berkeley proposed that the omniscient mind of God perceived everything all of the time, and thus conveniently relieved simple mortals of the responsibilities for thinking about all those trees out in the forest. To Locke's proposal that the mind's concept of reality was rooted in external matter, Berkeley riposted that reality was all in the mind. *"Esse est percipi,"* he said—"To be is to be perceived."

Berkeley's rigorous arguments for the superiority of mind over matter riled many philosophers. Samuel Johnson's biographer, James Boswell, reports:

> We stood talking for some time together of Bishop Berkeley's ingenious sophistry to prove the non-existence of matter. . . . I shall always remember the alacrity with which Johnson answered, striking his foot with might force against a large stone, till he rebounded from it—"I refute it thus."[10]

At the age of twenty-six, the Scottish skeptic David Hume (1711–76) metaphorically stepped in between Locke and Berkeley and announced that both were wrong. Mind, according to Hume, is only an abstraction that knits together perceptions, memories, and emotions to become the "I" of each individual person's identity. The self is nothing but a collection of experiences that are not solely dependent on either sensation or matter,

but rather on both. Therefore, neither Berkeley's mind nor Locke's matter could be the sole source of thought. Hume wrote:

> When I enter most intimately into what I call *myself* I always stumble on some particular perception or other, of heat or cold, light or shade, love or hatred, pain or pleasure. I can never catch myself at any time without a perception, and never can observe anything but the perception.[11]

Initially, Hume's book *A Treatise of Human Nature* was not widely read, but eventually it inspired advocates who proclaimed that Hume proved that experience and reason have no explicit connection to each other. One wit, advised that the controversy between the materialist Locke and the mentalist Berkeley had been put to rest, said, "No matter, never mind."[12]

With a certain irreverence, Hume also proclaimed that ultimately the laws so painstakingly discovered by the vaunted discipline of science were not an inherent part of the world but only artifacts of the scientists' minds. "Note," said Hume, "we never perceive 'causes' or 'laws.' We only observe events that occur in space in a certain sequence. Sequence, however, should not be confused as a 'law' of causality."[13] Just because B follows A, it does not mean that A caused B. The twentieth-century philosopher Bertrand Russell expressed Hume's views when he wrote:

> The "law of universal causation" . . . [is an] attempt to bolster up our belief that what has happened before will happen again, which is no better founded than the horse's belief that you will take the turning you usually take.[14]

For Hume, the foundations of science were nothing more than "customs" agreed upon among scientists, and there was no "necessity" of cause and effect in any long sequence of events. Our minds imposed something we called continuity on these events generated by our unshakable belief in cause and effect. There was, however, one certainty, one exception. Mathematical equations, he said, have necessity; they alone are inherently true and immutable: Two plus two will always equal four. Thus he sentenced philosophically inclined scientists to house arrest, forcing them to refrain from speculative excursions. Henceforth they would have to remain within the restrictive confines of abstract mathematics, which his colleagues protested would be like a sterile echo chamber. Hume threw into doubt the basic premise that individuals could communicate anything meaningful to

each other because he skeptically proposed that we all live within our own worlds of belief and therefore cannot prove the independent existence of anything outside each of our frames of reference.

In addition to weakening the chain of causality, another casualty of Hume's tight logic was the idea of the "soul," which was essential to any sort of religious belief. But Hume reserved his most ferocious attack for his fellow philosophers:

> When we run through libraries, persuaded of these principles, what havoc must we make! If we take in our hands any volume of school metaphysics, for instance, let us ask, "Does it contain any abstract reasoning concerning quantity or number?" No. "Does it contain any experimental reasoning concerning matter of fact and existence?" No. Commit it then to the flames, for it can contain nothing but sophistry and illusion.[15]

At this juncture, some philosophers were not sure whether being rescued from the dogma of the Church was any great emancipation. Earlier metaphysicians had hoped to design a new philosophy that would be in synchrony with the art and physics of the age. Hume had shredded their carefully composed blueprints and then lit a match.

Upon this scene arrived an unlikely hero, Immanuel Kant (1724–1804). The little German professor rescued philosophy from Hume's arguments and set it on a solid enough foundation that it could indeed coexist with realistic art and Newtonian physics. He began the construction of his grand edifice of thought by focusing on the Achilles' heel of Hume's entire argument—mathematics. Kant wrote, "How far we can advance independently of all experience, in *a priori* knowledge, is shown by the brilliant example of mathematics."[16] As a result of this observation, he made a simple declaration that had previously been missing from the earlier European philosophers: Our knowledge of the world is *not* completely derived from our experiences.

Kant proposed that there is a substrate of knowledge about ourselves and the world that is built right into our minds the moment we form *in utero*. He asked, What if we have knowledge that is independent of sense-experience, knowledge whose truth is certain to us even before experience—a priori? If this were possible, then for Kant, absolute truth and absolute science would be possible. Kant posed these questions because he observed that experiences never give us the complete truth about the world. There are things we are sure have always been and will always be true

everywhere in the universe, such as "two plus two equals four." We do not need to return to our experience each time we run into such examples of simple addition in order to verify that they are true. Since the ability to add arises logically from human judgment's capacity to discriminate objects in space and time, Kant reasoned that some truths must be independent of experience—clear and certain in themselves. According to Kant, the axiom that "the straight line between two points is the shortest" is a priori because "it carries with it necessity, which cannot be derived from experience."[17]

For Kant, the mind must use a selection process to impose order on what Plato called the "rabble of our senses." Kant proposed that this process depended first and foremost upon two categories of appearance—space and time. Kant believed that these two coordinates, the basic constructs of Newton's external system of the world, were built directly into the structure of our thought. Space and time, according to Kant, were organs of perception.

Since in his century causality, the premier agent of reason, depended exclusively on the notion of absolute space and invariant time, Kant proposed that our ability to analyze the world in terms of causal relations was an innate skill humans used to organize thought. We "know" how to use causality because it is a priori knowledge existing before experience and without the need of sensation.*

Newton had constructed his *Principia* on the sturdy crossbeams of external absolute space and invariant time. Kant, in essence, extended the length of those absolutes from the outside material world and thrust them through the brain-mind barrier until their ends protruded into the basement of Kant's hypothetical human consciousness. After bringing these "outer" absolutes "inside," Kant founded his philosophical edifice on them as he explained how the mind works.† Space, according to Kant, had to be Euclidean and it could have only three dimensions. Euclid's axioms were a priori truths on the same order as two plus two equals four. Further, Kant argued that "time is nothing but the form of inner sense, that is, of the intuition of ourselves and of our inner state."[18] Nevertheless, he implied that time flowed in one direction at a constant rate and that we were born with the knowledge of its features. He answered Hume's skepticism by

*The two senses most important for the appreciation of space and time are sight and hearing. The blind and deaf Helen Keller's ability to reason affirmed Kant's theory of the mind's a priori ability to use an *internal* sense of space and time to think.
†Kant did attempt, albeit halfheartedly, to reconcile Newton's absolutist views with the views of his own countryman Leibniz, who believed that space and time could be relative.

proposing that space, time, and causality are conceptual and intuitive categories inherent in the human mind. This a priori knowledge allows us to agree that our inner worlds are similar enough that we can believe we each think and see the world the same. He thus rescued philosophy from the isolating arguments of Hume.

The community of philosophers eventually was impressed by the lucidity of Kant's arguments and most embraced his philosophy of Transcendental Idealism. Art, then science, then wisdom—it all seemed to fit so perfectly. Unfortunately, it was not quite correct.

Beginning early in the seventeenth century, poets were the principal group who tried to resist the juggernaut of scientific causality and logic. As science began to triumph over religion, they saw reason ascending as well over art and intuition. Their concerns were well founded, for Newton's authority soon became so immense that his *Principia* made determinism seem irrefutable.

Anticipating science's domination of thought, John Donne, in 1611, expressed apprehension over what he perceived to be the installation of a new overlord—scientific determinism—that reflected the inevitability of causality. He grappled with this depressing philosophy in his poem *An Anatomy of the World*.

> And new philosophy calls all in doubt,
> The element of fire is quite put out;
> The Sun is lost, and th'earth, and no man's wit
> Can well direct him where to look for it.
> And freely men confess that this world's spent,
> When in the planets, and the firmament
> They seek so many new; then see that this
> Is crumbled out again to his atomies.
> 'Tis all in pieces, all coherence gone;
> All just supply, and all relation:[19]

Alexander Pope's 1728 "Dunciad" also lamented science's triumph:

> In vain, in vain,—The all-composing Hour
> Resistless falls: The Muse obeys the Pow'r.
> She comes! she comes! the sable Throne behold
> Of *Night* Primaeval, and of *Chaos* old!

Before her, Fancy's gilded clouds decay,
And all its varying Rain-bows die away.
Wit shoots in vain its momentary fires,
The meteor drops, and in a flash expires.
As one by one, at dread Medea's strain,
The sick'ning stars fade off th'ethereal plain;
As Argus' eyes by Hermes' wand opprest,
Clos'd one by one to everlasting rest;
Thus at her felt approach, and secret might,
Art after *Art* goes out, and all is Night.[20]

Later, at the outset of the Enlightenment, the romantic, poetically in-
clined philosopher Jean-Jacques Rousseau (1712–78) tried to stem the
rising tide of logic by proposing that intuition and feeling were guides
superior to reason. He came to this conclusion because "I realized that
our existence is nothing but a succession of moments perceived through
the senses."[21] Rousseau reframed Descartes's "I *think,* therefore I am" to
"I *feel,* therefore I am." Yet, he could not turn back the waves of reason.
Rousseau's voice was washed away by the the success of science.

As scientific determinism gradually replaced the Church's doctrine of
fate, people who still believed in free will found themselves intellectual
prisoners bound within the iron-clad cage of Newton's arguments, which
demanded that every effect have a cause. Even so free a spirit as Voltaire
was forced to conclude, "It would be very singular that all nature, all the
planets, should obey eternal laws, and that there should be a little animal,
five feet high, who, in contempt of these laws, could act as he pleased."[22]
And yet, free will had always been the problem the logician could never
adequately explain. Dr. Johnson put his finger on it when he said, "All
theory is against the freedom of will; all experience for it."[23] John Milton,
in a well-parsed phrase in *Paradise Lost,* summed up the paradox, "But
God left free the Will; for what obeys Reason is free."[24]

The most outraged prophet, railing against the Western soul's anesthesia,
was the artist and poet William Blake (1757–1827). Blake was a mystic
who routinely experienced otherworldly visions. He wrote to his patron,
Thomas Butts, "I am not ashamed, afraid, or averse to tell you what Ought
to be Told. That I am under the direction of Messengers from Heaven, Daily
& Nightly."[25] He even set aside regular hours during the day, not unlike
lawyers and doctors, to receive these "visitors." Edith Sitwell said that
Blake was "cracked," but she believed it was through this crack that his

light shone. When, in one trenchant line of poetry, Blake warned against "Single vision and Newton's sleep," he accused Renaissance perspective and Newton's mechanics of mesmerizing the human spirit.

The opposite of Kant, Blake was an unabashed proponent of antirationalism. In his 1793 *Marriage of Heaven and Hell*, he asserted, "The road of excess leads to the palace of Wisdom" and "The tigers of wrath are wiser than the horses of instruction." "Sooner murder an infant in its cradle than nurse unacted desires," Blake advised.[26] Blake believed "Antichrist science" destroyed the soul of art and religion; for "Art is the Tree of life" and "Science is the Tree of Death."[27] When he wrote, "Reason is the bound or outward circumference of Energy,"[28] he attempted to return humanity to a more even balance between reason and intuition. He warned:

> The Spectre is the Reasoning Power in Man, & when separated
> From Imagination and enclosing itself as in steel in a Ratio
> Of the Things of Memory, It thence frames Laws & Moralities
> To destroy Imagination. . . .[29]

He believed that we are all divine beings and that God shines through our imagination which ". . . manifests itself in the Works of Art (In Eternity All is Vision)."[30]

He saw with clarity that Western man had fallen under the spell of his own creations. In Psalm 115, the biblical writer long ago cautioned against making stone idols, for, "They that make them shall be like unto them; Yea, everyone that trusteth in them." Blake now warned that realistic art and scientific causality were the new stone idols, and that Western man shared the ancient idol maker's danger in that "they become what they behold."[31]

Blake was one of the few poets who was also a visual artist. In the long reign of perspectivist art, his refusal to draw figures in their exact perspectivist relationships was conspicuous. Until the modern era, most critics dismissed Blake's paintings and engravings as childlike and primitive, claiming that his technique was crude. The one critic to ever review his only one-man exhibition (which Blake himself had arranged) said he was

> . . . an unfortunate lunatic whose personal inoffensiveness secures him from confinement, and consequently of whom no public notice would have been taken. . . . Thus encouraged, the poor man fancies himself a great master, and has painted a few wretched pictures. . . . These he calls an Exhibition, of which

he has published a catalogue, or rather a farrago of nonsense, unintelligibleness and egregious vanity, the wild effusions of a distempered brain. . . .[32]

Blake made Newton the subject of one of his works. He portrayed the distinguished physicist naked, sitting hunched on the sea's floor, totally immersed in his ocean of space and time. In Blake's version Newton appeared to be lost in concentration, reducing the world to a set of calculations with a compass and calipers.

Blake, of course, had a very different view of space and time than either Newton or Kant had. They saw space as Euclidean and time as sequential; in *Auguries of Innocence*, Blake wrote:

> To see a World in a Grain of Sand
> And a Heaven in a Wild Flower,
> Hold Infinity in the palm of your hand
> And Eternity in an hour.[33]

Northrop Frye, one of the twentieth century's principal literary historians to rescue Blake's work from obscurity, wrote that for Blake, "every act of the imagination, every union of existence and perception, is a time-space complex, not time plus space, but time *times* space, so to speak, in which time and space as we know them disappear."[34] In the coming chapters we will see just how prescient Blake's views were. "If the doors of perception were cleansed," Blake wrote, "everything would appear to man as it is, infinite. For man has closed himself up, till he see all things through narrow chinks of his cavern."[35]

Blake dismissed Locke's "in here"/"out there" logic, which formed the underpinning of philosophy and science in his day, as "Two Horn'd reasoning, cloven fiction."[36] Further, Blake believed that academic artists had sold out to science and that realistic art was dead and inert. He especially targeted for his contempt Sir Joshua Reynolds, the leading academic painter in England, characterizing him and his rule-laden disciples as "Sir Sloshua" and his "gang of hired knaves."[37] He held that the way to truth and higher consciousness was through the contemplation of art. He proposed that by immersing oneself in art, a person could experience it not just as an aesthetic but more akin to the meditative exercise a mystic performs in preparation for achieving a higher state of spiritual enlightenment. Blake declared that every man who is not an artist is a traitor to his own nature. Blake was uncompromising in this belief.

You Must leave Fathers & Mothers & Houses & Lands if they
stand in the way of Art.
Prayer is the Study of Art.
Praise is the Practice of Art.
Fasting &c., all relate to Art.
The outward ceremony is antichrist . . .
The Eternal Body of Man is The Imagination.[38]

And in the introduction to *Jerusalem*, he wrote, "Poetry fetter'd Fetters
the Human Race. Nations are Destroy'd or Flourish in proportion as Their
Poetry, Painting and Music are Destroy'd or Flourish: The primeval state
of Man was Wisom [*sic*], Art and Science."[39]

In his time, Blake resembled Cassandra, King Priam's daughter from
Homer's *Iliad*, who could accurately foretell the future. The gods' gift to
Cassandra, however, was not without a curse: Even though her predictions
were correct, no one would believe her. Blake was Western civilization's
Cassandra.

The coughing and sputtering to life in the early nineteenth century of
the Industrial Revolution reinforced Alberti's realistic perspective, Newton's
mechanistic ideas, and Kant's reasoned explanations. The translation of
airy equations into brutish engines that replaced beasts of burden led all
scientists and most artists, philosophers, and common men to glorify the
mechanistic mode. Even the rebellious artists of the Industrial Revolution's
counterrevolution, the Romantic Period, still conformed to perspective's
laws and logic's rules while fighting a futile rearguard action. The cyclopean
eye and clicking cogs of the automata's mechanism held Europe in a
tyrannical grip. Unnoticed by anyone at the time, however, a true revolution
was in the making that would overthrow these paradigms. A century later,
Alberti's perspective, Newton's mechanics, and Kant's arguments would
come to be viewed as interlocking schemes within a grander design.

Great art can communicate before it is understood.

T. S. Eliot

The artist is always engaged in writing a detailed history of the future because he is the only person aware of the nature of the present.

Wyndham Lewis

CHAPTER 8

MODERN ART / NEWTON TRIUMPHANT

The wintry ice sheet blanketing Western art and thought began to thaw in the middle of the nineteenth century. Where cracks appeared, inflows began to erode the reigning Newtonian mind-set and the tyrannical system of perspective. At the time, these innocent-looking freshets issued forth from so many different quarters that they would not have appeared to an observer to be the beginning of a flash spring flood. Yet they were interconnected in an indiscernible pattern that would eventually profoundly change both art and physics.

The invention of photography was one such current that affected people's common notions of space, time, and light and also had a major impact on art. Through knowledge gained in the fields of optics and chemistry the scientist built a little machine that could create in an instant what it took an experienced artist days and sometimes months to accomplish. The ma-

chine's product was a piece of paper that reproduced a single moment frozen from the space of visual reality. It would come to be called, appropriately enough, a snapshot. With the click of a shutter and the flash of magnesium, the camera could record the *here and now* with stunning accuracy. By the middle of the nineteenth century, photographs were ubiquitous throughout Europe.

The new contrivance was named a *camera* because of its similarities to the camera obscura invented in the fifteenth century. *Camera obscura* means "dark room" in Italian. Leonardo described its principles in his unpublished notes, and they remain the same today. If, on a sunny day, you sit in a darkened room with only a pinhole open on one side, images of the outside world will be projected upon the opposite wall. Trees, passing vehicles, pedestrians strolling, all appear in lifelike detail—except they are upside down. If, next, you place lenses in the pinhole, the images are righted. The room is already something of a small box; if you reduce its size still farther, to that of a portable box, the camera obscura becomes an instrument you can aim at a group of people at a lawn party. In the sixteenth century in Europe magicians did just that to the pleasure, amazement, and mystification of the well-to-do.

The miniaturized camera obscura quickly became an indispensable aid for painters to solve problems of perspective. Some found it easier simply to trace the lenses' two-dimensional image on the camera's glass than to work out the geometrical details of depth. The idea of preserving images had to wait for advances in chemistry.

The vast numbers of images this instrument has produced has made it difficult to remember that, like the telescope, microscope, and sextant before it, the camera is a scientific instrument that measures space and time. The crucial element necessary to conduct these measurements is light. "Photography" literally means "writing with light": *photo-graphy*.

Most paintings executed at the dawn of fixed-image photography were versions of what the artist thought he saw. The new space/time/light machine confirmed the validity of most visual data. The images provided by the camera, however, also included distortions that were routinely filtered out by the brain. The camera had no brain, and so short-circuited the aesthetics of the interpretive process. Since a photograph contains precise information about the visual relationship of parts to a whole, which is the basis for the science of perspective, the camera allowed artists for the first time to compare their own observations about nature against an objective standard.

Much to many people's surprise, the photographic record and that of

the artist were not always the same. For instance, the peculiar distortion of a hand that is made gigantic when photographed too close to the camera lens created an optical oddity that was not apparent when someone put a hand up close to the beholder's eye. The fact that such deformations existed at all threw into question the truth of the proverb "seeing is believing" and replaced it with "the camera doesn't lie." This shift in platitudes actually reflected a more important shift—the relocation of optical truth from the visual center of the brain to a piece of silver-impregnated paper—and did not go unnoticed by a few of the new generation's artists.

Besides reassessing some rules of perspective by accurately measuring space, the camera interrupted the flow of time, bringing it to an abrupt halt. The camera could freeze one moment, thus allowing an observer to inspect it at leisure. The first major dispute to be settled with the camera was the age-old question, How does a horse run? A trotting and galloping horse's legs move too quickly for the human eye to perceive their exact sequence. Some people believed that at any given moment all four hooves could be off the ground; others believed that the horse's gallop did not include a moment when the horse was airborne. Artists portraying galloping horses could not afford the luxury of indecision: They had to choose one position or the other. Before the camera, the academic convention was to depict a galloping horse with both forelegs extended forward at the moment that both hind legs were extended backward.

The camera ended this uncertainty. In 1872 two horsemen placed a wager on the question and one of them, Leland Stanford, hired Eadweard Muybridge to settle it. Muybridge set up a series of cameras along a track and, using a complicated system of trip wires, recorded a running horse on multiple film exposures. The gambler who bet that all four hooves were off the ground at once won the wager.

The results, however, were not anything anyone could have anticipated. Instead of the elegant idealized motions envisioned by generations of artists, the gallop seemed an awkward way for a horse to propel itself forward. When painters began to represent this new information in their canvases, critics were disturbed and condemned these works because "something didn't look right." Rocking horses still depict the gallop the old way.

Having measured the space within the moment of stopped time, Muybridge devoted the rest of his life to studying time and motion of objects passing through space. His studies had a seminal influence on the artists of the next generation. He also invented the basis of an entirely new art form—the motion picture.

The rapid proliferation of photographs caused artists to wring their hands

in despair. The academic painter Paul Delaroche declared, "From today, painting is dead!"[1] Artists were concerned that the camera would compete unfairly in the business of image reproduction, threatening their economic bases because a principal source of the nineteenth-century artist's income was the portrait. Everyone of note had to sit for a portrait at one time or another. But with the advent of the camera, the time required for this tedious task was dramatically reduced.

Concurrently with the development of the camera, mathematicians began a long-overdue reassessment of Euclid's assumptions about space. Euclid began his original work by declaring that his new science of space was rooted in ten axioms so self-evidently true that no sound mind would question them. These were then used to formulate five equally self-evident, seemingly indisputable postulates. The first four were obviously true. The fifth, which states that through a given point on a line can be drawn only one parallel line to a given line that intersects the first, was more complex. Throughout the centuries mathematicians attempted unsuccessfully to use the other axioms, definitions, and theorems to demonstrate that the fifth postulate while true was not independent of the other four and should not have the status of a postulate. If this could be accomplished then the fifth postulate could be reduced to just another theorem, leaving but only four basic postulates. The amount of candle wax that has melted in this futile attempt is incalculable.

It was not until the nineteenth century, however, that any mathematician could prove that Euclid was wrong. If the fifth postulate was not true, then the way was opened to construct an alternate space to the flat one so ingrained in our psyches by almost twenty-three hundred years of believing that Euclid was sacrosanct.

In 1824 Karl Fredrich Gauss, a mathematician, tentatively proposed that perhaps an alternative to strict Euclidean space might be possible. He never published his thoughts, probably for fear of ridicule by his colleagues, and so the honor of being the first to publish went to the Russian Nikolai Ivanovich Lobachevski, who, in 1840, brashly announced an imaginary non-Euclidean geometry based on the assumption of the fifth postulate's incorrectness. Gauss's prudence proved justified: The Russian professor indeed lost his job because of his blasphemy against Euclid. But unbeknownst to him, and virtually to anyone else for that matter, a young Hungarian, János Bolyai, had buried a description of non-Euclidean space as an afterthought in an appendix to his father's mathematical treatise, *Tentament*, in 1830. Like Lobachevski and Gauss, Bolyai questioned the sacred fifth postulate. All of these non-Euclidean geometries seemed un-

imaginable because the sum of the angles of the triangles in their systems had to be *less* than 180 degrees and as every schoolchild knew, that was impossible.

In 1854 Georg Riemann, a twenty-eight-year-old German mathematician, unaware of the earlier publications on this subject, delivered a lecture at Göttingen in which he proposed another non-Euclidean science of space, one in which the sum of the angles of the triangle would be *greater* than 180 degrees. In Riemann's peculiar geometry, there are *no* parallel lines and the shortest distance between two points is an arc, not a straight line. Riemann's lecture was not published until 1867, the year after his death. During the interval between Gauss's first tentative proposal for an alternative space and the publication of Riemann's speech, no one outside a small group of mathematicians took note of the importance of these advances in abstract thought. This apathy was in no small part due to the arcane nature of the subject.

In Euclid's system, space was unbounded and infinite. If an adventurer headed off in a straight line upon a Euclidean planar surface it was certain that he would never be seen or heard of again, and that his journey would be endless. Not so on Riemann's non-Euclidean system; sooner or later, whichever direction an explorer traveled on a Riemannian surface, the shape of Riemann's space ensured that he would arrive back at the place from which he started.

The possibility of curved space was incompatible with the rectilinear axioms of Euclid. In Riemannian non-Euclidean space objects within this curved space could not maintain their absolute form and changed depending upon their location in space. For someone to imagine the shape of objects existing in such a non-Euclidean world, he would have to acknowledge distortions not present in the visual Euclidean world of Western sensibility.

Concurrent with the photographic revolution and the mathematicians' speculations, warnings to the public that the Western paradigms about space, time, and light were about to change came, as they usually do, from perturbations in the field of art. In the 1850s, France in general and Paris in particular was the center of the art world. The Academy of the Beaux Arts on the Rive Gauche comprised a dictatorial committee of elderly painters and politicians who set the standards for what constituted good art and ruled the art world with an autocratic hand. Critics, for the most part, were the minions of the academy and they enforced official policy with such slashing, acid-tongued diatribes against apostates that their vituperation has rarely been duplicated. An example is the deadly attack by Alex-

andre Dumas's son upon Gustave Courbet, the popular leftist realist painter of the time:

> From what fabulous meeting of a slug with a peacock, from what genital antitheses, from what fatty oozings can have been generated this thing called M. Gustave Courbet? Under what gardener's cloche, with the help of what manure, as a result of what mixture of wine, beer, corrosive mucus and flatulent swellings can have grown this sonorous and hairy pumpkin, this aesthetic belly, this imbecilic and impotent incarnation of the Self?[2]

Most artists paid servile obeisance to the dictates of the academy and slavishly accepted its criteria. To be singled out by the academy's jury for an exhibition in the official salon was the key to the commercial success of an artist. It was not immediately apparent to the juries that, after almost six hundred years, the illusionist perspectivist art favored by the academy's traditions had lost its vitality. Many of the paintings submitted to the salon were trivial exercises in draftsmanship. Despite the importance of the jury's imprimatur for any ambitious young artist, the time was ripe for someone to announce that the emperor had no clothes.

The unlikely rebel who performed this mission was the urbane, sophisticated Édouard Manet. In his youth Manet trained with the academic painter Thomas Coutre. When he reached the age of twenty-seven, however, he destroyed virtually all his paintings in a fit of disgust and announced to his close circle of young artist friends, "From now on I will be of our times and work with what I see."[3]

Manet went on to unveil several paintings that created an uproar in the art world. In 1863 he exhibited his large composition *Le Déjeuner sur l'herbe (Luncheon on the Grass)* (Figure 8.1) in the Salon des Refusés, an unofficial exhibition organized by artists to protest their rejection from the official salon. Many art historians mark this event as the beginning of modern art.

Within the conventions of any period, artists can choose both their subject, and the manner in which they depict their subject; their particular interpretations embrace the ways they see the world. Since the beginnings of art thousands of years ago, this vision has almost always been decipherable. The spectator could use the rules of common sense to figure out the work of art. In the academy, there was a veritable mandate that art had to be understood.

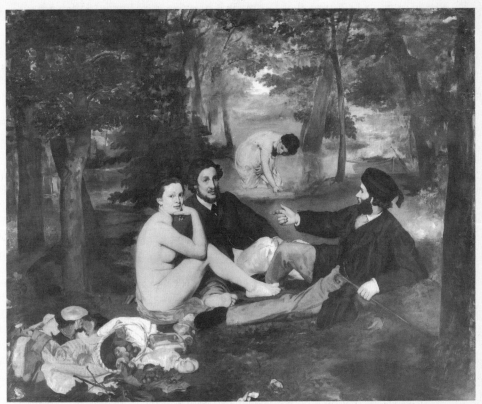

Figure 8.1. *Édouard Manet,* Le Déjeuner sur l'herbe *(1863)* MUSÉE D'ORSAY, PARIS

In a flurry of brushstrokes Manet challenged this fundamental dictum by composing a painting that had no logical consistency. There was no story, the allusion to myth was tenuous, and it was not picturesque. In short, no easy interpretation was possible. The four characters in *Le Déjeuner sur l'herbe* were all disconnected and were not even looking at one another. The juxtaposition of an undressed woman staring at the viewer while two fully clothed boulevardiers discoursed on some subject, oblivious to her proximity, outraged Parisian critics. Unlike all previous art, this painting made no sense and they considered it immoral. Most critics believed that Manet was either mad, incompetent, or a prankster.

Besides the obvious incongruities regarding the painting's theme, *Le Déjeuner sur l'herbe* contained other, subtler, revolutionary peculiarities. Manet purposefully violated the reified laws of perspective. He disconnected the foreground from the background by eliminating the middle ground. The woman who is bathing in the pool in the rear of the composition

would have to be a nine-foot-tall giant if her size were corrected for perspective. Previously, when a painter tampered with perspective, it enhanced the composition. Manet's bathing giant serves only to trouble the viewer. Further, Manet treated shadow irreverently. He purposely confounded the critics by lighting up the canvas from two different directions. The work looks as if it were painted using floodlights in front of the subjects, in addition to the natural light filtering through the trees. (Even here, Manet paradoxically arranged these shadows as if the light from the sun were coming from several directions simultaneously.) The painting's inflammatory content and strange construction tacitly challenged Aristotle's logic and Euclid's space, and called into question an entire paradigm built upon reason and perspective.

The critics excoriated Manet for his composition as well as for the crudeness of his technique. They could not understand how so promising a young artist could be so clumsy and inept about the rules of perspective. They derisively called Manet's figures flat playing cards.[4] But Manet was a master draftsman. If he chose to violate perspective's sacred canons, it was because he knew the old style of painting was exhausted. His subsequent paintings introduced his viewers to many fresh ways of seeing the world.

In his *Music in the Tuileries* (1862) (Figure 8.2), painted about the same time as *Le Déjeuner*, he presents a chaotic scene without a focus. The vanishing point is smeared across the rear of the canvas. No central character emerges around which a viewer can begin to build a coherent view, so the hierarchy of subjects evident in previous art is missing. To add to the visual stress, Manet eliminates the perpendicular line.

As I have mentioned, the only two naturally occurring vertical lines (of consequence) in nature are the perpendicular alignment of the human form and tree trunks. These two verticals intersect the equally straight horizon line to form the right angle of experience. This convention is so ingrained that all amateur photographers, when lining up the camera to take a snapshot, first align the frame of the picture with the vertical and horizontal. In *Music in the Tuileries* Manet obscures the guiding verticals and camouflages the horizon. Every tree trunk is curved; every man's hat tilts. All is askew even though anyone who has visited the Tuileries knows that the tree trunks there are not curved. In fact, the gardeners who carefully tended these trees made sure that they were straight as arrows in keeping with the geometric designs favored by the Age of Reason. While many other artists had created canvases that did not contain any perpendicular verticals, theirs were for the most part done to enhance the com-

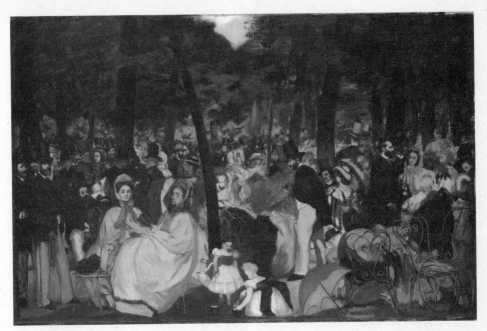

Figure 8.2. *Édouard Manet,* Music in the Tuileries *(1862)* LONDON NATIONAL
GALLERY

positions' emotionality. Manet's *Music,* on the other hand, has more to do
with revising the viewer's notions of space.

If Manet tampered with the vanishing point and challenged the rectitude
of verticals, it should come as no surprise that he was also the first artist
in Western history to curve the hallowed horizon line. The horizon, the
orienting line of all perspectivist art, is the most crucial stripe on a canvas.
Anyone who has attempted to draw a picture using perspective knows that
the first decision regarding the composition must be the location of the
horizon line.

Before Manet, virtually all paintings were created so that this line was
visible, or if hidden, implied.* The Western tradition's unquestioning faith
in the veracity of a straight horizon line is reminiscent of the stylistic

*The one major exception to this rule was the trompe l'oeil ceiling paintings by the eigh-
teenth-century Italian master Giovanni Tiepolo. Trompe l'oeil is a style that stuns the viewer
with illusionary tricks. However, although his paintings lacked a horizon line, Tiepolo sub-
stituted an overheard vanishing point and always maintained the integrity of the concept of
perspective.

conventions of Egyptian artists who for three thousand years represented the human figure in the same configuration: face in profile, torso full view, and legs in profile. But Manet was a true revolutionary. In his work *Boats* (1873) (Figure 8.3) as well as in many others, he tampers with the one razor-sharp straight line of consensus reality and bends it ever so slightly into a gentle arc. The elucidation of the concept of "curved spacetime" and its place in the physical world was still fifty years away, but in the 1860s this prescient artist anticipated the idea and tantalized his puzzled viewers. By defiantly presenting arabesque verticals and a curved horizon, Manet challenged a mind-set about space that had been born in antiquity and (except for a hiatus during early Christianity) had remained essentially unchanged until it became petrified.

The horizon we *see* appears straight, but in fact we *know* it is curved. Each visible straight segment is but an exceedingly small arc of a circle twenty-four thousand miles in circumference. Manet had a larger view than the rest of his colleagues, and at some deep level he knew that the flat, pancakelike space of Euclidean appearance was in need of revision.

In addition to obscuring the vanishing point and curving the horizon,

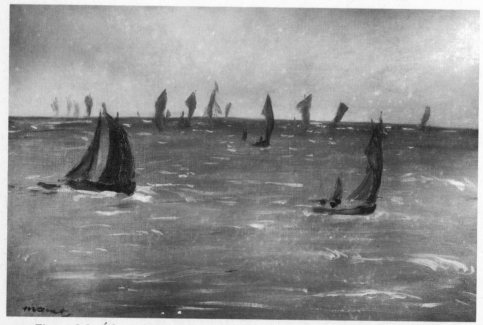

Figure 8.3. *Édouard Manet,* Boats *(1873)* THE CLEVELAND MUSEUM OF ART, PURCHASE FROM THE J. H. WADE FUND (40.534)

Manet began to move the horizon up off the picture plane. In a series of paintings executed in 1864 concerning a battle at sea involving the ship *Kearsage*, this orienting line continues to rise, getting ever higher, until finally, in 1874, it floats off the canvas. In that year Manet painted his remarkable work *Boating* (Figure 8.4). This innocent-looking work does not seem very revolutionary to the eye of a twentieth-century viewer. In it, however, Manet elevated the perspective of the point of view so that the horizon was left out of the picture frame altogether. In this, he joined his contemporary Edgar Degas, who also presented many of his subjects, principally ballet dancers and women at their bath, using an angle of vision that did not contain within the work the horizon or vanishing point. Manet tried to capture the offhand, random, candid moment. The pervasive influence of the camera is evident in his works.

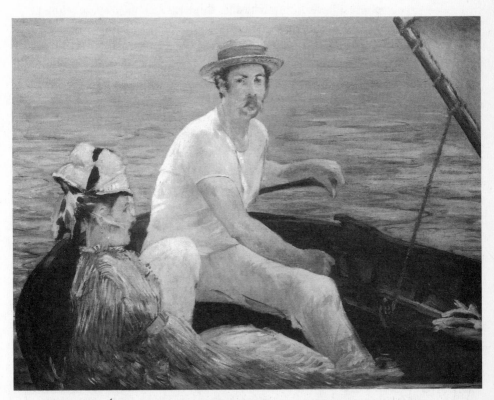

Figure 8.4. *Édouard Manet,* Boating *(1874)* THE METROPOLITAN MUSEUM OF ART, BEQUEST OF MRS. H. O. HAVEMEYER, 1929, THE H. O. HAVEMEYER COLLECTION (29.100.115)

While Manet was questioning some very fundamental assumptions regarding the perception of space, his contemporary and equally revolutionary colleague Claude Monet became the first artist since the Renaissance to investigate the dimension of time. Monet realized he could not re-create the essence of an object by painting it in only one frozen moment. To convey that essence fully, Monet needed to show how the object changed in time.

In 1891 Monet began to paint the same scene repeatedly viewed from the identical position in space, but at different times of day. He portrayed the entrance of the cathedral in Rouen in forty separate works (Figure 8.5). Viewing these paintings when they are placed in sequence creates a cathedral that begins to exist in time, as well as in the three dimensions of space.

Monet, a simple man with a child's outlook on life, and no formal academic training, had seized upon a great truth about time before anyone else: An object must have duration besides three extensions in space. Monet did not write down any theories or express one as an equation; rather he illuminated this truth in the limpid colors of his silent images.

Monet's ideas about time were as subtle as they were radical. Unintentionally, he became the herald of change. In 1895, a few years after Monet had discovered a way to introduce this notion in paint, H. G. Wells raised the same issue in literature. At a dinner party, Wells's protagonist in *The Time Machine* playfully attempts to controvert some ideas that are almost universally accepted. He begins by stating that a mathematical line, a line of nil thickness, has no "real" existence in the prosaic, as opposed to abstract, sense. All present agree. Nor, he says, has a mathematical plane any existence. Again, all agree. Neither, then, can a cube with only length, breadth, and thickness have a real existence, he says. At this, of course, his dinner companions all protest. But the Time Traveler counters, can an *instantaneous* cube exist?

> Clearly, any real body must have extension in four directions: it must have length, breadth, thickness *and* duration. . . . There are really four dimensions, three of which we call the three planes of space, and the fourth, time.[5]

By introducing series painting Monet incorporated the concept of changing time into the frozen moment of art. The word "series" itself is not an art term but rather is borrowed from mathematics and connotes sequence. Sequence is the backbone of time. Monet painted twenty separate moments

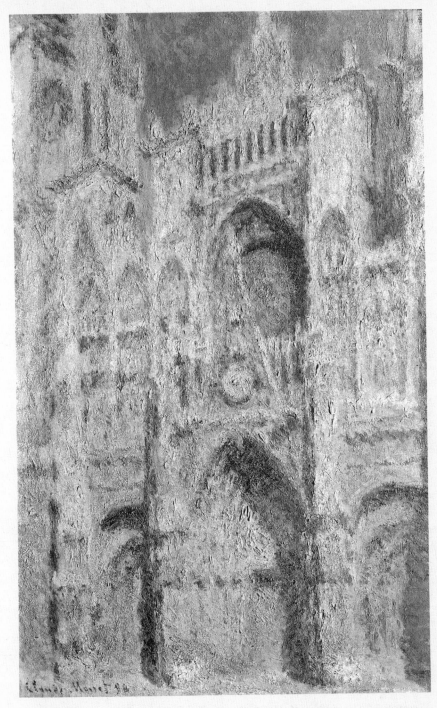

Figure 8.5. *Claude Monet,* Rouen Cathedral *(1894)* THE METROPOLITAN
MUSEUM OF ART, BEQUEST OF THEODORE M. DAVIS, 1915, THEODORE M. DAVIS
COLLECTION (30.95.250)

of haystacks because he wanted to demonstrate how they changed with the seasons. It is as if Monet were saying, "If you want to know the complete nature of haystacks, you must see them through time as well as in space" (Figure 8.6 and Figure 8.7).

In his concern for time, Monet enlarged the moment of the present by capturing the fugitive impression of *now*. He even invented a name for his style: He called it "Instantaneity." This word comes not from the visual world of space, but rather from the abstract notion of time. Monet was not at all scientifically informed. He would have been surprised had anyone told him he had invented a radical new way to *see* time before anyone devised a correspondingly totally new way to *think* about time.

Besides time, Monet's paintings introduced other innovations concerning the nature of space and light. He was one of the early artists in the post-academic tradition to dispense with the all-important direction of Euclidean vectors of orientation. A painting is a flat surface that holds an assortment of colored pigments. Visual clues are needed for the viewer to decipher the basic orientation, or direction, of a painting. Euclid's space depends upon the descriptive words "top," "bottom," "right," and "left,"

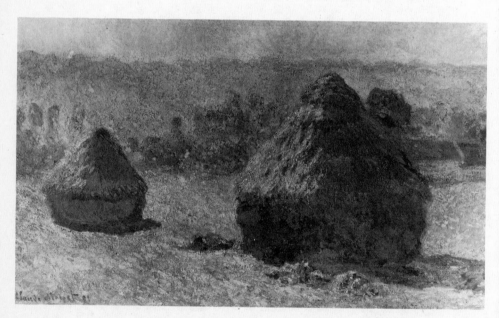

Figure 8.6. *Claude Monet,* Haystacks, End of Summer, Evening *(1891)*
MUSÉE D'ORSAY, CLICHÉ DES MUSÉES NATIONAUX, PARIS

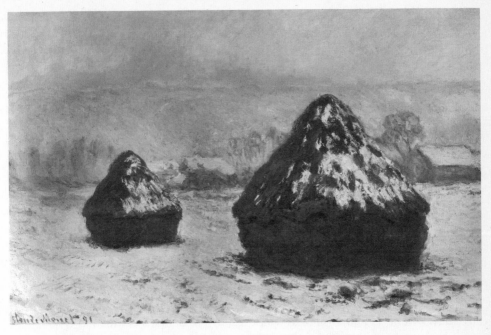

Figure 8.7. *Claude Monet,* Haystacks, Snow Effects *(1891)* SHELBURNE MUSEUM, SHELBURNE, VERMONT

the vectors of plane geometry. Solid geometry adds the notion of near and far. Artists refined this latter vector when they discovered perspective.

From the fifteenth to the twentieth centuries, Western civilization was restricted to using Euclidean coordinates. Then the seeds of doubt about the inviolability of the Euclidean conception of geometry began to sprout in the field of mathematics. The artist, unaware of these doubts, nevertheless found a way to express them visually.

After Monet retreated to his garden at Giverny in 1881, he began to concentrate on representing the surface of a pool of water (Figure 8.8). Building on Manet's manipulation of the horizon line, Monet raised the viewer's angle of vision until the horizon was somewhere off the canvas. Then, unlike Manet, he reduced the variety of elements on the canvas to two: water lilies and water. His paintings in these later years became increasingly diffuse. The distinction between what was *in* the water, *on* the water, or *reflected upon* the water became ever more difficult for the viewer to discern until they became a continuum of elements and color. Finally, in compositions that tested the limits of realism and bordered on abstract

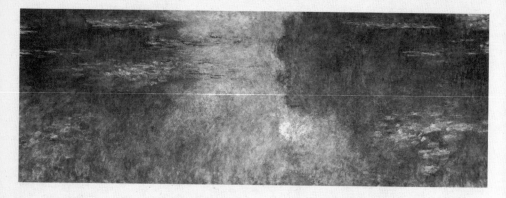

Figure 8.8. *Claude Monet,* Water Lilies *(ca. 1920)* COLLECTION OF THE
MUSEUM OF MODERN ART, NEW YORK, MRS. SIMON GUGGENHEIM FUND.

art, Monet's image became so blurred that all orienting visual clues disappeared. Along with work by the early abstract painters, Kandinsky, Malevich, and Mondrian, Monet could claim the dubious distinction that it was accidently possible to hang some of his late paintings upside down. His innovation, however, challenged the veracity of Euclid's vectors.

Unlike previous painters, he was not as interested in the geometry of shapes and forms as he was in the massing of colors. In trying to capture his "impressions," he blurred the outline of objects and his smudged straight line was no longer the sharp boundary restraining an object's color.

Given his work with color it is not surprising that Monet is most remembered for his contributions in the field of light. By trying to capture the nature of light *en plein air* instead of reproducing it in the artificial confines of his studio, Monet released the brilliance inherent in the color of everyday natural objects until the identity of the objects in his compositions became less important than their color.

Monet once said that he wished he had been born blind and later gained sight. That way he would be able to look at the world freed of the knowledge of what the objects were so that he could more fully appreciate their color. The archaic Greeks, as I have mentioned, used the same word for "eye" and "light." In a similar vein Paul Cézanne remarked, "Monet is only an eye, but—oh, what an eye!"[6] Monet proposed that color, which is light, should be elevated to the throne of art.

The third master of the modern era, Paul Cézanne, devoted a lifetime to studying the relationship of space, light, and matter. To consider these in isolation he adopted an opposite approach from that of Monet, finding

it expedient to eliminate the variable of time. Cézanne said of his own work:

> A minute in the world's life passes! To paint it in its reality, and forget everything for that! To become that minute, to be the sensitive plate ... give the image of what we see, forgetting everything that has appeared before our time. . . .[7]

His early works contained some elements of motion, but as Cézanne's oeuvre developed, time slowed and finally stopped. In his cardplayer series, for example, executed between 1885 and 1890, the players sit motionless; there is a minimum of action. His interest in the architectonics of composition led Cézanne to turn away from transient effects and beginning in 1878 concentrate on still lifes and landscapes, both of which are entirely devoid of action. The sense of timelessness in Cézanne's later works is enhanced by his abandonment of the convention of linear light. This innovation proved to be precognitive indeed, when later physicists revised human understanding of the whole compound subject of space, time, and light.

As part of the resurgence of Euclidean thinking during the Renaissance, artists when expressing light had it traveling in rays, sheets, or beams, but always in the straightest of lines. To emphasize this apparent truth artists had faithfully employed the stylistic convention of shadow. Shadow in nature almost always results from the slant of the sun. By using shadow, in addition to defining depth the artist gives to the viewer a crucial visual clue about the time of day or, for that matter, time of year in which a particular painting is set. In the art of the frozen moment that predated modern painting, this convention was so important to the correct "reading" of a painting that from the time Piero della Francesca worked out the optics of shadow within the rules of perspective, no artist ever asked whether it could be any other way. With the exception of a few trompe l'oeil paintings, this convention was not violated—shadows always fell to the side opposite the light source.

The light in Cézanne's late work became increasingly diffuse because the source and direction of light became ever less discernible. In his later paintings of Mont Sainte Victoire in Provence (1888–1904) (Figure 8.9), light suffused the painting rather than shone across it. In many other of Cézanne's landscapes, linear light became so scattered that there seemed to be no distinct direction of origin. Shadow failed to provide the viewer with the critical clues necessary to tell time.

Figure 8.9. *Paul Cézanne,* Mont Sainte Victoire *(1902–4)* PHILADELPHIA MUSEUM OF ART, GEORGE W. ELKINS COLLECTION

John Canaday, a contemporary art historian, said of Cézanne's innovations concerning time and light:

> Cézanne discards the idea of capturing transient effects. In the world he paints there is no time of day—no noon, no early morning or evening. There are no gray days, foggy days, no "effects" of season or weather. His forms exist in a universal light in the sense of directed rays from a single source, not even the sun. It is not light as an optical phenomenon to be investigated and experimented with. It is a uniform and enduring light, steady, strong, clear and revealing, not a light that flows over objects and not a light that consumes them. It is light

integral to the canvas; it is "painted in" with every stroke of color. It is a static and timeless light.[8]

Cézanne challenged in an image Western culture's assumptions regarding the nature of light by eliminating the angle of declination that had prevailed in previous art. In doing so, he also called into question the a priori assumptions about the other two constructs, space and time. As we will see later, Cézanne's ideas fit in exactly with the new conceptions of space, time, and light that were to be elaborated by a physicist in the early years of the twentieth century.

Cézanne's investigation of space produced several profound revelations that inspired many of the art movements that were to follow. One of the most important of these was the discovery that *space was not empty*. For centuries space was a negative container within which artists and physicists could arrange objects without affecting the space that surrounded them. The corollary was also held to be true: that space did not affect the movement of objects. In his powerful works, by interlocking broad planes of space with equally broad planes of mass, Cézanne demonstrated that the objects in a painting were integral to the space of the work and were therefore affected. Later in Chapter 22 we will see just how interconnected are space and mass.

Cézanne also eroded single-point perspective by introducing the unheard-of notion that a painting can have multiple perspectivist points of view. In his *Still Life with Fruit Basket* (1888–90), he portrayed the various objects in the painting as if each were seen from a separate angle of vision (Figure 8.10 and Figure 8.11). Cézanne's innovative quirk threw into question the validity of a nexal vanishing point that was behind the all-important idea of the relative hierarchy of the visual world as well as the notion of a privileged place to stand.

Cézanne viewed his objects as if seen from the entire periphery of vision instead of restricting them to a detailed scrutiny by the retina's focal point. In doing this, he modernized a more primitive way of viewing the world that had been naïvely present in pre-Renaissance art and in the art of all preliterate societies. In his early paintings, Cézanne was less interested in imitating the features of a landscape than he was in revealing how our visual perception of the world is composed of interlocking planes. In his later landscapes, Cézanne became increasingly fascinated with one mountain situated in Provence: Mont Sainte Victoire (see Figure 8.9) It became for Cézanne a stationary studio model upon which he could carry out his

Figure 8.10. *Paul Cezanne,* Still Life with Fruit Basket *(1888–90)* MUSÉE D'ORSAY, PARIS

experiments concerning visual reality. He began to paint this same mountain from many different points of view. Unlike his still lifes, which contained multiple points of view within each canvas, in his Mont Sainte Victoire series each canvas represented the mountain from a different location in space.

Cézanne further altered our ideas about space by desecrating the integrity of the straight line. In his still lifes, the drape of a tablecloth usually obscures part of the edge of the table upon which his painted objects rest, and in these paintings the straight edge of the table, which in experience we know to be ruler-sharp, is inevitably broken and discontinuous (see Figure 8.10).

In terms of the scientific discoveries their paintings heralded, Cézanne's

investigation of Mont Sainte Victoire complemented Monet's exploration of haystacks. In Monet's series of paintings he showed how an object changed through *time* when viewed from the same place. Cézanne illuminated the same object from different points in *space*. It is implicit in these series that Cézanne had to move *in time* in order to set up his easel in different places, and Monet had to come back at *later times* to produce different versions of the same object in space. Both masters enlarged upon the idea of the double exposure first expressed in modern art by Manet, and each developed it using a different coordinate.

Manet first curved the straight line of the horizon, Monet blurred his straight boundaries, and Cézanne splintered the straight edge of his tables. What we see at the focusing point of vision are clean-edged objects arranged around the vanishing point intersection of the upright vertical and rectilinear horizontal. The view from the periphery of vision—that is, the wider, more encompassing one—is unfocused and curved and has more than one

Figure 8.11. *Diagram showing how parts of the Cézanne are in correct perspective for eyes situated at different heights and at different angles of observation.* From Erle Loran, *Cézanne's Composition* (Berkeley: University of California Press, 1943), Plate 14.

point of view. These three artists presented just such a view. Their revolutionary assaults upon the conventions of perspective and the integrity of the straight line forced upon their viewers the idea that the organization of space along the lines of projective geometry was not the only way it can be envisioned. Once people began to *see* space in non-Euclidean ways, then they could begin to *think* about it in new ways too.

If the questions these three artists raised were misunderstood by their contemporaries it was only because no one at that time could know that the whole conceptual framework of reality was soon to be supplanted. It would take the elegant calculations of an Einstein years later to provide the proof in black and white of what had been stunningly accurate artistic hunches expressed in form and color.

> If we do not expect the unexpected, we will never find it.
>
> Heraclitus

> Imagination is more important than knowledge.
>
> Albert Einstein

CHAPTER 9

EINSTEIN / SPACE, TIME, AND LIGHT

To appreciate the prescience of Manet, Monet, and Cézanne, it is necessary to understand the revolutionary breakthrough that occurred in physics at the start of the new century. In 1905, a year before Cézanne died, Albert Einstein, an obscure patent official, published an article in the German *Annalen der Physik* which would become known as the special theory of relativity. (Galileo had already discovered the original theory of relativity.) Einstein never had much interest in or affection for modern art, yet many of the conclusions to be drawn from his graceful equations about space, time, and light bear an uncanny similarity to the innovations introduced by Manet, Monet, and Cézanne.

Einstein's contribution erupted against the backdrop of an imposing and thoroughly entrenched belief in the omnipotence of classical mechanics. Newton's system had worked so well for more than two hundred years that many physicists at the turn of the century believed it was only a matter of time before the book of physics, like the book of anatomy before it, could

be closed. Certainly new problems would arise, they thought, but just as certainly those, too, would be solved within the Newtonian framework.

Despite this confidence, by the end of the nineteenth century some thin cracks began to appear in classical mechanics that could no longer be ignored: Two niggling features of light did not fit. In 1900 Lord Kelvin, a distinguished physicist, in an address before the Royal Institution, waxed expansively about the triumphs of Newton's mechanics. He then brought up the subject of these unsolved problems concerning light calling them "two remaining clouds on the horizon of the Newtonian landscape."[1] Dispelling these two clouds, each involving light, however, proved very difficult, despite the attention of many of the best investigative minds. The physicists involved could not know they were asking the wrong questions. It would take the beginner's mind of a child to rephrase one of them.

In 1873 the physicist James Clerk Maxwell had mathematically demonstrated how light travels through space as a wave. As a child, Einstein had asked himself what the world would look like if he could travel astride a speeding light beam, and he also wondered how the wave would appear if he could dismount and travel beside it at the same velocity. His simple questions resemble those asked by Copernicus and Kepler centuries before in that they were essentially artists' perspective problems posed by changing the point of view.

Lacking the mathematical skills to answer his naïve question, he had to wait until he was twenty-six years old. In 1905, after many frustrating failures, Einstein found himself underutilized as a minor civil servant in the patent office in Bern, Switzerland. Though regretting that he was a disappointment to his parents, he wrote to his friend, "I have a few splendid ideas which now only need proper incubation."[2] And it was that year that he not only got his doctorate, but he also had the revelation that would force a change in the way we think about the world—he published his account of the special theory of relativity.

To understand this scientific revolution we must first define for ourselves, as did Einstein, the three terms "space," "time," and "light." Newton had asserted that space was absolute. It was flat, homogeneous, and inert. Space, according to Newton, was everywhere the same. If you could measure a yardstick traveling in orbit about Alpha Centauri it would be the same length as the one here in your mother's closet on earth. Space and time were inviolably separate; neither affected the other. Space and matter, too, had no reciprocal functions; space did not interact with objects placed in it.

Newton also held that time was absolute: an ever-constant, irresistible

river that flowed in but one direction. Even though human consciousness might perceive time differently, depending upon whether an individual is in a dentist's chair or riding in a roller coaster, time itself remained outside consciousness. Time was conceived as a lofty jet stream high above human affairs whose rate of change forever remained invariant. A minute ticking by on a hypothetical clock situated on Halley's speeding comet was the same as the minute on a kitchen clock.

Since, according to Newtonian physics, space and time were rigid and constant, light must be the messenger of information traveling from here to there across space in a certain amount of time. To measure the speed of light in this model, it had to be established whether the one doing the measuring was at rest, moving with, or moving against the direction of the light beam. The best place to measure the speed of light was thought to be from the position of absolute rest, which was supposed to be in the ether. The ether provided an ideal platform that was absolutely motionless as far as the measurer was concerned. In the early nineteenth century, Augustin Fresnel successfully used this concept of absolute rest to determine that the speed of light was 186,000 miles/second, which in physics is represented by the symbol c.

Newtonian notions of space, time, and light are part of our a priori knowledge. They seem self-evident and confirm our common sense. Einstein turned everything upside down by declaring that space and time are relative and only the speed of light is constant. Einstein based his entire special theory upon two deceptively simple postulates. The first is that the laws of physics take the same form in all inertial frames of reference (that is, there is not one privileged inertial frame—or place in the ether—that is at absolute rest). The second is that the speed of light is constant for all observers regardless of how fast and in which direction they are moving. These two gentle tremors below the crust of classical thought had the tectonic effect of toppling many supports holding up an entire edifice.

Einstein's insight is so foreign to everyday experience that it can best be illustrated by examples.* Imagine, if you will, the young patent official Einstein leaving his office for lunch. He steps onto a train, which departs

*Throughout the remainder of this book I will be making a comparison between the artist's image and what an imaginary observer would *see* with the eye and *photograph* with a camera when traveling at relativistic speeds. This is different from what a scientist, using sophisticated instruments, would *measure* traveling at the same speed. For example, relativity effects can be measured at everyday speeds using extremely sensitive measuring devices. It was not until 1959 that scientists began to address in earnest the question of what an observer would actually *see*, and even today, with the use of advanced computer simulations, there is no unanimity among relativity experts as to the precise visual effects at present at relativistic speeds. *(continued)*

the station in central Bern at precisely the moment the clock tower there strikes 12:00 noon (Figure 9.1). If the train pulls away and begins to move along the track at a leisurely five miles per hour, Einstein can look back and observe time passing as the minute hand of the clock moves slowly and reaches 12:01. At five miles per hour, space and time appear absolute and light seems to travel across these two coordinates.

To "see what time it is" we look at a clock. Light originating from the sun strikes the clock, imprints the image of the arrangement of the hands, and then ricochets off the clock and heads for our eyes. The light entering our pupils carries with it the image of the face of the clock. Although the interval the light takes to get from the clock to our eyes is infinitesimally short, it still is measurable. When we "see what time it is" we are really seeing the state of the face of the clock a moment before. Light always carries within it the frozen moment of an image's creation.

Let us suppose now that this particular train hurtled away from the clock tower at the velocity of light; that is, instead of five miles per hour, the train sped away at 186,000 miles per second (Figure 9.2). If this acceleration began at precisely 12:00 noon, then the light that contained the message "12:00 o'clock" would always travel with the train because that light that had bounced off the clock containing the message "12:00 o'clock" would be moving at exactly the same speed as the train.

To Einstein and to any other passenger on this high-velocity train looking back in the direction of the clock tower, time could never change. It would appear forever frozen at 12:00. This would produce a queer effect because, for the passenger looking back at the tower, from this special rapid-transit train moving at the speed of light, *time on the clock stands still.* Yet, if Einstein, puzzled by the observation of time standing still, were to take out his watch from his vest pocket while riding on this same train, he would be confronted by the fact that it continued faithfully to tick off the minutes oblivious to the train's amazingly high velocity.

In this illustration there are now two times, one frozen on the face of the clock tower as seen by the passenger looking backward *from* this rapidly moving train, and the other recorded by the watches of the passengers *in*

Hendrick Lorentz and George FitzGerald were physicists antedating Einstein who suggested that an object's appearance would seem to shorten if it moved past an observer at very high speeds. Many subsequent workers in this field believed—incorrectly—that the Lorentz-FitzGerald contraction, as it is called, would not be observable. By 1961, however, scientists realized that the contraction would indeed be visible.

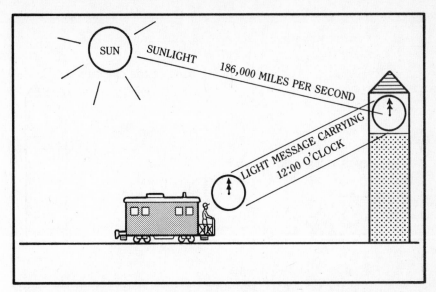

Figure 9.1. *A train moving away from a clock tower at 5 miles per hour. After a minute passes, the observer on the train notes that the time on the clock is 12:01.*

the train. Einstein concluded from this type of thought experiment that time was not absolute, but rather relative. Time, he realized, depended entirely upon the speed of the observer relative to the position of a clock (or, conversely, the speed of the clock relative to the observer). This weird effect is unnoticeable in the everyday world because nothing travels anywhere near the speed of light; further, 186,000 miles per second is so fast that it *appears* to us that light transfer is instantaneous. The relativity of time, however, is still present at velocities slower than the speed of light, though to a lesser extent. At one half this speed, that is, at 93,000 miles per second, the time on the clock tower does not stand still but rather passes more slowly than time on the passengers' watches.

This peculiarity of the nature of time has the additional effect of seeming to bring the past and the future closer together when traveling at ever increasing speeds. This illusion, however, is really the result of the present moment enlarging to encompass more of the past and more of the future. Finally, at *c* the present incorporates all of the past and all of the future so that all time exists in one still moment of *now* (Figure 9.3).

With the help of such "thought" experiments or *gedankenexperiments*,

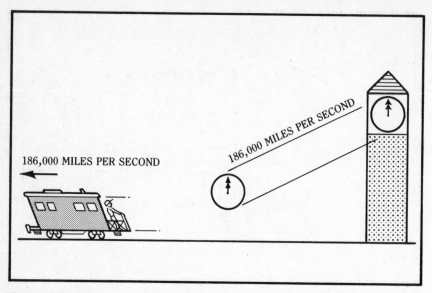

Figure 9.2. *A train moving away from a clock tower at the speed of light. After a minute passes, the observer on the train notes that the time on the clock remains 12:00 o'clock.*

as Einstein called them, he realized that time, which had hitherto been assumed to be constant, unvarying, and absolute, in fact depended solely upon how fast an observer moved relative to various clocks. The faster an observer moves relative to any clock, the more dilated (slowed) the moment of time becomes for that observer.

Traveling at high relativistic speeds also introduces bizarre distortions in the shape of ordinary objects. According to the special theory of relativity, rigid forms change their appearance when viewed at speeds that begin to approach the speed of light. An object's shape in the world where observers move at less than one half the speed of light appears fixed. That is, it seems to hold to its form no matter how fast and in what direction an observer travels relative to the object. Any deformation of that shape can only occur if it is acted upon by some other agent. This truth is contained in Euclid's fourth postulate (all right angles are equal to one another) and the nineteenth-century physicist Hermann von Helmholtz proposed that it was an inviolate law of physical reality. A beer can, a ruler, and a tree maintain a constant form unless some force intervenes to change them. Object per-

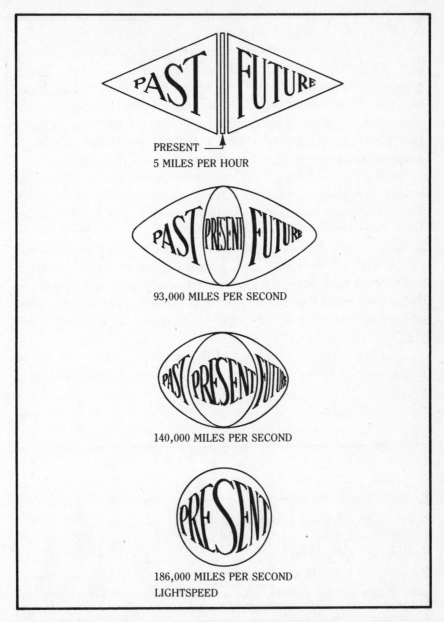

Figure 9.3. *Time slows as one approaches the speed of light. The present moment expands from a narrow sliver until it encompasses both the past and the future. At lightspeed, time ceases to change because it contains all change.*

manence is part of the intuitive knowledge we have about the world because nothing in our consensual experience ever contradicts this truth.

Einstein's thought experiment revealed that physical objects in space as well as time begin to undergo a transformation whenever an observer approaches the speed of light. Furthermore, these deformities are always the same. For example, things seen off to the side from the train traveling at one half the speed of light appear vertically elongated, and at higher speeds their tops begin to curve away from the perpendicular; right angles disappear and are replaced by arcs (Figure 9.4 and Figure 9.5).

The truly astonishing thing about these deformations is that for the observer the objects themselves actually change shape due to a plastic transformation in the space in which they reside. Space that Euclid had declared was homogeneous and inert, space that Newton proposed was absolute, turns out to have the properties of Silly Putty depending upon an observer's relative speed. Space has the capacity to deform any object that happens to be within the observer's relativistic speed zone. The notion that space is interactive with the volume, shape, and size of objects residing within it is one of the crucial insights of Einstein's special theory of relativity.

The other bizarre optical effect of the relativistic viewpoint is the simultaneous appreciation of more than one side of an object when seen

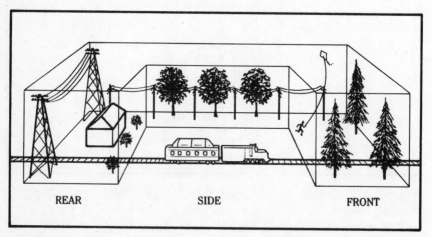

REAR **SIDE** **FRONT**

Figure 9.4. *Countryside viewed from a train traveling past at 5 miles per hour*

REAR SIDE FRONT

Figure 9.5. *Countryside viewed from a train traveling past at 93,000 miles per second*

from the windows of the train. In our everyday world, to view the sides of an object after seeing it from the front, time must elapse and our position must change in space. From the high-speed train, however, the front and the side of an object can be seen simultaneously (Figure 9.6).

As the train continues to accelerate, space becomes even more contracted until finally, at the speed of light, space along the train's axis of direction contracts into an infinitely thin plane having height and depth but *no length* (Figure 9.7). One of the Euclidean dimensions essential to our conception of reality will actually disappear at the speed of light!

In addition to space and time, the special theory of relativity also changed our perception of light's nature. Sophisticated experiments by nineteenth-century physicists fixed light's speed at 186,000 miles per second, which implied that light traveled *through* space (miles) *in* time (seconds). Scientists had assumed that this speed, like the speed of any other object in our world, was relative. They assumed that if an observer moved against the direction of a light beam, the beam would appear to move faster, whereas if an observer traveled alongside it, the light beam would appear to slow down. We observe this kind of relativity every day and it seems indisputable.

When a passenger in a car observes a train moving along tracks parallel to the highway, the train seems to fly past at faster than its real speed if its direction is opposite to that of the car. If the train is headed in the

Figure 9.6. *(left) View of a house from a train traveling past it at 5 miles per hour*

(right) View of a house from a train traveling past it at 93,000 miles per second

Figure 9.7. *An infinitely thin slice of compressed countryside as seen from the side windows of a train traveling past at lightspeed*

same direction as the car, then to the passenger the train seems to slow or even, if the car's speed is exactly that of the train, to stop.

This phenomenon of relative speed is so central to our consensus beliefs that Einstein's pronouncement that light's speed is absolute and invariant came as a major cultural and scientific shock. Einstein said that c, the speed of light, is not the same as the speed of cars, trains, or comets, but rather a true constant of the universe, an immutable superparadigmatic fact that stands high above previous opinions about reality. For all observers, regardless of which direction or how fast they are moving relative to a light beam, the speed of light, as measured by any of them, will *always* be the same, 186,000 miles per second. This numerical value is the speed limit of the universe.

An interesting way to compare the innovations of Manet, Monet, and Cézanne with Einstein's special theory of relativity would be to take a trip in an imaginary rocket train that accelerates gradually toward the speed of light. The precognition of our three artists will become increasingly apparent as we compare the visual effects outside the train's windows with the artists' painterly styles. In this experiment we will be like the child Einstein who wanted to know what the world would look like if he were sitting astride a beam of light.

Einstein's equations prohibit anything of substance from traveling at the speed of light because objects approaching this velocity become more massive and therefore ever more resistant to acceleration. Eventually, they acquire infinite mass, requiring infinite energy to overcome their infinite inertia. While nothing made of matter can achieve the speed of light, in order to answer the young Einstein's question and to finish this *gedankenexperiment*, let us imagine that our special train is exempt from this limiting process and has now achieved lightspeed. How would the world appear to us from this unique viewing platform? This is the *only* platform in the universe that is "absolute."

Imagine that we are in the observation car of our special train in a seat that allows us to swivel and see what is approaching and receding as well as to be able to look to our side and see the passing countryside. We have sitting alongside us the eminent painters themselves to comment on the scenery. As the train begins to accelerate, no effects of relativity will be noticeable until the train achieves about one half the speed of light. Here several peculiar visual distortions come to our attention. Looking forward, we first notice a strange flattening of the appearance of objects. The background to our scenery begins to move closer to the foreground contracting the middle ground. This creates the illusion that perspective has flattened.

Things look "scrunched up." Space between objects is truncated, and figures begin to look two-dimensional, less rounded, and take on the appearance of flat playing cards.

At this point, Manet could not help but smile and nudge us with his elbow, pointing out that he had anticipated these effects when he painted *Le Déjeuner sur l'herbe*. If we turn around and look behind us, the same effect is apparent. Despite the fact we are hurtling away from the scene behind, it still appears flatter and the distant landscape seems much nearer to the objects closest to the rear of the train. Both looking forward and backward we see that shapes are flattened and perspective is foreshortened.

If we look out to the side while traveling at one half the speed of light, we see the objects whizzing past us also beginning to change their shape. There is a noticeable contraction of their width and a corresponding increase in their height, so that objects we see off to the side give the illusion of being taller and thinner than they were when viewed from slower speeds. Further, their tops curve away from the perpendicular. Right angles have disappeared to be replaced by gentle curves.

Shadows also change at these high speeds. Traveling at slow speeds creates the impression, *which in relativity is not correct*, that light travels from here to there in time. In this misconception, the side opposite the source of light must *always* be in shadow. But as our velocity approaches the speed of light, shadows become less crisp, and the contrast between light and dark lessens. By way of illustration, if we can see two sides of an object at once, and one of those sides is in shadow while the other is not, then the simultaneous appreciation of both will tend to blur the distinction between clear light and dark shade. The clear-dark of chiaroscuro will be smudged. Monet could not help but comment that the normal chiaroscuro of the landscape is gradually becoming more sfumato, and the effect becomes more obvious as our speed increases relative to the landscape. As our velocity nears 186,000 miles per second, shadows all but disappear.

Besides this lessening of chiaroscuro, the colors of objects in the landscape begin to change at very high speeds. This is not only a function of relativity, but also of the Doppler effect. The hee-haw sound of an ambulance siren or train whistle as it passes us is an example of how sound waves are influenced by movement relative to a listener, a phenomenon first described by Christian Doppler in 1842. Light waves, too, are affected by the Doppler effect and change colors for an observer who is in motion relative to them. Einstein in 1905, through a set of equations that expressed the transformation law for light frequencies, merged the classical Doppler effect with his special theory and in so doing explained the exact nature of relativistic

color changes. These shifts in the spectrum with movement do not become apparent until an observer attains relativistic speeds.

Viewed from the rear platform, trees, houses, and people become redder. Objects in front of the train become bluer. Off to the side, objects' colors also change. Monet, peering out the side windows, would exclaim, *"Mon Dieu,"* and excitedly point out the peculiar rainbow effect that appears to blanket the countryside. The entire tableau is changing colors, those objects slightly past becoming redder, and those slightly ahead more blue-violet. Those directly off to the side take on an orange, yellow, and green cast.

While all these changes take place in the coordinate of space, a similar relativistic transformation occurs in the coordinate of time. Clocks seen off in the far distance both front and back begin to slow.* To passengers in the train, the interval between events in the past—in the rear—behind the train, and events in the future—in front—ahead of the train, appears to shorten. The past and future, separated by the present, seem to approach each other, but this is an illusion. The present moment outside the train, the *now*—what Monet called instantaneity—is actually dilating so as to include both more of the past and more of the future. Thus, objects and events viewed from the *rear* of the train (space) and the *past* (time) squeeze closer to the *front* of the train (space) and the *future* (time).

At the speed of light the scene at the rear of the train fuses with the scene in front! The words "ahead" and "rear" lose their meaning and space outside the train contracts so severely that these two spatial directions are in contact with each other. Because of this queer effect, any individual looking forward sees the rear platform of the train! Front, back, and side are all squeezed into an infinitely flat, two-dimensional, vertical plane. Length, the first dimension of Euclidean space, has disappeared. A similar fantastic distortion of time occurs at the speed of light. As I have mentioned, the closer we approach the speed of light, the smaller the interval between past and future is because the present is enlarging, oozing in both directions, swallowing up what was and what is yet to be in the single moment of *now*. At the speed of light these three durations of time merge. But, for everyone *in* the train nothing is amiss: The colors, shapes, shadows, and boundaries of objects *inside* remain unchanged.

Now Cézanne would most likely point out that for the passengers on this train determining if time were passing for events outside the train would be impossible. As in his landscapes and still lifes, proper time (from

*Classical Newtonian physics would predict that time as recorded by clocks in the rear of the train should dilate, while those in front should appear to speed up.

the German *eigenzeit*, literally translated as "owntime"), blurs to encompass one motionless *everlasting now*. Time as measured by change does not exist. Einstein said, "You have to accept the idea that subjective time with its emphasis on the now has no objective meaning . . . the distinction between past, present and future is only an illusion, however persistent."[3]

Before Einstein, the Western mind conceived space and time as separate coordinates. The measurement of each was a qualitatively different function, as distinct as telling time on a clock was from gauging inches with a ruler. But as we have seen on our train journey, once we break free from the very slow speeds of our earthbound existence, time and space are a complementary pair, intimately intertwined: As time dilates, space contracts; as time contracts, space dilates.

In 1908 Hermann Minkowski, a German mathematician and former teacher of Einstein, expressed in equations this reciprocal relationship and recognizing that it comprised the fourth dimension, named it the *spacetime continuum.* The new phrase coined for this revolutionary mind-expanding concept joined two old words, space and time, fusing them in order to emphasize the fact that each, which for millennia had been held separate, was in truth a magnificent unity. Before the eightieth Assembly of German Natural Scientists and Physicians, Minkowski began his speech in words that were revolutionary:

> Gentlemen! The views of space and time which I wish to lay before you have sprung from the soil of experimental physics, and therein lies their strength. They are radical. Henceforth space by itself, and time by itself, are doomed to fade away into mere shadows, and only a kind of union of the two will preserve an independent reality.[4]

In his 1905 article Einstein nullified the concept of absolute rest as meaningless since the immovable ether does not exist—the laws of physics are the same in all inertial frames. Since everything of substance is moving relative to everything else, there is no physical location that is motionless in the universe.

The special theory of relativity thus became a democratic bill of rights for all inertial frames of reference. The theory does not say that everything is relative, but rather that perceptions of the world are observer-dependent. Only light itself, which cannot be used as a platform because nothing of substance can ever achieve this speed, can possibly be the ideal—and unattainable—vantage point.

According to Einstein, light is elevated to a supremacy over both space and time. Indeed, it seems instead to be the very *source* of space and time. Prosaically, we believe light rays journey light-years across vast intergalactic distances. On the contrary, as the physicist Edward Harrison wrote:

> Spacetime is constructed in such a way that the distance traveled by light rays is always zero. Light rays . . . travel no distance whatever in spacetime. In the world of spacetime we are in contact with the stars.

Or as he said later, "In one heartbeat one could traverse the universe."[5]

Einstein's insight also upset the fundamental philosophical belief in the law of causality, the law that forms the very bedrock of common sense. When anything violates this law, we say that it is absurd, amazing, or impossible. Yet the special theory of relativity demonstrates an exception to the law by showing how two investigators traveling at relativistic speeds in different directions and observing two different events could logically arrive at different conclusions as to the sequence of the two events they observed. The first one could state with conviction that as a result of his measurements and observations the two events followed each other in time. The other investigator could state with equal conviction that the two observed events occurred simultaneously! Travelers such as they, moving at relativistic speeds past one another, perceive time differently.* Or as Arthur Buller's clever limerick expresses it, exaggerating relativity's violation of common sense:

> There was a young lady named Bright,
> Who traveled much faster than light.
> She started one day
> In the relative way,
> And returned on the previous night.[6]

The causality law, rewritten, would now have to include special circumstances which according to nineteenth-century formulations would have been outright violations. Einstein's was the first real challenge since Zeno of Elea proposed his four paradoxes concerning space and time in the fifth

*The Beatles in their fey movie *Yellow Submarine* have a scene in which they pass another twin submarine containing identical Beatles going in the other direction. They then note the strange inversions of relativistic time as time speeds up for one and slows for the other.

century B.C. (one of which was the Achilles and tortoise footrace mentioned in Chapter 2). Sequence had been the crux of causality. The radical idea that notions of sequence and simultaneity were solely dependent upon an observer's relative speed came crashing through the well-supported roof of everyday logic, scattering debris and fragments everywhere.

The opposite of sequence is simultaneity. By this statement I mean that two events can be said to have occurred either one after the other or to have occurred at once. Until Einstein, this was a fundamental either/or choice that needed no qualifiers. Both sequence and simultaneity were a priori truths. As no one could question if-then logic, so no one could seriously doubt that there were simultaneous events. When we say, "Something happened *at the moment* I was talking on the phone," we imply that there is some universal *moment* to be *at*. A universal present implies that at any given moment of time, a simultaneous occurrence of events is taking place everywhere in the universe. Many people still can remember exactly what they were doing *in time* and where they were *in space* at the precise moment when Neil Armstrong planted the American flag upon the moon.

But just as Einstein's special theory derailed the moving train of sequence, it also detonated the station house of simultaneity. The idea of a static moment that contains events concurrent with one another blew to scattered bits because, according to Einstein's equations, each exploding piece of debris existed in its own inertial frame of reference with its own time and space *relative* to every other reference frame each containing its own special time and space. Einstein not only abolished the concept of *absolute rest*, he also destroyed the idea that there could be such a thing as a *universal moment* that is simultaneous throughout the cosmos. He called this principle the *relativity of simultaneity*. Alan J. Friedman and Carol C. Donley in their book *Einstein as Myth and Muse* state:

> The failure of simultaneity to be an absolute property implies that "the universe at one moment" has no verifiable reality. Moments are not universal; the present is a parochial concept, valid for each observer, but with a different meaning for any observer in any other inertial frame.

They go on to say that "the idea of a universal present is so important that it should be afforded the status of a myth."[7]

Art, like science, has relied heavily upon the notion of a universal present: that events taking place in different regions of space are *simultaneous*.

When Giotto arrested time in his paintings in the thirteenth century, he did so by selecting one moment and freezing it; arranging the people and objects in the painting into their relative positions in space. The result was a three-dimensional perspectivist painting of one simultaneous instant of time. In order to paint in such a manner he had to *believe* in the simultaneity of the universal present. For the succeeding six hundred years, apart from certain trompe l'oeil paintings of Hogarth and others, no painter ever painted a scene any other way. Art reflected the thinking of the times.

Science and art were unreservedly in accord. Before relativity, no scientist could conceive that the present moment was not a clear picture of many events in space occurring in one arrested instant of time. According to Einstein, however, this clarity was an illusion that shattered into broken chips like the reflections of different facets of a highly polished diamond, each twinkling at a slightly different instant. Breaking up the simultaneous present into multiple different instants has, however, one exception: The view from a beam of light would *not* shatter into a flux of images. From this one imaginary platform, the world would retain a momentous lucidity.

The change Einstein wrought in the human conception of light brought about a fascinating shift in our ideas regarding color (which will be covered in more detail in Chapter 13). Light is visible to our perceptual apparatus in its most multifarious form, that of color. One of the most deeply ingrained beliefs of human experience is that the color of an object is an inherent characteristic of that object. Grass is green and even though we see it in the purple shadow of twilight we still *know* it is green. Scientists have explained that grass is green because its principal molecule, chlorophyll, reflects light of the specific wavelength that we see as green because it absorbs all the others. They have shown that color is a function of an object's atomic and molecular structure. Therefore, we have inferred that color is a property belonging to the understructure of reality. The reflective surfaces of an object could be affected by atmospheric conditions, but the object's essential color seen in clear light depends upon its constituent atoms.

The special theory of relativity revealed otherwise. Color, too, turned out to be relative. An object hurtling away from an observer at a relativistic speed shifts into the red end of the spectrum; one approaching shifts to the blue. The startling implication for both artist and scientist is that color is dependent not only on an object's atomic makeup but also on the speed and direction it is moving relative to the observer. Einstein inadvertently released color from the strict confinement of light's wavelength reflection.

At high relativistic speeds, *color is free to change with movement*.* Green is not necessarily green. Under certain circumstances and relativistically speaking, it can also be red or violet. Astronomers, beginning with William Huggins, had been aware of stellar spectral shifts since 1868. Relativity theory when combined with the Doppler effect demystified this phenomenon.

The special theory of relativity also weakened the sacrosanct notion that the world outside our consciousness is an objective reality. Aristotle, Bacon, Descartes, Locke, Newton, and Kant all based their respective philosophical citadels upon the assumption that regardless where you, the observer, were positioned, and regardless how fast you were moving, the world outside you *was not affected by you*. Einstein's formulas changed this notion of "objective" external reality. If space and time were relative, then within this malleable grid the objective world assumed a certain plasticity too. The simultaneity or sequence of events, the colors of objects, and the shapes of forms did not solely belong to a world outside human affairs; instead they were also dependent on the speed of the mind hurtling through space that was doing the observing.

Subjectivity—which before the twentieth century had been the bête noire of all science while revered as the inspiration of all art—crossed the great divide. With a sense of foreboding and unease, science was forced to admit this bastard child into its inner sanctum. The so-called objective world changed size, form, color, and sequentiality when a subjective observer changed speed and direction relative to it. Many scientists would argue that relativity is not subjective because each frame of reference can be mathematically connected with any other frame. Although Einstein himself did not believe that there was anything subjective about his special theory, philosophically inclined readers can make their own judgments when confronted by the paradox of whether the distortions seen by an observer "really" exist or whether they are an "illusion." Einstein in 1911 addressed this issue:

> The question whether the Lorentz(-FitzGerald) contraction does or does not exist is confusing. It does not "really" exist . . . for an observer who moves [with a rod]; it "really" exists, however, in the sense that it can . . . be demonstrated by a resting observer.[8]

*A physicist can calculate the speed of an object relative to the earth by this color shift and then convert the object back into its "true" color. The discovery of color shift as a result of relativity/Doppler effect, however, casts into doubt the meaning of the phrase "an object's 'true' color."

Readers who hold to the strict mathematically correct position that relativity is not subjective must feel a little uneasiness when reflecting upon Einstein's statement: Something that is "real" for one observer, but an "illusion" for another, depends solely upon one's *point of view*. This statement is an accurate definition of subjectivity.

In review, the fallout from the special theory of relativity changed some very fundamental beliefs about reality after 1905. Henceforth, the following principles would have to be integrated into an entirely new conception of the world:

- Space and time are relative, are reciprocal coordinates, and combine to form the next higher dimension called the *space-time continuum*. They are not constant, absolute, and separate.
- There is no such thing as a favored point of view. For objects of substance, there is no inertial frame of reference at absolute rest, and the ether does not exist.
- The rules of nineteenth-century causality under certain relativistic circumstances are abrogated.
- Color is not only an inherent property of matter but depends also upon the relative speed of an observer.
- A universal present moment does not exist.
- Observations about reality are observer-dependent, which implies a certain degree of subjectivity.

As radical as all of these principles were, artists anticipated each and every one without any knowledge of this theory of science. With sibylline accuracy, revolutionary artists incorporated all these new perceptions of reality into the picture plane of their art. In my interpretation of art history, it was these very innovations that brought down upon their heads the scorn and ridicule of the public and critics alike, who could not know that they had been privileged to be the first to glimpse the shape of the future.

> Nature wants children to be children before men . . . Childhood has its own seeing, thinking and feeling.
>
> Jean-Jacques Rousseau

> There are children playing in the street who could solve some of my top problems in physics, because they have modes of sensory perception that I lost long ago.
>
> J. Robert Oppenheimer

CHAPTER 10

NAÏVE ART / NONLINEAR TIME

In the latter half of the nineteenth century, before physicists realized that there was something terribly wrong with their notions of reality's basic constructs, a diverse group of artists introduced motifs derived from the worldview of the child, primitive, and Asian. These images, like the systems of thought they represented, were at odds with prevailing Western European beliefs about space, time, and light. The first of these alternative outlooks was that of the child.

It was Kant who proposed that our assumption of the permanence of objects was as basic to the structure of thought as the a priori organization by our minds of space and time. Jean Piaget, the child psychologist of the early twentieth century, however, discovered that the perception of the world as consisting of permanent objects whose constancy exists indepen-

dent of changing viewpoints does not occur until the age of ten to twelve months. For an infant objects do indeed change their shape and form with movement. Further, until ten to twelve months of age the infant exists in a state of timelessness: Space and time are fused. Once an object's shape becomes indelibly fixed and stabilized in the infant's developing brain, the perception of space and time go their separate ways and become different and distinct coordinates. This category formation—space, time, and object permanence—was so ingrained in Western sensibility that until Einstein no one could conceive of the world in any other way. But Einstein's incredibly simple yet sophisticated theory posits a view from a light beam that can be conceived by adults only with great difficulty but is the perception of all infants in their prams.

The similarity between Einstein's new conception of space, time, and light and that of a very young child was noted by Piaget. In the preface to his *Le Développement de la notion de temps chez l'enfant*, Piaget refers to an exchange with Einstein. The great scientist asked Piaget whether time's subjective intuition is "immediate or derived and whether it was integral with speed from the first or not?" His curiosity aroused, Piaget considered the problem of time with particular regard to its relationship with speed (movement) in an attempt to create a meaningful isomorphism between the concept of time in experimental psychology and the description of time in physics.[1] The results of his studies suggest a strong similarity between an infant's rudimentary perceptions of time and space and those experienced by an observer traveling at lightspeed.

The relationship between twentieth-century physics and the lively inner realm of a child's imagination will become more apparent after reviewing some other distinguishing characteristics of a child's worldview. One of the several striking features that separates young children's thought processes from those of adults is "magical" thinking. Children blur the border between thinking and doing, between the inner space of imagination and the outer space of objectivity. The young child confuses the volitional act of willing with causality. Thus, children fancifully may believe that concentrating their inner mental faculties on some desired end—wishing it, in effect—will affect the outcome of actual events. Young children accept in their minds a high degree of subjectivity about the external world.

I propose that in our understanding of magic, as in many other ways, the history of civilization parallels the development of a single child. Before the sixth century B.C., all civilizations believed in the subjectivity of occurrences. A people's collective conviction that spirits or gods intervened

in their affairs led them to devise collaborative rituals, many of which represented group wishing. The belief that a ceremony can end a drought or cure an epidemic depends upon cultural and religious values.

As we have seen, a new system based upon objectivity emerged in ancient Greece. By introducing rational doubt, the Greeks began the difficult task of separating the arena of science from the realm of magic. Their discovery that the world is orderly, and that its order can be reduced to number, was a triumph of the logical left brain and led the Greeks to elevate its status at the expense of the right brain's intuitive musings. Early philosophers, trying to extricate the mind from its passionate past, had sufficient reason to distrust the emotions, instincts, and sheer unpredictability of the older brain. Cicero, the great first-century A.D. Roman orator-philosopher, looked back upon this decisive point in history and proposed that Socrates was the first influential thinker to split the mind from the heart or, as we would say today, the left brain from the right.[2]

Magical thinking is the antithesis of reason. Because children are unable to separate the Cartesian *res extensa* (outer) from the *res cogitans* (inner), they place their faith in the verisimilitude of dreams, myths, and fairy tales. The psychiatrist Carl Jung explored these currents that well up from the psychic underground and proposed that the archetypal heroes, heroines, and monsters that dominate the mental lives of children arise from this universal pool. Though Jung believed that their power continues to affect us all our lives at a deep unconscious level, nonetheless our literal belief in them gradually dissipates as we grow older. The frequency and intensity of dreams and nightmares generally taper off with age, and most adults will readily concede that these epiphenomena lack the vividness and punch they once had in childhood. To be recognized as an adult, an individual must give up his or her belief in the Tooth Fairy, the Sandman, and Santa Claus.

Van Gogh once wrote, "A child in the cradle has the infinite in its eye."[3] But in the course of modern socialization the infinite is replaced by the finite. Parents, teachers, and other elders firmly and steadily encourage children to put away childish things and to accept the tenets of the reigning paradigm. This process begins in earnest in Western civilization when, in kindergarten, there is sent into the child's mind an attack force of Cadmus' soldiers.

In the Greek myth of the origin of the alphabet's letters, the Phoenician prince Cadmus, later to become king of Thebes, slew a fearsome serpent and sowed the monster's sharp, deadly teeth. An aggressive army of warriors

sprang from the ground where the teeth were planted. The military image is apt because a uniform row of teeth closely resembles the strict repeatability of soldiers on parade, and it also resembles a line consisting of letters of the alphabet.

The linear alphabet and its equally linear comrades-in-arms, the numerals, are loosed like soldiers to destroy the child's belief in discontinuous space and mythical time. After their victory, the alphabet and numbers impose a new order in line with the essential premises of Euclid's and Aristotle's teachings. This process occurs in the West at such a defenseless age that the child is never aware of what's happening until, of course, it's too late. Once begun, "education" continues inexorably in the higher grades with the formal teachings of geometry and logic. As language, math, and logic take hold, they drive magic out of the child's being, and by early adolescence, rationality stands triumphant over the pale atrophied survivors of the once-powerful juvenile convictions about magic, mystery, and myth. Coleridge once wrote, "I was a fine child but they changed me."[4] The price we pay in order to think as adults is the loss of our former naïve and innocent outlook. Most of us never look back, because the road is overgrown with thicket and we abandon hope of return.

Another quality that distinguishes children from adults is the child's desire to engage in games that have as their goal a wondrous concept called "fun." Adults have systematized "games" into rituals involving competition, ranging from organized sports to war, whose goals are more specifically money, sex, or power. The delight and abandonment of playing a game in which the conscious aim is fun is generally lost to adults. Recognizing this fall from grace, adults usually resort to drugs or alcohol in order to recapture the essence of fun with no obvious objective. Fun, of course, has no logical explanation or justification, it's just . . . fun. The outward expression of the internal state called "fun" is laughter, which Wyndham Lewis called "mind sneezing."[5] Laughing is a unique behavior pattern fully developed only in Homo sapiens.

Another universal characteristic of childhood is the impetus to make art. Every child is born with a desire to re-create the world in his or her own terms. This powerful motivation for producing art has always been a means of imposing order on the disjointed pieces of the child's emerging worldview. For the child, with a few exceptions, magic and art are fun. Art translates curiosity and wonder into mastery over the environment.

In the West, the stuff of dreams, magical thinking, games, fun, laughter, and a desire to re-create the world on one's own terms are restricted in

the adult world. Lamenting this loss, some scientists have urged their colleagues to retain a childlike sense of wonder. Hans Selye, a Nobel laureate, wrote:

> The fairest thing we can experience is the mysterious. It is the fundamental emotion which stands at the cradle of true science. He who knows it not, and can no longer wonder, no longer feel amazement, is as good as dead. We all had this priceless talent when we were young. But as time goes by, many of us lose it. The true scientist never loses the faculty of amazement. It is the essence of his being.[6]

Newton's paradigm did not accommodate any of the criteria fundamental to children's thought systems. To accept the tenets of his 1687 *Principia*, it was absolutely necessary to reject all the features of the child's world. It is no surprise that the world at large viewed Newton as a strict disciplinarian. Yet, ironically, Newton himself retained a child's curiosity and outlook, and saw himself as a youth engaged in play:

> I do not know what I may appear to the world; but to myself I seem to have been only like a boy playing on the sea-shore, and diverting myself in now and then finding a smoother pebble or a prettier shell than ordinary, while the great ocean of truth lay all undiscovered before me.[7]

In this statement Newton uncharacteristically revealed a personal side of his nature. For a long time, the repression of the child's worldview was so complete that the very concept of childhood as a distinct phase of human development was not even recognized. Nowhere was this blind spot more evident than in art.

Before the 1860s there is a conspicuous absence of solitary children in Western art. In the ubiquitous Christian theme of Madonna and Child, the child is one half of a complementary pair. Except for commissioned portraits of noble families, few paintings portray only children and virtually none portray them playing with adults absent. In the early Renaissance, despite an evident sophistication and mastery of technique that was characteristic of the art of this period, accomplished Northern European artists adhered to the convention of the times and depicted infants and children not in their natural anatomical proportions, but in those of miniature adults.

From the Renaissance onward, artists painted many infants in the form

of cherubim, and adolescents as nubile sexual beings—young adults, really. But representatives of the human species between the ages of five and fifteen were missing. This strange absence can be construed as a clue that in this culture of Renaissance Europe the values of the child were actively repressed.

Children did not begin to appear consistently as the solitary, central, and exclusive focus of painting until the advent of modern art. Édouard Manet included them in his works *Boy with Sword* (not shown) and the *Fifer* (1866) (Figure 10.1). Impressionist painters, such as Pierre-Auguste Renoir and Edgar Degas, chose lone young children as subjects for their paintings. Renoir took delight in childhood's innocence, and Degas chose to study children as objects in an adult world. Pablo Picasso, in particular, consistently represented the missing ages of five to fifteen in both his blue and rose periods. Although the subject of these works was children, the execution of these paintings was far from childlike. All of these artists used skills acquired from a formal education in the academic tradition. These demanding standards for art were so entrenched in the public taste that popular acceptance of an artist who used not only children's themes in his art but also employed a child's technique came as a puzzling surprise.

Henri Rousseau, a retired customs officer (hence the name, Le Douanier) and self-taught artist, produced works in the 1880s that in and of them-selves were childlike (Figure 10.2). This view of the world as seen through the child's eye is absent from the work of prominent artists working in the Greek, Roman, Renaissance, or academic period. Rousseau breached the wall of technical sophistication which is the chief distinction between child artists and adult master painters. He followed his own instinct about per-spective, painted lush jungle plants from his imagination, and chose themes from his dreams. What made his work arresting was that his vision of the world was not only the vision of a child, but one actually executed as if by a child, albeit a very skilled one.

Rousseau himself was without guile. Naïvely oblivious to the smirks of other artists, he brought his canvases to the salon in a wheelbarrow. When he first saw the works of Cézanne, he ingenuously offered to "finish them."[8] Once he congratulated Picasso, observing that the two of them were un-doubtedly the world's greatest painters.[9] Rousseau, according to Werner Haftmann,

> was wholly under the spell of his own magic; he lost himself so completely in his pictorial world that sometimes he had to fling open the window in order to escape the eyes that were staring

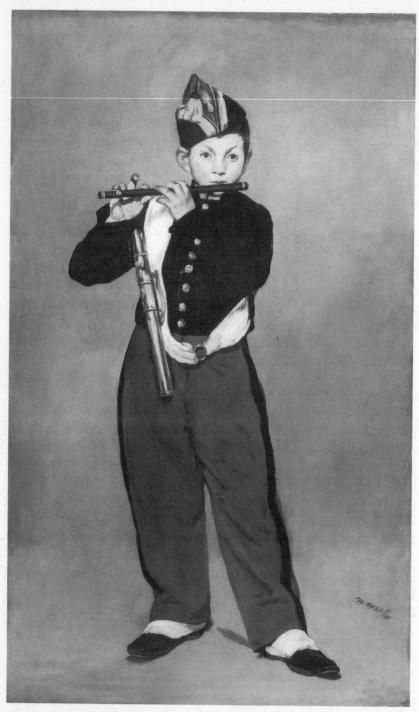

Figure 10.1. *Edouard Manet*, Fifer *(1866)* MUSÉE D'ORSAY, PARIS

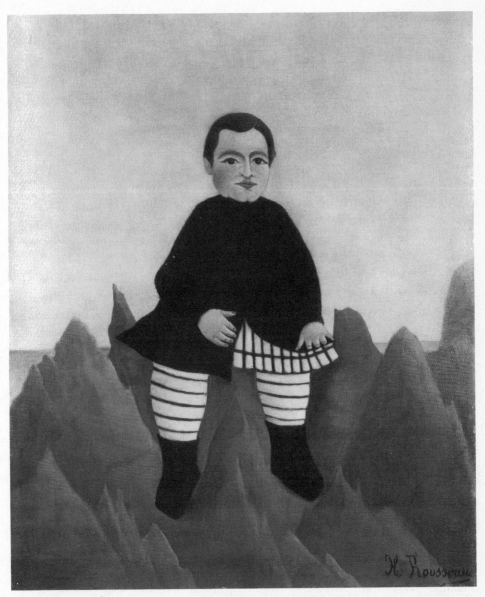

Figure 10.2. *Henri Rousseau,* Boy on the Rocks *(1895–97)* NATIONAL GALLERY OF ART, WASHINGTON, D.C., CHESTER DALE COLLECTION

at him from out of the prehistoric plants of his strange mythical forests.[10]

With a kind of perverse timing, the child's paradigm emerged in art at just the moment when Newton's mechanical view of reality was most triumphant. The Chinese yin and yang symbol is a graphic representation of this relationship between opposing principles. The rival viewpoint makes its first tentative appearance at the height of the power of its complementary obverse.

How very appropriate that just before Einstein's discovery, a naïve artist like Rousseau, whose paintings could be the settings for fairy tales and who routinely distorted forms, would be hailed as one whose view of the world was a valuable contribution! It is an amusing exercise for anyone to speculate upon the reception Rousseau's work would have received at the court of Lorenzo de' Medici. Then the Humanists were proclaiming that man was the measure of all things. For a long time, children were not to be trusted to measure anything.

Soon after Rousseau's charming, childlike paintings met with success, other artists began to note that however much serious fine art illuminated, recorded, and mirrored life, it was not "fun." Even when paintings portrayed scenes in which people, gods, and cherubim were playing, viewing such art could not be considered to be an activity that in and of itself was fun. Art was a serious business. As the nineteenth century drew to a close, several other artists began to incorporate childlike elements of fun into their work.

Jacques Villon (Marcel Duchamp's brother) was a founder of the 1904 Society of Cartoonists. Marcel soon joined his brother and defined a new concept of graphic humor. Caricaturists, formerly called satirists or parodists, would henceforth lay claim to the title of humorists.[11] As a result, the modern-day cartoon was born—an interactive art form in which the viewer actually laughs while contemplating a work of art.

In a similar vein, Marcel Duchamp, whose work will be discussed more fully in Chapter 15, experimented with forms that seemed to be simply clever practical jokes. In one instance, he entered a urinal purchased in a hardware store in an art competition, claiming that since he was an artist, whatever he said was art was art. Another time, he painted a mustache upon a reproduction of the sacrosanct *Mona Lisa*, then entitled his work *LHOOQ*, the letters of which when pronounced in French mean "She has a hot ass."

These early attempts to integrate fun into art exploded with the force of a belly laugh in the Dada movement, which burst forth in 1916 in, of all places, the staid city of Zurich. The poets, painters, sculptors, and playwrights associated with this movement idealized the behavior of children, which they endeavored to emulate. They believed that the child's system of belief made more sense than the adult's because at that moment the latter was playing itself out in the grim trenches of World War I. What the Dadaists did not know, but would have appreciated as a cosmic joke, was that a few blocks away from the Café Voltaire in Zurich, their own meeting place, Albert Einstein was that year putting the finishing touches on his general theory of relativity. This second of Einstein's great theories explained the mystery of gravity. Even more than his special theory, it would dismantle adult notions of reality.

After the Dada movement dissipated, another artist emerged to paint with a whimsy reminiscent of childhood. The Swiss artist Paul Klee created a body of work that was in size, scale, and content clever and cerebral, but also refreshingly childlike. Klee acknowledged his debt to the child within him when he wrote, "Just as a child imitates us in his playing, we in our playing imitate the forces which created and create the world."[12]

While a child's existence seems to be a great distance from Einstein's equations concerning relativity, Einstein arrived at his insight because originally, as a child, he naïvely framed his light beam question no adult had ever seriously entertained. Henry Le Roy Finch, one of many biographers of Einstein, elaborated upon this connection:

> It has been said that common sense is the prerogative of the good, and the bad are destroyed by their lack of it. We may wonder if something similar does not apply to truth—that truth is the prerogative of the simple, and only those who are in a certain sense without guile are able to recognize it. In the case of someone like Einstein we cannot but feel that there is indeed an inner and necessary connection between the extraordinary theoretical simplicity of his work and the personal simplicity of the man himself. We feel that only someone himself so simple could have conceived such ideas.[13]

A peculiar trend in the deterministic nineteenth century, was the paradoxical emergence in written form of fairy tales. First, the Grimm brothers' collection of German folk stories was published in 1812–22, and then Hans

Christian Andersen's delightful fairy tales followed in 1835. Mythology, fantasy, and the supernatural prepared the way for the immediate and enthusiastic acceptance of a radically different kind of children's book, *Alice's Adventures in Wonderland*. In 1865, forty years before the special theory of relativity overhauled the paradigm of reality, a Cambridge mathematician named Charles Dodgson, using the nom de plume Lewis Carroll, published his classic. He wrote this playful book for the youngest daughter of one of his colleagues. The heroine, Alice, ventures into a world where distortions of space and time and the nonpermanence of objects are an integral part of the story. The telescopic changes that Alice endures as she experiments with various comestibles produce visual distortions of space that bear an uncanny resemblance to the plasticity of objects and people at the conditions of velocities approaching c. In spacetime there is no interval through which to travel; so too in Wonderland. "Now, *here*, you see," says the Red Queen to Alice, "it takes all the running *you* can do, to keep in the same place." The distressed rabbit in *Through the Looking Glass* who mutters, "The faster I go, the behinder I get," could not have summed up the condition of spacetime at the speed of light any more succinctly.

In Wonderland, causality's laws of sequence are frequently violated. When the Red Queen huffs, "Sentence first, verdict later," the reader is made aware that the observer's point of view is critical to the relativity of truth. When Humpty Dumpty asserts, "When I use a word, it means just what I choose it to mean," he confirms the relative views of each observer, and Dodgson questions the ability of everyday language to convey absolute truth. The absurdity of many incidents of Dodgson's fantastic tale also corresponds with the alogical aspects of quantum mechanics, the other revolution that took place in physics in the early years of the twentieth century. In the child's magical worldview, the subjective act of wishing can effect changes in the objective world of "out there." Einstein's conception of relativity and the later notion of quantum mechanics confirmed that the observation and thoughts of the observer enter into the calculations and measurements of the "real" world. Children at play, artists at work, and scientists measuring quantum effects share this in common: They are all creating reality.

The view from the cradle and the child's imaginative world are the antithesis of both the Newtonian mind-set and academic realism. The Victorian public, who repressed the values of children, was puzzled by the

emergence of juvenile values in art and literature. But they could not know that everyone soon would have to revert mentally all the way back to infancy in order to comprehend the funhouse mirror of spacetime distortions. Ironically, the latter could be more easily imagined by Dodgson's real Alice than by her parents.

> I am the primitive of the way I have discovered.
>
> Paul Cézanne

CHAPTER 11

PRIMITIVE ART / NON - EUCLIDEAN SPACE

T he word "primitive" has pejorative connotations in many circles, but it has denoted a particular style or attitude within the art world, and in this book I use the term with that specific meaning. A primitive is someone who belongs to a nonliterate society; primitive art, by extension, is born of or represents such a society, where the visible written word has not subverted the primacy of aural meaning.

Primitive art differs from art of the Western academic tradition chiefly in that the tribal artist does not seek to "match" reality so much as to "make" it. This distinction, as elaborated by Ernst Gombrich, proposes that primitive artists create works that conform to internal visions more than they do to external appearance. By doing so, primitive artists directly contradict both Plato and Aristotle, who believed that mimesis, mimicking nature, was an innate impulse of the human personality.

Like the worldview of the child, the worldview of the primitive differs radically from Newton's. For instance, primitivism does not separate the proper time and "real" space of the objective world from the artist's inner mythopoetic vision. Further, primitive societies invest many art objects

with magical powers. The similarity between the child's and primitive's outlook prompted one wag to say, "The worldwide fraternity of children is the greatest of savage tribes, and the only one which shows no sign of dying out."

Because the primitive's ideas about space, time, and light were quite different from those of the Newtonian, tribal art contains distortions that were unacceptable by the standards of academic art. In response to Plato's rhetorical question, "Is ugliness anything but lack of measure?" the anthropologist Edmund Snow Carpenter contrasts the preliterate Eskimo's idea of space with that of Euclid and Plato.

> I know of no example of an Aivilik describing space primarily in visual terms. They don't regard space as static, and therefore measurable; hence they have no formal units of spatial measurement, just as they have no uniform divisions of time. The carver is indifferent to the demands of the optical eye, he lets each piece fill its own space, create its own world, without reference to background or anything external to it. . . . The work of art can be seen or heard equally well from any direction. . . . In the oral tradition, the myth teller speaks as many-to-many, not as person-to-person.[1]

Carpenter tells a story that highlights the clash of Western and Aivilik conceptions of space. The Eskimos had pasted to the domes of their igloos photographs torn from magazines to prevent dripping. They puzzled over Western visitors' attempts to look at these pictures "right side up." The Eskimos watched with amusement while the "white man" craned his neck while turning in tight circles in order to see the pictures from the "correct perspective." For the primitive, who had not learned that there was a "correct" way to see things, this behavior was inexplicable. This multidirectional spatial orientation encourages an Eskimo who may start a drawing or carving on one side of a board to continue right over the edge to the other side. Without an acknowledgment of the idea of a privileged place for a viewer to stand, the tribal artist would never invent perspective.

Their holism is also the reason many nonliterate people have a difficult time "reading" a photograph or deciphering an illusionist painting. In learning how to read a page of print, we members of literate societies have learned to "fix" our eyes slightly in front of the page. With this acquired skill we can not only read the printed page but we can "look" at perspectivist paintings. By fixing the focus of our eyes somewhere in front of the painting,

we are able to see the illusions of perspective; otherwise the canvas would appear to be just a jumble of differently colored splotches. Erwin Panofsky, the art historian, characterized perspective as just one convention among many possibilities. He said we think the world is in perspective because we *learn* to see in perspective. And Marshall McLuhan observes:

> Nigerians studying at American universities are sometimes asked to identify spatial relations. Confronted with objects in sunshine, they are often unable to indicate in which direction shadows will fall, for this involves casting into three-dimensional perspective. Thus sun, objects, and observer are experienced separately and regarded as independent of one another. . . . For the native, space was not homogeneous and did not *contain* objects. Each thing made its own space, as it still does for the native (and equally for the modern physicist).[3]

There remains in art and psychology circles a lively debate as to whether the world is actually in perspective or whether we learn to see it in this particular way. But, the very acknowledgment that not everyone can "see" perspective casts doubt upon the "truth" of our belief in Euclidean space as the only imaginable one.

Primitive notions of time as well as of space are different from those developed in Europe. Anyone who has had to study any European language knows that the conjugation of verbs, that complex jungle of present, pluperfect, and future subjunctives, is the most difficult part of the language to master. The expression of the correct location an action takes place in *in time* is an obsession running through all of the Romance languages. Consider then, Benjamin Lee Whorf's stunning revelation that a Southwestern Indian society had evolved whose language, had no past, present, and future tenses:

> The Hopi language contains no reference to "time" either implicit or explicit. At the same time [it] is capable of accounting for and describing correctly, in a pragmatic or operational sense, all observable phenomena of the universe. . . . Just as it is possible to have any number of geometries other than the Euclidian [*sic*] which give an equally perfect account of space configurations, so it is possible to have descriptions of the Universe, all perfectly valid, that do not contain our familiar contrasts of space and time. The relativity viewpoint of modern physics is

one such view, conceived in mathematical terms and the Hopi Weltanschauung is another and quite different one, nonmathematical and linguistic.[4]

Similarly, the aborigines of Australia do not celebrate birthdays because no one in these tribal cultures conceptualizes time that can be measured and divided, and therefore "birthday" has no meaning.

Primitive art expresses just these sorts of attitudes about space and time. The Hopi, for example, create intricate sand paintings by carefully allowing varicolored sands to trickle through their fingers in a manner evocative of the hourglass while they walk all around their circumscribed earthbound creation. Their earthworks do not have the spatial orientation of that which occurs in the Western tradition when an artist sets his canvas upon an easel and defines an up-down and right-left vector with the first tentative pencil line. The Hopi artist, by coming at his work from any and all directions, defeats Western attempts to orient the art in Euclidean planar space. Moreover, since tomorrow's winds will alter or efface it, the painting lives only in the moment and generally cannot be preserved for posterity. Its existence literally has no future.

Elsewhere in the world of primitive art, the most common mannerisms are elongated forms, a preference for curves rather than straight lines, the lack of perspective, and an absence of shadows. Primitive art does not seem to have the obsessive interest in chronicling the past events evident in the West; each piece is essentially timeless. These attributes, characteristic also of Minkowski's spacetime continuum but not of Newton's or Kant's universe, are parallel to aspects of the visual world when viewed by anyone traveling at relativistic speeds.

Beginning in the Renaissance, whenever Western civilization "discovered" primitive cultures, it held them in contempt. "Savages," as non-literate, non-Caucasian people were called, were considered by European explorers to be childlike and less evolved than their own advanced form of the human species. Literate philosophers and sociologists such as Giambattista Vico, Auguste Comte, and more recently, Lucien Lévy-Bruhl perpetuated this prejudice, asserting that the mental operations of the "savages" were inferior to those of "civilized" Caucasians. None of these authors, however, could know that the primitive conceptualization of space and time is more in harmony with spacetime and non-Euclidean geometry than were the allegedly advanced ideas of the white European.

Théodore Géricault, a painter, was one of the first Europeans to recognize the vitality inherent in the primitive paradigm in his 1818 Romantic period

painting *The Raft of the Medusa* (Figure 11.1). In the grand style typical of historical paintings, Géricault depicts the scene of a sea tragedy that had recently occurred. A group of survivors, floating upon a makeshift raft, had been rescued after a long ordeal; many others had died at sea. In the artist's version, it is the white Europeans who are dying and who appear to have given up hope. In contrast, the black African at the top right of the painting has spotted the rescue ship, and he alone has the vigor to signal it. Géricault was alluding enigmatically and allegorically to the importance of the primitive. It is as though Géricault somehow knew that in order for the Western mind to achieve liberation from its compulsive fascination with right angles, alphabets, and logic, it would have to be rescued by "savages" who had not internalized these three mental constructs.

In the 1880s, as if refining Géricault's intuition, Paul Gauguin began to fuse the realm of the vibrant primitive with the stiffer, rule-laden world of the French academy. Gauguin's mother was a Peruvian Indian and he felt the animistic spirits of her heritage coursing through his veins. He also had had no formal training in art, and so had less to unlearn.

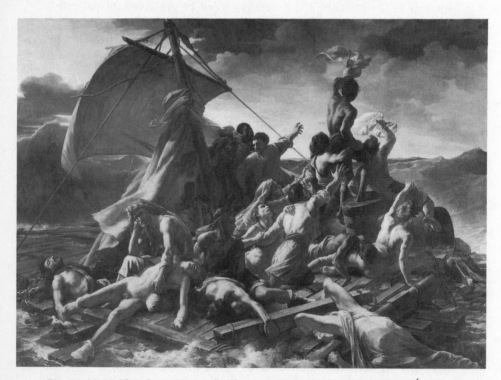

Figure 11.1. *Théodore Géricault,* The Raft of the Medusa *(1818)* MUSÉE D'ORSAY, PARIS

Gauguin was dispensing with the congealed rules of academic art even before he emigrated to Tahiti in 1891, but once he was transported both in time and in locale, he threw off altogether what he considered to be the shackles of European convention. Using instead a style that closely resembled that of his host country's primitive art, Gauguin combined minimal perspective, arbitrary bright colors, and exotic subject material to create a lush, decorative compositional style as in his *Fatata te Miti* (1892) (Figure 11.2). His paintings had a freshness lacking in the exhibitions of the official academic salons. By letting each figure fill its own space, Gauguin stumbled upon the truth, later explored more fully by Cézanne, that space is interactive with mass. Most art critics reacted with hostility to Gauguin's paintings; yet, Gauguin anticipated the devaluation of uniform space, linear time, and relative light that Einstein would formalize in equations a generation later.

Henri Rousseau, the exemplary child–primitive artist, used primitive

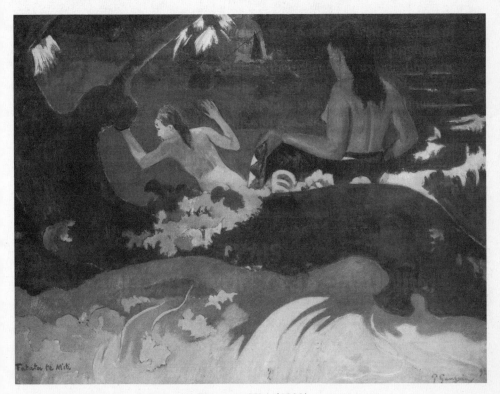

Figure 11.2. *Paul Gauguin,* Fatata te Miti *(1892)* NATIONAL GALLERY OF ART, WASHINGTON, D.C., CHESTER DALE COLLECTION

motifs frequently. In his painting *The Snake-Charmer* (1907) (Figure 11.3), a solitary primitive plays a Dionysian reed instrument. For those attuned, his presence and the strains of his exotic music presaged the transformation of Western thought. We can almost hear the haunting refrain that was to become the leitmotif of the overture to the twentieth century.

Despite these early forays by the artist-savage into the walls of the cities, the painter most responsible for the resurrection of primitive values in art was the young Pablo Picasso. In 1907, visiting an exhibition of African ceremonial masks and other tribal artifacts at the Trocadero Museum in Paris, he had a transcendental insight. What he saw so affected him that

Figure 11.3. *Henri Rousseau,* The Snake-Charmer *(1907)* MUSÉE D'ORSAY, PARIS

he literally began to shake as if he had a fever. He hurried back to his studio and began to experiment with primitive images, abandoning the physiognomic norms of classical Greece and instead portrayed faces composed of broad interlocking planes. In collaboration with his close friend and colleague Georges Braque, he brought forth Cubism, the most radical new art movement since Giotto's revolution over five hundred years earlier.

Picasso's first major Cubist work was a disturbing vision of women and a chaotic treatment of space entitled *Les Demoiselles d'Avignon* (1907) (Figure 11.4). Horrified by the "ugliness" of this painting, Braque later claimed that during its gestation Picasso was "drinking turpentine and

Figure 11.4. *Pablo Picasso,* Les Demoiselles d'Avignon *(1907)* COLLECTION OF THE MUSEUM OF MODERN ART, NEW YORK, LILLIE P. BLISS BEQUEST

spitting fire."[5] Art historians consider this work because of its Cubist intimations to be one of the seminal paintings of the twentieth century. Picasso began work on this canvas after Einstein's 1905 paper and before Minkowski's 1908 formulation of the spacetime continuum.

The importance of Cubism will be discussed more fully in Chapter 14, but for now it is pertinent to note that the crux of this style lay in its revolutionary conceptions of space and time. Its principal departure point was the use of figures untainted by Western civilization, derived more from the savanna of the Serengeti than from the studios of Paris. In retrospect, the use of primitive motifs seems to be almost an artistic necessity, a spear, if you will, hurled by Picasso in his opening attack upon the walled citadel of perspective and causality. Umberto Boccioni, an Italian futurist, summed up the feelings of the new century's artists when in 1911 he declared, "We are the primitives of an unknown culture."[6]

In order to conceptualize the formidable concepts of the new physics, it is first necessary to let go of the belief that continuous linear Euclidean space underlines the objective world; that time is an ever-constant flowing stream outside human affairs; that causality is the chain-stitch link that binds the events we see; and that the world exists in the tessellation of the perspectivist grid. All these deeply ingrained beliefs were part of the conventional nineteenth-century paradigm, as they are part of ours. They are *not*, however, integral to the next higher dimension of spacetime or the alogical aspects of quantum mechanics.

The Western artist discovered a new way to see the world through the eyes of the artists of Africa and Oceania before physics began to understand a common bond between itself and a worldview long expressed in tribal cultures. Waldeman Bogoras, an anthropologist, said, "In a way one could possibly say that the ideas of modern physics about space and time, when clothed with concrete psychical form, appeared as shamanistic."[7] The shamans of the preliterate tribal cultures would be amused to discover that their ideas about reality have more in common with the new physics than do the views of a nineteenth-century scientist.

Form is emptiness, emptiness is form.
> The Heart Sutra in *Prajnaparamita Sutras*

We have let houses that our fathers built fall into pieces, and now we try to break into Oriental palaces that our fathers never knew.
> Carl Jung

CHAPTER 12

EAST / WEST

In 1853 Commodore Matthew Perry sailed his fleet into a Japanese harbor and forced upon a reluctant people the first Japanese-American treaty and a demand for the exchange of goods. The commerce that ensued was not just in goods but also in images and ideas that had hidden within them subtle variations on Western conceptions of reality.

The increase in world trade that occurred during the latter half of the nineteenth century accelerated the introduction of Japanese art forms into Paris. Inexpensive knickknacks shipped from Japan in the 1860s and 1870s came wrapped in throwaway paper on which were pictures from wood-block prints. Popular with the common people of Japan, wood-block prints now found their way into the hands of interested Parisian artists. Eventually, Manet, Monet, Degas, Gauguin, and van Gogh all would acknowledge their debt to this Asian influence.

They and other artists quickly appreciated nuances inherent in Oriental notions of space, time, and light. Space to a Westerner was an abstract nothingness; it did not affect the objects moving about in it. Because space was the very essence of null, nothing could ever come forth out of it. Western artists before the 1880s worked diligently to fill up all the empty space on a canvas with representations of "things," including sky, water, mountains, and figures. Empty space was taboo to a Western artist because art was supposed to be a "something," and space according to Euclid was a "nothing."

In the predominant Eastern philosophies, however, empty space was the void. In Zen teachings, this plenum contained within it the pregnant possibility of everything. From this invisible cornucopia issued forth all that was substance. The large empty spaces contained within an Asian work of art are a representation of this idea (Figure 12.1). In contrast to a homogeneous Euclidean space that *never* changes, the Eastern view suggests that space evolves. In the one, space is dead and inert, in the other it has organic characteristics.

Figure 12.1. *Kano Tanyu (attr.),* Misty Landscape *(1602–74)* THE METROPOLITAN MUSEUM OF ART, ROGERS FUND, 1936 (36.100.79)

To the scientist working in the nineteenth century, the idea that empty space was an invisible generative living tissue was fanciful, childlike, and not to be taken seriously. It came as a surprise, therefore, when early-twentieth-century Western scientists discovered that particles of matter can in fact be wrung out of a seemingly empty field by quantum fluctuations. From out of a desertlike vacuum can come a squirming proliferation of inhabitants from the particle zoo. This confirmation of the ancient Eastern idea that empty space is alive and procreative forced a reluctant West to rethink its ideas about space. Eastern conceptions of space turned out to be closer to the truth than the flat angular sterile space of Euclid.

Eastern artists never developed on their own the kind of perspective that was sacrosanct in the West, which, like the philosophy of Descartes and Kant, splits the passive viewer off from the objective world and places him outside looking in (or, as in the case of Kant, inside looking out). But while they did not invent linear perspective, the ancient Chinese landscape painters did develop a coherent scheme to organize space. Instead of establishing a point of view somewhere off and in front of the canvas, as in the West, the central point was *within*, inside the landscape.[1] Their landscapes do not tell us where the beholder stands in relation to the view depicted. This subtle shift creates within the mind of the viewer more of a connectedness to the objects within the work. The Chinese landscape painter assumed that the beholder, along with the artist himself, was *in* the landscape, not looking at it from the outside.

In contrast to a typical Western painting, the smaller number of visual clues and details in a Chinese landscape forces the spectator to become both art and artist in order to supply the missing connections. In this way, too, the Eastern artist undermined both the nineteenth-century Western artist's idea of perspective and the Western scientist's idea of absolute rest, both of which assume—as the Orient denied—that there is a passive, motionless, favored platform from which to observe and measure the world.

Seventy years before the formal explication of relativity, the Japanese artist Hokusai anticipated Cézanne's multiple views of Mont Sainte Victoire by painting Mount Fuji from thirty-six different points of view (Figure 12.2). By portraying Mount Fuji from different places in space and different moments in time, Hokusai not only suggested the reciprocal nature of space and time, but also disputed the sovereignty of a favored place to stand.

Flower arranging (ikebana) and paper folding (origami) are two Japanese art forms that make clear the contrast between Eastern and Western ideas about space and mass. The ikebana artist uses flowers to define the space

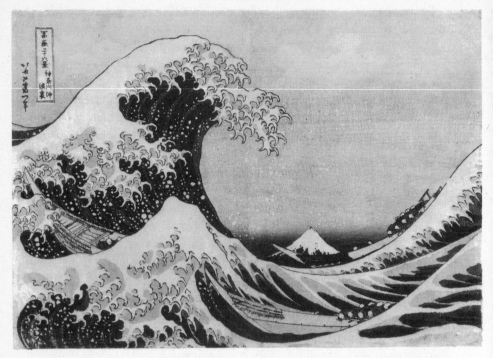

Figure 12.2. *Katsushika Hokusai, from* The Thirty-Six Views of Fuji *(1823–29)* THE METROPOLITAN MUSEUM OF ART, HENRY L. PHILLIPS COLLECTION

that, containing them, sets off the flowers. Ikebana emphasizes asymmetry and the organic nature of forms rather than the rectilinear.

Origami too contains a subtle idea about the relationship between space and mass. To our Western sensibilities, nothing resembles the concept of planar Euclidean space more than a blank, smooth, flat piece of very thin paper. The Western artist looked on this as a nothingness on which he could arrange things by simply drawing them on its surface. At no time does the space *of* the paper interfere with the forms *on* the paper. The dimensions and shape of the paper and therefore the objects drawn on it will never change.

The origami artist, in contrast, begins with the same flat, uncreased piece of paper. By folding it in various complex sequences, the paper takes on a recognizable form that contains and is contained by the empty space the paper represented. By folding space in a certain sequence, the origami artist creates something of mass. Contemplating the process of origami reveals a truth that is difficult to imagine about Einstein's ideas concerning

space, time, and mass. That an empty piece of paper can be creased in a pattern so that it becomes a "thing" reveals how the Asian conception of space differs from that of the West. It is also a tribute to the flexibility of art which allows art forms to express the central conceptions underpinning a culture.

Both ikebana and origami imply, as they are founded on, the plastic interrelationship between space and mass. They have shown for centuries the truth, so lately described by Cézanne in art and Einstein in science, that space is a matrix that is interactive with the mass of objects placed within it.

Whereas Western artists faithfully re-created the external world on canvas, representative Eastern artists would have considered it childish and silly to imitate nature realistically. Their art's original purpose was to create forms of such beauty that they would become aids to meditation. When meditating upon a sheaf of bamboo leaves, the meditator attempts to hold constant before the inner eye the object of meditation. In order to grab hold of it and fix it, the object is looked at from all sides, preventing the distraction or intrusion of any other thoughts. To portray a one-directional, correct perspectivist landscape that included bamboo leaves would defeat the purpose of this kind of Eastern art.

The very act of learning the technique of Eastern art was taught in such a manner as to increase not only the power of observation but, more important, the facility to meditate. Some Chinese silk screens were kept rolled up in precious containers and unrolled only in quiet moments of contemplation.[2] For all the reasons just mentioned, perspective, the revolutionary artistic invention of the West, was not ever developed independently in the East.

Eastern and Western concepts of time are as different as the two conceptions of space. In the West most people believe the past is something we have left behind and cannot see unless we turn around, while the present is where we exist momentarily as we stride confidently facing forward into the future, in front of us. But in a more accurate metaphor, the Chinese liken time to a river and human awareness to a man standing on its bank facing downstream. The future approaches him from behind and becomes the present only when it arrives alongside where he is standing and he is first conscious of it out of the corner of his eye. Thus, before he can assimilate the present, it is past already. The present washes away to become history in front of the observer. The recent past is nearer and it can be seen more clearly. The distant past is far away ahead of him, its features only dimly perceivable. Instead of squarely facing the oncoming future as

in the Western metaphor, this more accurate allegory acknowledges how the present, as we all know, continuously blindsides us from an angle of vision that assures that we will be unprepared.

Royal families in Confucian China used this metaphor in their evening entertainments. Streams were designed to meander through the royal estates and benches were placed beside their banks, facing downstream. After dinner, while princes and their friends sat on these benches, servants upstream launched toy wooden boats containing alcoholic beverages. The royal entourage could never know what the future behind them was about to deliver because they were facing the past by looking forward. Many a pleasant evening was passed among the members of the court as they became inebriated by these surprises from the future arriving from behind.

Another, more pervasive Eastern belief about time is the notion of cycles, or periodic return. Circles are a common symbol of unity, recursiveness, and oneness in Asia. Also in the New World, the *Ouroboros* of the Aztecs, the snake who has turned around to bite its own tail, was the symbol of the circle of time in early Central America. Similar symbols are present in most Asian countries. A circle stands in contrast to the arrow's straight line, which is the West's prevailing metaphor, and different yet from the Hindu mystics' idea that both linear and circular notions of time are but a single, still *everlasting now*. In India, ancient Hindu tradition posits that both the wheel and the arrow are illusions. Each is simply a different manifestation of *maya*, the flickering lantern show designed by providence to distract and mislead us. Hindu and Zen mystics believe that time doesn't "progress." There is one time, and it is the *everlasting now*. Because we are constantly entertained by the intriguing show put on by maya, we are unable to see time as it really is: a dilated instant that contains all tenses—past, present, and future. In this suspended still point, where all is motionless and changeless, sequential time is but a compelling mirage. In contrast, in the West no scientist ever gave any credence to the idea that time, the driving mechanism behind sequence, logic, and reason, could be anything other than regularity—until 1905.

The Eastern conception of time bears an uncanny resemblance to the worldview Einstein conjured up while imagining he was sitting astride a beam of light. When he was perched upon this constant of the universe, the continuously flickering *now* of prosaic existence would dilate enormously, expanding into the past and the future until it contained the entire spectrum of time. At this speed, all change and motion would cease and all would be still. Einstein's proposal that time could be absolutely at rest was expressed in the thirteenth century by the Zen master Kigen Dogen:

It is believed by most that time passes; in actual fact, it stays where it is. This idea of passing may be called time, but it is an incorrect idea, for since one sees it only as passing, one cannot understand that it stays just where it is.[3]

Since Eastern artists were imbued with their cultures' conceptions of time, transitory effects familiar to Westerners are largely absent from their work. Instead of depicting specific events from specific dates, most classic Asian art concerns subjects that in and of themselves are timeless. Bamboo leaves, white cranes, chrysanthemums, and calligraphy transcend chronology. The depiction of events fixed in time never developed into the frenzy of painting historical scenes that occupied so much of the output of Western artists. Even the Western obsession with cataloguing an artist's work and having all his canvases signed and dated was almost unknown in Asian art until very recently. When the Japanese artist Hokusai, influenced by the West, did date his work, he did so with such lack of attention that it is impossible even today to sort out with certainty his early works from the later ones.

This unconcern for linear time is particularly evident in the Japanese art form called *sumi-e.* Using only rice paper, black ink, and a brush, the artist places himself in an almost trancelike, ever-present *now* and paints in a rapid flurry of strokes. There can be no touching up, erasing, or revising. *Sumi-e*, flowing from the artist's hand, is the very embodiment of the Eastern concept of time. By contrast, mechanistically inclined Western artists could stop the creative process at will in order to change the past and plot a new future. The pentimenti of old oil paintings, ferreted out with modern technology, reveals how frequently Western artists revised and changed their original visions. The Flemish painter Hubert van Eyck in the fifteenth century played a crucial role in the perfection of painting with oil-based paints. Other artists hailed this major advance that made possible the creation of static legacies that would resist the ravages of time. Rice paper and ink has rarely achieved this goal because *sumi-e* artists, more interested in the *now*, did not concern themselves primarily with posterity.

Another example of the profound difference between Eastern and Western perceptions regarding time is the absence of a Western art form comparable to the Eastern cultivation of bonsai. While most people in the West think of bonsai as a form of gardening, in the East it is a traditional art form. In the West a work of art is considered finished (in time) when the artist signs and dates it. From that moment on, it is arrested, subject to

an irresistible slow rotting decay. How different a bonsai tree is: an organic form that is constantly in evolution. It can be altered by the action of the artist and is ever changing even though it has the appearance of the *everlasting now*. Because the rate of change is so slow, change cannot be seen from day to day. Its evolution becomes subtly apparent only from month to month. Bonsai subliminally reinforces a different conception of time by deemphasizing the idea of its passage. Time progresses in the cultivation of a bonsai tree, but this progression must always be matched with the visual day-to-day appearance of the bonsai tree, which remains essentially the same. This paradox of change within the context of no change forces one to reconsider notions of linear time. A bonsai tree can outlive the artist, attesting to the profundity of this ever so slowly evolving art that never becomes static and "finished" in time.

The Eastern notions of time and space, which differ so fundamentally from those held in the West, necessarily contain a contrasting conception of light. In the Newtonian paradigm, light is relative. Therefore, it must travel from here to there (space) in a certain allotted amount of time. If the light is obstructed by an object in its path, then it illuminates the side facing the direction of the light beam and the other side must be in shadow. Shadows are the visual clue necessary for a viewer of Western paintings to tell time. Many Italian masters of the Renaissance used this technique by throwing their figures into the stark relief of chiaroscuro. Rembrandt elevated the use of shadow to a pinnacle never again achieved by any artist. When all is said and done, however, shadow is an optical phenomenon that is at the heart of Western fundamental beliefs about space, time, and light. But if time is not linear and space is not empty, then light does not necessarily travel *in* time *through* space. A culture that believed this contrasting view of space and time would manifest it in their art.

For example, shadow is all but absent from traditional Japanese art (Figure 12.3). Without shadow, the viewer cannot fix a painting's time of day, or the direction of a light source. Also, space fails to develop fully the third Euclidean dimension of depth. The Japanese artist, by treating shadows as irrelevant, is expressing something about that culture's belief in the interrelations of space, time, and light that later would emerge in Einstein's equations.

As I mentioned previously, before the discoveries of the new physics, Asian influences had already begun to appear in Western art. Many artists, acknowledging the influence of Eastern art, included in the background of their compositions actual reproductions from Japanese wood-block prints. Gauguin, Cézanne, and Matisse became the first Western artists since the

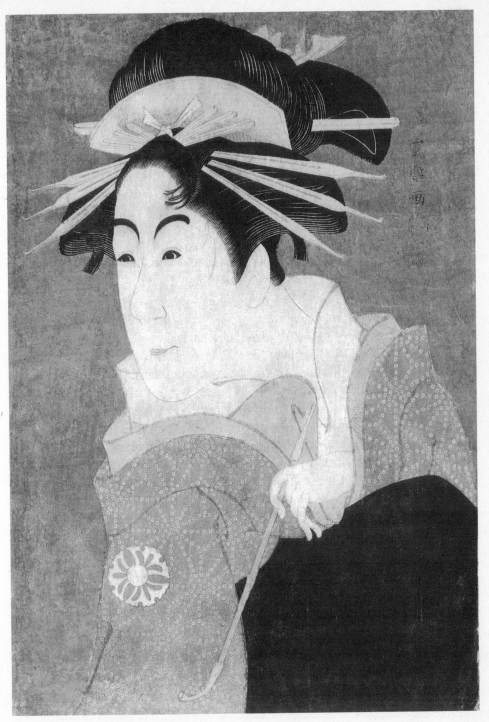

Figure 12.3. *Toshusai Shiraku,* Matsumoto Yonesaburo in a Female Role
THE METROPOLITAN MUSEUM OF ART, ROGERS FUND, 1914

onset of the Renaissance to leave patches of bare canvas in their finished works. By letting the raw material of the canvas complement the painting rather than filling it in, they called attention to the importance of the idea of nothingness. In sculpture, Auguste Rodin was the first artist of the modern era whose figures arose from an amorphous mass of stone: something arising out of nothing.

Eastern art had crucial features of relativity long before Einstein formulated them in equations. Intuiting the value of these Eastern concepts, Western artists embraced many Asian stylistic conventions and incorporated them into their art just as they did those of the child and the primitive. Art historians have speculated about the causes for this surge of interest in these three art styles. Few, if any, have related their appearance to the coming changes in physics. The emergence of nonrational styles of art merely served as the introduction to the unimaginable notions of space, time, and light that were to occur in the new physics in the early years of the next century.

In the subsequent chapters I will integrate art principally with the special and general theories of relativity, and occasionally with quantum and field theory. From the time these descriptions of physical reality were published, I can no longer claim that artists were prescient. For the most part, however, artists continued to be ignorant of these new insights long after their explication in equations and explanations in the popular press. I will draw attention to the peculiar congruence of artists' images even if they were made after the physicists published. Those relevant artists' images created after appearance of the physicists' theories can best be understood as unconscious expressions of a new way to see that paralleled the physicists' new way to think.

A new painting is a unique event, a birth, which enriches
the universe as it is grasped by the human mind, by bring-
ing a new form into it.

<div align="right">Henri Matisse</div>

Color is energy made visible.

<div align="right">John Russell</div>

CHAPTER 13

FAUVISM / LIGHT

I n the latter half of the nineteenth century, while scientists fidgeted
uneasily at their inability to explain puzzling features of space,
time, and light, Impressionist and post-Impressionist artists alike
incorporated into their art eccentric images that challenged long-held no-
tions about these same three elements. The twentieth century opened with
Einstein's brilliant 1905 solution to one of physics' unsolved problems and,
simultaneously, introduced three artists who would thrust modern art
through a transformative barrier.

Early in their respective careers, Henri Matisse, Pablo Picasso, and Marcel
Duchamp assaulted the art world with works that both announced and
represented three radical movements: Fauvism, Cubism, and futurism.
(Although Duchamp, a Frenchman, was not involved in the founding of
Italian futurism, his 1910 *Nude Descending a Staircase* is probably the
most universally recognized image of this movement.) Fauvist painters

were singing the praises of light in the form of color just as Einstein was enthroning light as the quintessence of the universe. Cubism presented a new way to visualize space, which was the first creative alternative to Euclid's views in more than twenty-two hundred years. Einstein also proposed an alternative concept of space. Futurism declared war on the traditional modes to represent time. By dilating the present into the past and the future, futurist painters captured an idea that paralleled Einstein's lightspeed. It was an extraordinary coincidence that these three different art movements, each focusing on a separate element of the special theory of relativity, erupted synchronistically with Einstein's radical publication. In a strange way, it is as if the art world with forethought decided to fracture the trinity of space, time, and light to better understand each element in isolation. Within a few years clustered around 1905, an explosion of the eye accompanied a hyperinflation of the mind.

Fauvism, the first of the three movements to emerge, was color's Declaration of Independence. Until the mid-nineteenth century, materialist scientists like Newton, who only described color, affirmed that it was a unique property of matter. Idealists like Goethe, who wrote a treatise on color's effects on the emotions, propounded the opposite view: that it existed chiefly in the mind of the beholder. By the early nineteenth century, scientists strengthened the position of the materialists by demonstrating that color is light of varying wavelengths, thereby reducing to number what had always been a sensation.

The retinas of our eyes contain cells called cones that fire upon being stimulated by light of certain wavelengths. The electrochemical signals from the cones then travel to the rear of our brains to illuminate in technicolor a magical screen on the opposite side of the head from the eyes called the visual cortex. Thus our perception of the color red and its assignment to the wavelength spectrum of 7,000 angstroms represent two complementary aspects of a truth about color that unifies the idealists and the materialists. Color is the subjective perception in our brains of an objective feature of light's specific wavelengths. Each aspect is inseparable from the other. This complementarity is also the link between the style of Fauvism and the scientific theory of relativity. Color is, after all, light; and though it exists in a specific location within the electromagnetic spectrum, it demands a cone-eyed conscious mind if its chromatic energy is to be known.

Matisse was older than Picasso or Duchamp—thirty-six when he exhibited his works with a maverick group of young artists including André Derain and Maurice de Vlaminck—and was thrust into the public's atten-

tion in the 1905 Salon d'Automne held in an old gallery which had in its
center a sculpture by the Renaissance sculptor Donatello. The critic Louis
Vauxcelles, confronted by walls covered with canvases that resembled a
festive fireworks display, left the hall, muttering, *"Donatello chez les
fauves"* ("Donatello, surrounded by the wild beasts").[1] *Fauve*, the French
word for "wild beast," was appropriate. Parisians had never before been
exposed to work so vital, ebullient, and disturbing. The Fauvists' assault
on the senses led one critic to warn pregnant women to stay away from
the exhibition because he believed the paintings were so disorienting they
could possibly cause a miscarriage. The hostile reaction of the crowds
prompted Matisse to forbid his wife (who was not pregnant) to attend out
of fear for her safety. To understand the revolution Matisse and his group
incited and the way it presaged Einstein, a short history of color is necessary.

While many sun-drenched, vibrant paintings containing bright colors
were produced in the Renaissance, a casual perusal of any comprehensive
art collection reveals the Stygian darkness of most art before the modern
era. From the Renaissance onward, with few exceptions, color had been a
subordinate value in art. Besides the technical problems inherent in pro-
ducing vivid pigments, artists did not seem to believe color to be as im-
portant as composition, subject, line, or perspective. The tightly logical,
left-brain attitude that has ruled Western culture for six hundred years has
regarded color with a certain suspicion. It has generally been believed that
people who responded to color rather than to line were not wholly trust-
worthy. Love of color was somehow instinctual and primitive, indicating
a Dionysian cast to one's psyche rather than the restrained and Apollonian
one appropriate for a proper man. Color precedes words and antedates
civilization, connected as it is to the subterranean groundwaters of the
archaic limbic system. Infants respond to brightly colored objects long
before they learn words or even complex purposeful movements.

Most evaluations of reality depend upon a synergy of two or more senses.
Sound can be heard and felt. Mass can be seen and touched. Liquid can
be tasted and smelled. Color alone defies corroboration by a sense other
than sight. Color cannot be described to someone who has been blind all
his life. I cannot even be sure that the color I call green is the same color
you call green. While a consensus can be built about most other features
of the world, there is only an uneasy, unspoken agreement among people
about color. It is both a subjective opinion and an objective feature of the
world and is both an energy and an entity. Color is tied to emotions as
well as being a fact. The discursive and eloquent left side of the brain
becomes stymied when attempting to describe the experience of color.

Civilizations strive to channel instinctual behaviors toward a common goal. Throughout the ages, people in authority have considered it prudent to regulate color. For example, in the late medieval period, color was considered so important it was the subject of "sumptuary laws" that determined who could wear what costume and in what color. The nobility and the Church reserved for themselves the right to dress in colorful clothes. They mandated that peasants and serfs must dress only in black or brown. Royalty alone could wear purple. Red, gold, and silver were reserved for the king's councillors, the next tier of importance. The colors worn by knights, squires, even archers, as well as their wives, were as much a badge of rank as their insignia and uniforms. Grudging exception was made for doctors and lawyers, who, while not members of the nobility, were allowed to dress in colored clothes. The first estate jealously guarded its rights and sumptuary laws were primarily designed to prevent members of the upstart merchant class from engaging in the practice of wearing audacious clothing. Judging by the frequency with which sumptuary laws were revised, it is probable they had limited success.[2]

There are many other examples throughout history of those in authority harnessing the power inherent in color and using it in the service of their policy. One has to think only of the patriotic surge of emotion that is evoked by the red, white, and blue for Americans. Observing how the spectators respond to a home team's colors or counting the lives of young men who sacrifice themselves in battle to protect their battalion's colors are just three examples of color's potency.

The need to control color is evident in all so-called rational endeavors. Governmental gray, army olive drab, corporate blue serge, and lab coat white serve to repress color's impact on awareness, removing temptation and distraction, as if someone consciously knew that bright hues would interfere with the cool logic necessary for the conduct of these enterprises. In contrast, the exuberance of color in operas, parades, carnivals, pageantry, flags, rock concerts, and art attests to the proper placement of chromatic appreciation into the right hemisphere of the human psyche.

Since color is an essential component of art, how the art of an age treats color reveals much about that culture. The Western academic tradition, based on alphabet literacy and perspective, imposed upon the eye a linear method of seeing the world. While the eye functions naturally to let light and color in from the outside, line and form derive from notions influenced by what we already know; they are then projected *out* from the eye upon the world—the opposite process for appreciating color. We have a name for almost every form and shape we see. In Sanskrit, the word for "form"

and "name" was even the same. What we *see* is preconditioned by what we *saw* in the past, so that knowledge of the names of things prevents us from seeing new things afresh.

The spokesman for the Enlightenment, Immanuel Kant, in his *Critique of Judgment*, published in 1790, revealed this prejudice against color:

> In painting and sculpture, the *design* is the essential thing. . . .
> The colors which give brilliance to the sketch are part of its
> charm and they may, in their own way, give an added liveliness
> to what we are looking at. But they can never, in themselves,
> make it beautiful.[3]

The neoclassicist painter Jean-Auguste Ingres (1780–1867) agreed with the subjugation of color by proclaiming that "drawing is the probity of art."[4] His contemporary, the English connoisseur Sir George Beaumont, summed up the academic European attitude toward color when he succinctly remarked, "A good picture, like a good fiddle, should be brown."[5] In the early nineteenth century, this devaluation of color led the embittered Constable, upon hearing of a prospective buyer for one of his landscapes, to write to a friend:

> Had I not better grime it down with slime and soot, as he is a
> connoisseur, and perhaps prefers filth and dirt to freshness and
> beauty? . . . Rubbed out and dirty canvases . . . take the place
> of God's own works.[6]

Across the Channel the great Romantic Eugène Delacroix was among the few painters to confront the staid bourgeoisie with the possibilities that lay dormant in color. So confident was he in his skill with color, he once claimed, "Give me mud and I will make the skin of Venus out of it, if you will allow me to surround it as I please."[7] Delacroix opened the window a crack in the dark room that contained so many works of European art. The pure spectrum that poured through was a harbinger of things to come. Allies such as Joseph Mallord Turner in England and Caspar David Friedrich in Germany also attempted to roll back the weight of the thick sludge favored by the predominantly "brown sauce" school of art. The colorists' efforts were not in vain, though for a while academic tradition perpetuated the subjugation of color because, in the technical tradition of painting, color was always added last. Beginning with the decision regarding subject, the artist had to work out the details of composition. Hierarchy of subjects,

angle of vision, and perspective were the next problems that had to be solved. What usually followed were sketches; penciled black-and-white cartoons known as preparatory drawings made before the composition was outlined on the blank canvas. Finally, after he had determined all these other values, the painter would pick up his palette and add color.

With the advent of Impressionism in the 1860s, color became brighter and lighter. Manet began to use color patches, placing lighter tones on top of darker ones, reversing the previous tradition in which light colors were placed first and then scumbled with darker shades. Monet blurred objects' boundaries. He did not first outline his objects; he began with color instead of ending with it, so that the colors of objects became for the very first time in art more important than the objects themselves. Working rapidly outside the studio *en plein air*, Monet tried to seize the chromatic energy contained within a single fleeting moment rather than to engage in an excess of cerebration after the fact. Painting for Monet depended upon which cones fired in his eye. He became the artist of the transitory moment and his weapon, destroying the sepia shades of the past, was his palette.

Georges Seurat also abandoned the convention calling for line to define figures and carefully juxtaposed small dots of pure color. Pointillism can be seen as Seurat's way to create forms and volume out of tiny pieces of unabashed light, giving color and composition ascendancy over line and subject. Critics denigrated Seurat, calling him "the little chemist," and outraged Parisians physically attacked with umbrellas his most famous painting, *A Sunday Afternoon on the Island of the Grande Jatte* (1884), at its presentation.

One of the first artists in this era to recognize the emotional power of color was Paul Gauguin, who discovered by trial and error that color could be used as a silent language to evoke a visceral reaction antecedent to words.[8] Color became the component Gauguin used to manipulate the viewer's emotions. His new rule for art—expressive intensification of color and the simplification of form[9]—stood in contrast to the rules of the neoclassicist painters, exemplified by Jacques Louis David, who, in the late eighteenth century, used the graphic realism of his compositions for this same end, as Rembrandt had earlier used shadow to establish the mood of his paintings. By inventing a new language of color, Gauguin discovered that the color of an object can be a relative rather than an absolute value.

Gauguin's revolutionary choice of red for the color of the broad expanse of grass in his painting *The Vision After the Sermon—Jacob Wrestling with the Angel* (1888) has more to do with his need to control emotions and balance the composition than with any requirement to represent grass

as green. The startling idea that the color of an object depends on the whim of the artist anticipates Einstein's adaption of the Doppler effect to relativity which explains how the color of an object at very high speeds depends upon the velocity and direction of the observer. Gauguin's imperative was "Pure color! You must sacrifice everything to it" Werner Haftmann describes Gauguin's paintings as large flat canvases over which "color flows like lava from a volcano."[10] Once Gauguin assigned color to objects according to his inner vision rather than to any accurate rendering of nature, the Bastille shackling the power of color began to crumble. The way was clear for an explosive emancipation of color and its minions came pulsing and pushing forward.

Vincent van Gogh pursued Gauguin's innovation with greater intensity. Van Gogh resonated to the harmonic vibrations of color like the tines of a tuning fork. He was so moved by the purity he squeezed out of his tubes of paint that many times he didn't even bother to brush it on. Instead, van Gogh, the noble savage of color, abandoned the paintbrush in favor of the palette knife, transferring the bright pigments directly from their tubes and molding them to his canvas. This thick pastiche of cobalt blue, cadmium yellow, and vertiginous green overpowered the other elements on the canvas. Declaring that color was free and therefore relative, he wrote:

> *Color expresses something by itself*. Let's say that I have to paint
> an autumn landscape with yellow leaves on the trees. If I see it
> as a symphony in yellow, does it matter whether the yellow that
> I use is the same as the yellow of the leaves? *No, it doesn't.*[11]

Van Gogh's love of color led him to return to Western painting the icon and source of all color and light—the sun. To cut down on glare, academic art had long ago banished the sun as a primary subject for paintings, and in all these years the sun can barely be found in art.* Since the sun was usually reduced in power to a weak red disk setting upon a distant horizon, the elemental power of the sun had been absent from Western art since the Egyptians. This primal subject is all but missing from Greco-Roman, early Christian, medieval, Renaissance, and academic art. Van Gogh, recognizing the sun as the primordial furnace out of which are forged all the colors, celebrated it in his famous 1888 composition *The Sower*. There, an enormous yellow disk fills the canvas to bathe the tree and sower in the

*An earlier exception to this convention was the Romantic painter and friend of Blake, Samuel Palmer.

foreground in an enormous, almost palpable light. The principal subject in this work is the sun.

Paul Cézanne was not a wild man like van Gogh or Gauguin, but he, too, set for himself the task of liberating color. Cézanne had more in common with the analytical Seurat and, like the pointillist, developed a new theory of color that enabled him also to eliminate black line as one of a painting's components. "Color *is* perspective,"[12] Cézanne once said, and its function was to structure space.

Cézanne discovered how to create a sense of volume and a tactile sense of mass by juxtaposing colors. He discovered that warm colors advance and cool ones recede, and so was able to create a sense of depth and mass without using line or perspective. By carefully juxtaposing certain colors, he could illuminate volume and borders, something that previously had been the domain only of drawing and shading. Cézanne wrote, "Nature is more depth than surface, the colours are the expressions on the surface of this depth; they rise up from the roots of the world."[13] He was able to show how pure color without an outline could create a sense of something's existence in space, which implied the subversive idea that light was the preeminent element of reality.

These five artists—Monet, Seurat, Gauguin, van Gogh, and Cézanne—all contributed directly to the emancipation of color. Monet was the first to immerse the viewer in the delight of color for color's sake. Seurat created designs by juxtaposing minute dots of pure color. Gauguin set the mood of a painting with color. Van Gogh imbued color with a reverberating vitality. Cézanne substituted color for the crucial elements of line, shading, and perspective. The stage was now set for the exuberant jubilation that would accompany the coronation of color.

This celebration took place at the Fauvist exhibition in the Salon d'Automne in 1905, where the innovations made by these earlier diverse artists converged in the art of the Fauvists. Matisse and his group finally declared that color superseded all the elements of painting; that the color of an object was entirely arbitrary; and that color was an end in itself. Violently, Fauvist art declared that the colors in a painting *were the painting*. Fauvists could violate the integrity of objects, composition, subject, and line. Capriciously trees could be red, skies purple, and a human face could be painted with a broad green stripe down the center. Vlaminck, whose speech was as colorful as his paintings, said, "We treated colours like sticks of dynamite, exploding them to produce light."[14]

Two decades later, in 1927, the relative quality of color turned out to

be the clue that led the American astronomer Edwin Hubble to discover that the entire universe was expanding. According to the Doppler effect and Einstein's relativistic light transformation equations, objects speeding away from us at velocities approaching the speed of light appear redder— a change that was called the "red shift" by late-nineteenth-century astronomers who did not appreciate the significance of this phenomenon. Everywhere they looked beyond our solar system all distant galaxies were in the red end of the spectrum. Taking his cue from Einstein, Hubble proposed that every galaxy was speeding *away* from us at a speed proportional to its distance. This meant the universe was expanding, rather than just existing as the static piece of mechanical clockwork conjured by the seventeenth-century philosophers and physicists.

Hubble's discovery was all the more interesting because for a very long time color was not a property that figured into the calculations of science. Pythagoras, Plato, Euclid, and Aristotle did not take color into account in their contributions. Early Renaissance scientists paid little heed to the spectrum, as, for example, Copernicus when he formulated his heliocentric theory of the solar system. Galileo did not utilize color in his discovery of mechanics, nor did Kepler when he calculated the planets' elliptical orbits. Newton did not need color to formulate his magnum opus, the *Principia*. He did make the seminal discoveries regarding the nature of color using a prism, but the publication of his *Opticks* came after his insights about gravity, motion, and the calculus, and did not have the impact or significance of the *Principia*. In coining the word "spectrum," Newton took as his source a Latin word that meant "apparition," as if for him the spectral qualities of color and light occupied a liminal position between this world and another. From the early Renaissance to the end of the Enlightenment, color played a subsidiary role in the great dramatic works of science. During these years, the quantifiable properties of number and measurement were superior to the qualities of texture and color.

Coincident with the rise of Impressionism, however, science began to take a livelier interest in the subject of color. In 1859 Gustav Kirchhoff and Robert Bunsen (of Bunsen burner fame) firmly established spectrum analysis. They observed that when light shone through a heated gas emanating from one particular element of the periodic table, analysis of the emerging light revealed distinctive lines peculiar only to that element. It was as if each atom's spectrum, seen through the spectroscope, had its own unique signature. No one knew why these lines were so constant, but by 1863, the year of the Salon des Refusés, Kirchhoff and Bunsen had

catalogued the sequences of these strange lines in each of the spectra of the elements.

One night, while working together in their laboratory in Heidelberg, they observed a fire raging in the port of Mannheim, ten miles away. Playfully they turned their spectroscope in the direction of the fire and were amazed to observe the resulting light from the distant fire revealing the telltale lines of barium and strontium. Kirchhoff looked at Bunsen, who, reading Kirchhoff's thoughts, wondered out loud if it would be possible to focus their spectroscope upon the sun and learn that distant body's composition. Bunsen said, "People would think we were mad to dream of such a thing."[15] Kirchoff, undaunted, immediately set to work on this problem.

While Manet and Monet altered people's experiences of color, Kirchhoff altered our knowledge about it and discovered that the sun was made up of constituent elements of the periodic table identical to those that made the earth. Contrary to previous speculations, he could find nothing alien 93 million miles away.

In London, when the wealthy amateur astronomer William Huggins learned of Kirchhoff and Bunsen's finding, he saw at once that their method might be applied to the stars and nebulae. By studying the spectra of the bright stars Aldebaran and Betelgeuse he provided conclusive evidence that the stars consist of the same elements as the solar system. In one of the greatest triumphs of science, Kirchhoff, Bunsen, and Huggins revealed that the genealogy of the stars had a first cousinship to the mountains of our earth. The key to this dazzling discovery was the nature of color.

In 1873 James Clerk Maxwell formulated the laws that govern electromagnetic fields. One of the key facts to emerge from his equations was that the visible spectrum of color existed as a thin sliver notched along an immensely larger continuum of radiant energy, most of which the human eye could not discern.

Maxwell's equations, which were an extension of Newton's mechanical interpretation of the world, however, failed to predict one feature of reality. This failure, which was the inability to explain why heated bodies change colors with an increasing rise in temperature, became known in physics as the problem of the "ultraviolet catastrophe." The problem remained unsolved until 1900, when Max Planck explained this mystery. With the formulation of a deceptively simple equation, his solution opened the vista upon a whole new field of physics that would be called quantum mechanics. Planck proposed that the energy possessed by matter can be changed into radiation only in discrete chunks he called *quanta*. Formerly, it had been

believed this energy traveled through space as a smooth continuous wave. Planck's tiny packets came as a surprise to physicists. Color was the clue to unlocking this mighty secret of nature.

Shortly after Planck's enunciation of quantum theory, physicists with heightened interest pondered the structure of the atom. It was already known that every atom had its own particular weight and number. As a result of the discovery of the periodic table, atoms with similar properties could be grouped together as families. But what remained to be worked out was the atom's actual configuration. The sharpest minds worked with white chalk at blackboards, trying every conceivable permutation of weight and number while struggling to unlock the enigma of the atom's form. Try as they might, no amount of speculation could solve the puzzle of the periodic table. What was the reason, they wondered, that the elements were grouped as they were?

In 1913 Niels Bohr, influenced by J. J. Thomson and Ernest Rutherford, proposed a radically innovative solution to the structure of the atom. He arrived at his hunch by first musing on the uniqueness of each atom's color signature as seen through a spectroscope. Later, when shown Johann Balmer's equations, he was able to mesh the atomic weights and numbers with the spectral colors of each atom. Bohr's atom, despite some later revisions, was basically sound, and nuclear physics, as a distinct branch of science, with all its pregnant implications for the future of humanity, was born.

From antiquity to the 1860s, all scientific discoveries of moment were based upon sharp-edged black-and-white numbers and measurable quantities. Then, within the next sixty years, a few physicists stared in childlike wonder at the spectrum of colors and discovered the following: the composition of the stars; the fusion of magnetism, electricity, and light; the genesis of quantum mechanics; the structure of the atom; and the expansion of the universe. These five discoveries rank among the most profound insights in the history of science.

Einstein's realization that light (which is color) is the quintessence of the universe paralleled the apotheosis of light by the artists. Before Einstein made his discovery, Claude Monet announced that "the real subject of every painting is light." Echoing this sentiment, Einstein later commented, "For the rest of my life I want to reflect on what light is."[16] Both artist and physicist confirmed a great biblical truth. In Genesis, God's grand opening act was the creation of light. He did not say, "Let there be space" or "Let there be time." He said, "Let there be light."

* * *

In the nineteenth century, the connection between colors and their associations was profoundly transformed as the hierarchy inherent in the spectrum was dramatically reversed. Since the time of cave paintings, the most vital primordial color had always been red. Red was the color of blood, passion, life, and flame. It represented power, glory, and courage. Blue, on the other hand, was associated with restraint. Blue was the color of melancholy, dormancy, and involution. Blue bloods, blue noses, blue laws, blue Mondays, and having the blues are still associated with dispassion and a lack of energy. In the mind of early humankind, the world was divided into fire and ice, the fundamental contrast between red and blue. In the kingdoms of old, the most important and respected councillor sat to the king's right. This position was superior to whoever sat to the king's left, an intuitive convention that is recognized whenever one praises the virtue of someone who acts "as my right-hand man." The pecking order of dominance is apparent in the representation of the rainbow. Most people coloring the spectrum place red to the right and blue to the left.

But early civilizations did not seem to grasp the importance of the color blue, as the study of comparative etymology reveals. Two American linguists, Brent Berlin and Paul Kay, who wrote *Basic Color Terms: Their Universality and Evolution*, studied the words for colors in a variety of languages, from unwritten primitive dialects to modern European tongues. They began with the assumption that since all humans (except the color-blind) appreciate colors, color terms would have to be universals found in all vocabularies. They reasoned that all lexicons must have individual words in them to describe the six hues of the spectrum.

Their basic premise was partially correct: In the eighty-eight languages and dialects they examined, they found that a totally color-blind language does not exist. The least sophisticated, the vernaculars spoken by the bushmen of Africa and the aborigines of Australia, had separate words for only black, white, and red. These were the bedrock minimum that could always be found in the speech of every ordinary or exotic inhabitant of the planet. Many diverse religions have traded upon the primitive evocative power of this combination. The Catholic Church intuitively understood the fundamental sovereignty of these three. Hitler, who plumbed the emotions of the German people, perversely manipulated these same three when in a stroke of brilliance, he personally chose black, white, and red for the emblematic swastikas of the Third Reich.

Those languages that had a fourth color word identified either orange, yellow, or green. The study revealed a curious pattern—as societies advanced and added to their vocabularies, the words for color followed the

spectrum of visible light from red to blue. Only in the most mature languages, belonging to the most sophisticated civilizations, does a separate word for the color blue make an appearance, and usually it does so very late in the culture's development.

The Romantic poets Byron, Keats, and Shelley rhapsodized about the pellucid, azure sky they found over the Greek Acropolis in the nineteenth century A.D. The sky must have been just as blue in Homer's day, yet no mention of its color appears in the *Iliad*. Despite its numerous references to the heavens and firmament, the Bible also fails to note that the celestial vault is blue. An awareness of this color seems to have been mysteriously absent from early people's descriptions of their world. Even Shakespeare, writing in the late sixteenth and early seventeenth centuries, hardly mentions the color blue compared with his liberal notice of red. In Roget's *International Thesaurus*, there are three times as many synonyms for shades of red as there are for blues. Before the modern era, besides the difficulty of producing blue dyes and pigments, cerulean seems not to have been as significant as vermilion.

I would speculate further that another reason for this disparity between red and blue is that ice is not as intriguing as flame. Imprinted in the collective human memory are the millennia of the great glaciations, during which proto-man spent long dark winter nights huddling about the fire, staring into its depths. Moreover, at the energy levels that exist on earth, red has always been the primordial color. Oxyhemoglobin is the red protein that stains our blood, flushes our cheeks in anger and orgasm, and tints our flesh the color of life. The flame from the hearth contains the energy to cook a meal, shape metal, and stave off winter's piercing chill. The sun, the source of most of the manifest energy on the planet, is also this hue. Of all the truths that humankind considers indisputable, it is this: The color red stands for vitality, energy, and power. In 1704 Newton expressed this idea scientifically in *Opticks*, his ground-breaking analysis of light. In Query 29, he wrote that rays of light are

> bodies of different sizes, the least of which may take violet, the weakest and darkest of the colours and the most easily diverted by refracting surfaces. The largest and strongest light corpuscles carry red, the color least bent by a prism.

This is the way matters stood until the middle of the nineteenth century, when scientists acknowledged that the color of energy had to be revised. The ordinary Bunsen burner, a fairly common fixture in the burgeoning

scientific laboratories, produced a flame that contained red, orange, yellow, and blue sections. Contrary to popular assumptions, the blue part of the flame was the hottest. Blue, hot? Blue had always been associated with cold. Despite all the accumulated impressions of the past and commonsense intuition, scientists demonstrated without a doubt that the color of highest energy in the flame of a Bunsen burner was not red but blue.

As if blue heat were not confusing enough, Johann Ritter, in 1801, discovered the presence of a strange "black" light. This invisible light, as some people called it because the human eye could not see it, resonated from the blue-violet end of the spectrum and later was named ultraviolet. Ritter discovered the light because it was a "hot" color, capable of raising the temperature of water and causing sunburn. Maxwell's electromagnetic scale, which spans high-energy gamma rays at one end and the long undulations called radio waves at the other, reversed the traditional order of the color of energy—the shorter the wavelength, the higher the energy. Ultraviolet, nearest to blue, has a shorter wavelength and therefore a higher energy than infrared, whose longer wavelength is adjacent to red.

Astronomers, among other scientists, soon confirmed Maxwell's formulations when they learned that the hottest stars are the young ones that burn with a blue-white light. The Pleiades, in the constellation of Taurus, contain a whole nursery of these infants. On the other hand, contrary to previous opinions, the big red giants, such as Betelgeuse, turned out to be old, cooling stars.

Geologists learned that the blue-white diamond, traditionally the most highly valued, requires the greatest force over the longest time for its creation. We use yellow-red diamonds, made by a lesser force, as industrial-grade drilling tips. The blue star sapphire is similarly more valued than the ruby.

Combining the Doppler effect with Einstein's high relativistic speeds revealed that an object hurtling toward an observer at near the speed of light appears bluer than those left behind and fading away, which appear to be redder. Thus, in the new physics, red is the color of aperture, dilation, and distance, and blue is the color of attraction, collision, and contraction. The red shift of galaxies is the crucial fact that informs us that the universe is expanding. In a complete reversal of the truth before our eyes, blue turns out to be the color of fire; red the color of ice.

If this profound about-face occurred in science, what, may we ask, was the artist's attitude toward this reversal? At the outset of the Renaissance, Italian artists, conflating the sky with heaven, almost always depicted it as gold. Then Giotto, in a bold artistic stroke, made the immensely simple

observation that the sky was blue and painted it this color! Once he pointed out the obvious, artists did not revert to gold skies.

Giotto's observation notwithstanding, artists continued to feel more comfortable with red rather than blue. A casual perusal of any art book containing pre-1860 art confirms the preference for red-brown colors to blue-violet ones. Sir Joshua Reynolds, a conservative academic painter, held that blue should be restricted to background sky and water, and taught his students that it must not be used in the foreground of a painting. When his leading rival of the day, Thomas Gainsborough, a freer spirit, learned about Reynolds's dogma, he promptly created the first predominantly blue painting, *The Blue Boy* (1770), in order to prove that an artist *could*, from a compositional standpoint, use blue in the foreground.[17]

By the time blue Bunsen flames lit chemistry laboratories all over Europe, the French Impressionists had discovered the excitement inherent in the color blue. Moreover, new shades of blue paint pigment were being created in those laboratories. In both art and science, blue abandoned its languid restfulness and began to awaken from its long sleep. After Monet, Gauguin, and van Gogh began to use its high energy, blue gradually came to dominate the compositions of one painting after another by the artists throughout the late nineteenth century. Starting slowly, like a dervish, blue became the color of swiftly turning dancers in several works of Edgar Degas.

The hummingbirdlike vibration of blue burst forth in Fauvism, where it was released from its prison in the sky and then could be a tree, a face, grass, or anything. In 1901 Picasso chose blue not just for one painting but for a whole period of his work. Never before had an artist executed an entire monochromatic series of canvases using tonal variations of a single color.*

In 1917 Einstein speculated upon a new form of light hitherto unseen. White light, such as light from the sun or any other conventional source, contains the various wavelengths of all the colors of the spectrum, but none can be appreciated in isolation because together they are incoherent. Like a crowd of people, some colors run, some walk, and a few saunter, and all are out of phase with one another. Einstein theorized that under certain conditions light could be emitted from excited atoms in such a way that the waves would fall into lockstep and travel through space much like a drill-perfect, goose-stepping army on parade. If light could be tamed and

*Picasso also had a rose period named after another predominant color he used. Unlike his blue period, however, these works are not monochromatic.

forced to march in such military precision, then this light, according to Einstein, could be of only one pure color, which would be determined by its source, the emitting atom. Forty-three years later in 1960 Theo Maiman generated the first laser light. Laser, which is the acronym for Light Amplification by Stimulated Emission of Radiation, is the actualization of Einstein's 1917 speculation.

The striking feature of laser light is that it is coherent; it doesn't diverge and it is pure. Blue laser light cannot be anything but blue. Passing it through prisms, filters, or different media cannot change its color fastness. Picasso's eccentric adherence to a monochromatic scheme sixteen years before Einstein spoke of it, and almost sixty years before Maiman made it real, foreshadowed this immutable new kind of light and Picasso chose blue—the color of high energy—rather than green, yellow, or red.

Art supply stores at the beginning of the twentieth century had to increase their orders of cobalt and cerulean pigments as one artist after another attempted to outblue the other. In a declaration that couldn't have been made in earlier art periods, Franz Marc, an early abstract painter, declared, "Blue is the masculine principle, robust, and spiritual."[18] The German Expressionists decided collectively upon the name Blue Rider and made a large number of paintings whose dominant color was blue. Paul Klee was a member of that group and a little over a decade later he and three others formed a successor group to the Blue Rider called the Blue Four. In 1910 a group of Moscow artists called themselves the Blue Rose.[19] Frenetic blue began to appear with a vengeance as if making up for lost time. Late in the 1960s, Yves Klein, like Picasso before him, created a series of all blue paintings. These flat canvases were covered exclusively with several layers of pigment he called International Klein Blue. Later in his career, he progressed to painting with "living brushes": nude models who covered themselves with fresh blue paint, and pressed and wiggled against blank canvases under Klein's direction. This artist reaffirmed the primitive sexual nature of blue without words or numbers.

But for all the blue expended in this century's art, the "Blue Award" must go to Matisse, the Fauvist, who best captured the essence of blue. In his famous 1909 work *The Dance* (Figure 13.1) a vibrant, monochromatic lapis lazuli background provides the atmosphere for the wild, circular dance of five Dionysian maenads. While previous artists such as Degas, Renoir, and Toulouse-Lautrec represented the vitality of the dance, few artists had ever painted a circular one.

A few years after Matisse's painting, nuclear physicists discovered that life itself is based on the carbon atom, which has in its outermost orbital

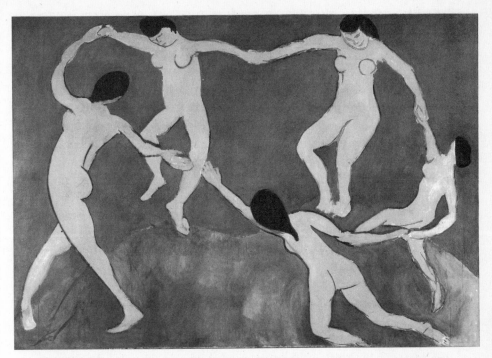

Figure 13.1. *Henri Matisse,* The Dance *(1909, first version)* THE MUSEUM OF
MODERN ART, NEW YORK, GIFT OF NELSON A. ROCKEFELLER IN HONOR ON ALFRED H.
BARR, JR.

four negatively charged electrons whirling about the stationary, positively
charged nucleus. These four dancing electrons are always looking for four
more to join them. When their entreaties are answered, they begin to build
the interlocking chain-link pattern of life. In Matisse's version, there are
five dancers, but there is a break in the hands of two of them as if inviting
a sixth or more to participate. The immense deep blue background is quite
startlingly prescient because physicists have discovered since the painting
was made that the representative color of nuclear energy is blue. The
beautiful and awesome photos taken of radioactive piles at nuclear energy
plants are a familiar image of their power. Rather than the roaring red
glare from the interior of Bessemer blast furnaces of the nineteenth century,
the ultimate image of energy in those times, the silent mysterious blue
Cerenkov emanations of a nuclear pile in this century supersedes all pre-
vious images. The dance of carbon's electrons and the dance of Matisse's
maenads is one and the same dance; it is the dance of life.

Perhaps assigning gender characteristic to atomic particles such as neg-

ative electrons and positive protons is not so farfetched. After all, the act of copulation itself, with its implications of creation, is often referred to as blue, and movies containing explicit sex are called blue movies. Music, too, recognized the power of blue when, with unerring perspicacity, a new movement called jazz, wilder and more energetic than its classical cousin, arose from the birth of the blues. Ellsworth Kelly, the field painter of the 1960s, offered a belated recognition of the reversal of the spectrum. In his 1966 rendering of the familiar rainbow, entitled *Blue, Green, Yellow, Orange, Red*, he placed blue to the right and red to the left. This subtle artistic change is the result of a dramatic turnaround in our perception of the color blue.

One year after Matisse painted his incredible blue sky for *The Dance*, Einstein finally solved the problem troubling scientists for centuries; that of the exceedingly basic question: Why is the sky blue? It had gone unanswered by generations of physicists, but not for lack of trying. In 1910 Einstein, building upon Lord John Rayleigh's work, published a paper concerning "critical opalescence" that explained in detailed and complex equations the physical basis for the phenomenon of the sky's blue color.[20]

Matisse, the sophisticated colorist, luxuriated in the sumptuousness of variegated light. Einstein, the enchanted child-man, changed the shape of our minds forever because of his incessant curiosity about light and color. Both in their own way assisted light to claim the crown as the rightful heir to the throne of reality.

I paint things as I think of them, not as I see them.

Pablo Picasso

No one has ever been able to define or synthesize that precarious, splendid, and perhaps untidy instant when the creative process begins. This is what the uniqueness of the artist is all about. The transcendent right of the artist is the right to create even though he may not always know what he is doing.

Norman Cousins

CHAPTER 14

CUBISM / SPACE

After the Fauvists celebrated light, the next essence to be revised by artists was space. Einstein, too, thoroughly revamped our notion of space. Contained within the filigree of his mathematical equations were such severe distortions of mundane, commonsense experience that few could imagine them. Because of this difficulty, the radical changes in the conception of reality buried in his deceptively simple formulas did not trouble the world until some time after their publication in 1905. However, a graphic representation of relativistic principles coincidentally appeared in a revolutionary new art style—Cubism.

In the everyday world of experience, a second of time delineates a segment of space that is spread out like a 186,000-mile-long caterpillar. But,

like a character in *Alice's Adventures in Wonderland*, this space contracts for an observer moving through it at ever-increasing speeds, becoming shorter and thicker just like the accordion segments of a compressing caterpillar. When an observer achieves the speed of light, the space outside his frame of reference both ahead of him and behind merges so that the space he sees is infinitely thin. Front and back as well as sides can be imagined to be *all here*. Gertrude Stein's devastating description of her hometown, "There is no there, there," could also apply to the condition of space at the speed of light: There is no *there, there* because it is *all here*. This excruciatingly difficult mental exercise demands that the thinker imagine that all the points in space along the path of observation occupy the same location simultaneously.

Whenever space contracts, time, its complement, dilates. The *now* of our prosaic existence is but a blink of an eye. The literary critic Georges Poulet lamented this irony:

> For an instant! Shattering return to the misery of the human condition and to the tragedy of the experience of time: in the very instant man catches his prey, experience dupes him, and he knows he is duped. His prey is a shadow. In the instant he catches the instant, and the instant passes, for it is instant.[1]

To think of *now* is too late; the moment is already past. Nor is it possible to sneak up on the present, because it is still the future. Only as a traveler approaches the speed of light does the frame we call the present begin to ooze, amoebalike, over our ordinary temporal boundaries and spill into the past and the future.

These strange distortions of visual reality peculiar to relativity were simultaneously expressed in art. At the close of the nineteenth century, some art critics were exhausted by the task of trying to explain all the recondite new styles since Impressionism. A few declared that that was it, the show was over. Some predicted that art would grow stale because there could be nothing new under the sun. These seers did not take into account the creative genius of Pablo Picasso. Picasso, a Spaniard, shuttled back and forth between Barcelona and Paris beginning in 1901 when he was nineteen. He settled permanently in France in 1904. By then he was recognized as a rising young artist who had already developed two distinctive styles in his blue and rose periods. His budding genius appeared at a watershed moment in art. In 1905 in Bern, Einstein engaged a friend, the mathe-

matician Michelangelo Besso, in long conversations over coffee, struggling to understand how the world would look to someone sitting astride a beam of light or looking at it while traveling alongside it. After Einstein had the answer and before Minkowski defined the four-dimensional manifold of spacetime, back in Paris Picasso was experimenting with a new way to conceptualize space and formulated just such a view early in 1907.

Picasso lived in an artists' colony in a dilapidated old building affectionately called *le Bateau Lavoir* ("the laundry barge"). His neighbor was Georges Braque, a young French artist. Where Picasso was impatient and passionate, Braque was cool and logical. In the years between 1907 and 1909, this unlikely pair teamed up and brought forth a startling new style of painting that demanded a new way to imagine space and time and made its viewers reconsider the nature of reality. Asked about this period later, Braque said, "We were like two mountain climbers roped together."[2]

When Picasso and Braque exhibited their strange works, the critic Vauxcelles (the same Vauxcelles who labeled Matisse and his crowd Fauvists) acidly commented, "These new works look like a bunch of little cubes."[3] Vauxcelles thereby unwittingly gave to the new style of art a name derived from the geometry of space. Cubism was a perceptive label even if Vauxcelles intended it to be derogatory. Despite the critics' initial hostility, Cubism took the art world by storm. A typical example is Picasso's *Ma Jolie* (1911) (Figure 14.1).

In importance, Cubism has rightly been compared to the revolutionary discovery of perspective in the Renaissance. While the latter took two hundred years to perfect, Cubism—appropriately—compressed the time of its development into a few years. Cubism was a singular event in the history of art, you might say the most astounding transformation in the entire history of art. In Cubist painting, solid, apprehensible reality, located in space and fixed in time, crumbled; and, like Humpty Dumpty, its pieces could not be reassembled. Objects fractured into visual fragments then were rearranged so that the viewer would not have to move through space in an allotted period of time in order to view them in sequence. Visual segments of the front, back, top, bottom, and sides of an object jump out and assault the viewer's eye *simultaneously*.

The various surfaces of a cube had always required the observer to view them in sequence. It takes time to walk around an object: After you view the front, time must elapse and your position in space must change in order for you to see the sides and the back. Yet here were two artists whose disconnected planes brought forth the complex idea of the inextricability

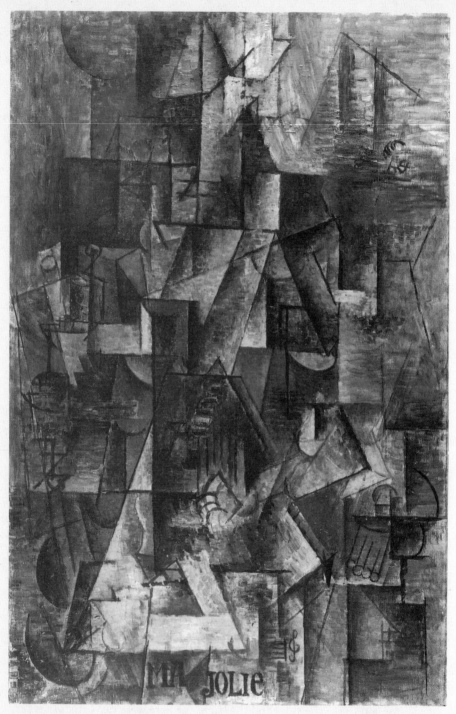

Figure 14.1. *Pablo Picasso,* Ma Jolie. *(1911)* COLLECTION OF THE MUSEUM OF
MODERN ART, NEW YORK, LILLIE P. BLISS BEQUEST

of space and time by abrogating classical causality. According to the Cubists, the world did not need to be processed in sequence.* It did not matter that the canvas was an inchoate jumble of facets. These chopped-up, reflective surfaces of objects represented the maya of experience, which Picasso and Braque had cleverly rearranged to persuade the viewer that if he could see all facets of an object at once, he was seeing space as *all here*. Further, seeing all sides of an object simultaneously dares the hapless spectator to take the leap to the inescapable conclusion that the work exists in the *everlasting now*. The only place in the universe from which an observer could actually see the ideas contained within a Cubist painting would be from astride a beam of light.

Besides its strange geometry, Cubism, for the first time since the Renaissance, dispensed with the need to produce an accurate facsimile of external reality. The Cubist painter frankly acknowledged that a painting is a flat surface on which colored patches of pigments are arranged. Coincident as it was with two radical new ways to think about the world, quantum mechanics and relativity, no other movement in art sits as squarely upon the hinge of history. Cubism embodied the first new way to perceive space since Euclid formalized his system twenty-three hundred years earlier. With the exception of early Christian art, Western artistic and scientific notions of space had always conformed to Euclid's postulates. The primitive view of space and time is quite different from Euclid's and Aristotle's. Picasso's deliberate use of African motifs helped to subvert the reigning mechanistic paradigm whose most indisputable feature states that classical causality rules the world and reality rolls by as a series of scenes on the temporal conveyor belt of sequence.

The precursors of Cubism were Monet and Cézanne. Picasso and Braque took the successive frames of time Monet created in his "series" paintings and combined them with the idea of multiple viewpoints Cézanne used in his still lifes. Then they rearranged the realistic picture of nature so carefully constructed in Western academic tradition into a flux resembling the pieces of a jigsaw puzzle. Shifting and mixing up different facets of space and

*Delo Mook and Thomas Vargish in their book *Inside Relativity* give a detailed description of how this happens scientifically and then conclude:

> In effect, you no longer see Gertrude's car "side-on" when she moves past you. The car effectively appears somewhat rotated and now presents a kind of "cubist" image of itself. In fact, it turns out that if you view the car from a great enough distance, the side and the rear edge appear foreshortened in exactly the way that you would observe if the car were simply rotated a bit. The faster the car moves along the track, the greater the amount of the observed "rotation."[4]

time, they rearranged the linear vectors of direction and duration until Cubism appeared to be in a state of splendid confusion.

In Buddhism there is a parable concerning the wind on the water. When a gentle wind crinkles a pool's still surface, the reflections on it are broken into a shimmering random light show. The world as seen reflected on that surface is a fractured jumble of multifaceted images. The viewer loses her way in the complexities of the reflection, and her confusion distracts her from trying to see what is within the pool. It is only when the wind quiets and the pool becomes still again that it is possible to discern what lies beneath the surface. Then the viewer is no longer distracted by the show *on* the water and may at last see what lies *in* the water. Cubism reflects this parable. By chopping space and time into little chips, Cubism exaggerates the ruffled appearances of reality's surface as wind does on the water, but at the same time it forces us to think about what is beyond, behind, and within the surface of the pool. With its variegated, kaleidoscopic, fly's eye vision, Cubism is a gift from artistic geniuses who made visible an exceedingly difficult concept.

Explicit in Einstein's formulas and implicit in a Cubist painting is the concept that all frames of reference are relative to one another. The only unique seat from which to have a unified view of reality is the theoretical one astride a quicksilver beam of light, where front and back lose their meaning, and past and future cease to exist. It is important to remember that space and time are reciprocal aspects of reality even at nonrelativistic speeds. This connection is not apparent to our visual apparatus only because we move so slowly in relation to other objects. But a scientist using sophisticated instruments can detect relativistic effects even in our sluggish inertial frame. Our inability to sense these changes compels us to continue to imagine that light travels only *through* space *in* time. In fact, light just *is*, while space and time change in relation to it. The mathematician Hermann Weyl described the spacetime view of reality, "The objective world simply *is*; it does not *happen*. Only to the gaze of my consciousness, . . . does a section of this world come to life as a fleeting image in space which continuously changes in time."[5]

Another extraordinary coincidence between Cubism and the visual world as seen from a train approaching the speed of light has to do with color. As previously mentioned, an observer accelerating to velocities approaching *c* would note that an object's color depends upon his speed. When viewed from the rear platform on a train approaching the speed of light, grass receding into the distance appears not green but red. Conversely, grass approaching in front of this same train seems blue. Off to the side of this

train, grass takes on the yellow, orange, and green hues of the middle of the spectrum. All these color changes occur because space is becoming severely contracted as speed increases. At the speed of light, all these colors merge because the front and rear become one.

Indulging in a bit of whimsy, we might ask what color this infinitely thin slice of reality would be? White light contains all the colors of the spectrum, so the argument could be made that at the speed of light, only white light is visible. But as we may remember from kindergarten, mixing all the colors of the rainbow results in a muddy grayish-brown, so one could say space would be these tones. Black, the absence of color, would be the only shade to remain unchanged at the speed of light. Only four neutral tones could exist at the speed of light: white, black, brown, and gray, all devoid of any trace of the colors of the rainbow.

Unaware of these highly technical features of the Doppler effect combined with relativity theory, Picasso and Braque decided to eliminate the spectrum's colors from their new art. While Fauvism assaulted the viewer's perceptual apparatus with a pyrotechnic carnival of color, the Cubists defined their new space using principally the earth tones of white, black, brown, and gray—the only hues that could possibly be visible to our imaginary lightspeed viewer.

The Cubist vision also tampered with the integrity of shadows. In Newton's paradigm, the shadow of a thing must fall on the side opposite the source of light; any change in this convention would call into question the correctness of absolute space, absolute time, and relative light. If shadows fell capriciously upon each facet of a Cubist painting without regard to the direction of the light, then the viewer would have to reconsider the meaning of the truism "light casts a shadow." In many of his Cubist works, Braque inverted the artistic concept of *disegno*—contour drawing—which is based on the principle that things high in contrast appear closer than things low in contrast. While a Renaissance painter, highlighting an apple, painted a white dot where the apple was closest to the viewer's eye and progressively shaded the rest of the apple evenly toward the periphery, Braque placed a *black* dot where the white should have been and lightened the apple's outline as he moved toward its circumference. His disordering of shadows, flattening of length, and ambiguity of modeling faithfully represent the way shadows most likely would appear at speeds approaching c.

The third dimension of depth had been glorified by the Renaissance painters. Modern painters, however, consistently introduced a flattening of perspective. Background and foreground were regularly "scrunched up." Since Manet and continuing through the works of Cézanne, Gauguin, and

van Gogh, artists increasingly preferred flattened perspective to illusionist depth. The Cubists severely compressed depth in their paintings, so the viewer's eye could not even penetrate it. In *Les Demoiselles d'Avignon* (see Figure 11.4, page 157), the work that began the Cubist movement, Picasso flattened his airless cramped canvas so completely that the viewer's eye could not pierce through to the background because there *was* no background. Maurice Denis, a Symbolist painter, wrote in 1890, "A picture before it is a picture of a battle horse, nude woman, or some anecdote is essentially a plane surface covered by colors arrayed in a certain order."[6] The modern artists increasingly forced the viewer to confront paintings that did not have illusory recession. In their concerted assault upon one of three vectors of space, they could not know that it was also a visual feature of a new reality whose theory had yet to be formulated.

As the new century progressed, post-Cubist artists developed styles that refined flatness in their images. Kandinsky, Malevich and Mondrian all eliminated the very notion of perspective from their work, and modern art then entered a phase in which lack of depth was de rigueur. Depth became anathema, and its absence has carried forward into the remainder of the century until one can safely say that painting-as-pancake has been one of the most enduring features of this century's art. This compressed space is what a viewer would see looking forward or backward from the observation car of a high-speed relativistic train.

Just as depth gradually disappears from the landscape in front of and behind the train, the opposite effect can be seen off to the side. The length of objects viewed from the side windows of the relativistic train becomes increasingly contracted, creating the illusion that height elongates. This strange distortion of form is one of the quirks of the special theory of relativity. Knowledge of it did not disseminate into the general population until the late 1920s, and even then, the number of people able to understand it was small. And yet, it was Cézanne who began to explore elongation as early as the 1880s, and this odd convention went on to become a ubiquitous feature of modern art. Almost simultaneously, a wide range of artists who were not necessarily influenced by Cézanne elongated their figures. For example, Seurat's hieratic figures were taller and thinner than normal; so, too, were the women painted by Amedeo Modigliani. In his monochromatic blue period, the young Picasso depicted subjects that were tall, thin, and lanky, and in his rose period, his jugglers, acrobats, and harlequins appeared to be squeezed in from the sides as if by some unknown force. It was as though an international conspiracy among the artists occurred by prior agreement, as in country after country the idea took hold. The Frenchmen

Duchamp and Robert Delaunay adopted it; so, too, did the Russians Antoine Pevsner and Marc Chagall. The German Expressionists likewise populated their compositions with long, reedy figures. Not since the Mannerist followers of the style of El Greco in the sixteenth century had so many artists consistently portrayed the human figure as stretched tall and thin.*

The Swiss sculptor Alberto Giacometti squeezed elongation to its extreme. His aim, as Sartre once wrote, was "to cut the fat off space."[7] To Giacometti's inner eye, figures such as *Man Pointing* (1947) (Figure 14.2) assumed the physiognomy of the Watusi. His spindly sculptures could also be used in any physics class to demonstrate how people would appear to an observer traveling past at close to the speed of light. What intuition prompted these artists to adopt a peculiar deformation that was in coincidental compliance with the strange equations of an obscure theory of space that was not yet common knowledge? Was this some extraordinary random coincidence? Or were all these artists in tune with a new way to conceptualize space?

Even before Minkowski announced in 1908 that he had fused space and time into a four-dimensional continuum, there had been a quickening of interest in the idea of a higher dimension and non-Euclidean geometry. Beginning in the 1870s, Hermann von Helmholtz, a German physicist, had popularized the notion of curved non-Euclidean space and the geometry of *n* dimensions.† He had challenged no less an authority than Kant who had used Euclid's axioms as the prime example of a priori knowledge— knowledge that is truth, not opinion. Helmholtz proposed that our knowledge of space is not some a priori postulate encoded into our minds before we are born but rather simply a belief that conforms with our perception of the world.

The French mathematician Henri Poincaré had thrown his weight behind Helmholtz, saying in 1901, "Thus, the fundamental hypotheses of geometry are not experimental facts. It is, however, the observation of certain physical phenomena which accounts for the choice of certain hypotheses among all possible ones . . . the group chosen is only more convenient than the others and one cannot say that Euclidean geometry is true and the geometry of Lobachevsky is false. . . ."[8]

*There were a few artists who deformed space so that objects and figures were thicker and squatter. The paintings of Picasso's neoclassical period (1910–14) and Fernand Léger's works are the most familiar, but even these conventions have correlations with Einstein's later discoveries about the relationship of mass to spacetime, formulated in his general theory of relativity, as we shall see in Chapter 22.

†In mathematics, *n* refers to any number in a sequence. A geometry of *n* dimensions usually refers to a geometry with more than three.

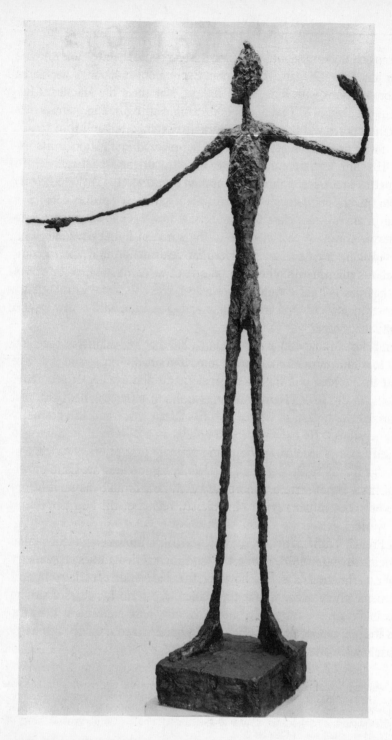

Figure 14.2. *Alberto Giacometti,* Man Pointing *(1947)* THE MUSEUM OF
MODERN ART, NEW YORK, GIFT OF MRS. JOHN D. ROCKEFELLER 3RD.

Speculation about a higher dimension had no real meaning for most people because they could not see in their minds' eyes a new dimension of space that was perpendicular to the three of our familiar world. Looking at the corner of a room where three perpendicular lines of adjoining walls and ceiling intersect dramatically concentrates the problem: Where would one insert a fourth perpendicular?

In 1880, E. A. Abbott, a mathematician, wrote a short novel entitled *Flatland: A Romance of Many Dimensions* which heralded the change in worldview. *Flatland* is a fictional account of two-dimensional beings who live out their lives on a geometrical plane. One day, the hero, a square, is sitting in his house with all the doors locked. Imagine his amazement when he is visited by a sphere, a being from the next-higher dimension of space who enters the square's house but doesn't come through a door. A sphere passing through a plane would appear first as a point, then as a small circle slowly enlarging until the circumference of the sphere passes through the plane. Thereafter, the sphere would appear as a circle growing ever smaller until it, too, shrank to a point and disappeared. Teaching the square to recite over and over, "Upward, yet *not* Northward," the sphere tried to illuminate the next-higher dimension for his two-dimensional friend. Once the sphere lifts the square out of his flat world, the square's inquiring mind leads him to ask,

> But my Lord has shown me the intestines of all my countrymen in the Land of Two Dimensions by taking me into the Land of Three. What therefore more easy than now to take his servant on a second journey into the blessed region of the Fourth Dimension, where I shall look with him once more upon this land of Three Dimensions, and see the inside of every three-dimensional house, the secrets of the solid earth, the treasures of the mines of Spaceland, and the intestines of every solid living creature, even of the noble and adorable Spheres.[9]

The square's newfound appreciation of higher dimensions so offends his spherical erstwhile mentor that the sphere casts him back to his flatland world. There the beleaguered square is promptly imprisoned on charges of sedition brought because of his attempt to relate to his fellow squares the experience of another dimension. Abbott's charming tale is a metaphor that allows human beings who live out their lives in a three-dimensional sphere to imagine a visit to our own world by a fourth-dimensional being. His analogy to a world without one of our dimensions is compelling and,

more important, the kind of mental exercise that encourages us to consider that a higher dimension might even be plausible.

At the turn of the century a spate of articles began appearing in popular publications encouraging laypeople to imagine the new geometries. These journalistic explanations culminated in 1909 when *Scientific American* sponsored an essay contest offering five hundred dollars to the winner who supplied the best lay reader account of the fourth dimension. Entries poured in from all over the world. Despite their inventive conjectures and the many sophisticated credentials of the entrants, not a single one made any reference to Einstein's special theory of relativity. Neither did anyone mention Minkowski. The complete absence until 1919 of listings for "Einstein," "Minkowski," "Relativity," and "Spacetime" in the *Reader's Guide to Periodical Literature* emphasizes how unlikely was the possibility that artists of the day could have known about spacetime or relativity.[10]

Even though Picasso began work on his revolutionary Cubist work *Les Demoiselles d'Avignon* in 1907, no artist wrote about non-Euclidean space or the fourth dimension until 1911. The first reference in art appeared in a speech by the French poet Guillaume Apollinaire who took it upon himself to defend the new Cubist art against its many detractors. In his speech, he spoke about young painters' preoccupation with the "new measure of space, which in the language of the modern studios are designated by the term, fourth dimension." He also fulminated against "that miserable tricky perspective, . . . that infallible device for making all things shrink."[11]

In 1910 two young Cubist painters, Albert Gleizes and Jean Metzinger, attempted to explain Cubism in an essay, *Du Cubisme*. The mathematician Riemann's name appears here for the first time in the writings of artists (albeit misspelled), but missing in this exhaustive theoretical work by painters is any reference to either Einstein or Minkowski. Despite artists' lack of understanding of the intricacies of relativity and mathematical higher dimensions, it was the mute image and poetic metaphor of the artist that described what could no longer be explained simply and clearly by scientists. When Picasso brought forth *Les Demoiselles d'Avignon*, he responded to his inner voice of artistic necessity. This painting was more an expression of the rumbling volcano of his creative genius than a conscious attempt to create an image of an abstract mathematical concept.*

*Picasso's and Braque's circle of friends included an insurance actuary, Maurice Princet, who considered mathematics an art form. While he was conversant in the ideas of non-Euclidean geometry, there is no evidence that he was aware of Einstein's and Minkowski's work.

Still, artists and art historians have long debated the connection between Cubism and relativity. Sigfried Gideon, an art historian, commented in 1938:

> Cubism breaks with Renaissance perspective. It views objects relatively: that is, from several points of view, no one of which has exclusive authority. And in so dissecting objects it sees them simultaneously from all sides—from above and below, from inside and outside. . . . Thus, to the three dimensions of the Renaissance which have held good as constituent facts through-out so many centuries there is added a fourth one—time. . . . The presentation of objects from several points of view intro-duces a principle which is intimately bound up with modern life—simultaneity. It is a temporal coincidence that Einstein should have begun his famous work, *Elektrodynamik bewegter Körper*, in 1905 with a careful definition of simultaneity.[12]

Gideon's views were endorsed by many other figures from the art world.

An opposing camp of art historians and physicists believe with equal fervor that Cubism and relativity are not connected, holding that their differences are more significant than their similarities and that the apparent connection is an illusion. Most recently, the physicist Géza Szamosi states in his book *The Twin Dimensions*:

> The cubist space, for example, tended to be a two-dimensional surface which excluded the third; the mathematics of relativity works in four-dimensional space-time. And one can continue indefinitely; looking for similarities in these two enterprises is quite useless.[13]

The fallacy in Szamosi's argument is that while relativity indisputably concerns mathematical four-dimensional spacetime, it contains within it a special case, the imaginary view from c, in which one of the vectors of space disappears. Further, in this special case, changing time for all intents and purposes ceases to exist. An observer traveling at the speed of light would confront the nearly unimaginable fact that length, the first Euclidean dimension of space, would be squeezed out of existence. At c, space com-presses along the axis of motion until it becomes infinitely thin. "Infinitely thin" is another way of saying it has disappeared. Furthermore, at c time

dilates infinitely so that it cannot be appreciated. Thus, at lightspeed, the world has but two remaining appreciable dimensions, height and depth. At c, along the axis of motion there is no time or length.

Illusionist perspectivist art has four dimensions: the three of perspective, and the moment of time the realistic painting portrays. Picasso's visionary insight just before Minkowski's formulation of spacetime was the development of an art form that eliminated time. The sequential frozen moment common to all previous art is gone. Cubism is an art form that has neither implicit nor explicit sequential time. Before Cubism all art in Western culture was either the depiction of a specific moment or a representation of a timeless ideal. In either case, the element of time was implicit in the artwork. Picasso and Braque eliminated both transient and eternal time. In a Cubist painting time does not exist. The viewer cannot *imagine* any next moment in a Cubist painting because there *is no* next moment. Further, by destroying perspective Cubism eliminates depth. Without time or depth the Cubist painting has been reduced from four dimensions to two. The genius of Cubism is that it allows the viewer to escape from the system of reference that has three vectors of space and the coordinate of time. Einstein's answer to his original question is that the only place in the universe that would allow for a similar escape would be astride a beam of light. It behooves us to incorporate this view into our thinking. Cubism is a visual aid to this end. To Szamosi's assertion that relativity is about four dimensions, I would point out that at c only two would be visually appreciated. So, too, with Cubism.

In *Modern Art and Scientific Thought*, John Adkins Richardson denies any relationship between Cubism and relativity as emphatically as Szamosi does.

> Cubism has nothing to do with the Theory of Relativity and that is the end of the matter. . . . Surely, it must be obvious to any careful reader that the space of painting cannot accommodate the field concept of modern physics; those two things have nothing in common. What is more, the paintings do not represent such a concept symbolically. The fragmentations of Cubist art did not derive from simultaneous presentations of shifting points of view, but even if they had they would be unconnected with the Theory of Relativity. Thus, it can be argued that the entire notion of a hermetic connection between Einstein's theory and Cubism is false.

He softens his statement by adding:

> To argue this, however, is not to assert the absence of any
> significant relationship between the painting style and modern
> science—or, more definitively, between Cubism and the total
> culture to which science has contributed so vast an influence.
> Besides, the prominence of a belief in some kind of hermetic
> geometry associated with the paintings done between 1909 and
> 1913 is inescapable and should somehow be accounted for.[14]

Richardson supports his refutation of a connection between the two by
relating in an *argumentum ad hominem* how Einstein, too, repudiated any
linkage between Cubism and relativity. He reports that in 1946 art critic
Paul Laporte submitted to Einstein an essay he had written arguing for a
connection between the two fields and asked Einstein for his opinion by
mail. Responding to Laporte's essay, Einstein very generously gave his own
views on the similarities between art and science, and then disagreed:

> Now, as to the comparison in your paper, the essence of the
> Theory of Relativity has been incorrectly understood in it,
> granted that this error is suggested by the attempts at popu-
> larization of the theory. . . . This new artistic "language" has
> nothing in common with the Theory of Relativity.[15]

Einstein's repudiation of Laporte's proposed linkage has been relied upon
by many art historians to prove that there is no connection between Cubism
and relativity. Unfortunately, they presuppose that Einstein understood and
appreciated modern art. In fact, although much has been made of the fact
that Einstein played the violin, he expressed little or no interest in the
exploding movements of art going off like Roman candles all about him.
Einstein made the following observation in 1934 giving us an insight into
how he felt about contemporary art:

> Let us now consider the times in which we live. . . . The lack
> of outstanding figures is particularly striking in the domain of
> art. Painting and music have definitely degenerated and largely
> lost their popular appeal.[16]

Genius physicist and mathematician that he was, Einstein was unaware
that he was living through one of the greatest artistic revolutions in history.

When art historian Meyer Schapiro inquired of Margot Einstein, his step-daughter, what her father's preferences were in the visual arts, she replied in a letter:

> In visual art, he preferred, of course, the old masters. They seemed to him more "convincing" (he used this word!) than the masters of our time. But sometimes he surprised me by looking at the *early* period of Picasso (1905, 1906). . . . Words like *cubism, abstract painting* . . . did not mean anything to him. . . . Giotto moved him deeply . . . also Fra Angelico . . . Piero della Francesca. . . . He loved the small Italian towns. . . . He loved cities like Florence, Siena (Sienese paintings), Pisa, Bologna, Padua and admired the architecture. . . . If it comes to Rembrandt, yes, he admired him and felt him deeply.[17]

To credit Einstein with knowing enough about Cubism to determine the nature or extent of its connection with his theory is too much to ask. Alexander Pope observed that genius seems to grace but one endeavor at a time:

> One science only will one genius fit
> So vast is art, so narrow human wit.[18]

The most impeccably researched book on the subject is Linda Dalrymple Henderson's *The Fourth Dimension and Non-Euclidean Geometry in Modern Art*. Henderson documents that Cubist artists did not know anything about Minkowski's spacetime continuum, and that allusions in artistic literature to a fourth dimension are references to a fourth *spatial* dimension which, of course, is not what comprises the fourth dimension of spacetime.

Henderson concludes that because artists did not know what was going on in the field of physics there can be no direct correlation between these two endeavors. Her logic cannot be faulted. If the artists did not consciously know about relativity, then their art could not actually specifically relate to this theory. She does not entertain the possibility that the artists' vision of a new way to see the world accurately reflected its scientific explication in equations. This explanation, imputing to the artist a prescience, exists outside the framework of logic. Nevertheless, her arguments unwittingly support the thesis of this book, which is precisely that the artist did not know about the scientific intricacies of relativity.

As physicists began to formulate theories that would propose unimag-

inable features of the visible world, the artist jettisoned the imperative to represent that visible world faithfully. Measurement and mathematics, the substrate of perspective, were abandoned as artists increasingly relied on intuition in attempting to portray their inner visions. Nowhere was this conjunction between revolutionary art and visionary physics sharper than the intersection of Einstein's relativity theory and Picasso and Braque's Cubism which occurred despite a virtual absence of contact between the two fields. This radical art movement's disjointed images incorporated the features of Einstein's equations and subliminally changed the way people see and think about space. Cubism ended the tyranny of the one-eyed cyclopean point of view. Once hailed as the apex of artistic triumph, per-spective now became a plinth upon which to erect a higher, grander vision.

Only motion crystallizes outward appearance into a single whole. . . . A speeding train fuses the separateness of the cars into a compact mass. . . . When at last we shall rush rapidly past objectness we shall probably see the totality of the whole world.

Mikhail Matyushin, avant-garde spokesman, 1915

 As soon as we start putting our thoughts into words and sentences everything gets distorted, language is just no damn good—I use it because I have to, but I don't put any trust in it. We never understand each other.

Marcel Duchamp

CHAPTER 15

FUTURISM / TIME

As the Fauvists investigated the myriad manifestations of light, and the Cubists brought forth a new analysis of space, so the futurists dissected time. Futurism was born in Italy. Its *agent provocateur* was Filippo Tommasco Marinetti, a strutting Fascist and, paradoxically, a poet who believed society was too beholden to that which had already transpired. For fifteen hundred years Western art had been obsessed with history painting which told stories about what *had* happened. Marinetti attacked the past with operatic zeal and proposed that only by erasing history could people live in the present and see the unprecedented beauty

that exists here and now. Though Marinetti wanted to emancipate all of Western civilization from its willing enslavement to the past, he was particularly appalled by his countrymen's reverence for the glories of an Italy that was no more, and he was determined to pull them kicking and resisting into the present with their eyes looking to the future. He called himself *la caffeina dell'Europa*, "the caffeine of Europe."[1]

In 1909 Marinetti and a group of young Italian artists began their movement by first issuing a futurist manifesto filled with wild braggadocio. "Come on! Set fire to the library shelves! Turn aside the canals to flood the museums!"[2] Their aggressive stance might have seemed a little odd by conventional standards because they published this declaration of principles before any of them had created the art the principles were supposed to support. Of course, that art was still in the future, which made their cart-before-the-horse approach the perfect embodiment of futurism!

Having proclaimed an end to mankind's preoccupation with everything bygone, the futurists set for themselves the daunting artistic task of destroying not only collective history, but individual memory as well. Marinetti pugnaciously proclaimed, "All forms of imitation are to be despised. All subjects previously used must be discarded. What was truth for the painter of yesterday is falsehood for the painters of today."[3] He railed against antiques, respect for heritage, and the slavish copying of ideas from old traditions. His movement became so popular in Italy that for a while children played futurists instead of cowboys and indians.[4]

The futurist manifesto owed much to the Impressionist art of Monet. Like Marinetti, Monet had no use for the past. He felt that if he tried to reproduce in his studio the images he had recorded mentally out of doors, his memory might trick him into painting something else. Therefore, he transferred his "impressions" directly onto canvas without the editorial interference of later reflection. In this way, Monet concentrated only on the present. He attempted to capture the transient flicker of the *now*; that *now* is what is preserved in the work of this great Impressionist.

Emboldened by Monet, the futurists went him one better and lurched from the present into the future. They demanded that artists depict what had not yet happened by incorporating the idea of motion into the stationary canvas. For artists working within the confines of the frozen moment that characterized Western art from Giotto onward, breaking through the implacable immobility of congealed pigment upon dry canvas seemed an impossible challenge. But a few years after the manifesto's publication, the futurists found they could pull the future into the present by representing sequential frames of individual frozen moments within a single canvas. By

superimposing a series of successive single instants in time upon one another and squeezing them all into one work, they effectively sped up the sequence. The idea was not original. The futurists blatantly stole the concept from Eadweard Muybridge's and Jules-Étienne Marey's groundbreaking serial photomontages. The futurists' innovation was to translate this idea of chronophotography into paint, and in doing so they proposed a new way to see time, just as the Cubists inserted a multitude of different perspectives into one work and thereby invented a new way to envision space.

What underlay Cubist space and futurist time was the concept of simultaneity. Though Newton, Kant, and virtually all of Western thinkers since the Renaissance proceeded on the assumption that events *must* be processed in sequence, Einstein's relativity theory muddied the precise sequencing of events in frames of reference moving relative to one another. The speed of light, however, brought all of these different frames back together in one still, pellucid moment. At *c* there is no sequence because there is no time: Time comes to a halt and consequently there can be absolutely no movement. At lightspeed in spacetime everything is simultaneous.

As simultaneous views in space are at the heart of Cubism, allowing the front and sides of an object to be represented all at once, so simultaneous views of time are at the core of futurism, allowing the viewer to see the past, present, and future in one holistic *now*. In futurist paintings, academic art's petrified still moment shattered into little slivers, each fragment containing within it a separate moment of time. In *Dynamism of a Dog on a Leash* (1912) (Figure 15.1), Giacomo Balla infused his canvas with kinetic motion and energy by overlapping successive frames of time. Rather than paint the moving dog with four legs, Balla made each one a blur of motion, demonstrating, as Umberto Boccioni, another futurist, said, that "a galloping horse has not four legs; it has twenty."[5] Balla melted the static conventions concerning the representation of time accumulated over centuries. He used flowing paint to present fluid motion in a way that although his paint, too, congealed, he managed in his images to thaw time.*

The futurists' deity, had there been one, would have been speed, which is the distance traveled (space) in a finite time. The futurists sought to use speed to sweep away all the static notions that came—and stayed—before them. To them, speed manifested itself in the motorcar. A roaring speedster became the icon of futurism. This idea, expressed in art, coincided with

*This style of painting motion can be seen in some of the Paleolithic cave paintings at Altamira. This convention, then, is at least twenty thousand years old!

Figure 15.1. *Giacomo Balla,* Dynamism of a Dog on a Leash *(1912)*
ALBRIGHT-KNOX ART GALLERY, BUFFALO, NEW YORK, BEQUEST OF A. CONGER
GOODYEAR AND GIFT OF GEORGE F. GOODYEAR, 1964

Einstein's revelation that a true invariant of the universe was a number that represented the *speed* of something.

Einstein's 1905 article in an arcane German physics journal did not make its way to Italy to influence the new painters. Once again, artists had divined a change in the direction of the wind blowing through a culture and they produced a body of work that heralded the change before the popularizers of scientific ideas were able to elaborate the concepts. In their 1909 manifesto, the futurists pronounced with confidence, "Time and Space died yesterday. We are already living in the absolute, for we have already created eternal, ever-present speed."[6] This poetically charged line could easily be transposed to summarize Einstein's 1905 paper. After Einstein and the futurists, conventional ideas of space and time did indeed die, and the key to unlocking that mighty secret was the invariant speed of light!

Once they discovered a way to represent the concept of simultaneity, futurist artists created works with strobe-light staccato speed, much like the overlapping frames of time in their paintings. They invested their sculpture with suggested movement too: The flowing lines of Boccioni's *Unique Forms of Continuity in Space* (1913) transcend the static objectness of a chunk of bronze, as his use of the airfoil connotes a sense of striding motion.

But the single canvas that epitomized the futurist manifesto, embodying the concept of simultaneity, was painted by Marcel Duchamp, who was not really a futurist. Born into an artistic family, the imaginative Duchamp developed an early, intense interest in new styles of painting. His limited oeuvre created a mystique about him, and throughout his career he continued to create works that were to be seminal for much of the art that ensued. He was cerebral and iconoclastic, and his idiosyncratic images made him, along with Matisse and Picasso, part of an elite triumvirate that dominates the art of the twentieth century.

In 1912, before he saw any works by the Italian futurists, Duchamp created his *Nude Descending a Staircase, No. 2* (Figure 15.2). The work was powerfully futurist, with Cubist intimations. Duchamp was invited to exhibit his *Nude* in a show that was organized only for Cubists. The Cubists were chiefly French and had a smirking sense of superiority toward what they perceived as their popinjay artistic colleagues to the south. Duchamp, proud to be included in a show with such illustrious artists as Picasso and Braque, brought his *Nude* to the gallery to be displayed. When he saw Duchamp's *Nude*, Apollinaire, Cubism's spokesman, experienced anxiety, believing the work was too futuristic to be exhibited alongside the works of Picasso and Braque. Apollinaire said nothing to Duchamp, however, and once Duchamp had seen to his painting's hanging in the early evening, he went home. After he left, Apollinaire and the remaining Cubist artists who were part of the exhibit argued vehemently about this work's compatibility with theirs. A heated debate lasted until well past midnight. Finally in the small hours of the morning, Duchamp's brothers were dispatched to awaken him and ask him to come down to the gallery and remove the offending work. After bundling his painting into a taxi, Duchamp swore he would never again have anything to do with any "groups" of painters.

The Italian futurists, equally offended, repudiated Duchamp's masterpiece solely because its central subject was a nude. In their famous manifesto, the futurists had denounced all nudes as "nauseous and tedious." They ardently believed the nude was so hackneyed and such a cliché that

Figure 15.2. *Marcel Duchamp,* Nude Descending a Staircase, No. 2 *(1912)*
PHILADELPHIA MUSEUM OF ART, LOUISE AND WALTER ARENSBERG COLLECTION

they called for its total suppression as a fit subject for art for the next ten years.

Duchamp defended his *Nude* against Cubist and futurist critics alike as "an expression of time and space through the abstract presentation of motion"[7] and soon was vindicated. *Nude Descending a Staircase, No. 2* was easily the most provocative piece in the now-famous 1913 Armory show in New York. This exhibition allowed Americans their first glimpse of the radical new art coming out of Europe at the century's turn. A crowd constantly surrounded the painting. American critics, used to tamer fare, did not know what to make of the young artist's succès de scandale. Julian Street won a minor niche in art history by calling it "an explosion in a shingle factory." Another critic said it reminded him of "a staircase descending a nude." The then president, Teddy Roosevelt, compared it unfavorably to a Navaho rug.[8] Behind the dizzying chaotic motion on Duchamp's canvas, however, lay the idea of stillness, contained within the concept of the simultaneity of time at *c*. The Cubists had represented the simultaneity of space by blowing it into disjointed fragments. By compressing the durations of time, Duchamp, too, had paradoxically stilled the wind on the water.

Had Einstein commissioned Duchamp to render diagrammatically what happens to time at nearly the speed of light, the painter could not have achieved a more lucid representation. Duchamp's *Nude* can be observed as existing in the past, present, and future. The only place in the universe that this observation would be possible would be aboard a beam of light. At the time he created his *Nude*, however, it is doubtful that he had even heard of Einstein.

After the controversial triumph of *Nude Descending a Staircase*, Duchamp experimented with other ways to portray motion: by actually making objects change in space through time. The first piece of moving modern art was his fanciful *Bicycle Wheel* (1913), consisting of a bicycle wheel set upon the top of a stool. Duchamp said he just liked to spin the wheel and watch its motion. In 1923 he constructed his *Revolving Glass* (Figure 15.3) in which a row of separated individual propellers, perched upon a tripod, turn about one central axis. Not since the trivial mechanical automata of the Renaissance had a work of art contained within itself not just the *idea* of motion but *actual constant movement*. With his typical flair for debunking cherished ideas, Duchamp examined the stationary point of view and revealed it as merely another optical illusion.

To power his construction, Duchamp used the futurists' favorite dynamo—a motor. If the motor is on, and the viewer stands in the one

Figure 15.3. *Marcel Duchamp,* Revolving Glass *(1923)* YALE UNIVERSITY ART GALLERY, GIFT OF COLLECTION SOCIÉTÉ ANONYME

spot usually reserved for the perspectivist point of view, the separate spin-
ning propellers create the illusion of a static image of concentric circles
resembling an archer's target. If the viewer stands off to the side and the
mechanism stops, it becomes apparent that the circles were neither sta-
tionary nor concentric, and what the viewer thought he saw was in fact a
trompe l'oeil. At rest, there are only the superimposed linear propellers,
painted with cross-hatch marks, none of which contains a circle.

Duchamp also cast doubt on the validity of the portrait, one of art's
economic mainstays. He questioned how just one representation of a person
who lived fourscore years could accurately capture the essence of that
person. Which moment, Duchamp asked, in the moving train of a person's
life should be chosen as the exact one that best exemplifies that person's
individuality? Duchamp painted portraits of his two sisters both within one
canvas that revealed two different versions of both their lives, including a
futuristic version of each woman in an old age that had not yet transpired.

Duchamp intuitively knew that space and time are one continuum, time
ending where space begins and vice versa. While Duchamp's principal
statements concerned time, his art also expressed profound insights about
space. His interest in n dimensional geometry and the fourth dimension
lay behind an enigmatic piece, *The Bride Stripped Bare By Her Bachelors,
Even*, more commonly known as *The Large Glass* (1915–23) (Figure 15.4).
Entire books have concentrated on this work, as art critics have attempted
to understand and interpret the many levels of its rich iconography. Perhaps
Duchamp's most radical innovation for this work was to abandon canvas
altogether and to make a "painting" on clear glass. The effect is that viewers
see not only the outlines of figures painted *on* the glass in two dimensions,
but they can also see *through* and *beyond* the glass to the real world of
three dimensions.

Duchamp was the first modern artist to use clear glass instead of an
opaque canvas as the substrate of art. The stained-glass art of the medieval
period cannot be compared to *The Large Glass* because its statement was
entirely different. The earlier stained glass, inspired by religion, commu-
nicated the idea that light was a spiritual essence that could shine through
objects. The Rose Window of Chartres was set so high in the cathedral's
walls that congregants could not see anything beyond it. They could only
know that light was coming *through* the glass. The figures in stained glass
were *illuminated* because they were backlit. Duchamp, on the other hand,
set his *Large Glass* at eye level and because much of it is transparent, a
viewer can see through and beyond the material of the work. The artist
called *The Large Glass* "an apparition of an appearance."[9]

Figure 15.4. *Marcel Duchamp,* The Large Glass *or* The Bride Stripped Bare By Her Bachelors, Even *(1915–23)* PHILADELPHIA MUSEUM OF ART, BEQUEST OF KATHERINE S. DREIER

In 1843 August Möbius, a German mathematician, proposed that a fourth dimension of space must exist because in our world there is a right and left orientation that cannot be reversed.[10] For instance, there is no way to rotate your right hand in our three-dimensional space so that it becomes a left hand without turning it inside out. In lower dimensions, one has only to rotate a two-dimensional object 180 degrees in the third, the next higher, dimension to reverse its right/left orientation. Möbius argued that there must be a fourth dimension in which it would be possible to rotate three-dimensional objects from a right-hand to a left-hand orientation and vice versa. As a see-through work of art apprehensible from opposite vantages, Duchamp's two-dimensional *Large Glass* suggests the higher dimension of space in which rotation would be equally possible for three-dimensional right/left objects. A spectator can reverse left to right in *The Large Glass* simply by walking around the piece and looking at it from the opposite side.

Unlike most artists of his day, Duchamp always maintained an intense curiosity about the new physics. In 1967, when an interviewer asked him whether his interest in the fourth dimension had persisted, Duchamp replied:

> Yes, this is also a little sin of mine, because I'm not a mathematician and I'm now reading a book on the fourth dimension and notice how childish and naive I am about that fourth dimension so that I just jotted down these notes thinking I could add something to it but I can see that I'm really a little too naive for this kind of work.[11]

Still, though Minkowski discovered the nature of the four-dimensional manifold in 1908, and Duchamp began work on his *Large Glass* in 1915, there is no evidence in the writings by or about the artist to suggest that he knew anything about Minkowski's ideas. Intertwining space and time into the construction of *The Large Glass* in a manner that suggests their unity appears to have been entirely Duchamp's original idea. Moreover, he incorporated a very corporeal manifestation of the passage of time into his work, as Calvin Tomkins describes:

> Duchamp's efforts to finish it became more and more sporadic. For six months the *Glass* lay untouched in the studio, gathering a thick layer of dust which Duchamp then proceeded to use as a pigment, gluing the dust down with varnish to one part of

the "bachelor machine" (the "sieves") and then wiping the rest away. This gave him a color that did not come from the tube. Man Ray recorded the "dust breeding" in a 1920 photograph that resembles a weird lunar landscape.[12]

The inclusion of dust motes, the miniature milestones of time's passage, into a planar but transparent work that implies all three vectors of space reifies the artist's vision of the next higher dimension of spacetime, and is prescient indeed.

Duchamp acknowledged that he never quite conceived of actually finishing *The Large Glass*. He worked on it in a dilatory fashion from 1915 to 1923, and his friends and patrons despaired of his ever completing it. Duchamp did not feel that arresting time for one moment and declaring the work finished had any meaning. In 1963 he said:

> It was too long, and in the end you lose interest, so I didn't feel the necessity to finish it. I felt that sometimes in the unfinished thing there's more, there's still more warmth that you don't get, that you don't change or you don't perfect or make any more perfect in the finished product.[13]

During the long period that Duchamp worked on *The Large Glass*, he moved to Argentina for six months. He didn't like the provincial atmosphere of Buenos Aires and became depressed. Perhaps his mood is behind the work he called his *Unhappy Readymade*. Tomkins describes this bizarre treatment of Euclid's treatises:

> In a letter to his sister Suzanne in Paris, Duchamp sent directions for her to hang a geometry textbook from the balcony of her apartment, where the wind could turn its pages and subject the theorems to the daily test of sun and rain. Suzanne followed his directions and she painted a picture of the result.[14]

It cannot be known what Euclid would have said about his abstract system of thought being put to such a rigorous experimental test of its truths.

Over and over again, the highly cerebral Duchamp devised mute, concrete constructions that graphically represented complex ideas inherent in the new physics that even the physicists themselves could not put into words. In 1913–1914 he again stepped down one dimension to make a point about the next dimension higher in his *3 Stoppages étalon (Standard*

Stoppages) (Figure 15.5) currently in the Museum of Modern Art in New York City. After dropping, one at a time, three very thin wires exactly one meter long from a height of exactly one meter, Duchamp laboriously duplicated the sinuous configurations they assumed upon landing, cut templates of the course of these previously straight but now undulating lines, and put the templates in an impressive-looking scientific instrument box (which previously had housed a croquet set).

At first glance, *Standard Stoppages* seems like a fairly nonsensical exercise; however, the mathematical definition of a geometrical line is a one-dimensional figure of nil width and nil depth, having only length. A meter-long, very thin wire comes close to fitting this definition. By dropping it through space, the line describes a plane as it falls. The falling wire completes its journey within a certain duration. The plane the wire describes when falling cannot be seen, but it can be imagined because it exists in both time and space. If this expression were the end of his artistic exercise, Duchamp would already have helped his viewers to understand that four-dimensional spacetime must include time. But there is more. When the wire lands it is no longer straight. While still measuring an exact meter, due to its now sinewy configuration, the wire no longer occupies a meter's length of space. By traveling through the next higher dimension of space-time the original straight line uses up less space! It is extremely difficult to visualize the Lorentz-FitzGerald contraction, or Einstein's curious deformation of lengths occasioned by an observer traveling past a meter-long ruler while approaching the speed of light. Yet the artist combined into one gestalt several of these very complex concepts. Moreover, Duchamp made not one *Standard Stoppage* but rather three. Could he have been alluding to the fact that although we live in three dimensions yet each of us in the duration of our lifetime, like the wires falling, describes a fourth? At all these levels Duchamp's *Stoppages* are about the word "measurement."

Einstein's special theory of relativity was also about the word "measurement." Indeed, a few years earlier the Western scientific community convened the International Bureau of Weights and Measures in 1889 in order to set the standard of the meter worldwide. They agreed that there would be kept in a vault in Paris at a constant temperature a platinum rod that measured exactly one meter. The scientists proposed that this metal rod be used as the precise length of a meter for every other bureau of standards. Within a few years of when the scientific community agreed to agree on this issue, Einstein, who rewrote the book about what we mean when we say we "measured" something, demonstrated conclusively that it

Figure 15.5. *Marcel Duchamp,* 3 Stoppages étalon *(1913–14)* COLLECTION OF
THE MUSEUM OF MODERN ART, NEW YORK

is an illusion to speak of an exact absolute meter. Duchamp's baffling work implies exactly the same thing!

After 1923 Duchamp, having achieved an enviable level of artistic recognition, channeled the mainstream of his intellectual energy into the game of chess. He said later that he preferred chess to art because chess, unlike art, could not be corrupted by money.[15] Thoroughly absorbed in the study of the game, he took lessons from the grand master Edward Lasker, who would later rank Duchamp as one of the top twenty-five players in the United States.[16]

Duchamp's fascination with chess goes back to his early days when he executed several paintings based on the game's themes. Germane to this book's subject is that under special circumstances chess "thinking" had been proposed by several as an example of how to envision the fourth dimension. Charles Hinton, a late-nineteenth-century English mathematician and passionate proponent of a higher dimension, suggested that the mysterious faculty of blindfolded chess masters, able to play several different games simultaneously, was due to their extraordinary ability to envision the multiple chessboards holistically. Instead of linearly memorizing each game's configuration, these players reported that they visualized the multiple chessboards by "seeing" them all at once as if drawn in their thought in an interior mirror. Although Hinton preceded Minkowski's formulations, his description of the chess master's mental process fits exactly when superimposed upon the physicist's spacetime.

Duchamp became friends with George Koltanowski, a chess champion capable of this blindfold feat, and coincidentally maintained an interest throughout his life in the problem of representing in three dimensions the invisible fourth. Duchamp, intrigued by the chessboard's mirror-image layout present at the game's start, proposed in his notes for *The Large Glass* that the fourth dimension would appear like a chessboard. For example, moving down one dimension by looking into a mirror we see reflected our three-dimensional world but it is on a planar surface. We have a distinct sense of volume and depth even though the reflected image is clearly only two dimensions. Extrapolating from this, Duchamp described a four-dimensional line perceived by three-dimensional beings.

> For the ordinary eye in a space any point is the end of a line (whether straight or not) coming from a continuum. The eye could go endlessly around the point (in the 3-dim'l), it will never be able to perceive any part of this 4-dim'l line other than the point where it meets the 3-dim'l medium . . . It is certain that

every point of space conceals, hides, and is the end of the line
of the continuum.[17]

There are many other examples of Duchamp creating images as well as
gestures that were consonant with the recondite concepts of modern physics
even though he himself did not have the background of advanced math-
ematics to understand thoroughly what was happening in this isolated field.
Despite this limitation, Duchamp made many other contributions to the
store of images necessary to understand the new reality described by rel-
ativity and quantum mechanics. They were just in time—the general public
would soon need them.

Each thing we see hides something else we want to see.

René Magritte

Beautiful as the chance encounter, on an operating table,
of a sewing machine and an umbrella.

Lautréamont

CHAPTER 16

SURREALISM / RELATIVISTIC DISTORTION

Although Einstein developed his special theory in 1905, and Minkowski used it a few years later to define the fourth dimension, both ideas incubated in almost complete isolation until 1919. Few people became aware of Minkowski's contribution partly because he died of appendicitis in the year following his dramatic pronouncement, before he could be acclaimed. During the intervening years, the insights of these two men were shut away from popular discourse and few people outside the esoteric field of theoretical physics learned anything about the visual and temporal effects of relativity or the implications of the spacetime continuum.

These two new ways to think about the world emerged from their chrysalis in 1919 when Sir Arthur Eddington confirmed Einstein's general theory of relativity (discussed in Chapter 22). As a result of worldwide press

coverage, Einstein streaked into the public eye like a shooting star. So limitless was Einstein's genius that when he won the 1921 Nobel Prize it was not for his theory of relativity but for his proposal that light could exist in a form other than the familiar wave. The quantum particle of light he described would later be named the photon. After he won the coveted prize, Einstein's name went on to become a household word; his leonine visage became an icon of the age.

Einstein had been accustomed to working in solitude; he was unaccustomed to the glare of the massive publicity that both he and his theories generated. In addition, he found it difficult to explain to anyone what, precisely, was so wondrous about his insight. A London *Times* correspondent interviewed Einstein at his home and asked for an account of his work that would be accessible to more than twelve people. Einstein laughed good-naturedly but still insisted on the difficulty of making himself understood by laymen. At the end of the famous report Eddington delivered to the Royal Society, Ludwig Silberstein, a physicist not held in high regard by Eddington, asked him if it was true that there were only three people in the world who could understand Einstein's theories. Eddington demurred and Silberstein pressed on, "Don't be modest, Eddington," and Eddington replied, "On the contrary, I am trying to think who the third person is."[1]

The public's desire to understand his theories, combined with Einstein's own desire to clarify and communicate them, led him to write two books on the subject for the educated lay reader. *Relativity* was published in 1918 and *The Evolution of Physics*, which he wrote in collaboration with Dr. Leopold Infeld, appeared in 1938. Intended to be his exegeses for the masses, these books for the most part failed. Einstein erred in presuming that an enlightened general public could venture into the thicket of higher physics' abstract ideas and then hack its way out armed only with the machete of verbal metaphor. In fact, few people who were not trained in advanced mathematics could even make sense of this dense jungle. Einstein's concepts violated everyday experience as well as common sense, and as a result his books did not successfully explain relativity in everyday language. To the end of his life, Einstein sadly acknowledged that he could not make his theory easily accessible. When pressed, he fell back on the excuse that his concepts seemed so difficult because they had outdistanced the language necessary to build mental images. If Einstein lamented the absence of a vocabulary with which to communicate his remarkable theories, he had only to look to art to find the appropriate images. Unfortunately, like other physicists of the period, he never made the connection.

All previous scientific discoveries had been generally apprehended, appreciated, and applauded by the sophisticated public—until Einstein's theory about the interrelationship of space, time, and light eluded an educated audience. Around the same time, intelligent readers felt rebuffed by the other, equally abstruse theories in the field of quantum mechanics. People knew that something momentous had happened concerning the nature of reality; but for the first time in history, no one except the discoverer and a select number of cognoscenti were able to understand it.

In the early years of the twentieth century, successive movements of art, too, like the corresponding discoveries in physics, presented to the discomfited public an ever-increasing array of unrecognizable forms. Beginning with Fauvism, Cubism, and futurism, and continuing through Expressionism, suprematism, Dadaism, and surrealism, new art styles assaulted the collective aesthetic sensibility of the West until the general public recoiled in confusion and gradually retreated from the challenge of trying to understand any meaning at all that might lie behind these tumultuous displays of apparent graphic chaos.

Art has existed for at least thirty-five thousand years. During this long procession of time, not one of the many shifting styles was ever entirely incomprehensible to its audience. People felt repelled by some, indifferent to others, and even outraged by a few; but never before had the general public felt the art of its own civilization to be incomprehensible. It is unlikely, for example, that any Egyptian ever stormed out of the hall at Luxor because a sculptor had unveiled a statue whose form he could not recognize. No townsperson in Renaissance Florence stood before a new masterpiece by Leonardo or Raphael and muttered, "I don't get it" or "What is it supposed to be?" All artists working in all eras before the modern one strove to make their work recognizable. Never in the history of art spanning millennia and varied cultures had one group of artists so systematically and deliberately developed an art that *could not be understood*. In a con-centered and fantastic coincidence, the branch of science primarily responsible for explaining the nature of physical reality became unimaginable at the very moment that art became unintelligible.

The inescapable question must be asked: Did the abrupt appearance of unfathomable art have any connection to the sudden unhorsing of the general public from the saddle of science? At the same moment that art retreated behind an enigmatic and inscrutable mask, repulsing the efforts of those trying to recognize her, science became an unfriendly, wildly bucking bronco. The answer to that question would have to be a resounding yes!

Somehow artists, rummaging about in the musty back rooms of the collective imagination, had managed to bring forth radical new means of representing equally radical new physical concepts that had barely been enunciated. Without any actual awareness, they developed a whole new language of images that described the impenetrable, untranslatable ideas conceived by physicists. The silent icons contained within the art of this century are our artists' unconscious response to the muting of the scientist at the very moment he became tongue-tied, fumbling, and stuttering whenever attempting to equation-speak to the public.

Several generations have come of age this century, immersed in a culture that has witnessed the diffusion of the concepts behind relativity and quantum mechanics, ideas that originally could not even be verbalized. Perhaps now, near the end of this century, we can look back and recognize that those artists, once thought inaccessible, were finding ways to express the inexpressible. We cannot know how much of an influence their art's subliminal messages has had upon our subsequent thought patterns: The change from one system of seeing and thinking to another is inevitably a complex event.

At the turn of the century, another revolutionary concept bubbled up from the cauldron of ideas seething in the *zeitgeist* of that time. Sigmund Freud proposed the existence of an unapprehended monster who subversively controlled the actions behind the civilized workings of daily intercourse, much like the charlatan operating the levers behind the façade of the Wizard of Oz. Freud stripped away the carefully contrived camouflage and revealed the identity of this phantom. He called it the unconscious. Once Freud disclosed its identity as the amorphous treacle that has so often gummed up the well-laid plans of life, artists jumped right in and began to revel and wallow in this fount welling up from the primordial ooze.

Freud's unmasking would not at first glance appear to be related to Einstein's revisions of our notions of space and time. Einstein's scientific theory about the "real" world and Freud's conjecture about the dark vortex at the center of the mind would seem to be disparate entities. Dreams, however, according to Freud, were the royal road to the unconscious. The same people who turned away from trying to understand Einstein's special theory of relativity because of its complexity, or from deciphering Picasso's baffling Cubist compositions, readily acknowledged the aberrations of time and space they experienced while they dreamed. Dream time does not obey the linear commandments of train time, nor does dream space conform to Euclidean axioms. Dreams also mangle all the usual laws of causality.

Relativity, Cubism, and psychoanalysis share this feature: Profound distortions of everyday time and space occur regularly in each theory. Within a few years of when Einstein the physicist and Picasso the artist began to explore the possibilities of a new kind of space and time, Freud, in his momentous book *The Interpretation of Dreams* (1900), illuminated the peculiar spacetime of the unconscious by establishing the validity of dreams.

The dream mode soon became the means certain artists used to plumb the depths of their own unconscious, mining them for symbols and juxtapositions that violated all rational sense. In 1917 Apollinaire named this new movement *sur*realism, which means *above* reality. Surrealism worshipped at the altar of the unconscious. Surrealism, André Breton, the poet and the movement's chief spokesman, wrote, "is based on the belief . . . in the omnipotence of dreams, in the undirected play of thought."[2] Despite their apparent lack of connection to the crisp blackboards of science, the dreamlike paintings of surrealist artists reveal many crucial images that can help people understand the vision of reality wrought by modern physics.

Freud's investigation gave meaning and value to everyone's nocturnal wanderings, and encouraged surrealists to transfer their dreams on to canvas. Poets as well as painters seized upon the dream state as a viable alternative to the harsh glare of objective reality. Jorge Luis Borges noted, "While we are asleep in this world, we are awake in another one; in this way, every man is two men."[3] Hippolyte Taine came to the conclusion, "Exterior perception is truthful hallucination."[4] William Butler Yeats wrote, "The visible world is no longer a reality and the unseen world is no longer a dream."[5] Stephen Dedalus, the protagonist of James Joyce's *Ulysses*, calls history "a nightmare from which I am trying to awaken."[6] Two major elements of dreams are the juxtaposition in space of unlikely people or things and the abrogation of linear time—elements that suspend the laws of causality—and these elements also appear at the heart of surrealism.

Because of surrealism's jarring incongruities, and impossible juxtapositions, most of this movement's art inevitably challenges the viewer's beliefs about space and time. One artist who seemed to understand the fallacies of Newtonian absolutism was Giorgio de Chirico. De Chirico founded what was to become a surrealist art movement in Italy known as *pittura metafisica* in 1917. He distorted space, but used a method different from that of the artists who preceded him. De Chirico violated perspective by *exaggerating* the depth of his canvases, making them appear even deeper than they were. Many of his paintings have the appearance of viewing something through the wrong end of a telescope. In addition to distorting space, de Chirico upset the usual conventions of time by inserting into his

dreamscapes enigmatic figures who cast shadows of paradoxical lengths beneath skies of unsettling hues.

Apart from the intervals between sounds, the change in shadows due to the earth's rotation is the single most important indicator that time is passing. Consequently, noting changes in the color of daylight and in the cast of shadows is the most reassuring means we know to mark the movement of time. Anyone awakening from a deep, jet-lagged sleep in a strange hotel room need only look out the window to know the approximate time of day. If the sky overhead is cerulean blue and objects on the ground cast minimal shadows, it is safe to conclude the time is around midday. If the sky is pink, mauve, orange, yellow, or red, and shadows are long, the time can be deduced as sunrise or sunset. If the sky is a consistent leaden gray and shadows are absent no accurate time estimate can be made without a clock. Our intuitive knowledge about the length of shadow and the color of the sky has always made it possible for anyone to estimate the hour with reasonable precision.

From the time Piero della Francesca worked out the details of painting accurate shadows in the fifteenth century, his system remained unchanged until the 1860s. Like della Francesca, de Chirico understood that shadow was inextricably bound to the perception of time, but he sensed a need to overthrow the old convention and embarked upon a blatant mission of sabotage.

In *The Nostalgia of the Infinite* (1914) (Figure 16.1), long shadows suggest the time of sunrise or sunset but the harsh sunlight drenching the Kafkaesque tower is more in keeping with the glare of noonday. The airless, mordant light is somehow incompatible with the pennants flapping briskly in what seems to be a vacuum. The sky is a disturbingly dark shade of green, such as occurs only under extremely rare atmospheric conditions. By fusing such a sky with elongated shadows created by a source that bathes the rest of the canvas in brilliant sunlight, the artist leads the viewer to question all her intuitive knowledge about time.

De Chirico used the same set of optical tricks in his *Mystery and Melancholy of a Street* (1914), where the color of the sky, the slant of the shadows, and the nature of the light again confound the viewer with conflicting clues about time. In *Enigma of the Hour* (1912) (Figure 16.2), a solitary person stands in a plaza with an arched colonnade in the background. Nothing seems amiss. Upon the face of the building there is a clock that reads 2:55. Since it is obviously daylight, the viewer can assume it is P.M. The long shadow cast by the lone figure on the plaza is, however, unmistakably that of someone standing in either a rising or setting sun.

Figure 16.1. *Giorgio de Chirico,* The Nostalgia of the Infinite *(1914)*
COLLECTION OF THE MUSEUM OF MODERN ART, NEW YORK

Figure 16.2. *Giorgio de Chirico,* Enigma of the Hour *(1912)* MILAN, PRIVATE COLLECTION

De Chirico could not have known at the time that Gustav Kramer, a biologist, would demonstrate in 1949 that birds are able to cover vast distances in their migrations because they use the sky's color, the light's intensity, and the sun's angle as precise navigational devices to locate their positions in both space and time. Here is an artist who strikes at the heart of what was assumed to be instinctual knowledge for humans and birds. Can we impute to de Chirico's artistic radar the need to warn the public that another way to conceptualize space and time was on its way?

Although de Chirico dated all of his paintings, he willfully dated them incorrectly. The date on *The Nostalgia of the Infinite* reads 1911, but in fact he completed the work in 1913 or 1914. To further confound future art historians, he occasionally was reported seen stealthily approaching works of his own hanging in a museum and, whipping out paint and brush from under his coat, surreptitiously changing the date on his canvases! Critics claimed to be baffled by this odd behavior, but isn't de Chirico's temporal grafitti—a crime perpetrated upon his own work—really an an-

archistic statement whose cause is to overthrow the tyranny of the Western idea of absolute time? These guerrilla-style attacks by a lone artist can be interpreted as a hit-and-run terrorist assault upon the domination and inflexibility of this invariant concept.

After 1920 de Chirico began to reproduce his earlier work. These copies, made ten to fifteen years later, bore the dates of the originals. His behavior was considered to be such a breach of artistic integrity that André Breton, the Grand Inquisitor of surrealism, excommunicated de Chirico from the movement by publishing a hostile encyclical condemning the Greek-Italian artist for his dishonesty concerning time. It is ironic that this objection to tampering with time should come from within the surrealist movement itself, since it could be said that de Chirico's attempts at subverting linear time were consistent with the surrealists' overall program.

Although he was not scientifically sophisticated, de Chirico was the first artist to routinely combine trains, clocks, and rulers in many of his works. The clock and the ruler are the basic measuring devices to gauge time and space. Einstein challenged the veracity of both these common devices in his special theory of relativity and demonstrated how not only their measurable values but they themselves change at very high speeds. In all of his examples, he used the train as his hypothetical mode of transportation. Yet, though there is nothing in de Chirico's writing to indicate that he understood Einstein's revolution, the confluence of clock, ruler, and train is too rich to be dismissed as mere coincidence. At least it is another example of the early twentieth century's *zeitgeist*. René Magritte, a later surrealist, paid tribute to de Chirico's prescience, saying he was "the first painter to have thought of making painting speak of something other than painting."[7]

It is hard to imagine someone less scientifically inclined than the Spanish painter Salvador Dali. Enraptured by love, mysticism, sexuality, and dreams, he produced a series of realistically drawn, but artfully disordered images. Each contains the artist's self-referential iconography. Many are like navigational charts to be used to negotiate the treacherous subterranean currents of the unconscious. "The difference between a madman and me," Dali was often quoted as saying, "is that I am not mad."[8] In the aftermath of his recent death, an aura of charlatanism has risen about him, and only in time will we know posterity's judgment concerning his art. But from early in his career, in many brilliantly conceived works, Dali created a fund of much-needed symbols for the visually barren language of the new physics.

In one of his most famous paintings, *The Persistence of Memory* (1931) (Figure 16.3), Dali juxtaposes two ordinary symbols of time: clocks and

Figure 16.3. *Salvador Dali,* The Persistence of Memory *(1931)* THE MUSEUM
OF MODERN ART, NEW YORK, GIVEN ANONYMOUSLY

sand; but in Dali's arresting vision the clocks are melting over a vast and
lonely beach that resembles the sands of time. To emphasize the painting's
temporal images, he also incorporates a swarm of crawling ants, whose
uniquely shaped bodies resemble hourglasses. Sand, hourglasses, and
watches all connect below the threshold of awareness till the viewer's mind
swings around to focus on the very nature and meaning of time. Dali's
gelatinous timepieces, crawling with patient ants, ooze and melt upon an
immense beach stretching into the distance. The molasseslike plasticity of
his watches suggests the possibility of slowing to sludge the flow of the
invisible river of time.

The key revelation enabling Einstein to revise the fundamental con-
structs of space, time, and light was understanding the nature of time's
dilation at close to the speed of light. Had someone asked Einstein or any
of his contemporaries to represent the dilation of relativistic time in one
visual metaphor, he could not have produced a more strikingly appropriate
image than *The Persistence of Memory*. If a work's symbolic content strikes

a chord deep within our collective psyche, then it will continue to resonate for us indefinitely. Mention the name Dali to a sampling of people and more often than not, melting watches will be included in the response. This surrealistic painting mesmerizes us because it translates an idea into symbols when conventional words and phrases have never been sufficient.

In his religious painting entitled *Crucifixion (Hypercubus)* (1954) (Figure 16.4), Dali rendered another recondite idea into graphic symbols by incorporating an arcane geometrical shape. Although he painted the suffering Christ upon the Cross with crisp, traditional realism, Dali's Christ is not bound to the cross. This feature by itself gives the painting a haunting spiritual power. But close examination of the cross also reveals that its shape is unique. A cube protrudes in front of, as well as behind, the center pole at the junction of the crossbeam. Further, the cross has been divided into cubic partitions. This unique cubic cross, although foreign to art, is a familiar shape to those geometers conversant with the realms of higher mathematics.

To explain what this figure represents, a review of some basic geometry is necessary. In Euclid's three-dimensional geometry, a point is defined as something that has no sides and no dimension. A line, which is a form that exists in the first dimension, has no depth or width, only length. Moving up a dimension, a plane exists in two dimensions, for example, a square, which has four sides. A plane has width and length, but no depth. A cube is a form that exists in three dimensions and has six sides.

When mathematicians began to tinker with the possibility of a geometry of higher dimensions, they tried to imagine the spatial configuration of a four-dimensional cube. The human brain unfortunately has evolved to deal only with a three-dimensional world, and the exercise is virtually impossible to complete. As we saw earlier, the problem can be graphically posed by simply looking at the corner of any room where the ceiling and two side walls intersect, and trying to determine where a fourth perpendicular might be inserted. Contemplation of the problem for a few moments sharply focuses the difficulty of forming a three-dimensional mental model of a fourth-dimensional object.

Difficult as this problem was, mathematicians were able to calculate that such a four-dimensional cube, or *hypercube*, as it is called, would consist of eight cubes, just as a three-dimensional cube is made up of six squares. One aesthetically pleasing figure that could be created economically, using eight child's building blocks, would have seven cubes, each sharing one contiguous side, and one cube that shared all its sides (Figure 16.5). The actual solid geometrical shape would be the crucifix Dali painted. The

Figure 16.4. *Salvador Dali,* Crucifixion *(1954)* THE METROPOLITAN MUSEUM OF ART, NEW YORK, GIFT OF THE CHESTER DALE COLLECTION, 1955

Figure 16.5. *A three-dimensional figure of a four-dimensional hypercube*

artist's use of this unusually shaped crucifix complements and reinforces the figure of the levitating Christ. Both aberrations suggest another, higher reality while rendering accurately a hypercube of the fourth dimension.

There is another interesting almost concealed visual feature in this painting having to do with shadow. Our real world of three dimensions has no "things" that are truly two-dimensional objects. Trying to conceive of an object that has only width and length but no depth is quite difficult because virtually everything, no matter how thin, has some depth. There are, however, two exceptions: reflections and shadows.

A shadow has no thickness. Given that there exists a fourth dimension, the question must be asked: If shadows are two-dimensional projections of three-dimensional objects, could we and the objects in our world be three-dimensional shadows of beings and things that exist in a fourth dimension? If we consider the shadow's pale insubstantiality compared to its full three-dimensional source and contemplate how the next higher dimension would appear in relation to our anemic shade of it, the thought must give us pause.

Dali created in his painting an image of this idea. The hypercube cross floats above the ground on which there is a checkerboard pattern of black-and-white squares stretching to the horizon. This repetitious pattern, how-

ever, is not present directly under the hypercube. Rather, there is a simple cross outlined on the ground. It represents the shadow cast by Dali's hypercube Crucifixion cross if a light source shone directly down from above. Viewing the simple cross on the ground and comparing it to the complex three-dimensional object of the hypercube challenges the viewer to contemplate that his three-dimensional world is but the pallid shadow of Dali's higher fourth-dimensional hypercube.

René Magritte, a Belgian surrealist, disliked being called an artist, and preferred instead to be considered a thinker who communicated by means of paint. Although not an official member of Breton's group, he, like Dali, created compositions containing images that further aid us in understanding Einstein's special theory of relativity. For example, Magritte's 1935 painting, *Time Transfixed* (Figure 16.6) features a miniature train coming out of an ordinary fireplace on whose mantel rests a clock. That the clock is a symbol of time is evident. Less apparent is that a fireplace is a potent symbol of transformation, for here a person can witness under ordinary circumstances the transubstantiation of one form of matter (logs) into another (ashes) with the release of energy. Watching wood turn into flames is a mysterious process that has held humankind in the thrall of quiet fascination since fire was tamed.

In Magritte's subversion, an improbable miniature *silver streak* erupts from a fireplace into a prosaic living room. The locomotive has, in effect, just crossed a transformative barrier in the painting. The title, however, is *Time Transfixed*. To *transfix* means to stop. In the special theory, time and motion stop under only one condition—the speed of light. As has been repeatedly observed, the illustration most commonly used to demonstrate this concept from Einstein on has been of a clock outside a train at the transformative barrier of the velocity of light. While any artist today might select the same peculiar set of images to make a relativistic point intentionally, no such conscious motive can be ascribed to Magritte. When asked by Harry Torczyner, his biographer, why he chose to make this particular painting, Magritte replied in a long letter:

> The question you ask concerning the conception of the painting *Time Transfixed* can be given an exact answer insofar as *what I was thinking of*. As for trying to explain *why* I thought of painting the image of a locomotive and *why* I was convinced this painting should be executed, I cannot know nor do I wish to know. Even the most ingenious psychological explanations

Figure 16.6. *René Magritte,* Time Transfixed *(1935)* THE ART INSTITUTE OF CHICAGO, THE JOSEPH WINTERBOTHAM COLLECTION, 1970.426

would have validity only with regard to a "possible" interest in an understanding of an intellectual activity that posits relationships between what is thought and what has nothing to do with thought. Thus, I decided to paint the image of a locomotive. Starting from that possibility, the problem presented itself as follows: how to paint this image so that it would evoke mystery—that is, the mystery to which we are forbidden to give a meaning, lest we utter naïve or scientific absurdities; mystery *that has no meaning* but that must not be confused with the "non-sense" that madmen who are trying hard to be funny find so gratifying.

The image of a locomotive is *immediately* familiar; its mystery is not perceived.

In order for its mystery to be evoked, another *immediately* familiar image without mystery—the image of a dining room fireplace—was joined with the image of the locomotive (thus I did not join a familiar image with a so-called mysterious image such as a Martian, an angel, a dragon, or some other creature erroneously thought of as "mysterious." In fact, there are neither *mysterious* nor unmysterious creatures. The power of thought is demonstrated by unveiling or evoking the mystery in creatures that seem familiar to use [out of error or habit]).

I thought of joining the locomotive image with the image of a dining room fireplace in a moment of "presence of mind." By that I mean the moment of lucidity *that no method can bring forth*. Only the power of thought manifests itself at this time. We can be proud of this power, feel proud or excited that it exits. Nonetheless, we do not count for anything, but are limited to witnessing the manifestation of thought. When I say "I thought of joining, etc.," exactitude demands that I say "presence of mind exerted itself and showed me how the image of a locomotive should be shown so that this presence of mind would be apparent." Archimedes' "Eureka!" is an example of the mind's unpredictable presence.

The word *idea* is not the most *precise* designation for what I thought when I united a locomotive and a fireplace. *I didn't have an idea*; I only thought of an *image*. . . . *After* the image has been painted, we can think of the relation it may bear to ideas or words. This is not improper, since images, ideas, and words are *different* interpretations of the *same* thing: thought.

> However, in order to state what is *truly necessary* about an
> image, one must refer exclusively to that image . . .
> Very cordially,
> René Magritte[9]

Torczyner diligently catalogued the artist's various areas of interest,
detailing Magritte's preferences regarding books, movies, politics, and trav-
els. His page devoted to science is the shortest. In Magritte's words:

> I am, of course, unable to appreciate science, not being a sci-
> entist. That doesn't imply contempt for it, merely lack of in-
> terest. . . . It happens that scientific conquests and the more or
> less precise goals of scientific endeavor don't interest me at all.[10]

Despite Magritte's avowed disinterest in the new physics, this reclusive
painter's oeuvre gives form to many of these concepts helping his viewers
to understand physics better than discursive explanations. Michel Foucault,
who wrote a book on Magritte's works, said, "It is in vain that we say what
we see; what we see *never* resides in what we say."[11]

Taking a cue from de Chirico, an artist he much admired, Magritte also
conflated two images that mark the passage of time. Where de Chirico used
the length of shadow and the color of the sky, Magritte fused a daylight
landscape with a nighttime sky. Elsewhere he reversed the lighting and
created mirror images. The only possible way these two opposite times of
day could ever be perceived simultaneously is when time dilates close to
the speed of light. Night following day is such a routinely sequential event
that to be forced to contemplate their occurrence *together in one moment*
is but another incremental step toward the comprehension of time trans-
fixed.

Magritte also created an image for the difficult concept of spacetime
contraction at c. In Einstein's theory, as a traveler's speed closes in on the
velocity of light, space eventually becomes so infinitely thin outside around
the traveler that there is *no* journey through which he can depart. At
lightspeed space would infinitely flatten. The rear has moved around to
the front! When space is this compressed the traveler, looking forward,
confronts the fact that the back of his head would be the only thing
visible—as the figure does in Magritte's playfully impossible painting *The
Glasshouse* (1939) (Figure 16.7).

The Dutch artist M. C. Escher also was not a member of the surrealists,
yet his precise pen and ink prints incorporate clever optical sleights of

Figure 16.7. *René Magritte,* The Glasshouse *(1939)* MUSEUM BOYMANS-VAN
BEUNINGEN, ROTTERDAM

hand consonant with the ideals of the movement. Escher's wood-block
prints' persistent popularity attests to their hold upon the public's imag-
ination. And behind his disconcerting imagery lie the essential ideas of
relativity and quantum mechanics.

Escher's greatest fame stems from his clever manipulation of the ele-
ments of perspective. At first glance, his *Waterfall* (1961) (Figure 16.8)
appears to be optically correct. Upon further contemplation, however, the
viewer begins to sense something is very wrong with its space. It turns out
that Escher tampered with the vanishing point so that the viewer feels
disoriented even though the structures appear to be perfectly drafted. By
creating this kind of visual paradox, Escher calls into question what be-
fore had been our clear understanding of the shape and nature of three-
dimensional space and makes room in our imaginations to consider other
kinds of geometry.

Figure 16.8. *M. C. Escher*, Waterfall *(1961)* COLLECTION HAAGS
GEMEENTMUSEUM—THE HAGUE

Escher also addresses the recursiveness of time and space in many of his prints. In *Gödel, Escher, Bach: An Eternal Golden Braid*, Douglas Hofstadter elaborates upon this aspect of Escher's work and upon its connection with relativity theory. For example, one of Escher's favorite symbols is the Möbius strip. On this puzzling geometrical ribbon with two seemingly distinct sides and neither a beginning nor an end, *Möbius Strip II* (1963) (Figure 16.9), it does not matter where one starts to travel because one will have to return to that place by the end of one's journey. Although Minkowski's spacetime is not shaped like a Möbius strip, the latter's surface can serve as a helpful aid for visualizing the unity of space and time. If at any point along this continuous strip you imagine one side of the Möbius strip to be space and the other side time, you can have a sense of the way relativity unites what in our three-dimensional world are two separate faces of reality. For this reason, like the koan a Zen monk wrestles with, the paradoxical Möbius strip can be a mental exercise to aid in imagining the spacetime continuum.

Spacetime, too, seems to have two distinct sides, one labeled space, the other time. But the distinction, like the apparency of opposing surfaces on the Möbius strip, is an illusion. When followed out to their own ends, both sides meet in one seamless, endless, recursive continuum. Though Escher's repeated use of this fascinating mathematical figure can help the rest of us to understand spacetime, he never evinced any interest in Einstein's theories. Nowhere in his letters, lectures, or writing does he ever mention the founders of modern physics.

The Möbius strip is a visual artifact that silently refutes Aristotle's declaration that extremes cannot be united through an excluded middle. This ancient doctrine, known as *tertium non datur*, long a cornerstone of logic, was first repudiated in the 1400s by Nicholas of Cusa, who created a system of logic that could join opposites through an excluded middle. Despite his efforts, the type of thinking prevalent in Western culture has been heavily dualistic. Beginning in the fifth century B.C., Parmenides divided the world into being and not being. His pupil Democritus soon followed with the strict separation of atoms and the void. Both Plato and Aristotle endorsed either/or logic and Christianity incorporated a Manichaean duality in the doctrine of good and evil and heaven and hell. Later Descartes divided the "in here" from the "out there" and in so doing strongly influenced all subsequent philosophers and scientists. The dogma central to all these beliefs was that one could not get from one extreme to the other by gliding through the middle simply because *no middle existed*.

Carl Jung lamented this Western blind spot when he wrote:

Figure 16.9. *M. C. Escher,* Möbius Strip II *(1963)* COLLECTION HAAGS
GEMEENTMUSEUM—THE HAGUE

Our Western mind lacking all culture in this respect, has never yet devised a concept, not even a name for *the union of opposites through the middle path*, that most fundamental item of inward experience which could respectably be set against the Chinese concept of Tao.[12]

— Jung

Figure 16.10. *M. C. Escher,* Sky and Water I *(1938)* COLLECTION HAAGS GEMEENTMUSEUM—THE HAGUE

However, the two principal theories of modern physics each contained just such a bridge. Einstein's special theory of relativity and Bohr's theory of complementarity both propose ways in which opposites can be annealed into a seamless alloy with no beginning and no end but just an endless loop.

Without the use of logic or equations, Escher, an artist, addressed this question that had bedeviled Western thinkers for twenty-five hundred years. His fascination with the problem of uniting opposites through an excluded middle is most readily seen in his imaginative positive/negative wood-block prints, for example, *Sky and Water I* (Figure 16.10). Beginning with the polar opposites of black and white, his repetitive figures of fish, birds, frogs, and salamanders undergo a gentle metamorphosis in the center until they emerge transformed on the other side. With such mute, elegant graphics, Escher repudiated a linchpin of Western logic established by Aristotle twenty-three hundred years ago. To paraphrase Aristotle's position, if A is a fish and B is a bird, and A's are not B's, then A cannot be B. Escher slides right through this either/or dichotomy and his genius was his ability to fashion prints for the viewer containing complex ideas that could be visualized without the use of equations. Einstein and Minkowski would have said if fish represent space and birds stand for time, in the spacetime continuum both are interchangeable.

The surrealists created images that exist in a dream mode. Within their many baffling constructions were a considerable number that contained novel and refreshing ideas about space and time. These paintings helped to break the rigid rectilinear barriers that previously contained the traditional Western imagination. Yet, none of these painters worked in concert with their döppelganger, the physicist. After the outburst of styles early in the twentieth century, many art critics wondered whether much more could ever occur in art. The ideas behind the physicists' equations were so strange, however, that even more radical styles of art would be necessary to help the general public assimilate a new way to think by first confronting a new way to see.

No more painting with the wrist. The result was secondary; *process* was all.

<div align="right">Calvin Tomkins</div>

Fields are not states of a medium [the aether] and are not bound down to any bearer, but they are independent realities which are not reducible to anything else . . .

<div align="right">Albert Einstein</div>

CHAPTER 17

ABSTRACT ART / IMAGELESS PHYSICS

I n the first three decades of the twentieth century, so much had happened in the world of art that people needed an uneventful period just to assimilate its diverse new forms. The hothouse rapid phase of growth that characterized the early years slowed near the end of the 1920s. After 1930, art became pervaded by morbid images that seem in retrospect to have been predicated on some awful artistic premonition. As the terrible events that were destined to close out the first half of the twentieth century began to pile up on the horizon like ominous thunderclouds, artists, like sensitive weather vanes, turned away from the task of creating new forms and symbols and began instead to point toward the impending maelstrom.

Max Beckmann, Salvador Dali, and George Grosz, among others, forewarned of the coming events in a series of troubling canvases; but like

Cassandra's words, their painted prophecies were ignored by a populace preoccupied with a global economic depression. Picasso responded to the Nazi bombing of a civilian target in the Spanish civil war with what was to become the master image of brutality, terror, and impotent rage in his *Guernica* (1937). This and other paintings were like posters for some supremely gruesome horror film, foretelling the cataclysm that would soon engulf the entire civilized world.

In the 1930s the European physics community was also catching its metaphorical breath by coming to terms with relativity and quantum mechanics. The period of intense international collaboration characterizing both art and physics in the first three decades of the new century was insidiously interrupted in the 1930s by the rise of fanatically chauvinistic national barriers. Communication was arrested further when these philosophical barriers were literally finished off with barbed wire. In every European nation people shared an eerie sense of déjà vu: This nightmare had already occurred once in the century. In that earlier event, the vitality and creativity of many promising young artists and physicists seeped away in the brackish bottom waters of scarred trenches that disfigured Europe's landscape. In the 1930s warring nations pressed physicists into prominent roles in their service because of their expertise on energy and matter.

In conflict, theoretical considerations gave way to the need for practical applications. $E = mc^2$ was a fine insight for theoreticians to contemplate, but now political and military leaders wanted the concept transformed into concrete action. Hurling missiles became more imperative than exchanging ideas, and World War II became a Götterdämmerung for the old mechanistic worldview of Newton's classical physics. His laws of motion, translated with precision into trigonometric trajectories and armored blitzkriegs, were emphatically superseded by Einstein's on August 6, 1945, in a single flash of light. Robert Oppenheimer in reference to the *Bhagavad Gita* described it as "more brilliant than ten thousand suns." The world watched slack-jawed and awestruck at the mushroom cloud billowing up over Hiroshima. The American unleashing of the atomic bomb in 1945 ended the war and changed forever the fate of the planet. What began with Einstein doodling some calculations on paper napkins at outdoor café tables in Bern transmogrified into a stupendous burst of energy forty years later. This event ushered in a new paradigmatic era as well as a new physical one.

In 1945, with Europe and Asia in chaos and ruin, America alone stood triumphant among nations. Not surprisingly in the context of this book's thesis, America's technological and scientific tour de force was accompanied by another sort of explosion in that same year called the New York School

of Abstract Expressionism. This radical movement changed once again in this century the very premises upon which art had been based for thousands of years. The shift in art, of course, reflected an analogous transformation in physics as both turned their attention away from "things" and instead concentrated on the incorporeal field.

As a result of insights garnered from both relativity and quantum mechanics, the field more than the particle came to be recognized as the true nexus of reality. Walter Thirring, a physicist, said:

> Modern theoretical physics . . . has put our thinking about the essence of matter in a different context. It has taken our gaze from the visible—the particles—to the underlying entity, the field. The presence of matter is merely a disturbance of the perfect state of the field at that place: something accidental, one could almost say, merely a "blemish." . . . Order and symmetry must be sought in the underlying field.[1]

In Einstein's formulation of the special theory it was the field of light itself that determined the structure of space and time. Quantum physicists discovered that "things" constructed out of matter originated in fluctuations of insubstantial fields of energy. Since the field was made of nothing and was invisible, it had to remain a mental abstraction. Painters, too, began to explore the idea of art without an image. Though the great movement of abstract art began in 1910 with Kandinsky, it culminated in 1945 with Abstract Expressionism in New York. This tight-knit group of artists went further than previous abstract painters to create new images that spoke directly to the issues Einstein considered concerning our perceptions of space, time, and light.

Jackson Pollock was the most revolutionary of these abstract painters. Among the several radical changes he introduced to art, one was to place the empty canvas on the floor instead of upright on an easel. In this practice, he mimicked the Indian sand painters of the American Southwest, whose traditions he had learned during his childhood in Wyoming. Like these tribal artists, in his most representative paintings Pollock came at the canvas from all different directions and even stepped into its center if necessary.

Because Pollock's finished works now hang on the walls of museums, viewers routinely orient each piece in conventional two-dimensional space: top and bottom, right and left. In creating his works, however, Pollock did not adhere to such a commonsense orientation. He was not interested in

creating a "thing" that existed in the context of homogeneous space and linear time. Like Monet, he wanted to seize the moment of *now*. This was also the same *now* that Einstein had shown dilated like an inflating hot-air balloon at the approach of *c*, blotting out the past and future. Monet, the first relativistic painter, transfixed *now*, as did Einstein, the first re-lativistic physicist. Monet's focus was the fugitive moment before his eyes; so it was for Pollock as well, but instead of representing what he *saw* as Monet had, Pollock recorded what he *did*.

The finished painting—a "thing"—had been the goal of art: a static object resulting from a laborious series of small motions made over time by an artist holding a brush. Unlike artists who had come before, Pollock wanted to translate the actual physical motion of the artist's wrist on to canvas. He therefore evolved an art form less concerned with portraying any image than with illustrating the *unseen* moment of the creative *process*. For example, in his *Number 26A: Black and White* (1948) (Figure 17.1), the process of painting itself became the subject matter of art.

Pollock's solution was inspired. Instead of using a brush to apply small daubs of colored pigment upon a dry surface, he abandoned the paintbrush altogether. He exaggerated the delicate, fine movements of his painterly hand into a wild, crazy body dance that took place at the edge of his huge works and the precipice of his sanity. By flinging, swaying, splashing, and dripping paint that flew from his frenzied body, he reenacted Shiva's dance of creation. What emerged was a sand painting in oil and enamel that was not a picture of a "thing" but rather a record of the psychographic energy-charged movements Pollock had made in the moment of *now*. His dripped line had a new elasticity that completely obscured its beginning and its end, an idea central to the concept of spacetime. Pollock described this process:

> My painting does not come from the easel. . . . I prefer to tackle the hard wall or the floor. . . . On the floor I am more at ease. I feel nearer, more a part of the painting, since this way I can walk around it, work from the four sides and literally be *in* the painting. . . .
>
> I continue to get further away from the usual painter's tools such as easel, palette, brushes etc. I prefer sticks, trowels, knives and dripping fluid paint or a heavy impasto with sand, broken glass and other foreign matter added.
>
> When I am in my painting, I'm not aware of what I'm doing. It is only after a sort of "get acquainted period" that I see what

Figure 17.1. *Jackson Pollock,* Number 26A: Black and White *(1948)*

I have been about. I have no fears about making changes, de-
stroying the image, etc., because the painting has a life of its
own. I try to let it come through. It is only when I lose contact
with the painting that the result is a mess. Otherwise there is
pure harmony, an easy give and take, and the painting comes
out well.[2]

The vitality and energy of his finished works, together with his personal
intensity, catapulted Pollock from obscurity to national fame and made
him an instant sensation, but most art critics as well as the general public
could not quite fathom his vision. Harold Rosenberg recognized the essence
of Pollock's style and dubbed it "action painting." In 1956, a few months
before his death, *Time* magazine referred to him more irreverently as "Jack
the Dripper." Two generations later, museum visitors still try to decipher
his paintings. Some see the heads of horses; others experience emotions
like happiness; still others feel unexpected surges of energy. Most are simply
confused by what they see.

Pollock's work reiterates a profound truth the physicist discovered: The
field is more important than the particle, the process supersedes the object.
The word "reality" has its origin in the Latin word *res*, which means "thing."
For twenty-five hundred years, Western thinkers believed that "real" and
"reality" were composed of "things" that existed in space and time. This
belief had the imprimatur of tradition and common sense; few Western
thinkers questioned it. But Pollock's vision, like the field in physics, is an
invisible *tension*, made out of nothing, that cannot be captured and placed
under the microscope for scrutiny. Pollock's painting is not a *res*. In physics,
the field becomes manifest only by its *effects* on the behavior of *things*
within it. Pollock found a way to express the same notion with paint. When
Hans Hofmann, an older painter, accused Pollock of not working from
nature, the artist huffed, "I *am* nature."[3] — fractal patterns

Objects in space conform to Euclidean vectors and dimensions. These
words do not have the same meaning when we speak about the charac-
teristics of a field. In Pollock's most famous paintings there are no things,
merely the expression of energy and tension. Typically, in his work there
are no vectors of direction. His paintings are not changed very much if
they are hung upside down. They have no center or hierarchy of interest
but instead give all areas of the picture equal importance. Pollock's canvases
are uniformly filled from border to border, just as a field does not occupy
a particular location but is ubiquitously spread out in space. His works
approximate the principle of the field as conceived in physics.

The space of Pollock's paintings meshes in a matrix with time. In his works, the paint itself flying through the air became a prolific metaphor. In all art previous to his, there had been a direct connection between the artist's intention and the effect when the brush was pressed against the canvas. This conversion of inner will into outer action expressed the essence of causality. The conscious mind directing the hand that holds the brush pressed against the canvas is the cause of the stroke; its imprint, the effect. By standing back and flinging paint instead of applying it, Pollock disconnected the artist from the canvas for the first time in Western art. For a brief moment as it traveled through *space*, paint arced in a fluid stream in *time*. In that crack between cause and effect, a brief moment occurred that was out of control. Like the gap in a spark plug, this moment is what Aristotle once proposed was the *potentia*.

In his original formulation of causality, Aristotle had allowed for the existence of an amorphous *potentia* between the rush of *cause* and the stamp of *effect*. It was the interface between the two where something unexpected could take place. Bacon and Descartes clanged shut this gap in their deterministic logic. In subsequent formulations of the laws of causality, there was no room for anything to squeeze between an action and its result. Pollock, leaving a dangling moment, re-created that chink through which *potentia* reinserted itself. He understood that this gap, this quantum fluctuation, this plenum of the void, is the crack in the cosmos through which all things and images enter the extant world of manifestation.

As if in acknowledgment of the importance of this transitory moment in Pollock's creative process, more photographs have been made of this artist engaged in his paint-dance than of virtually any other artist in the act of creating a painting. Why is that? Why is Pollock's choreography more interesting than a photograph of anyone else involved in the creative process? Perhaps because a photograph captures the crucial unseen segment of Pollock's finished work, and complements the original painting by arresting for a moment in time the action that the finished work records.

Barnett Newman (1905–70), another member of the New York School, was an urbane New Yorker who loved to debate all sides of an issue. He once ran for mayor of New York on a platform that included, among other things, playgrounds for adults. In contrast to the taciturn Pollock, who projected the image of an inarticulate cowboy, Newman quickly became one of the group's leading spokesmen and theoreticians.

Newman loved art passionately and continually questioned its mission. Although his early drawings reveal his less-than-expert draftsmanship, New-

man was confident that he could create an image consonant with the new era. At first, instead of experimenting with a brush, he deliberated. For five years he debated, pontificated, pondered, and delivered polemics about the requirements for a new art. "The central issue of painting," he wrote, "is the subject matter—what to paint."[4] Then he began to experiment with various styles, searching for one that would project his inner vision. After a series of frustrating attempts, he presented a distinctive manner of painting that became known as "Zip."

Newman covered huge surfaces with a single homogeneous color that was uniform in texture. The only interruptions in this monochromatic field were one or several exceedingly thin strips of contrasting colors that split the canvas vertically. His paintings could not be seen or analyzed in terms of their component parts. Their holistic quality, like that of Pollock's paintings, evokes the idea of a field. And as we shall see, the titles Newman gave his monumental canvases—*Day One, Onement, Creation*, and *Vir Herocius Sublimus* (1950–51) (Figure 17.2)—were as important as the canvases themselves.

Seen through the eye of a modern physicist, Newman's large color field paintings resemble nothing so much as a readout of the basic elements of

Figure 17.2. *Barnett Newman,* Vir Heroicus Sublimis
(1950–51) THE MUSEUM OF MODERN ART, NEW YORK, GIFT
OF MR. AND MRS. BEN HELLER

the universe—the atoms. Newman considered himself an "icon maker" and his introduction of an art style that resembles the atom's spectroscopic light signature emphasized the wave (field) over the particle (thing). While not explicitly saying so, at some level, he understood that static space, a chief artistic concept from Hellenism till the twentieth century, was no longer vital, and that the elastic tension of the field concept would have to be integrated into Western thought. Perhaps his intuition was the impetus for his abstract paintings provocatively entitled *The Death of Euclid* (1942) and *Euclidean Abyss* (1942).

The narrow lines splitting a uniform background field of color had their corollary in a nascent field of physics. Working in the area of cosmology, physicists Steven Weinberg, Roger Penrose, and Stephen Hawking, building upon Alexander Friedmann's equations of 1922 and George Lemaitre's dramatic "big bang" hypothesis in 1927, advanced the idea in the 1960s that the universe began in a tremendous fireball 18 billion years ago. They used Einstein's theories and their computer simulations to discover that time itself, along with space, was created in this incendiary instant. The physicists' proposal that there was a moment before "time," a void devoid of "space," and the emergence in a single instant of light, space, time, energy, and matter from a single, pointlike fiery crucible ranks as one of

the most profound discoveries of any age, along with the intellectual/ conceptual revolutions of Copernicus, Darwin, Freud, and Einstein.

A formless color field rent by a thin strip of light is metaphorically the picture of the precise moment of the dawn of creation that connected Newman's image in the universe's birth. *Day One, Creation*, and *Onement* are holophrastic titles; their inner truths resonating with their images. In the beginning was the Word, and Newman's words are synchronous with his images that, like the physicists' cosmological model, split asunder the fabric of the pre-universe to make way for a hypher-expanding fireball containing light, space, time, energy, and matter. Their simulation bears an uncanny similarity to the biblical story of Genesis. The creation of *light* was God's first act. Then He divided night from day *(time)*. Then He separated the firmament from the waters and land *(space)*. He then made the "things" in the world *(matter)* and finally set them in motion *(energy)*. The computer-generated beginnings of the universe mirror the Bible's cosmology.

After the marriage of quantum mechanics to the special theory of relativity in the 1940s, quantum physicists had to frame their questions in the context of the spacetime continuum. In order to calculate the fates and trajectories of minute particles, they had to pinpoint these particles' location in Minkowski's four-dimensional spacetime continuum. To aid in the visualization of these events, Minkowski suggested a figure of opposing light cones (Figure 17.3) in what has become known as a spacetime diagram.

This pregnant image, reminiscent of the ancient hourglass, consists of two geometrical cones, one inverted, touching each other exactly at their apexes, and each diverging from its center axis at exactly 45 degrees.* Minkowski named somewhat poetically the point at which the two cones kiss, the *here and now*. He acknowledged that not only was it necessary to locate an object in three-dimensional space, but it was equally important to know *when* in time an object was located *where* in space. The *here and now* is one exact locus point of the *here*, at the precise moment of the present. The lower cone is the repository of the past, the upper is the arena of the future. Every object moving through space and time, including people, traces a unique history. Minkowski referred to these spacetime lines wiggling through the light cones as "world-lines."

*Anaximander in the sixth century B.C. constructed a similar model to represent the world and all that was in it. He viewed the world as consisting of two interpenetrating cones, the apex of each being the center of the base of the other.

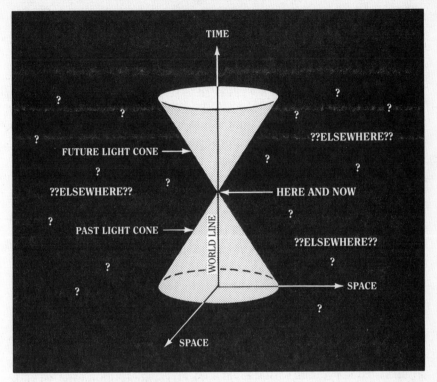

Figure 17.3. *A spacetime light cone*

The walls of the cones are determined by the properties of light because the speed of light constitutes a limiting barrier to the transfer of information. What is *in* the light cone, the region where causal effects are possible, is distinctly separated from what is *outside* where such effects are physically impossible. Paradoxically, even though the walls of Minkowski's model are light boundaries, from inside we can never see *through* these refulgent barriers, nor can an observer positioned outside the walls see through to us. Instead, the walls, though seemingly constructed out of light's features, would be matte black. Black is a color that doesn't allow vision or light to penetrate or reflect. The light cone containing our world and everything in it would appear to an observer outside our light cones as a black hourglass consisting of two cones, one inverted upon the other.

At the *here and now*, the farther one can see into the lower cone which holds the past, the wider that cone becomes. An observer can know about

more events in the wide part of the cone than he can in the narrow part because in the wider part more time has elapsed, enabling the light-bearing information from distant events to reach the observer's eyes. Similarly, the farther the light walls diverge from the *here and now* into the future, the greater are the number of possible events in the future. And, of course, as the light cone funnels back down to the *here and now*, the infinite possibilities in the distant future diminish in the narrowing tunnel confines, since fewer options exist in the immediate than in the distant future.

Keeping the preceding discussion in mind, let us return to Barnett Newman and contemplate his black sculpture, *Broken Obelisk* (1965) (Figure 17.4), presently residing in the sculpture garden of the Museum of Modern Art in New York City. Newman, who was interested in introducing the concept of the "sublime" back into art, delved into religious texts and was heavily influenced by the mystic Jewish tradition of cabalah. In his writings he did not express an interest in the details of the new physics. Yet Newman unwittingly created an artistic replica in steel of Minkowski's two-cone model used to visualize objects in the spacetime continuum.

His sculpture differs from Minkowski's juxtaposed light cones in several respects, the most important being that Newman balanced two opposing pyramidal shapes instead of cones. For his lower cone, Newman constructed a solidly based pyramid with sides at 45-degree angles. But a pyramid with its sides at 45-degree angles to its base is close enough to a cone to preserve the basic idea of Minkowski's model. In addition, the pyramids that survive from ancient Egyptian civilizations were constructed to be permanent reminders of the past and were used as mausoleums. A pyramid is an archetypal seminal image evoking the concept of a preserved past. The mysterious placement of an eye at the apex of the pyramid still adorns every American dollar bill. The view from the apex of a pyramid, like the position of the *here and now* in Minkowski's model, reaches into both the past and the future. The physicist's light cone model should have an eye positioned exactly at the *here and now* since the model refers to light *seen*.

The upper part of Newman's obelisk is different from the lower half. It still begins as a pyramidal shape, but shortly the pyramid becomes an extruded cube, whose top is jagged and unfinished. This is fitting because the future cannot be known with the same accuracy as the past; it hasn't happened yet. The past is secure, like a performer who is finished and has earned the right to sit on a solid base of data that have been recorded and cannot be changed. The future is slimmer, however, and its balancing act more tenuous. It trails off to an unknown finish, and in this regard New-

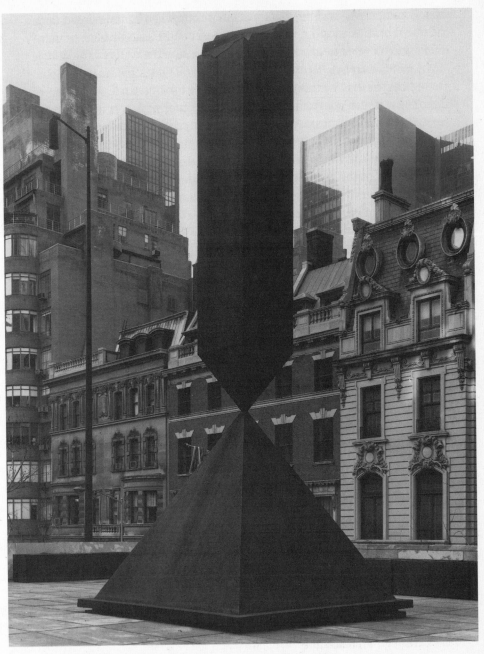

Figure 17.4. *Barnett Newman,* Broken Obelisk *(1965)* THE MUSEUM OF
MODERN ART, NEW YORK, GIVEN ANONYMOUSLY

man's compelling sculpture fits metaphorically when superimposed upon advanced physics' most important visual model of the spacetime continuum.

Physicists refer to anything that exists outside the walls of the double light cone as *??elsewhere??*, the frame of double question marks emphasizing the concept's strangeness. The reason for this frank admission of ignorance is the constraints imposed upon information transfer by the speed of light. We can say *nothing* about what exists outside our crystalline light cone prison. Beyond the light-suffused interior of the light cone lies a place as mysterious, dark, and misty as that of the home of mythic Cimmerians of the *Iliad*. This ephemeral region called *??elsewhere??* has become the terra incognita for the modern cosmologic cartographer.

The strange never-never land of *??elsewhere??* can be appreciated whenever an observer looks into the sky. The sun is 93 million miles distant from the earth. After being generated from its surface, sunlight embarks on an eight-minute-long journey before it reaches the earth. On any beautiful sunny day, a glance at the sun will reveal its status only as it had existed eight minutes earlier. If by some remote accident the sun suddenly disintegrated into incendiary pieces because of some internal nuclear reaction gone awry, this cataclysmic event would be unknown to us for exactly eight minutes because no information can be transmitted faster than the speed of light. During this brief interval, the disruption of the sun would be an event that took place in *??elsewhere??*. It is only after the requisite time had transpired that this catastrophe would move out of the *??elsewhere??* and enter our light cone to pierce the *here and now* of every inhabitant of the planet with devastating consequences.

The concept of *??elsewhere??* manifests on a much grander scale whenever we gaze into the nighttime sky. The starlight that falls upon each of our retinas has made a journey not of minutes but of eons. In our spacetime frame of reference, the light from a star that is one million light-years away needs one million years to cross space before it can arrive here on earth. That means that although we can admire its light in the here and now, the star itself might in fact be extinguished because the messenger proclaiming its existence began a journey that occurred over one million years ago. When we gaze at the stars across the immense distances of the universe we are not only looking out into deep space but are also peering back through archaic time.

Newman's creation, located in mid-Manhattan, is only a mile away from another, lesser-known obelisk. That one, which stands in Central Park, is known as Cleopatra's Needle. Its hieroglyphics are covered with grime; its spacetime world-line lost in the foreign context of its location which ob-

scures its past. This other obelisk was once one of a pair. From the fifteenth century B.C., they stood in the courtyard of the Temple of Tum in the city of Heliopolis in ancient Egypt, positioned hundreds of feet apart. On the summer solstice, the longest day of the year, the rising sun's first rays lined up with the tops of these two obelisks and then stabbed deep into the darkness of the temple's inner sanctum. This *one* moment at the beginning of this *one* day was the *one* time of the year light entered the sacred chamber located in the city of the sun.

After standing at attention, guarding the path of light from the sun's special day for over thirty-five hundred years, the obelisks were separated and presented as gifts to two governments in the 1800s by the khedives of Egypt. The second obelisk of the pair was positioned along the banks of the Thames in London. The story of these two obelisks, whose original positions in space determined an exact moment in time, is an ancient echo of Minkowski's future insight. Newman's *Broken Obelisk* recalls as well these two other guardians of space and time.

The essential nature of reality is a set of fields.

Steven Weinberg

I'm in favor of an art that does something other than just
sit on its ass in a museum.

Claes Oldenburg

CHAPTER 18

HAPPENINGS / EVENTS

A few years after the New York School splashed copious amounts of
paint all across the art world, a new generation of young American
artists began to emerge, taking art in an entirely different direction
from that of the earlier action painters. Jasper Johns, one of the most
significant of this new breed, traced his lineage not to the Abstract Expres-
sionists, but instead to the rich tradition of Duchamp and Magritte. Like
them, Johns was concerned with the meaning we attach to words and
images, and, like theirs, Johns's artistic responses contain within them
several stunning visual metaphors of Einstein's new vision of space, time,
and light.

The principal subjects of many of Johns's paintings were alphabets and
number series. The same innovations that initiated the Greeks' inquiry
into the nature of reality twenty-five hundred years ago became for Johns
a place to begin to explore their hidden significance. In his work *0 Through
9* (1961) (Figure 18.1), for example, Johns challenges the inviolability of

Figure 18.1. *Jasper Johns,* 0 Through 9 *(1961)* LEO CASTELLI GALLERY, COLLECTION OF TONY CASTELLI

sequence, one of the most sacred notions of Aristotelian time. No more precise metaphor for sequence exists than an arithmetic number series. The progression of 1, 2, 3, 4, . . . in time and space is the antithesis of simultaneity. Johns conflated these two opposing principles and made them complementary when he created a master image of all the cardinal numbers

superimposed upon one another, making it impossible to see them one at a time. Instead of the orderly marching seconds of a digital watch, in Johns's version numbers are piled one upon another in a neat simultaneous stack.

As the reader of this book knows by now, there exists only one condition of time in which the progression of all moments can be apprehended simultaneously, and that is when the world is seen from astride a beam of light. At c, all events would be superimposed on one another like Johns's numerals so that they would be seen simultaneously, instead of prosaically beaded together as on a linear string. Johns's painting is the most precise expression of the idea of the simultaneity of spacetime at c in the entire history of art.

In *Good Time Charley* (1961) (Figure 18.2), Johns conflates Einstein's two essential measuring devices by using a ruler as the hand of a clock. The ruler's counterclockwise sweep is about to collide with a real three-dimensional metal cup affixed to the two-dimensional canvas. The cup, evocative of the full panoply of spatial dimensions, will be conjoined to the basic measuring device of space—the ruler. In this work, however, the ruler is also a clock hand that connotes time. By using a ruler to serve simultaneously as a measuring device of both space and time, Johns symbolically represents the matrix of the spacetime continuum.

In his early years, Johns mixed hot wax and paint, then applied this mixture to his canvases in a rarely used, technically demanding, and time-consuming method called *encaustic*. Encaustic makes the task of applying a brushstroke seem like painting with meringue. The explanation Johns offered for seeking this added complexity was that it revealed the earlier brushstrokes beneath the surface. In Johns's own words:

> I wanted to show what had gone before in a picture and what was done after. But if you put on a heavy brushstroke in paint, and then add another stroke, the second stroke smears the first unless the paint is dry. And paint takes too long to dry. I didn't know what to do. Then someone suggested wax. It worked very well; as soon as the wax was cool I could put on another stroke and it would not alter the first.[1]

Pentimento, remember, is an art term that refers to the drawing and preliminary paint work that lies beneath the finished, visible surface of a painting. Before Johns, these early stages in a work's evolution were lost from sight altogether once the final layer of paint skin was applied. Nowhere in art had it ever been possible to view simultaneously the progressive

Figure 18.2. *Jasper Johns,* Good Time Charley *(1961)* LEO CASTELLI GALLERY,
COLLECTION OF THE ARTIST

moments that transpired in the creation of a work. By using a technique that reveals his pentimento, Johns allows the viewer to peer back through time to see sequential frames simultaneously within the spatial confines of a single canvas.

Johns's encaustic works resemble Monet's multiple paintings of the entrance of the Cathedral of Rouen and Duchamp's *Nude*. Like Monet and Duchamp, Johns wanted to capture in one image the restless river of time. Monet did so using successive canvases, Duchamp with successive moments of time within one canvas, and Johns with successive brushstrokes superimposed upon one another. Johns's use of a thick pastiche of hot wax transforms his paintings into a translucent archaeological tell allowing the viewer to squint through the usually opaque mists of an artwork's present and discern the ghosts of its past. Johns's painting embodies relativity's concept of the *everlasting now* at *c*. As Johns once said:

> Time does not pass
> Words pass.[2]

Johns's dense iconography makes it virtually impossible to divine with certainty the meaning of his paintings and sculptures, and his commentary is unenlightening. He was so uniquely taciturn and enigmatic whenever he spoke about his work that interviewers came to call his comments "Johnsian." When asked by one, "How do you work in a painting?" Johns replied, "Well, I begin at the beginning, and go on from there."[3] When another interviewer, angling for an invitation, commented, "I've never watched you paint," Johns replied, laughing, "Neither have I."[4]

Despite Johns's deliberate obfuscation about his explicit meanings, his images implicitly convey almost inexpressible scientific concepts. By changing the language of art, he presages a change in the general mode of thought. Johns understood that seeing, thinking, and speaking are linked in mysterious ways. Although his images are recondite, they are often powerful enough to penetrate the viewer's consciousness and burrow into the deeper layers of the unconscious perhaps to germinate in the silence and darkness there. Rising to awareness in another context, the original artistic messages, having interpenetrated one another, will affect the processes of thought concerning unrelated subjects. This is the mystery and majesty of great avant-garde art.

Robert Rauschenberg, a contemporary and close friend of Jasper Johns, was also a Post–Abstract Expressionist. Without setting out deliberately to do so, many of his innovative ideas embody Einstein's formulations of the

relationships among space, time, and light. In one of Rauschenberg's early efforts, for example, he and his artist wife, Susan Weil, interposed their bodies and those of models between sunlight and light-sensitive architectural paper, thereby creating art in which the element of light itself participated in the outcome. Later they learned that they could use a sunlamp and obtain the same result. Instead of paint, light became the new medium of art for Rauschenberg and his wife.

This transformation of light from a passive to an active medium was not entirely new with Rauschenberg. Beginning in the early 1900s, coincident with Einstein's insight of 1905, artists discovered that neon lighting could have other than industrial applications. By bending glass tubes into different shapes before filling them with neon gas they turned light itself into the content as well as the form of art.

Thomas Wilfred introduced the art form of light in 1905. His first work in this new aesthetic medium consisted of a small incandescent lamp, some pieces of glass, and a small cigar box. He called the new style *Lumia*. In another example of synchronicity concerning an entire culture's sudden appreciation for light, Wilfred wrote:

> Shall we . . . use the new art as a vehicle for a new message (and) express the human longing which light has always symbolized, a longing for a greater reality, a cosmic consciousness, a balance between the human entity and the great common denominator, the universal rhythmic flow?[5]

In 1915 Alexander Scriabin composed *Prometheus, the Poem of Fire* which was accompanied by an elaborate light show. Soon after, the American artist Man Ray, with the help of Marcel Duchamp, placed objects on top of unexposed photographic film so that the light could function as an active principle in shaping the final outcome of their 1921 "Rayographs." Rauschenberg and his wife, exaggerating this idea, interposed the artist's whole body between the architectural paper and the light!

In 1952 Rauschenberg exhibited a series of all-white paintings which had a high-gloss finish. When they were hung in a gallery together, the viewers could actually see their own dim reflections and movements as they walked by them. The only element visible in these paintings was light itself. Rauschenberg loved his all-white series. He said of them, "I always thought of the white paintings as being passive, but very, well, hypersensitive, so that one could look at them and almost see how many people were in the room by the shadows cast, or what time of day it was."[6] John

Cage, the composer and a friend of Rauschenberg, once described the all-white paintings as "airports for lights, shadows and particles."[7] The show, in collaboration with the artist Cy Twombly, also included a series of all-black paintings by Rauschenberg. When the older artists of Abstract Expressionism visited the exhibition they were outraged. Barnett Newman was supposed to have said, "What's the matter with him? Does he think it's easy?" Another muttered, "If he hates painting as much as that, why doesn't he quit and do something else."[8] Other painters before Rauschenberg had painted all-white canvases, most notably, Kazimir Malevich's *White on White* (1918). However, Malevich in his work created tension between an offset white square against a tonally similar all-white background, making a statement different from the reflective effect of white that Rauschenberg sought.

Since the first cave painting, light has been the necessary precondition to *see* art, as it is necessary to illuminate any work of the human hand: no light, no art. A painting's raison d'être disappears in the dark. In this capacity light is purely passive. It seems to emanate from its source traveling through space and time to strike objects such as paintings or sculptures and then rebound into the eye of the beholder. In this version of the old Newtonian paradigm light is still a relative essence that depends upon the absolute grid of space and time. In Rauschenberg's work, light became Einsteinian, connecting and giving form to space and time, the two plastic elements of the spacetime continuum. If, for Monet, "the subject of every painting is light," for Rauschenberg light is not only the subject of the work, but its medium as well.

Rauschenberg also unwittingly discovered a new way to portray the invisible dimension of time, incorporating it within the spatial confines of art. His happy accident began in 1954 when he built shallow boxes and packed them with soil. Unbeknownst to the artist, some birdseed had fallen into the construction, and grass soon began to sprout. Delighted with this serendipitous result, Rauschenberg planted even more seed. While his constructions clearly existed in space, they also changed each day so that a viewer had to see them over the course of time to fully appreciate them. Enthusiastic over his "grass paintings," as he called them, he tried to sell them to a gallery owner telling her that she should think of the piece as a sculpture. "The only difference," Rauschenberg explained disingenuously, "is that my grass grows a little faster than stone."[9] Rauschenberg's imaginative piece is related to Japanese bonsai, a form in which the artist-gardener also creates an organic piece of art that slowly evolves and changes over time.

In his examination of time, Rauschenberg continually questioned the concept of sequences, which are the vertebrae in the backbone of the laws of causality. Rauschenberg assembled collages, which he called "combines," made up of unrelated scenes that had no causal connections with one another. He arranged them like the front page of a newspaper: one image next to another with no obvious connection. McLuhan called this haphazard juxtaposition "information brushing information."

One of Rauschenberg's most outrageous ideas needed the collaboration of the much older and well-established artist Willem de Kooning. Rauschenberg asked de Kooning if he could have one of de Kooning's drawings. De Kooning, flattered, asked him what he intended to do with it. Rauschenberg replied that he wanted to erase the work. De Kooning, nonplussed, was understandably less than eager to comply, but the younger artist's boyish charm eventually persuaded him to part with a drawing in order to contribute to an important anti-art statement. Armed with an eraser, Rauschenberg set to work. When he was finished, Rauschenberg entitled this now blank surface *Erased de Kooning* (1954).

By laboriously erasing the drawing until the paper was empty, Rauschenberg takes the viewer backward in time beginning with Rauschenberg's undoing of de Kooning's creation, and then back further to where de Kooning created a work the viewer can no longer even see. The empty sheet then reverberates with the step before de Kooning when it was also blank. Even though there is nothing in the frame but an expunged piece of paper, this blank space is redolent with the reverse direction of the arrow of time. That something wasn't, then was, and then was no more again, introduces the dimension of time into what had previously been a static, two-dimensional piece of paper. As Meister Eckhardt, the medieval mystic, once wrote, "Only the hand that erases can write the true thing."[10]

In 1959 Rauschenberg assembled his most audacious work, *Monogram* (Figure 18.3). A large, low platform covered with unconnected scenes was placed on the floor. Standing in its center was a stuffed goat with a tire around its middle. The first viewers and critics to see it were baffled. Part of its disorienting presentation is that *Monogram* is an artwork that cannot be taken in all at once. First, the horizontal placement of a painted work on the floor creates a major visual surprise for the viewer. Accustomed to seeing paintings upright, and occasionally on ceilings, the viewer is forced by the strange spatial orientation of *Monogram* to think of space in a new way. Second, *Monogram* features the strange element of a real dead animal. All living organisms are the very embodiment of restless time. From birth to death, life is movement and change. A goat's life span manifests sequence.

Figure 18.3. *Robert Rauschenberg,* Monogram *(1959)* THE SWEDISH NATIONAL ART MUSEUMS

However, if the goat is stuffed, then this living form is arrested and will resist inevitable decay and remain unperturbed by the passage of time. The idea of the goat in *Monogram* is opposite and complementary to that in bonsai and Rauschenberg's "grass paintings." The goat is, to borrow a phrase from Magritte, "time transfixed."

Adding to this image is the placement around the goat's middle of the third new element—an old tire. A tire's function is travel. As such, a tire is the symbol of rotational change, motion, and speed. A real tire that will never roll again encircling a taxidermic goat's middle that will never move or change are two powerful symbols of stopped time. The disorienting horizontal canvas is the symbol of a new way to perceive the vectors of Euclidean space. Together these ingredients combine to form one of the most provocative art works in history. Yet, an interpretation of this seminal image could be that it is about our perceptions of space and time.

The name of the piece, *Monogram,* is as unrevealing as Rauschenberg's other titles. Another of his "combines" is entitled *Rebus* and in many ways

all his combines are really rebuses. A rebus is a kind of word game consisting of signs, symbols, and pictures of objects that by the sound of their names suggest words or phrases. For example, a picture of a bedspring followed by a picture of a meadow is a rebus for Springfield. Rebus writing, though now trivialized into a game people play principally on personalized license plates and T-shirts, was the crucial step in the transition from picture writing to alphabets somewhere around thirty-five hundred years ago. For ancient Sinaitic Semites to advance from making a picture of a "thing" (ideogram) to a picture of a "sound" (rebus writing) was a difficult bridge to cross. Yet, at the dawn of civilization, by combining a drawing, for example in English, of a bee with one of a leaf, Semites found they could express the abstract concept of "belief," and by so doing took the momentous step away from writing derived from images to a far more sophisticated written language based on meaningless sounds. From there it was only a short step to eliminate the picture of a bee and leaf and substitute meaningless abstract symbols that became the letters of an alphabet.

Rauschenberg's use of such an obscure word as "rebus" to name one of his inscrutable works is provocative and suggests that art has entered a profoundly important new stage where it is assisting civilization in the development of a language of symbols to think freshly about physical reality. The invention of the alphabet over thirty-five hundred years ago occurred most likely when an individual artist discovered a new way to communicate images—a new art form really. Rebus writing became the major antecedent step to alphabet writing. Perhaps today art is again performing this revolutionary function. If we could by time travel visit a Semitic culture of 1500 B.C. and ask the people if they could anticipate the momentous ramifications of rebus writing, they would doubtless say no. Yet rebus writing, initially just an innovative art form, was the precursor to the alphabet.

The diverse art movements of the 1960s exploded like sparklers from Roman candles. Many continued to produce striking artistic metaphors for specific features of Einstein's equations. Even the eccentric Andy Warhol expressed the physicists' ideas. It was difficult for some people to take Warhol's work seriously because of the way he used commercial trademarks and also because of his reputation for having a crass entrepreneurial spirit. However, some of his works resonate with relativity.

For example, Warhol conceived of the movie camera as an eye with a memory that existed outside his brain. Using it strictly as a recording device, he produced films in this mode that were exercises in tedium. For instance, in his eight-hour, fixed-focus film of the Empire State Building he recorded part of one day in the life of this static landmark without ever varying his

camera angle. Except for an occasional airplane flitting across the background, there is no perceptible action. The only things that evolve are shadows, which change ever so slowly as the sun journeys across the sky.

At first glance this work seems pointless, but upon further reflection Warhol was just continuing the tradition started by Monet, who was the first artist to introduce changing time into the geometrical space of illusionist painting. Warhol's film, admittedly a reductio ad absurdum, is a detailed explication of the multiple time frames Monet captured in his forty-painting series of the entrance of the Cathedral of Rouen. In both works, the artists make use of the subtle atmospheric conditions that change the appearance of two similar, implacable stone structures. Each work forces the viewer to consider the objects' existence in both time and space.

Warhol worked with technologies more advanced than Monet had and was therefore able to introduce another feature of time not amenable to paint and canvas: time dilation. Because his reels unwind a picture devoid of action, time seems to slow down and stretch out; the boredom attendant with watching its soporific passage produces a state of consciousness in which movie time seems to take considerably longer than clock time. Their relative different durations is a characteristic of Einstein's relativistic time. No work of art prior to Warhol had ever been able to induce this trancelike state.

The artists' obsession with incorporating time into art led the Post-Abstract Expressionist movement to develop a whole new art form, the *happening*, that took the art world by storm in the 1960s. In these *events*, artworks no longer existed only in space. In fact, their presence in space was explicitly transient; these Dadaist and surrealistic miniplays reinforced the idea that art must include moving time as well as static space.

Coincidentally, the word "event" began to be heard frequently in physics laboratories and seminars. Its scientific usage referred to points in the spacetime continuum and embodied the idea that everything must be located in the three dimensions of space as well as pinpointed in time. Thus the *event* became central to art and physics almost simultaneously, even though Minkowski's spacetime continuum was probably the furthest thing from the minds of audience members at these happenings. The irrationality of the artists' *events* also matched the alogical aspects of quantum spacetime *events*. In one of the earliest happenings, called *The Night Time Sky* (the title of which is evocative of space and time), Robert Whitman invited an audience to sit on the floor of a large tent while films played on the tent's

canopy. One typical film was of the act of defecation that appeared to be shot by a camera located inside a toilet bowl.

The Smiling Workman, another happening, featured artist Jim Dine, a white canvas, and a table with three jars of paint and two brushes on it. Dine himself later recalls this event:

> I was all in red with a big, black mouth; all my face and head were red, and I had a red smock on, down to the floor. I painted "I love what I'm doing," in orange and blue. When I got to "what I'm doing," it was going very fast, and I picked up one of the jars and drank the paint, and then I poured the other two jars of paint over my head, quickly, and dove, physically, through the canvas.[11]

As Calvin Tomkins commented, "The action painter's need to 'get into the painting' could hardly have been expressed more graphically."[12]

Innovative artists like Johns, Rauschenberg, and Warhol, without specifically setting out to do so, repeatedly invented new means to express features of the spacetime continuum in ways that were nonrational and unscientific. In so doing, they served as guides pointing the way to the arcane ideas contained within the equations of theoretical physicists. In another context, the Zen master Daisetz T. Suzuki wrote:

> When the sword is . . . held by the swordsman whose spiritual attainment is such that he holds it as though not holding it, it is identified with the man himself, it acquires a soul, it moves with all the subtleties which have been imbedded in him as a swordsman. The man . . . is not conscious of using the sword; both man and sword turn into instruments in the hands, as it were, of the unconscious, and it is this unconscious that achieves wonders of creativity.[13]

A great artist holding a brush, whose spiritual attainment is such that he holds it as though not holding it, imparts to the brush the soul of his creative spirit.

Einstein's 1905 special theory of relativity still remains incomprehensible to most people. Yet, images of these ideas have permeated our collective awareness in such a way as to make our whole Western culture receptive to them. Our artists have repeatedly given us topological maps to help us

identify the features of the surreal landscape that is relativistic reality. The one work of art that encompasses all of the features of the special theory of relativity is the 1966 construction by Lucas Samaras, *Mirrored Room*. A table and chair are set in a room containing only one door. Every surface of each object is covered with panels of mirrors; so are the walls, ceiling, and floor of the room. The viewer, like the stationary observer of perspectivist art, must stand in one spot (the only opening into the room) to look inside. Instead of a three-dimensional illusionist painting of deep space, coherent subjects, and organized composition, the viewer is confronted with a kaleidoscopic splintering of the reflection of light. The light ricocheting off one surface after another creates a holistic, Cubist, simultaneous representation of space until it is *all here*. Top, bottom, front, back, and sides are all visible in the fractured silvered slivers. Further, because it is hermetically sealed off from the world, the room will never change. Time stands still forever. Even though the viewer may come and go, when he returns the room is the same and will forever remain inviolate. The moment of *now* within the room is infinitely dilated until it stretches into a changeless *everlasting now*. The most striking feature of the *Mirrored Room*, however, is the directionless all-pervasive light that supersedes space and time and welds them together in a union that is the fourth dimension. As Zola said, art *is* nature as seen through a temperament; and the nature of space, time, and light is revealed for those who want to see it through the creations of the innovative temperaments of the great artists.

Music's exclusive function is to structure the flow of time and keep order in it.

Igor Stravinsky

Without music, life would be a mistake.

Friedrich Nietzsche

CHAPTER 19

MUSIC / ART / PHYSICS

U ntil now the focus of the book has been the connection between the visual arts and physical theories. However, the changing perceptions of space, time, and light are also evident in music and literature. Because each of these fields could be the subject for entire books, the chapters on these three subjects will touch only those aspects that relate to space, time, and light.

Visual art is an exploration of space; music is the art of the permutation of time. Like his counterpart the painter, the composer has repeatedly expressed forms that anticipated the paradigms of his age. In this chapter, I will place a brief history of music alongside those of art and physics as supporting evidence for my principal thesis. Music's leitmotif will be seen to have run a course that parallels Western society's revisions of space, time, and light.

While art and physics are solely human expressions, music is a common medium for many living forms. Song is the language of birds and whales.

271

Lions, tigers, and other animals are soothed by tranquil melodies. It has even been proposed that plants respond to music. The ability of species to generate and respond to music is one of the great unexplained mysteries of nature. Apparently, appreciation for music is built into the genetic foundation of all higher life-forms. In humans, perfect pitch seems to be encoded somewhere within the strands of DNA. If the fittest do indeed survive, then how does the ability to sing in key or keep time to rhythm complement or enhance that survival? Perhaps, as the essayist Lewis Thomas has suggested, we are part of a grand symphony that includes the "rhythm of insects, the long pulsing runs of birdsong, the descants of whales, and the modulated vibration of a million locusts in migration . . ."[1] He proposes we do not fully appreciate the music because we are not the audience, but rather members of the orchestra.

Evidence for musical ability in humans has been found in artifacts at Upper Paleolithic ritual sites. Musical instruments probably existed as early as thirty-five thousand years ago, a date that coincides with evidence of the first prehistoric art, and from these earliest times, all subsequent civilizations seem to have included music as part of their fabric. In classical Greece music played an increasingly important role during its rise.[2] The Greek word for "distinguished" also meant "musical." In Greek religion, the muse Calliope protected all who loved music. Among their mythical heroes, none was as loved as the poet-musician Orpheus. Music was part of everyday life as well as a manifestation of the divine, and played a crucial role in the new art form, drama. A chorus accompanied Greek theatrical productions, singing, dancing, and pantomiming in synchrony with the main action. The early Greek poets were actually wandering minstrels who chanted and sang rather than recited the epic poems. Later, in the Athens of Pericles, rich patrons sponsored annual musical Olympiads, whose winners—not unlike the winners of Grammy Awards today—were national culture heroes.

The Greeks believed that music possessed the power to drive men mad, as Ulysses' mythological encounter with the sirens in the *Odyssey* confirmed. The sirens' haunting song had the power to destroy mortals' reason. Curious to hear their song, Ulysses ordered his crew to stuff their own ears so they could navigate in safety, but he had them tie him to the mast with his ears open so he could hear the sirens as his ship sailed past their island.

The Greeks not only made music; they were the first to use reason to understand how it was produced. Early musicians had already observed that the tone produced by a plucked string could be varied by decreasing or increasing its length. In the sixth century B.C., Pythagoras found that

when he divided the string by whole numbers, he could produce half the notes of an octave of music. Thus, he demonstrated that intervals had a mathematical, which meant a rational, foundation, and music and physics entwined for the first, but not the last, time.

After he discovered the interval's arithmetic basis, Pythagoras proceeded to speculate about celestial music. He proposed that the movements of the planets and stars created vibrations for the gods, and he named this divine harmony, unheard by mortal ears, the Music of the Spheres. To the objection that no mortal had ever enjoyed this music, Pythagoras replied that the sound is present at the moment of our birth, but because there is no silence against which we can compare it, we cannot hear it.

Since the fourth century B.C. the changes in Western music have been so enormous that despite his knowledge and love of music, Pythagoras would be completely bewildered by what we listen to today. Ancient Greek music was monodic. Their word for melody, *melos modus*, literally meant the "road around," and Greek melody was a single-line theme that meandered through the musical register.[3] Though the Greeks understood the textures of harmony, they apparently had little knowledge of the complexities of counterpoint, and all members of a Greek chorus sang the same song in unison. This linearity reflected the ancient Greek outlook in other matters, including a reliance on Euclidean rectilinear axioms and a linear and pictorial narrative style best exemplified by vase paintings.

When Rome conquered Greece, the Romans usurped Greek music. As they did in art and science, the Romans refined what the Greeks had begun but they made few original contributions to music.

The ascent of Christianity accompanied the disintegration of the classical world beginning around A.D. 400. These contrapuntal forces clashed with such dissonance that they brought about a four-hundred-year-long European intermission in human knowledge and creativity we now call the Dark Ages. The statue of Calliope lay toppled from her pedestal. There was no one to reassemble the pieces in the midst of the mass migrations and almost constant warfare of those difficult times. As the vast Roman Empire fractured, Latin, its monolithic language, also disintegrated into many different dialects.

The musician, like the artist, sought sanctuary in the Church. Protected and surrounded by the new religion, music served it. In Europe, during this formless lump of centuries, what individual powers the kings could not claim, the Church subsumed. The Red and the Black created a checkerboard on which society could play out its destiny. Artists, authors, and composers did not sign their works; faith rather than reason dominated

intellectual debate, and people sang in chorus. The hypnotizing cadences of Gregorian chant, seeking to create a divine vibration that would resonate with the powerful message of the New Testament, became the song that would last a millennium. Scientific inquiry was lulled into a long hibernation.

As this aesthetic ice age began to melt, music suddenly blossomed forth in a most unexpected form. Love songs appeared like primroses after a cold, bleak February. These eleventh- and twelfth-century paeans to courtly love were something new. Passion had been the province of the Church, as in the Passion of Christ, not of sexual attraction. But when troubadours began to sing the praises of Arthurian romantic love, their songs became the musical fashion of their age.

Music remained relatively unchanged[4] until the thirteenth century, even though there were many cross-currents of innovation.* During the late medieval period, choirmasters chopped linear melody into segments and rearranged them so they could be sung out of sequence.[5] These superimposed melodies could now be heard simultaneously by the listener. By the beginning of the fourteenth century, composers were so excited about this new polyphonic musical form and the fledgling musical notation they developed in order to write it down that they called it *ars nova*, the new art. Polyphony had its beginning at a time when the simultaneity of multiple views was at its zenith in art, and logic and sequential causality had not yet reestablished their effectiveness as systems of thinking.† The towering themes built using polyphony resembled nothing so much as the style of Gothic architecture. It was almost as if the Gothic cathedral evolved to complement polyphony, which also resembled the mosaic and the stained-glass window in that its discontinuous segments could be linked together to make up a much grander, unified composition.

The introduction of polyphony made possible immense complexity for music. The ancient Greek *melos modus* had created a music timeline comparable to the Euclidean vector of length: Melody determined the horizontal direction of music. Polyphony now added the vector of height, so that instead of being a single thread, melody was a two-dimensional, chain-stitched, aural fabric complementing the visual tapestries of those times.

By the middle of the fifteenth century, accompanied by the reemergence of literacy, the discovery of visual perspective, and the reawakening of

*Most notable was the invention of musical notation which began in the late eighth century in St. Gall in what is now Switzerland.
†The popular canons "Row, Row, Row Your Boat" and "Three Blind Mice," when sung out of phase in a chorus, are examples of polyphony.

scientific inquiry, two inventions transformed music. The first was the standardization of written notation,* which allowed the components of melody to be read like the letters of the alphabet. The second was Johann Gutenberg's amazing new printing press, which made possible the rapid and widespread dissemination not only of the written word, but also of written music, which soon became so commonplace that by the end of the fifteenth century music could challenge Latin as the primary pan-European language.[6]

Literacy in both the printed word and music brought about the rise in the importance of the hand and the eye at the expense of the voice and the ear. Before the Renaissance, European music and knowledge depended for the most part upon an oral tradition that was written on the wind. But in the fifteenth century, what had been ephemeral became permanently transfixed by ink and sight: Music and speech became visible. As Marshall McLuhan has pointed out, the Renaissance citizen traded an ear for an eye.[7]

Musical notation allowed the invisible vibrations of sound waves to be synesthetically converted to black marks on white paper. As a result, an individual versed in this specialized language could compose a piece of music without making a sound other than the scratchings of pen on paper. These transcribed sheets could then be given to another musically literate individual who would be able to reconvert the notations imaginatively, from the visual to the auditory sense, without making a sound. All this could transpire without a single audible note—truly the sounds of silence.

As a result of notation and the printing press, music could at last break out of the narrow confines of the *here and now*. Monodic melody, the narrow-ribbon highway for the transportation of music, developed a long fracture on its surface. Vast tracks of time and space seeped into the crack. Printed scores allowed any complex piece to be performed many miles away from, and many years after, the place and moment of its origin. The functions of composer and performer could definitively become separate.

Once music could be seen, its transitory, undulating essence could be stilled and analyzed. Much like the anatomists who were their contemporaries, fifteenth-century composers began to dissect harmony in an attempt to learn the nature of its underlying structure. They teased apart its components and carried out experiments until they perfected polyphony.

*Musical notation, having been invented in the eighth century, was continually refined in the ensuing centuries. It varied from one locale to another, however, because of poor communication between them. The printing press rapidly ironed out these local differences, creating a widely accepted standardized form of musical notation.

In the Renaissance, as we have seen, art first and then science discovered the third dimension of depth; so, too, did music. Chords—multiple notes struck at the same time—deepened the richness of music and, like perspective in art and the Copernican system in science, allowed it to be truly three-dimensional: Music could now be considered a three-dimensional aural geometry that was structured by the flow of time. Perspective enhanced depth in art and chords deepened the timbre of music. The incredibly expressive possibilities inherent in a music that was not only melodious but also polyphonic and harmonious lifted the curtain on a new age beginning in the late sixteenth century.

In order to prevent chaos, composers constructed their intricate new musical compositions on a grid consisting of the upright of key and the crossbeam of counterpoint. These two sturdy supports provided the great composers the means to scaffold simple motifs and melodies into towering aeries which would rival the Music of the Spheres. The Great Age of Music had begun.

The invention and dissemination of musical notation continued to create many different branchings within music. The most significant was that which split speech from song, because it hastened the development of two separate new art forms: instrumental music without words, and poetry without melody.[8]

In the oral tradition, poems are mostly sung and songs are in verse. Musical notation signaled the end of the age of minstrels and troubadours. Once written language could be conveyed in silence, the melody in poetry died away like a fading echo. The bleached-out remnant of the song became known as verse. In the fifteenth century, as the importance of song in Western culture diminished, poetry became ascendant.*

If the lyrics of songs became poetry, then the pure melody, the other half of song, was transformed into a wordless achievement known as instrumental music. Before written notation, music was rarely composed without including the human voice. The oral tradition had been so pervasive that hardly anyone had ever thought to compose a piece of music without words. In the sixteenth century, however, coincident with the beginnings of the great age of European poetry, music was composed primarily for instruments alone, and from that time until the twentieth century, except

*It is notable that in the modern era the cycle appears to have turned a complete revolution and we have witnessed song's rebirth and a decline in poetry's general appeal. Byron's, Keats's, and Shelley's romantic poetry has been supplanted by the songs of Cole Porter and the Beatles. More people know the lyrics of Bob Dylan than they do the verse of Dylan Thomas. Very recently, however, it appears that poetry is enjoying a resurgence as songs seem to be in decline.

for operas, masses, and song cycles, words disappeared from music sheets altogether. From the sixteenth century onward, words and music would begin to go their separate ways.

The disappearance of the written word from music took place at the same time writing disappeared from art. During the Dark Ages, when literacy was at its nadir, what there was of art concerned itself with the letters of the alphabet. People invested the ability to read with magic and made the word an object of worship. Written language became the reverential subject of art. Monks in monasteries illuminated manuscripts, such as the *Lindisfarne Gospels* and the *Book of Kells*, which in and of themselves were works of art; and calligraphy, the art of lettering, superseded drawing, the art of image.

In the Renaissance, Gutenberg's press again made words common enough that they ceased to be the icons of religion. The printing press, which had squeezed the melody from verse, began to grind the calligraphy from script. Clear, spare Carolingian letters, briefly used in the ninth century, reappeared to replace the filigreed, crabbed Gothics of the medieval period. During the period that composers wrote songs without lyrics, artists returned to making visual images without words. Then, from the Renaissance until the advent of modern art, words remained virtually absent from inside the picture frame, even though they appeared in a painting's title which was *outside* the painting itself.*

Coincident with the invention of the printing press, emphasis on analysis informed all disciplines. Around the same time that composers began using notational scores, artists began to rely on sketchbooks and scientists recorded their observations in notebooks. Leonardo and Alberti wrote treatises for young artists on the science and mathematics of art, and urged them to use their powers of observation and to study their subjects from nature, not from imagination. Meanwhile Francis Bacon outlined a new scientific methodology, which was also based on precise measurement from direct observation. And the vocabulary of measurement also appeared in music's new lexicon. Words such as "scales," "measures," "meters," "parts," and "pieces" were used in music as they were in science.†

Music, art, and physics shared other important parallels, chief among which was the organization of all three based on an intersecting horizontal

*It was not until Picasso and Braque reinserted fragments of writing into their twentieth-century Cubist paintings that calligraphy reestablished itself in art.

†The apotheosis of this trend in music was reached in the early nineteenth century when the metronome, essentially an upside-down timepiece, became commonplace is music just when the measurement of absolute time was at its height in science.

and vertical. Soon after artists began laying out the coordinates of horizontal and vertical, the basis of perspective, composers refined the coordinates of musical notation, key and counterpoint, using horizontal bar and vertical staff. Almost simultaneously, scientists were greatly aided in their work by the widespread use of scientific graphs which plotted functions, otherwise not visual, on an abscissa and ordinate.

A single, favored point of view became fundamental to all three disciplines. In perspectivist art, the entire canvas was designed to be seen by a passive spectator, standing in the favored location several feet in front of the painting. In physics, an external reality could be measured because the observer was peering at it through a telescope from a favored position of absolute rest. In music, the principle of a single point of view became manifest in the form of key.

The discovery that key could unify a composition came about in reaction to the florid exuberance of polyphony, which had transformed music in the late medieval period and was reaching a crescendo climax in the Renaissance. As composers attempted to create compositions of ever greater complexity, music became increasingly disjointed. But late in the sixteenth century a group of innovative Italian artists and composers formed the Camerata, intending to resurrect pure linear Greek music in response to polyphonic compositions that, to their ears, were beginning to sound cacophonic.[9] They called themselves the Camerata because they met "in camera" behind closed doors (*camera* in Italian means "room"), and they met clandestinely because during the Inquisition an attempt such as theirs to free music from the Church's authority could still be considered subversive.

In accord with the rise of Humanist sentiment, and the need to hear individual voices, around 1600 the Camerata introduced the idea of the *basso continuo*—a shorthand indication of bass line harmony running through a piece of keyboard music usually accompanying the singer—which returned clear organization and Greek linearity to musical composition. *Basso continuo* was like a thin stiff rod thrust through the entire length of a composition that lent to the piece a certain sense of unity. As with perspective in painting, the *basso continuo* served as a horizon line in that it created a regulative framework in which to fit the different melodic lines. A series of harmonic chord progressions were explicitly defined and sounded by the *basso continuo*.

The idea of a home key arose in musical composition about the same time and embodied the same unitary principle. The *basso continuo* contributed to composers' early recognition of the importance of a unifying

key. Key became the favored and privileged tonal center of a composition, corresponding to the perspectivist viewpoint in art and absolute rest in science. One of the founding members of the Camerata was the peppery theorist-composer Vincenzo Galilei, the father of Galileo. The elder Galilei played an important part in introducing the concept of *basso continuo* which contributed to the acceptance of a home key. A single key corresponds in principle to the inertial rest frame in science coincidentally discovered by his son!

From the time the concept of key was established, beginning in the late sixteenth century, and continuing well into the nineteenth, a composer selected a specific key for each composition and rarely ventured far from this unifying construct. The single home key, like the focal point of perspective and the concept of absolute rest, represents a world whose point of view is monocular and mathematically organized. This principle allowed each discipline to order the parts of any of its compositions into a hierarchical and coherent set of relationships. Alberti's perspective, Newton's *Principia*, and J. S. Bach's *Art of the Fugue* each manifests this singular notion, and all represent nothing less than the reordering of thought itself.

As the Camerata stressed individuality, so the voice of the single performer unequivocally stood out in the Renaissance for the first time in the history of Western music. From the Greek chorus to Gregorian chant, singing had been largely communal, but as the individual was separated from the chorus, a form evolved to accommodate the solo voice: opera. The first opera, *Daphne*, by the Italian composer Jacopo Peri was performed in 1594.

The Renaissance citizens were eager to delve into all the pursuits of knowledge and creativity now available to them. Since great public libraries did not exist, every Renaissance Humanist who aspired to assemble one had to create a room to house these artifacts of the new age. The personal library emerged as a consequence, a special room in which to learn and study. It was also a place in which each Humanist could develop his own individuality. Along with the requisite shelves of books, a proper library was equipped with a writing table, where the newly literate individual could express his private thoughts in words. In another corner stood a telescope, a device owned by all who considered themselves part of the new age. The telescope, like the microscope invented around the same time, offered the inquiring eye a way to increase its observational power. These devices were singular: Only one Humanist at a time could peer through either. Gazing at the moon or examining a paramecium was as solitary an endeavor as reading or writing.

Another prominent item in the Renaissance Humanist's library was an earth's globe, which represented the triumph of the new Copernican perspective and offered its owner a God's-eye view of the spherical planet anytime he was so inclined.

Easels were fairly common as well, since the invention of stretched canvas and oil-based paints had allowed painting to become a portable hobby, and virtually every literate person practiced draftsmanship. To be able to draw from direct observation was not only a highly esteemed skill, it was also another way for the Renaissance Humanist to express his singularity. The credo of Humanism, "See the truth and be the complete man," expected nothing less. Thus the library gradually expanded to contain the means to define each person's individuality.

The Humanist's library would not be complete without music. Since reading, writing, gazing, and drawing were all solitary pursuits, it is no surprise that the Renaissance imperative to individuality gave rise to the most versatile musical instrument ever invented for one player: the keyboard clavichord. At the outset of the Renaissance, small claviers had been developed for personal use. Their sound was tinny because the player had no control over the force with which each string was struck by the hammer; nevertheless the arrangement of the presently used keyboard, common to all later pianos, dates from the early fifteenth century.*

The keyboard clavier-piano was a most perfect instrument. While it could be incorporated into a larger composition, it could also be played alone for one person's solitary enjoyment. On it, one could play chords, different simultaneous parts, and complex pieces, while leaving one's voice free to sing too. Due to its versatility, it has had composed for it the largest body of eclectic music written expressly for any one instrument; yet, in recognition of its place in the secular sphere, almost none of that music has been sacred.

Now the room was complete. The symbol of the Humanist's musical individuality, the clavier-piano, occupied a central place in the library. It joined the writing table, telescope, globe, and easel. These devices, along with the books lining the shelves, constituted the heraldry of a new separateness. The Catholic Church, Western civilization's organizing force for a thousand years, discovered a formidable assemblage of new icons arrayed against it. As a result of the ensuing struggle, Christianity was to undergo

*The beginning of the modern piano wasn't until 1709, when Bartolomeo Christofori, employed as a full-time keeper of Ferdinand de Medici's harpsichords, invented a mechanism that moderated how each hammer struck each string. This innovation, later refined in Germany, would permit the piano to become an instrument of great range and versatility.[10]

its own revolution: the Reformation, the crux of which was the belief that an ordinary congregant could read and interpret the Bible without the help of the Vatican.

With all the options available to them at the beginning of the sixteenth century, composers were naturally drawn to themes and their variations. As scientists used the rules of logic to construct detailed explanations of the world's workings, and artists created complex paintings organized about the laws of perspective, so composers explored *development* in music. In this form of musical analysis the composer states a theme and then exhaustively explores its variations. The complicated scaffolding of a single theme in the diverse compositions of Handel, Haydn, Mozart, Beethoven, and Brahms was possible because they all accepted certain agreed-upon conventions of music, the most basic of which was the unity of key. Mozart, and later Beethoven, were masters of the intricate manipulation of theme and variation. The seventy-piece symphony orchestra emerged early in the nineteenth century to serve as a vehicle for this unique form.

One result of this pervasive mind-set was that the observer was split off from what he observed in science, the viewer was separated from the landscape in illusionist art, and the audience was divorced from the performer in music. Classical music listeners sat in neat rows that resembled the repetitive lines of type on a printing press and behaved like silent viewers standing outside the frame of a perspectivist painting, or scientists quietly observing the sky through a telescope. The rules of etiquette increasingly demanded that audience members of a musical concert sit passively and not tap their feet, sing, move, or even cough. The music we think of today as classical included no audience participation; there were no operatic sing-alongs.

The singular point of reference that expressed itself as the central home key of a composition beginning in the late Renaissance reached the epitome in the late eighteenth century in the person of an orchestra's conductor. The one person in the orchestra who did not play any instrument, he was yet the focus of the music. The entire orchestra was placed in such a way that the sound issuing forth from each instrument converged upon him. In this regard, the conductor resembled the viewer of an illusionist painting in that all lines of sight converged on one point. These works were planned as if they were to be seen by a monocular eye. The conductor of an orchestra was this eye's counterpart, a cyclopean ear, as it were. Like the sun in the Copernican system, he stood in the very center of a musical system, the orchestra cupping him on one side and the audience on the other.

By the middle of the nineteenth century, the respective citadels of art,

physics, and music each had as its foundation a comprehensive hierarchical structure that seemed secure. Startling new discoveries in all three fields would change them radically. Both the composer and the artist anticipated the trumpet blast that would bring down their walls. The modern painter introduced a solitary musician playing a Dionysian reed instrument. Featured first in a work by Édouard Manet, *The Fifer* (fig. 10.1), and developed further in one by Henri Rousseau, *The Snake-Charmer* (fig. 11.3), this figure was soon resurrected by many different artists playing the haunting monodic melody of mythological times. The lone musician became the leitmotif of the new age. While the public was still applauding Beethoven's complex crescendos, the visual artists had presciently intuited the coming upheaval that would revolutionize art, music, and physics. As we shall see, composers, too, insinuated into their music the beginnings of this radical change.

In the early years of the twentieth century, music was caught up in the same turmoil that enveloped art and physics. These changes were so profound that the Western world would never again be the same. While the principal events of the Renaissance were scattered over a two-hundred-year span, a profound compression took place in the few years around 1905. In 1899 in Vienna a chamber group performed the first major composition by the young Arnold Schoenberg, a string sextet entitled *Transfigured Night* that contained an unusual programmatic nature and strange harmonies which outraged conservative program committees. Schoenberg developed atonality in his 1909 *Opus 11, No. 1*, the first Western composition since the Renaissance to dispense completely with "tonal" means of organization.

Atonality was a dramatic departure from previous forms of music because it destroyed the central unitary principle of a home key. In an atonal composition there is *no* key. Each note has the same *relative* importance as all the others. As a result, dissonance becomes harmony. A Viennese critic called Schoenberg "a man either directly devoid of sense or one who takes his listeners for fools. . . . Schoenberg's opus is not only filled with wrong notes . . . but it is a fifty-minute-long wrong note."[11] Thus Einstein pulled the stool out from under the stationary observer in science at the same time Schoenberg finally dethroned the two-century reign of King Key. Since Picasso and Braque soon replaced the singular viewpoint in art with the multifaceted vantage of an insect's eye, relativity found concurrent expression in physical theory, the visual arts, and music.

Like relativity and Cubism, atonality did not emerge from nowhere. It was the conclusion of a progression that had begun with Beethoven, who experimented by wandering away from a home key in his later works. Later

in the nineteenth century, Richard Wagner began to modulate from one key to another, disconnecting his motifs much as Cézanne was doing in his still life compositions. In the 1880s, fascinated by Eastern music, Claude Debussy began to compose music that departed from the unifying influence of central tonality. His musical "Impressionism" in *Prélude à l'après-midi d'un faune* (1894) ran parallel with the impulse of painters of the same era.

Richard Strauss assaulted the citadel of key from another direction, combining many different keys all at once. Inasmuch as each key constitutes a unique musical perspective, his use of polytonality can be likened to the principle of Cubism. A century of musical trends culminated in Schoenberg's "special (musical) theory of relativity," which was consonant with Einstein's democratic principle regarding the Galilean inertial frames of reference in time and space. Einstein had declared all frames equal; Picasso and Braque had shown all vantages to be equally correct; and Schoenberg sounded the equality of all tones and keys.

Schoenberg then carried this egalitarian principle to its logical extreme. In 1921 he imposed a new restrictive set of rules for atonal music with his twelve-tone method or dodecaphony. In this variation he asserted that no tone in the scale, including both sharps or flats, could be repeated until all twelve had been played. In dodecaphony not a single tone could be said to be favored because each note would have to be heard before any other one could be played again.

The atonal composers also tampered with time. Anton Webern, a student of Schoenberg, compressed one piece into nineteen seconds[12] and focused the listener's attention on the element of time. Since the Renaissance, musical time had obeyed a linear rhythm. Intervals for the most part had a regularity that was reassuringly predictable and fit right in with Newton's ideas about invariant time and determinism. Igor Stravinsky, the other great innovator to match Schoenberg, radically revised this by abruptly varying any semblance of a predictable tempo. He juxtaposed rhythmic dissonances with sudden changes so startling they unsettled his listeners. The first audience to hear this musical heresy became, as might have been expected, disoriented. In 1913, at the premiere of Stravinsky's *Le Sacre du Printemps*, the audience erupted in a riot during the performance. This sort of outburst was so rare, so seldom witnessed in the staid concert halls of Europe, that everything degenerated quickly. While members of the audience traded punches, the composer escaped into the night through a rear window. Among the other various reasons for this riot, Stravinsky had dared to challenge the idea of absolute metronomic time. The audience's reaction to a musical tempo that alternately and dissonantly compressed

and then dilated is a replica of how difficult it has been for the public to understand Einstein's notions of relative time.

Concurrent with these developments in classical music, Dixieland jazz emerged out of America and took Europe by storm with its recollections of medieval polyphonic music and the art of the mosaic. In Dixieland, many musicians play separate melodies within a single complex piece. The melody, broken into multiple, distinct, and seemingly disorganized fragments, resembles nothing so much as a Cubist painting.

The innovations introduced by the new composers of classical music and jazz were variations in the form and content of music. At the outset of the twentieth century, however, the most fundamental change to occur in music was in its *process*, that is, in the way that music was propagated through space and time. In the entire history of music, this transformation was the most profound.

Since music is sound, and sound cannot exist in a vacuum, music must therefore be transported on the wind. Until this century music had been mediated *only* by air. Sound waves are made up of tiny oscillating individual molecules and atoms. Although a wave, sound depends on corpuscular atoms of oxygen and nitrogen which make up the entity we call air. The kinetic energy of music dissipates over very short distances. As anyone sitting in the last row of the third balcony knows, air tires easily, and the music it carries soon dies out, to be lost forever among the jumble of the other colliding atoms and molecules that constitute the atmosphere.

Einstein in his stunning 1905 tour de force had elevated light to a preeminent position as the true constant of the universe. Minkowski also revealed that space and time are alloyed into a unity by the connecting shaft of pure light. It was at this time that music ceased to be a "thing" composed of oscillating molecules and instead became a "process" that glowed incandescently. Music converted into light.

The foundation for this amazing transmutation began in 1886, when Heinrich Hertz, a German physicist, detected the presence in the atmosphere of an electromagnetic wave that had an exceedingly long wavelength. The wavelength of visible light (the distance between peaks) is measured in nanometers, which are each 1/25,400,000 of an inch. The distances between peaks of Hertz's newly discovered waves could be measured in yards or even miles. They confirmed James Clerk Maxwell's 1873 pronouncement that electricity, magnetism, and visible light were just different manifestations of radiant energy. Hertz called these long, gentle

undulations "radio waves." Although radio waves are at the far end of the electromagnetic spectrum and are invisible, they are a form of light. When reporters asked him what practical application his new radio waves might have, Hertz replied that he didn't know, but he was sure someone would soon find a use for this invisible form of light. He could not anticipate that soon this light no one could see would become music everyone could hear.

In 1895 Guglielmo Marconi converted agitated, compressed molecules of sound into pure light in the form of radio waves. So transformed, the sound of music could then hitchhike a ride on these silent waves. Marconi put sound through a metamorphosis that began when sound waves struck sensors in the diaphragm of a microphone. These sensors converted the crowded waves of air into a varying electric current that traveled deep into the innards of his technical marvel called a radio transmitter. These signals then rushed up a tall thin metal rod called an antenna from where they propagated into space as an insubstantial radiant light that could cross empty space without needing any medium. Marconi's radio transmitter generated sound that had been converted into light (Figure 19.1).

The antennae of radio transmitters are shaped exactly like the previous millennium's Gothic cathedrals' spires that reached for the heavens. But the spires of Chartres are mute, and this new scientific creation vibrates

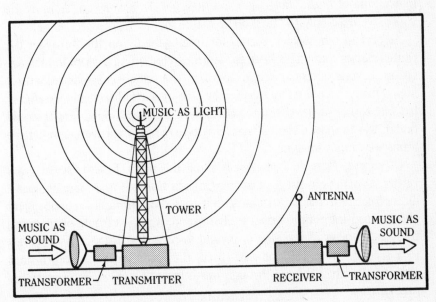

Figure 19.1. *The transformation of music into light*

at a frequency consonant with the silent music that is now light. It can traverse a vacuum and can penetrate soundproof walls. It spreads out from the antennae like the ripples on a pond at 186,000 miles per second in all directions. Because the ionosphere reflects these radio waves back toward the earth, they even reach over the curvature of the globe.

The radio transmitter's antenna is only one tine of a tuning fork, however. Its ethereal emanations must find the other tine before they can be converted back to sound. In other words, these radio waves must strike another antenna whose tuner is set to the same frequency. By simply turning on a radio that has an antenna and scanning the different frequencies on the dial, we allow the magical, soundless music to find its voice, which is what we hear emanating from our radio speakers. The cycle of transubstantiation is now complete. What began as air is once again air. What was broadcast miles away can be heard as if distance did not exist.

Because of music's transubstantiation into light, space has contracted like an accordion, and a vast, invisible electromagnetic net has been silently cast over all of humankind. Wherever we move, wherever we go, we are immersed in this gossamer veil we cannot see, smell, taste, or hear. It appears to travel with impunity right through our bones, heart, and brains. Every cubic foot of space on this planet is alive with the scintillating dance of crisscrossing electromagnetic waves carrying broadcasts of every imaginable kind of music, language, and message. To borrow an idiom of the 1960s, we need only to "turn on and tune in."

As part of our species' search for intelligent life in the universe, the United States flung a *Pioneer* space probe containing a graphic message far out beyond our solar system in 1972. The scientists associated with it hoped that it would be intercepted by some galactic beachcomber after it left our corner of the cosmos. Newscasters speculated upon how it would find its way to some distant planetary system to be turned over in prehensile limbs we cannot imagine.

Of course, Marconi had already done the same. Seventy-seven years earlier, a small percentage of the magic light from his first radio broadcast did not get reflected back to Earth but passed on through the ionosphere and escaped into outer space. Unlike sound, light is capable of spanning the void. It takes eleven days for sound to cover the distance light travels in a second. From 1895 onward, then, the incoming light from distant stars has had had to pass through our outward-bound radio wave transmissions.

Imagine the excitement that will be generated when some lone radio

ham, on a distant planet orbiting a different sun from ours, one night just happens to turn on and tune in to Earth. What a surprise will unfold, because it is all there—the entire history of the twentieth century as well as music since the Renaissance. Our new radio audience will be able to listen to all our electromagnetic radio transmissions falling on their planet as light from their sun falls on ours. They will hear our extraordinary talents and momentous events as they arrive encoded in these waves. Out somewhere beyond Alpha Centauri, there exists in an ectoplasmic state the messages of Amos and Andy, Adolf Hitler, and Bishop Fulton Sheen, and the music of Ludwig van Beethoven and Bing Crosby. Beginning in the Renaissance, music was recorded through notation. Because of it, the constraints of time were overcome. Now as a result, we can listen to the ensuing centuries' music. Radio has superseded the constraints of space as well because by converting music to light, Bach and Mozart will resound in outer space forever.

Anyone receiving our early broadcasts would be tuned to musical trends and historical events that have already happened here on Earth. Because of the time it takes light to traverse space, they will not know the outcome; having to wait in nail-biting suspense, like children at a Saturday matinee, to find out who wins World War II or the answer to the crucial question of whether we ultimately destroy ourselves in an environmental apocalypse.

With the advent of television we have dramatically increased the outpouring of light-as-information. Now our stellar audience can see what we look like as well as how we sound. The soap opera called the Twentieth Century has expanded out from Earth in a bubble of ghostly light. If, as some astronomers have speculated, there are many different planets out there capable of containing intelligent life, more and more planets will tune in as our programs fan out across space, and soon music and our story will be heard and seen at different times in different places from one end of the universe to the other.

Since the dawn of the age of radio astronomy in the 1960s, we have been able to detect all kinds of hitherto unseen objects in space, some of which emit prodigious amounts of energy. Of course, in the short span of ninety years, we have become a hot spot in space ourselves. As radio and TV transmitters continue to proliferate all over the globe, Earth has started to twinkle as a new item in the intergalactic *TV Guide*.

On the day our electronic net is cast upon the shores of an alien intelligent planet, so too might that be the precise moment their early broadcasts reach us. If they know enough to receive ours they would already have

sent us their version of *As the World Turns*—whatever that may be. If this were to happen, our planet's community of Homo sapiens would enter a new phase of evolution: Our solitary existence will have come to an end.

Life's first experiment was as a one-celled organism. Gradually, over billions of years, these cells formed a network to become a primitive, multicelled organism. Although every cell retained its own individuality, each cell was part of the greater whole. They were connected to one another by a primitive nervous system that consisted of electromagnetic and electrochemical signals. Perhaps we can think of our earth as a one-celled organism that one day will become part of a larger organism, enmeshed by the electronic net of each other's transmissions.

The eerie part of this highly likely statistical probability is that the reciprocal civilizations and planets from which the messages originated will have vanished by the time these messages are received. The music, people, networks, towers, and possibly the earth itself that generated all of our transmissions may also have ceased to exist. Yet all the programs will live on because of the length of time it takes for each transmission to cross the far reaches of outer space. The legend of the lost continent of Atlantis will be born again, but this time it will apply to civilizations that are not under waves of water but exist only as radio waves of light. Because of the constraints of Einstein's special theory of relativity we will never know if they still exist and they too will puzzle over this unanswerable question regarding us. We will all shimmer, like poltergeists, in the *??else-where??* of one another's Minkowskian spacetime diagrams.

For centuries, poets, lovers, and mystics have been praising one form or another of music as eternal. These paeans were premature since sound lasts only a few seconds. But when the first radio wave music escaped Earth's ionosphere, it literally did become eternal. As it filtered out through Earth's atmosphere, light began a journey into the places between the stars. Music, in this century, has been converted from sound into the clarity of pure light.

Another revolutionary implication of the conversion of music into light is that it can be stored, either as a light interference pattern on a magnetic tape or on a laser disk. Either way, listeners no longer have to sit passively waiting for the orchestra to begin a scheduled performance. By simply choosing from their tape or compact disk collection, music lovers can re-create more music at their whim than all the orchestras that existed in the nineteenth century put together. Furthermore, the listener chooses the time and place for the performance. Now, the audience can actively

participate in the phenomenon of music which, of course, is identical to the core principle found in the world of the atom: observer-created reality.

Thirty-five thousand years ago a solitary Paleolithic tribesman blowing across his reeds set in motion a holy vibration. Its reverberations against the cold, dark walls of the cave set up the resonance we call music that has carried forward throughout the ages. Much later, the monodic music of the Greeks followed the line of Euclidean geometrical principles. In the medieval period, music intertwined in the tapestry of that spiritual age. Beginning in the Renaissance, the composer organized music along the identical principles existing in perspectivist art and Newtonian science. In the twentieth century, music has been transformed in style, content, and form at the same time these changes were taking place in art and physics. The transubstantiation of music into light is the grand finale that expresses Einstein's enthronement of light as the quintessence of the universe.

The real problem behind these many controversies was the fact that no language existed in which one could speak consistently about the new situation. The ordinary language was based upon the old concepts of space and time . . .

Werner Heisenberg

I have been found guilty of the misdemeanor known as . . . making light of Einstein.

e.e. cummings

CHAPTER 20

LITERARY FORMS / PHYSICS FORMULAS

W hen asked late in his life to catalogue the most important influences upon his thinking, Einstein declared, "Dostoyevsky gave me more than any thinker, more than Gauss."[1] Einstein's stepdaughter reported that her father's favorite of the author's works was *The Brothers Karamazov*.[2] In this book, published in 1880, Dostoyevsky wrote:

And therefore I tell you that I accept God simply. But you must note this: if God exists and if He really did create the world, then, as we all know, He created it according to the geometry

of Euclid and the human mind with the conception of only three dimensions in space. Yet there have been and still are geometricians and philosophers, and even some of the most distinguished, who doubt whether the whole universe, or to speak more widely the whole of being, was only created in Euclid's geometry; they even dare to dream that two parallel lines, which according to Euclid can never meet on earth, may meet somewhere in infinity. I have come to the conclusion that, since I can't understand even that, I can't expect to understand about God. I acknowledge humbly that I have no faculty for settling such questions, I have a Euclidian [sic] earthly mind, and how could I solve problems that are not of this world?[3]

In acknowledging that the novelist affected him more than the discoverer of the first non-Euclidean geometry, Einstein tacitly recognized Fyodor Dostoyevsky as the first major literary figure to discuss both a fourth dimension and non-Euclidean geometry. As we will see, these two ideas were the rough nuggets that later became the diadems of both the special and general theories of relativity.

This anecdote serves to introduce the notion that literature, like her sisters, music and the visual arts, also anticipated the major revolutions in the physicists' worldview. In addition to the connection between science and literature, which we shall examine in this chapter, there is a well-documented close congruency between the verbal and visual arts that can be traced all the way back to the seventh through fourth centuries B.C. in ancient Greece. Then, three new literary forms—poetry, drama, and philosophical discourse—emerged in the West around the same time that sculpture, painting, and architecture flowered. As Greek natural philosophers were the first to consider and analyze the physical workings of the world independent of the machinations and interventions of gods and goddesses, so too in the visual arts the Greek classical tradition introduced the revolutionary idea that art's primary function was to please the eye of the beholder rather than to placate a deity. The classical culture's aesthetic considerations clearly superseded religious ones. There was, similarly, one crucial precondition before the literary arts could develop. The nascence of Greek poetry and drama was rooted in a tacit agreement that the storyteller was creating a fiction. In other civilizations, epics and tales were based on either religious myth or tribal legend, and listeners assumed the story was literally true. From the time Homer provided his listeners with his embroidered version of the Trojan War, and continuing until many

Greek writers literally made up stories that had no basis in fact, all of Western literature and drama have flowed from the basic tenet that it is permissible for an author to fabricate a story. While rational doubt, the right to *suspect* the truth, became the foundation of all science, its antipode, poetic license, the right to *make up* the truth, became the substrate of all literature. The "willing suspension of disbelief" Coleridge advocated for a reader is the best-known modern interpretation of this long, artful tradition.

The Romans continued the Greek tradition, harnessing their creativity to the Greek forms that were their models. Despite its exceedingly long run, the Pax Romana for some mysterious reason did not stimulate the playwrights' imagination. As testimony to the pragmatic Roman character, there are more Roman amphitheaters than memorable Roman playwrights.

The Roman Empire's loss of its papyrus-producing colonies in its final years resulted in a severe shortage of paper. This shortage led to reduced communication among the distant reaches of the large empire. McLuhan has proposed that the key factor that pushed Rome down the slippery slope to calamity was this shrinking of the written word, "For the Roman road was a paper route in every sense."[4]

With the fall of the Roman Empire in the fifth century A.D., the kindling crackle of the Western world's innate creativity and curiosity was virtually snuffed out. At the onset of the Dark Ages the written word, so treasured in the previous age, became the enemy of both barbarian and the Church. After the former torched the classics out of ignorance, the latter torched them out of zeal. We will never know what literary treasures were lost when the famous library at Alexandria was set afire by warring factions in the late third century A.D. In the God-drenched sixth century, Pope Gregory X ordered whatever remained of all secular manuscripts consigned to flames lest those tainted pagan writings detract from the Bible's purity. He did not want a single follower of the new religion to spend even a moment contemplating the profane. The sacred saturated the age of early Christianity.

The scope of this literary holocaust can be measured only by the fact that no secular literary achievements survived the Dark Ages. The Greek tradition, once a sturdy braid connecting minds on the far-flung islands of the Hellenes, became in this shadowy historical period the most fragile of threads, and Western civilization came close to losing forever the precious legacy of its parentage. In a fateful twist of irony, it was the world of Islam, the sworn enemy of Christendom, that protected the birth records of Europe's past during the West's long fog-enshrouded night. The Arab culture flourished from the seventh to the tenth centuries and, using translated

classical texts, made many significant contributions to the arts, medicine, and science.

After a Western amnesia of a thousand years, the precious foundations of the Greeks began to resurface in Europe in the second millennium as a result of the Crusades. The Crusaders' avowed objective was to return Jerusalem to Christian hegemony. Although they failed, through contact with the Levant they received an unexpected and far more valuable prize —Greek knowledge. The European tempo of acquisition of secondhand classical texts containing the West's heritage gradually increased through the Middle Ages, when, as logic, doubt, and literacy spread, the conditions were once again in place for the efflorescence of literature.

Because they did not have a thorough knowledge of Greek antecedents, isolated medieval writers for the most part had to create their own literary forms. The born-again literature of the medieval period reflected that era's Christian paradigm concerning space, time, and light, which held that space was discontinuous, time disordered, and light a spiritual essence. The idea of simultaneity was routinely interposed with sequentiality, resulting in a haphazard application of the laws of causality. Medieval writing resembled medieval mosaics.

Authorship was also a mosaic in the medieval period. Texts of this period do not give voice to the uniqueness of an individual author's "point of view." E. P. Goldschmidt, in his book *Medieval Texts and Their First Appearance in Print*, writes that

> before 1000 A.D. or thereabouts people did not attach the same importance to ascertaining the precise identity of the author of a book they were reading or quoting as we do now. We very rarely find them discussing such points. . . .
>
> Nowadays, when an author dies, we can see clearly that his own printed works standing in his bookcases are those works which he regarded as completed and finished, and that they are in the form in which he wished to transmit to posterity; his handwritten "papers," lying in his drawers, would obviously be regarded differently; they were clearly not considered by him as ultimately finished and done with. But in the days before the invention of printing this distinction would not by any means be so apparent. Nor could it be determined so easily by others whether any particular piece written in the dead author's handwriting was of his own composition or a copy made by him of somebody else's work. Here we have an obvious source of a great

deal of the anonymity and ambiguity of authorship of so many of our medieval texts.[5]

Writers of the medieval period did not maintain a consistent "point of view" in their works, as is evidenced by Chaucer's *Canterbury Tales* in the fourteenth century. There are three narrators in Chaucer's work: the pilgrim, the poet, and the man. For modern readers, it is demanding and sometimes confusing to have Chaucer switch back and forth between one narrator and another, each of whom happens to occupy the same physical body in space. However, the nonlinear writing that accompanies this multiplicity of points of view does not excuse the reader from keeping them distinct from one another.

Similarly, it is difficult to read Erasmus, whose *Praise of Folly* straddled the period between the Middle Ages and the Renaissance. Although he was a contemporary of Gutenberg and the first writer to recognize the power of the printed word, Erasmus's style remained firmly rooted in the medieval paradigm expressed best by the mosaic in art. There is no single "point of view" in his prose. Folly is the opposite of Wisdom, yet when one reads this trenchant satire it is difficult to know who is speaking; sometimes Folly, sometimes Wisdom, and many times it seems to be Erasmus himself.

An example of this type of writing occurred even as late as the sixteenth century in this typical paragraph from the sixteenth-century writer Thomas Nashe:

> Hero hoped, and therefore she dreamed (as all hope is but a dream); her hope was where her heart was, and her heart winding and turning with the wind, that might wind her heart of gold to her, or else turn him from her. Hope and fear both combatted in her, and both these are wakeful, which made her at break of day (what an old crone is the day, that is so long a breaking) to unloop her luket or casement, to look whence the blasts came, or what gait or pace the sea kept; when forthwith her eyes bred her eye-sore, the first white wheron their transpiercing arrows struck being the breathless corps of Leander: with the sudden contemplation of this piteous spectacle of her love, sodden to haddock's meat, her sorrow could not choose but be indefinite if her delight in him were but indifferent; and there is no woman but delights in sorrow, or she would not use it so lightly for everything.[6]

Following his train of thought is difficult because Nashe superimposes different times and varied locations one upon another, and the transitions between his thoughts are often disjointed. His writing is not constructed upon an ordered latticework of time and space.

Despite these impediments, it is well to remember that it was the writer's tacit acknowledgment of these two coordinates in the early 1300s that created the conditions for a new literary form to emerge known as the novel. Like the adjective from which this noun takes its meaning, the novel was something radically new. Its authors tentatively began to adhere to Euclidean space and Aristotelian time, spinning out their tales from an increasingly unitary point of view. Unlike their predecessors in medieval literature, early Renaissance narrators began increasingly to confine themselves to either the first- or the third-person singular. They began to pay attention to causality's laws, and by so doing were able to join together a long series of successive word pictures describing objects and people located in permanent space and flowing time. Causality in literature thus anticipated causality in science by well over a century.

Giovanni Boccaccio's *Decameron*, the first proto-novel, appeared in Italy in the mid-1300s at the same time Giotto was developing proto-perspective. Boccaccio's series of loosely connected ribald tales marks the beginning of long stories composed of multiple, intricate plots. As with Giotto's painterly style, the principle implicit in Boccaccio's literary form was that the reader and viewer always had a privileged perspective. Galileo would say as much for science 250 years later when he proposed that the position of rest within an inertial frame of reference was the favored place from which to view and measure the world.

In the novel, the plot was the organizing armature upon which the story was coiled. A plot is a plan of action; its components are foreshadowing (clues), climax, and dénouement or conclusion. The concept of the novel's plot has many features in common with the perspectivist point of view in painting. For example, both provide a unitary principle that organizes a large amount of data: In a painting, it is visual data; in the novel, it is verbal data. The novel form allowed a writer to collate a series of short stories into a long, integrated work containing many details, subplots, and characters; similarly, the artist's use of perspective created the framework for complex compositions that melded together a group of disparate, smaller scenes. Later, scientists would use Newton's system to organize a complex series of separate motions, forces, and masses to place them in their proper relationships in time and space.

Because paintings with perspective and books with plots were enthusi-astically accepted by the educated Renaissance public, both the viewers of paintings and the readers of books became more introverted and less in-volved with their community of faith.

A reader of the novel gradually stopped reading out loud, a practice common in the medieval period. Before the Renaissance, reading was a communal and cacophonic activity in the monasteries. During the tran-sition from an oral culture to a visual one, the ear still needed corroboration of what the eye was seeing on the printed page. In order to know what he was reading, a monk had to actually hear himself. The words pronounced were the "voices of the pages" reinforcing the monks' visual memory of the written word with a laryngeal muscular one. But a room full of reading monks set up such a din that it could drown out individual concentration; therefore, there appeared monastery "carrels" (reading rooms) which di-vided a room into little cubicles, much like university language laboratories today.[7]

Coincident with the advent of perspective, readers became silent. Monks from the medieval period would be astounded to learn that ensuing gen-erations read silently. In doing so, readers placed themselves quietly in the hands of the author. Novels had no chorus; the reader was dealing directly with the author. The reader of a novel felt more distanced and less involved with the outside world than when reading the Bible in church. A dispas-sionate detachment from human relationships would be fundamental to a science like Newton's that had to rid itself of the *argumentum ad hominem* mentality that dominated the preceding age.

The shift from the medieval context of simultaneous multiple characters, points of view, and events to the literary conventions of the late Renaissance where one character began to occupy one location in space at one moment of time was dramatic. Narrative gradually began to flow in a linear direction. Time became sequential and individuals emerging from a mosaic stood out in their singular significance. These changes in literature from one his-torical era to another correspond to the similar changes that occurred in art as a result of the artist's discovery of perspective.*

The novel progressed haltingly from its inception until the early eigh-teenth century when Joseph Addison and Richard Steele in collaboration

*This shift occurred even in drama. When Greek drama was resurrected as an art form in the Renaissance, the layout of theaters copied the nearly circular Greek amphitheater. As single point of view gained importance, however, theaters-in-the-round soon gave way to proscenium-arch stages presenting to the audience fixed scenery and a one-sided view of the action. This development made each audience member resemble a viewer of an illusionist painting.

published *The Spectator* in 1711. In this work, Addison and Steele introduced the concept of *equitone prose*: a literary device that restricted the narrator to a single consistent tone.[8] Their 555 essay-novellas were intended by their authors to improve morals and manners as well as to popularize new ideas in the sciences. Enthusiastic popular acceptance also ensured that equitone prose took root. Equitone prose is the auditory equivalent of the fixed view in perspective, the central place of key in music, and absolute rest in science. Once established, the novel, like art, music, and science, did not undergo any radical changes in its essential structure until the mid-nineteenth century.

From the Renaissance onward, Cervantes's *Don Quixote* (1605), Defoe's *Robinson Crusoe* (1719), Sterne's *Tristram Shandy* (1761), and Rousseau's *Julie, ou la Nouvelle Héloïse* (1761), each testified to the variety and suppleness of the novel as a literary form. Yet all these works faithfully adhered to the structure and rules of causality. Prose was rational and the narrative was clear, both of which practices were associated with the period's reverential regard for the Newtonian ideas of absolute time and space. In these early novels the narrative flowed in only one direction in time—there were no flashbacks—and the setting of the story was like the well-lighted stage of a perspectivist painting, each scene a carefully crafted description painted with words instead of pigment.

In the late eighteenth and nineteenth centuries the novel became the dominant literary form throughout the Western world: Jane Austen, the Brontës, Dickens, and Sir Walter Scott in England; Stendhal, Dumas, and Victor Hugo in France; Dostoyevsky, Tolstoy, and Turgenev in Russia; and Melville and Hawthorne in America. All these writers had their own distinctive styles, yet each worked within the conventions of a unitary plot unfolding in time and action transpiring in a delineated space.

In 1857, long before the physicists began to question the mechanistic paradigm, Gustave Flaubert wrote the first thoroughly modern novel, *Madame Bovary*, which contained narrative concepts that later would be restated scientifically by the new physics. This book was conspicuous because Flaubert concealed his personal point of view. He related his characters' stories and expectations neutrally, without judgment or opinion. Equally revolutionary, he veered away from equitone prose, introducing multiple points of view, as Cézanne later did in painting. In the very first line of his book, "We were in class when the headmaster came in . . ." Flaubert abandons the singular-person narrative and signals to his readers that Western literature and, as it turned out, Western civilization were finished with the favored, privileged frame of reference.

The absence of a pronounced authorial voice in *Madame Bovary* is a manifestation, I believe, of Flaubert's lifelong feeling that language was too limited to express any significant thought. The later failures of language to explain the concepts of the new physics or to clarify modern art's images seem to justify Flaubert's artistic apprehension.

In abandoning a personal point of view, Flaubert simultaneously smeared the single point of view that had traditionally been the reader's guide through the matrix of the temporal and spatial events in fiction. His critics objected to his invisible and neutral narrative role, claiming that his style eroded the dynamic flow of the story and left his experimental novel flat and uninteresting. Flaubert's deviation from literary conventions had its analogy in Manet's departure from the academy's visual forms. Manet, too, flattened his composition and, like Flaubert, challenged the conceptual underpinnings of society's assumptions, which were based on absolute space and time, and consistent causality.

Meanwhile, single-point perspective in literature suffered another setback in America in 1843. Edgar Allan Poe invented a new form for the novel. *The Gold Bug* was the first mystery novel, or whodunit, as it came to be known. Poe concealed the intricacies of his plot so that the reader knew only as much about it as the butler or the detective. Readers and characters alike solve the story's mystery (almost) simultaneously. By eroding the privileged frame of reference, the mystery novel subverted the reader's favored point of view quite as thoroughly as Flaubert subverted the author's.

Poe is remembered as a tortured poet and brilliant novelist who examined the dark side of the human psyche. What is not generally known is that Poe had an intense interest in the philosophical debates regarding the nature of reality. With a precognition that is startling, Poe's 1846 long metaphysical essay *Eureka* includes the following:

> *Space and Duration ARE ONE.* That the Universe might endure throughout an era at all commensurate with the grandeur of its component material portions . . . it was required . . . that the stars should be gathered into visibility from invisible nebulosity . . . and so grow grey in giving birth and death to unspeakably numerous and complex variations of vitalic development—it was required that the stars should do all this —should have time thoroughly [*sic*] to accomplish all these Divine purposes—*during the period* in which all things were

> effecting their return into Unity with a velocity accumulating
> in the inverse proportion of the squares of the distances at which
> lay the inevitable end.[9]

The first sentence of this passage thrusts right to the heart of relativity's fusion of space and time into the spacetime continuum—sixty years before Einstein. The rest of the passage anticipates the discovery of an expanding universe, which not a single contemporary scientist embraced, seduced as they were by the success of the mechanical Newtonian world of the nineteenth century. Poe proposed this concept, crucial to astrophysics, almost a full century before it became generally accepted by the astrophysicists themselves.

Poe was not alone in divining scientific truths. Jonathan Swift in his keen satire of English society, *Gulliver's Travels* (1726), hefted a considerable number of barbs at the scientific community and, principally, at Newton. In passing, Swift concocted two satellites for the planet Mars and surprisingly described their orbits in detail. A century and a half later, in 1877, Asaph Hall, an American astronomer, discovered these two satellites amazingly close to the exact orbits Swift had playfully predicted! The mathematical probability of Swift's guess being on target is close to nil. His accuracy in matters so removed from his fields of interest has never been adequately explained.[10]

Novelists after Poe and Flaubert began to express ideas about space and time that would bear a striking resemblance to the relativistic ideas of Einstein's as yet unformulated theories. These new literary conventions ran parallel with developments in the visual arts, such as Monet's Impressionistic attention to the moment of *now*, whose transient impressions he slowed down and made linger so he could capture them accurately on canvas.

In *Crime and Punishment* (1866), Dostoyevsky, like Monet, sought to dilate the fleeting moment by slowing time down, making the present more important than the past or the future. He packed the pages of his novel with a minute description of all of the protagonist's inner thoughts, which complemented the action. The plot of this complex psychological study unfolds over a period of only a few days (less time than it takes most readers to read the book). He examined the moment of *now* with microscopic fidelity, not allowing even one detail to flicker past without being chronicled. Dostoyevsky's focus on one brief period in a person's life and Monet's concentration on the transitory visual moment before his eye antedate by

nearly forty years Einstein's theory that time is relative and that to an observer traveling at very high velocities, the present dilates, so that all action slows.

Dostoyevsky's different time sense is revealed in a letter he wrote to a friend: ". . . because certainly a creative work comes suddenly, as a complete whole, finished and ready, out of the soul of a poet . . ."[11] That an entire linear novel could occur to the novelist *all-at-once* suggests that Dostoyevsky perceived time differently from the rest of us.

The theme of the dilating present accelerated on either side of the turn of the twentieth century. James Joyce, a contemporary of Einstein, used it in his novel *Ulysses* (1922), a long, convoluted story which unfolds in just twenty-four hours. Ambrose Bierce's short story *Occurrence at Owl Creek Bridge* (1893) truly approaches the speed of light. The entire action takes place between the moment a man is dropped from the gallows until the instant he dies, a fraction of a second later. Bierce's detailed and comprehensive examination of the hanged man's thoughts and fantasies occurring during this minimal duration demonstrates how inflatable can be the tiny sliver of *now*.

Another distortion of time's straight arrow appeared when other writers began to play fast and loose with the sacrosanct sequence of past-present-future. Science fiction, another new form of the novel, matured into an independent genre in the late nineteenth century. The principal innovation in these novels has to do with time and space. Science fiction tampers with time's unidirectional linear flow. Before this period, virtually all novels and paintings had been set in the past, either near or distant, or the present.

However, in the late nineteenth century, led by Jules Verne and H. G. Wells, novelists began to break the constraints of linear time by blurring the distinctions between the present and the future, as well as between the present and the past, and to transport the reader into the future. Once it became an acceptable setting for action in space, future time moved ever so subtly under the umbrella of the present. Space and time edged closer in literature.

Wells, who wrote *The Time Machine* in 1895, was particularly intrigued with the notion of traveling in time, suspecting that it must be a dimension much like space. He would be pleased to know that modern-day physicists have borne him out, using Feynman diagrams that accept the supposition that atomic events can go backward as well as forward in time. Wells would also be intrigued with the present-day speculations of theoretical physicists about the existence of tachyons. As light particles hypothesized to be capable

of traveling faster than the speed of light, tachyons would always have to move *backward* through time.

In his epic novel *The Remembrance of Things Past* (1913), Marcel Proust did for the past what Wells had done for the future. As if the constraints of linear time were absent, holding time as relative and local rather than absolute and universal, Proust folded time back upon itself like a piece of origami paper and traveled back into a past when he did not yet exist to tell Swann's story in the present. All this was further evidence that the writer at the turn of the century was beginning to grow restless, chafing against the confines imposed by the classical Newtonian mechanical view of the world. Encapsulating the idea of the speed of light and spacetime, in the very last line of *The Remembrance of Things Past*, Proust, wrote:

> . . . to describe men first and foremost as occupying a place, a very considerable place compared with the restricted one which is allotted to them in space, a place on the contrary immoderately prolonged—for simultaneously, like giants plunged into the years, they touch epochs that are immensely far apart, separated by the slow accretion of many, many days—in the dimension of Time.[12]

Another literary art form emerging around the same time was the biography. Boswell's detailed and entertaining *Life of Samuel Johnson*, published earlier in 1791, was different from previous biographies written sporadically in ancient and Renaissance periods in that Boswell painstakingly collated all available information about Johnson's life. He even followed Johnson around in his daily activities, taking notes on what Johnson said and did, giving readers insight into Johnson as a multifaceted individual.

Biography did not come into its own, however, until the late nineteenth century. The successful biographer reveals his subject from many different points of view. Unlike perspective in art and the early novels, the subject of a biography has to be seen from multiple vantage points all at once. The public, private, personal, and intellectual lives of the subject are presented to the reader simultaneously for any given moment in that subject's life. In this respect, the biography resembles a Cubist painting more than the single-point perspective that went before.

In 1898, the playwright Alfred Jarry created a scandalous figure, Dr. Faustroll, who made up new geometries in his make-believe science called

"pataphysics." Interestingly, Dr. Faustroll's pataphysics, a science of the "laws of exception," preceded by six years Dr. Einstein's special theory of relativity, which introduced special circumstances in which the obsidian laws of classical causality could be abrogated.

Gaston de Pawlowski, a contemporary of Jarry, wrote an epic adventure entitled *Voyage au pays de la quatrième dimension* in 1912. Pawlowski nibbled at the edge of the idea of the *all here* and *everlasting now* and proposed that the problem we have when trying to envision a higher dimension is rooted in the conventions of language.

> No doubt the fourth dimension, properly speaking, is not at all something analogous to height, width, or depth, such as geometers understand these three dimensions. It is another thing much more complex, much more abstract, which would not be able to be defined in any manner in our present language. Let us suppose, if you will, that it is a different point of view, a manner of envisaging things in their eternal and immutable aspect, a manner of freeing oneself from movement in quantity in order to conceive only the single artistic quality of phenomena. . . .[13]

In a later article he goes on to say:

> The vocabulary of our language is in fact conceived according to the given facts of three-dimensional space. Words do not exist which are capable of defining exactly the strange, new sensations that are experienced when one raises himself forever above the vulgar world. The notion of the fourth dimension opens absolutely new horizons for us. It completes our comprehension of the world; it allows the definitive synthesis of our knowledge to be realized; it thoroughly justifies these notions, even when they appear contradictory; and one understands that there is an intuition easier to perceive directly than to justify in our language. . . .
>
> When one reaches the country of the fourth dimension, when one is freed forever from the notions of space and time, it is with this intelligence that one thinks and one reflects. Thanks to it, one finds himself blended with the entire universe, with so-called future events, as with so-called past events.[14]

"What goes around comes around" is one of life's verities in general, and of the spacetime continuum in particular. This colloquialism demonstrates how the novel in the twentieth century came full circle. There is no hierarchy in Joyce's book *Dubliners* (1914), which is a loosely connected series of tales bound together only by a locale in space (Dublin). By overlapping these seemingly unrelated slices of life like the facets of Cubist painting, Joyce loosened the binding strands of the plot's unifying principle that had heretofore held the elements of a novel tightly together. This literary artifice is reminiscent of Boccaccio's *Decameron*, which heralded the novel six hundred years earlier.

The idea of recursive Riemannian spacetime is more directly developed in Joyce's *Finnegans Wake* (1939) which begins:

> riverrun, past Eve and Adam's. from the swerve of shore to bend
> of bay, brings us by a commodious vicus of recirculation back
> to Howth Castle and Environs

The reader is not aware that this is a sentence fragment until the book stops in midsentence four hundred pages later. It is only then that the reader learns that the first part of the beginning sentence is the continuation of the last sentence in the book, and that this first/last sentence describes the course of a circular river as it circumnavigates a particular place. *Finnegans Wake* is a monumental metaphor of the flow of time, and the river itself is one of its principal characters.

Joyce is saying something profound about space and time. At the end of *Finnegans Wake*, you, the reader, arrive not at the end but again at the beginning. Joyce has created a literary analogy of the recursiveness of the geometry of non-Euclidean spacetime. Einstein elaborated upon this idea using Riemann's abstract equations instead of a literary form. A traveler setting out on Riemannian spacetime continuum and a reader embarking on a journey through *Finnegans Wake* would both eventually discover that they had arrived where they started.

The view from aboard a beam of light was never so eloquently described as when Joyce writes:

> Down the gullies of the eras we may catch ourselves looking
> forward to what will in no time be staring you larrikins on the
> post-face in that multimirror megaron of returning-ties, whirled
> without end to end.[15]

The "whirled without end to end" might as well be the world of the space-time continuum. As the new physics supplanted determinism, the special theory of relativity introduced exceptions to the nineteenth-century laws of causality. Joyce playfully expressed this profound idea in literary terms. "Now the doctrine obtains, we have occasioning cause causing effects and affects occasionally recausing alter effects."[16]

Joyce, in this radical novel, was the first Western writer to undo the strict linearity of the alphabet. His fusion of poetry and prose freed syntax, grammar, and conventional spelling. He ingeniously used words like anagrams until the multiple meanings of each holophrastic word and phrase occur to the reader simultaneously. This *all-at-once* apprehension is the literary corollary of Cubism's multiple points of view, which are also perceived simultaneously, and it is congruent with the visual principle of Einstein's special theory of relativity, which states that at relativistic speeds an observer can see separated points in space at the same time.

A palimpsest is a parchment or tablet that has been inscribed several times. Its previous writings are imperfectly erased and remain still visible, if not legible. A palimpsest therefore simultaneously reveals multiple ideas contained in one line occupying the same space. A palindrome is a word or phrase (such as "radar") that spells the same forward or backward. Joyce's *Finnegans Wake* is a palindromic palimpsestic Möbius strip!

The *zeitgeist* enveloping Einstein's theory of relativity permeated all aspects of Western culture before its official, albeit abstruse, elaboration in 1905. Democracy broke out in the paintings of Cézanne and in the novels of Flaubert as well as in European political systems. The strict hierarchy explicit in monarchies evolved into gentler, more broadly based societies resting upon the central assumption of equality. For many centuries in art there had been a strict hierarchy in painters' compositions, and a distinct ordering of characters in writers' novels; the principal subject of a painting had its equivalent in a novel's protagonist and the king of a nation. This ranking of the subjects of attention in art, literature, and political systems began to flatten several generations before Einstein declared his Bill of Rights for all inertial frames of reference.

There is a case for saying that the creation of new aesthetic forms has been the most fundamentally productive of all forms of human activity. Whoever creates new artistic conventions has found methods of interchange between people about matters which were incommunicable before. The capacity to do this has been the basis of the whole of human history.

J. Z. Young

The artist is the antennae of the race.

Ezra Pound

CHAPTER 21

NEWTON'S APPLES / CÉZANNE'S APPLES

Einstein changed our perception and knowledge of space, time, and light. Had he discovered nothing else his name would reverberate forever down the long corridors of human achievement. But the inescapable conclusions emerging from his lacelike equations led him to question some other seemingly unshakable assumptions. One of these was the conception of gravity to which Einstein now turned his formidable intellect. His special theory of relativity had collided with Newton's universal law of gravitation like a cue ball shot at a high relativistic speed

hitting neatly racked billiard balls. Einstein had felt a mystical kinship with Newton and was somewhat dismayed to realize that his special theory exposed a major flaw in Newton's formulation of the inverse square law of gravity, the keystone of his *Principia*.

One of Newton's central assumptions was that the force of gravity acted instantaneously across great distances, transferred across space by the ether, whose other function was to support the passage of light waves. Newton posited that if the moon were budged from its orbit by a titanic collision with a large meteor, changes in gravitational forces between the moon and the earth would be transmitted across the intervening empty miles without any need for the passage of time.

Three centuries later, Einstein pointed out to the community of physicists that his special theory demolished the idea that there was any such thing as the ether. Furthermore, since the velocity of light was the speed limit of the universe, nothing could travel faster than it. The soonest that information, such as the news that the moon had moved, could reach the earth would be at the speed of light. The strict upper limit of c and the revelation that the ether did not exist scattered Newton's tight, interlocking arguments. In a now famous speech, Einstein apologized to Newton:

> Newton, forgive me; you found the only way which, in your age, was just about possible for a man of highest thought and creative power. The concepts, which you created, are even today still guiding our thinking about physics, although we now know that they will have to be replaced by others farther removed from the sphere of immediate experience, if we aim at a profounder understanding.[1]

Einstein's reverence for this earlier titan of physics was in no small part behind his determination to reconcile Newton's contribution regarding gravity with his own special theory of relativity.

To understand gravity's role in both human experience and its expression in art, we must not only review the ideas about it throughout human history, but also chronicle the scope of evolution in order to explain the central role this invisible force has played.

Sixty-five million years ago, the age of the dinosaurs ended rather abruptly. One instant they were there, then, within a blink of the planetary eye, mysteriously they were gone. Since nature abhors a vacuum, a small group of fur-covered creatures we call mammals emerged from what had been their nocturnal habitats and soon began to swarm over the empty

territory vacated by their principal enemies, the dinosaurs. Within the next twenty-five million years, due to their prodigious procreative powers (and safer ways of nurturing young than sitting on eggs), they occupied virtually every available environmental niche. Crowding actually began to occur, and a small group of adventuresome mammals decided to leave the traffic-congested ground and take up residence in the luxuriant trees that towered over the forest floor.

These tree dwellers became very satisfied with their new habitat. Food was bountiful, with fruits for the picking. The view was terrific, and most important, there were few natural enemies. The interlocking branches of closely spaced trees allowed primates, as they would be called, to range easily over great distances without ever having to venture down onto the dangerous ground. In due course, the primates multiplied. Due to civilization's recent encroachment upon their habitats, their numbers have diminished. Nevertheless, there still remain over a hundred different species filling the treetops of the world's more remote forests.

The primates evolved some unusual adaptations in response to their peculiar form of locomotion. Their forelimbs limbered and lengthened so their arms could rotate through a wide circle, giving them the ability to swing through branches. Their forepaws developed into delicate hands that contained a wondrous innovation, the prehensile opposing thumb, which gave these animals the first appendage that could effectively grip, grab, hold, carry, and otherwise manipulate the environment. The hand's thumb and fingers, initially designed to grasp vines and boughs, eventually would be used to pick apart the pieces of the world and reveal the secrets of the universe.

Besides the grasping hand, primates developed a protean eye capable of seeing with amazing clarity. Eagles may be able to spot mice at fifty yards, cats may have better night vision, and pigeons may be able to apprehend colors the primate cannot see, but the eye of the primate has the greatest versatility, in its combination of depth perception, color vision, night adaptation, focal capability, and visual acuity. And if the primate's is the best overall eye in the forest, the human eye would become the best of all primates' eyes. For, in addition, as humans evolved we learned how to correct for developmental flaws and disease; we evolved ophthalmologists and the corrective lenses they prescribe, and we invented telescopes, microscopes, X-ray tubes, and infrared night scopes to extend our range of vision to previously unimagined worlds.

Despite the grasping hand and the all-seeing eye, arboreal primates lacked an important accoutrement, the absence of which threatened their

existence. The early primates were soft, unprotected little animals that flew through the air with the greatest of ease without the benefit of a safety net. Unfortunately, they had not been issued wings. As a consequence, their most tenacious nemesis was not a predator: Lions, tigers, and even leopards could rarely hope to catch an agile primate. No, the tree mammal's stealthiest enemy was the strange, unseen killer force of gravity. For monkeys, chimps, and baboons, a moment of inattention or a solitary miscalculation could lead to instant death, just as today the most common cause of mortality among gibbons who live in the wild is an injury sustained during a fall.[2]

To compensate for their lack of wings, primates had to evolve a third critical adaptation. In order to process and coordinate visual and tactile information rapidly, the primate brain grew disproportionately large, allowing these aerial acrobats to make the split-second decisions necessary to judge the tensile strength of branches as well as the speed necessary to fly across a chasm. This triumvirate—the grasping hand, the far-seeing eye, and the specialized brain—made up for the absence of wings and foiled the deadly enemy, gravity.

Homo sapiens, the wise hominid, is first and foremost a primate. Although none of us flies among the treetops anymore, we still retain buried deep within our archaic collective memory an atavistic fear of falling. The most frightening recurrent theme in nightmares is falling, as the most common phobia is acrophobia, the fear of heights. The adrenaline pulsing into our bloodstreams when we are in danger of falling is one of the few instincts held over from a more primitive age.

As testimony to this primal fear, virtually all religions and mythologies feature falling as a punishment. According to the Bible, we fell, expelled, from the Garden of Eden. Lucifer was thrown down from the heavens by God. According to Greek mythology, in the Oedipus myth, the sphinx punished those who failed to answer her riddles correctly by throwing them off a cliff. As Icarus flew higher and closer to the sun, its rays melted the wax that held together the wings his father fashioned; his hubris was punished by falling. The same fate *befell* (even the verb is revealing) Phaeton for trying to command his father's sun chariot. He, too, plunged to his death.

"Fall" and "fail" come from the same etymological root, so the word "fall" itself has an ignominious connotation.* Empires fall; preachers con-

Fallere in Latin means "to deceive" or "to disappoint"; it is the root of both "fail" and "fall."

demn fallen sinners; politicians fall from favor; apostates fall from grace; unlucky people fall upon bad times; parents worry about their children falling in with the wrong crowd; one is crestfallen over bad news. No one ever wants to be a fall guy. In the Middle Ages, drowning was not a sailor's greatest fear; falling off the edge of the flat world was a more frightful prospect. In children's play, London Bridge falls down, and everyone knows what happened to Humpty Dumpty. "Rockabye Baby," the most familiar children's lullaby, contains the most chilling lines in literature: "When the bough breaks the cradle will fall, and down will come baby, cradle and all." Is a mother's loving, soporific, hypnotic intonation of these words supposed to ward off her most common fear concerning her baby? How else explain this gruesome paean to the baby-killer god of gravity?

The commonsense observation that what goes up must come down is so central to our experience that anything that defies this law attains the status of a miracle. For example, resurrection and ascension are central motifs in most religions. These same religions invested fire with the mantle of holiness—primarily because flame was one of the inexplicable phenomena that naturally rose instead of fell. Priests have long believed it has the power to purify.

It was evident to early people that objects that were not supported dropped to the ground. The obvious question then arose: Who was holding up the world? Ancient mythologies concocted many fanciful answers to this troublesome question. For example, the preclassical Greeks believed the earth rested on Atlas' broad shoulders, but they could not say where and on what Atlas himself stood. All the old explanations about gravity were framed in some sort of magical context because gravity itself was a matter shrouded in mystery.

Different civilizations populating the ancient world produced myriad competing cosmologies. Each attempted to explain the nuances of human existence in religious terms until finally, in a radical departure, Thales of Miletus, who sought rational explanations for cosmic events, declared that the gods didn't do it. For his courage, Thales is still recognized as the father of natural philosophy.

One of the very first misconceptions Thales addressed involved gravity. Imagine the surprise among the puzzled population of Miletus when he announced that spirits did not inhabit and guide the stars. He offered the provocative alternative explanation that the stars were actually gigantic balls of fire suspended in empty space. If we could put ourselves in the cultural context of sixth century B.C., this explanation would have seemed

far more irrational, implausible, and outrageous than the original belief in stargods.

Following Thales, there was a veritable alphabet soup of Greek thinkers who pondered the nature of existence free of divine intervention and interference. The most important, Plato, did not specifically concern himself with the questions posed by motion and falling. He believed movement was a perturbation that simply obscured the true reality of ideas. Thinking about motion, Plato warned, distracted the philosopher from discovering the ideal, motionless, changeless forms that lay behind the hurly-burly of everyday sensory phenomena. Plato's pupil, Aristotle, more pragmatic than his mentor, and intrigued by motion, developed one of the first explanations for its force by proposing that the earth was the center of fifty-four revolving concentric perfect spheres.

While Aristotle's model was symmetric and elegant, it did not explain what kept everything in the sky from falling, nor did it account for the impetus for motion in the first place. So Aristotle left the realm of science and conjured up a prime mover who, he said, gave the primeval shove that set into motion the outer concentric sphere; that movement soon caused the next inner sphere to begin to rotate; and so on and so forth. This original push became the source of all subsequent motion. The prime mover's only function in the cosmos was to provide this crucial flick of the wrist that eventually translated into the force that kept the moon from falling out of the sky.

Although the classical Greeks provided a working foundation for most subsequent branches of knowledge, they did not develop an accurate theory about mechanics or gravity. Their failure was in large part due to their disdain for physical work. Philosophers considered it unseemly to dirty their hands with experimentation. They were supposed to sit under trees and solve problems through reason, deduction, and speculation. The Greeks had many slaves who performed the manual labor and a free man did not engage in such demeaning activity.

Though Greek thinkers developed erroneous theories regarding the mechanics of motion and gravity, they did begin an inquiry into the nature of these forces that did not include any help from Mt. Olympus. Before the philosophers grappled with these questions, however, Greek sculptors made significant progress in reckoning with gravity. As early as the sixth century B.C. they began to free their figures from the rock that had imprisoned Egyptian statuary by carving freestanding statues called *kouroi* that did not need to cautiously hug the stone. Over a period of three hundred years, between 700 B.C. and 400 B.C., Greek sculptors were increasingly able to

make their statues stand on their own two feet. In observing the statuary succession from Egypt to Greece, we can watch the collective "baby of Western civilization" learning to walk. Greek sculptors during this period became ever more daring as, with growing skill, they defied gravity's mysterious force.

The subject of gravity was of similar interest to Greek architects, and their refined temples, which succeeded the massive Egyptian pyramids, embody their concern and sophistication with this force. Interposing empty spaces between fluted columns under the substantial mass of entablature (the horizontal superstructure supported by columns) allowed light to filter through a fenestrated architecture. As in everything else, the Romans imitated and refined Greek architectural conventions. Their two crucial innovations were the stone arch and the invention of concrete. Since arches are abundantly present in nature, from termite nests to wind-eroded rocks, and given the Romans' practicality and engineering impulse, it is not surprising that they, rather than the sophisticated but more theoretical Greeks, made these discoveries. The arch, held together by the distribution of load upon its central keystone and the plasticity of unset concrete, allowed the Romans to build colossal domed public buildings with dramatic interiors and arched colonnades such as the Pantheon.*

The fall of Rome, as the very phrase implies, was accompanied by a reassertion of the elemental power of gravity. The suspension of stone in midair came to an end, as did the towering arguments of classical philosophers. The ectoplasmic theories of early Christianity permeated reason and dissolved the mortar holding together the refined syllogisms of the previous millennium. The precise connections joining the granite blocks of the Greco-Roman structures underwent a parallel dissolution and their monumental stone structures toppled. So lost were all vestiges of this classical tradition that when the Renaissance began a thousand years later most ordinary people could not remember who had built the magnificent ruins that dotted the landscape of Europe. The consensus was that they had been erected by a vanished race of giants.

The central miracle of Christianity, which proved Jesus' divine parentage, was His death-defying Resurrection and His repudiation of gravity by Ascension. These two acts, witnessed by Jesus' apostles—dead flesh recapturing the life-force and then overcoming the grip of gravity—provided for them incontrovertible proof that Jesus was indeed Christ, the Son of God.

Asserting the power of faith, early Christian artists populated their paint-

*Their formula for concrete was lost in the Dark Ages and rediscovered only in 1774.

ings with archangels, seraphim, and saints, all of whom violated common sense and knowledge concerning density and mass. Since the spirit realm did not consist of substance, flying about there was taken for granted. But in architecture, where buildings had to withstand gravity's force, the urge to express the evanescent nature of the supernatural led to the unexpected emergence of the Freemason society. Beginning about A.D. 800, at the same time the enlightened Charlemagne established the Holy Roman Empire, a small group of stoneworkers formed a secret society for the purpose of learning how to levitate stone into space. At this time Europe was a disorganized collection of jagged-edged, jealously guarded kingdoms just emerging from the Dark Ages. Travel was dangerous and restricted. Yet safe passage was encouraged for this guild of secretive craftsmen because the Freemasons were believed to be magicians who knew how to erect towers of stone that aspired to reach the heavens.

As if by some precoded genetic instruction, in the late medieval period there began to arise throughout Christendom a forest of Gothic church spires that paid tribute to the luminous nature of the Kingdom of God and the intuitive ingenuity of these workmen-architects. The Freemasons routinely worked without the most basic tools and mathematics that modern-day architects and engineers consider indispensable—for instance, the mathematics used by Europeans did not have the concept of zero until the middle of the thirteenth century. But by use of the keystone, column, and flying buttress, they sculpted ponderous stone into an airy mass that enclosed delicate volumes of space and splinters of light. The splendid Gothic cathedrals were one tine of a tuning fork that set up a vibration within the souls of the congregation, which was the other. These two, supernatural and inner consciousness, began to resonate to produce the harmony that was the essence of this magical age.

The Renaissance brought things back down to earth both in reality and metaphorically. The Humanists began to observe worldly things rather than ephemera located in the mists of a realm no one could with certainty discern, and their novel idea that man, not God, could be the measure of all things inspired a new curiosity about the terrestrial environment. Artists discovered the laws of perspective and presented their subjects from a stationary human, earthbound point of view, rather than from on high.

The subject of gravity reemerged when Copernicus published *De revolutionibus orbium celestium*. By displacing the earth from the center of the solar system and replacing it with the sun, Copernicus in his book proposed a spherical revolving earth suspended in space that Atlas could not be summoned to hold. He so upset the prevailing cosmic paradigm

that the very word "revolution," when used in a social context, has come to mean "total upheaval." Yet, despite Copernicus's rearrangement of the heavens, an explanation for the balance between the unnamed force of gravity and motion remained elusive.

Galileo made the next important contribution to human knowledge of gravity. Apocrypha hold that he dropped two stones of different weights from the balcony of the leaning Tower of Pisa in 1589 in order to test Aristotle's previously unquestioned truth that heavy objects fall faster than light ones. Neither Aristotle nor anyone else had ever bothered to prove this obviously commonsense speculation. Galileo reasoned that it might be false, and indeed, amazed observers recorded that both rocks hit the ground at the same instant. These falling rocks began a scientific avalanche that eventually buried many of Aristotle's speculations. As a result of Galileo's seminal experiment, people reasoned that if Aristotle could be wrong about anything as fundamental as falling, perhaps his texts were not as unassailable as they had been held. Galileo performed other experiments on a wood incline and formulated his famous law of fall. For the first time in history, falling was expressed as an equation. In 1610, in *The Starry Messenger*, he publicly advocated the Copernican view that the sun, not the earth, was at the center of our solar system. Indeed, the earth was only a heavy rock traveling a well-plowed path about the sun. From little rocks to big ones, Galileo's contributions to ideas about gravity have been substantial.

If Copernicus and Galileo provided the foundation, it was Newton who made the watershed discovery about gravity. The story of his discovery has become another enduring myth of science. During his college days, the famous story goes, Newton's mother insisted that Newton leave Cambridge and stay at her farm to avoid an epidemic of bubonic plague. One evening, sitting under an apple tree, lost in reverie, Newton watched the moon float up from the horizon, and as it did an apple fell from the tree. In that instant, Newton realized that the force that pulled the apple to the ground extended high above the treetops and far into the sky. It was the identical force that kept the moon in orbit around the earth. This deceptively simple thought led him to the formulation of the law of universal gravitation, which states that the gravitational force between two objects is proportional to the size of their masses and inversely affected by the square of their distance. This law explained why the moon did not fall into the earth. Newton realized the moon *was* falling, just like the apple; but because at the same time it was moving horizontally with reference to the earth, pulled away from the earth by its speed and inertia, the moon never actually

fell into the earth. Newton demonstrated that if the sideways motion of an object equaled the downward motion, the two would balance each other. Therefore, the moon would occupy a stable orbit.

In formulating his law of universal gravitation, Newton, without calling it as such, discovered the concept of the force field. The first person to think of it, Newton was also the first to fathom its implications. For instance, his inverse square equation described how two objects separated by empty space, with absolutely nothing in between them, could act upon each other *at-a-distance*. Imagine two billiard balls placed a million miles apart, out in an empty corner of the universe, far from any large celestial bodies. If an exceedingly long-lived observer watched these billiard balls over an exceedingly long time, he would notice an exceedingly slow movement (imperceptible at first but gradually increasing with proximity) of these balls toward each other until eventually they would collide. The mysterious force that mediates this strange action, causing mutual attraction between inanimate objects despite the intervening nothingness between them, Newton called gravity. Newton's formulation of gravitational action-at-a-distance became the basis for field theory.

Though Newton went on to make a whole series of other impressive discoveries, the apple story immediately captured the European imagination and his popular fame has rested on it ever since. Newton had imbued the ancient word "gravity" with a new meaning. He had given a name to the mysterious force that was at the root of mankind's most archaic fear; naming is the first step toward controlling it.

There remained, however, one insoluble problem regarding the concept of gravity. Newton had described the *law* that governed universal gravitation, but he did not understand the *nature* of its force. "It is inconceivable," he wrote,

> that inanimate brute matter should . . . affect other matter without mutual contact. That gravity should be innate, inherent, and essential to matter, so that one body may act upon another at a distance, is to me so great an absurdity that I believe no man who has in philosophical matters a competent faculty of thinking can ever fall into it.[3]

In other words, if asked what gravity *was*, Newton would have had to reply that he didn't have the foggiest idea.

Before the scientist's triumph illuminated the concept of gravity, the artist had already begun to master it. Because of its mass, sculpture is the

epitome of gravity as art form. After clinging to church walls for a thousand years, stone statuary regained in the Renaissance the grandeur it had in classical times. Edging away from the safety of medieval sculptures' bas-relief, monolithic statues, fashioned out of granite, marble, or bronze, stood on their own pedestals. They were figures of substance that could not be easily moved. And the artists who worked with ever-larger, immensely heavy, freestanding blocks of stone had to know intuitively where the crucial center of gravity lay within the dense mass of their statues.

An important characteristic of this artistic endeavor was that the mass sharply displaced the space in which it was positioned. It is said that Michelangelo told a visitor that before beginning a new work he first visualized the finished statue within the stone block, then set as his task the removal of excess marble from around his vision. By replacing the superfluous rock with empty space, he allowed his statue to emerge. For Michelangelo, the distinction between negative space and positive mass, which Newton would later describe in algebraic terms, was clear and pronounced.

As has been mentioned, a common image in art before Newton was that of flying choirs of seraphim and cherubim. At about the time Galileo initiated his study regarding the nature of gravity, these levitating figures began to come down to earth. Artists became determined to portray the world realistically. Most abandoned floating figures and introduced gravity's laws into their works before Newton had even described them. By the time he decreed the law of universal gravitation in 1665, the subjects of most paintings were portrayed with their feet planted firmly on the ground. For the most part, flying and floating had come to an end in the paintings of Europe's northern, mainly Protestant, countries. The notable exception to this prohibition against levitation was the exuberance of the French and Southern European artists who created the rococo style to celebrate the Catholic Church's own counterreformation in the eighteenth century. Airborne figures were common in rococo art.

Newton himself had not perceived gravity's precise nature, and the solution to its mystery eluded his successors as well. Two hundred years later, by the late nineteenth century, his brilliant but incomplete laws still survived intact. Since no one could conceive of a mechanism by which the earth could affect the moon with nothing between them, scientists gradually accepted the necessary invention of an insensate luminiferous ether that filled the space between objects and mediated the force of gravity. In no other way could they explain how light might travel from here to there across a vacuum, or how the force of gravity could act across empty space.

This problematical thesis gained support throughout the eighteenth and

nineteenth centuries until ether was accepted as a real entity by virtually all physicists. The embarrassing problem remained, however, that no one could ever detect any evidence of its presence. Its discovery became a scientific quest much like the Crusaders' search for the Holy Grail. Fame, fortune, and prestige would go to the scientist who could capture this elusive prize. Albert Michelson and Edward Morley in 1887 conceived a brilliant experiment in hopes that it would surely detect the ether. These two American physicists, through the use of highly accurate mirrors, set out to detect the ether by measuring the earth's motion through it. But despite sophisticated theories and carefully calibrated instruments, they were unable to find the slightest trace of this entity. Their published null results stunned the scientific community.

Even before scientists realized that something was fundamentally incomplete about Newton's conception of gravity, Édouard Manet had begun to reexamine the sacrosanct conventions that had congealed about the notion of gravity in art, which required that painted objects of mass must rest firmly upon the painted ground. It is well known that Manet elicited an outpouring of scorn for his famous *Le Déjeuner sur l'herbe* (see Figure 8.1) in the Salon de Refusés of 1863. The presence of two men in business suits seated with an undressed woman whose discarded clothes lay next to her jolted the Parisian burghers who came to see this painting, since she was a naked woman, not a nude. The nude was art; the naked woman was pornography. But while the brouhaha surrounding this painting has become a legend in art history, it is less well known that Manet had also positioned another outrageous work upon the adjacent wall in that same salon, *Mademoiselle Victorine in the Costume of an Espada* (1863) (Figure 21.1). Victorine Meurent, the same woman who posed nude for *Le Déjeuner*, is featured in this companion work; here, however, she is inexplicably dressed in male clothing.

As the viewer walked from one wall to the next, the juxtaposition of this same model, naked in one painting, cross-dressed in a most masculine style in the other, increased the visual shock. But Manet further confused the viewer by cutting the ground out from under his matador/"matadoress." She is obviously in a bullring, but curiously, it is not clear exactly where she is standing. If the viewer uses the clues of perspective available from the action in the distance, he would have to conclude that Manet's matador is standing in midair! Most critics believed that Manet had painted the scene ineptly and lambasted him for his clumsiness. But Manet was a consummate draftsman: If he cut the ground out from under his subjects, he did so guided by his unerring artistic intuition. Somehow, the artist

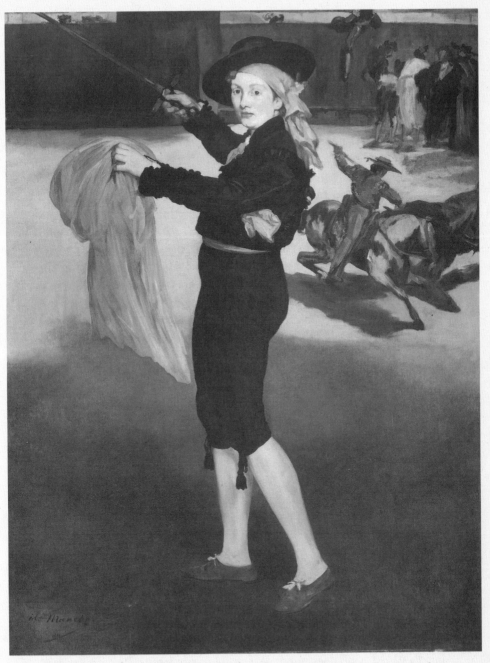

Figure 21.1. *Édouard Manet,* Mademoiselle Victorine in the Costume of an Espada *(1863)* THE METROPOLITAN MUSEUM OF ART, BEQUEST OF MRS. H. O. HAVEMEYER, 1929, THE H. O. HAVEMEYER COLLECTION (29.100.53)

knew that gravity was yet another unstable feature of the then-current conception of the world.

Manet continued to use this stylistic peculiarity, freeing the subjects in his compositions from the laws of gravity and introducing a whole series of quirks that suggested something was missing from the commonly held beliefs concerning the subject of gravity. *Woman with a Parrot* (1866) (not shown) and the *Fifer* (Figure 10.1) depict figures standing on an ambiguous surface that is, at least, not solid ground. In *A Bar at the Folies-Bergère* (1882) (Figure 29.1) and *Masked Ball at the Opéra* (1874) (not shown), Manet mischievously inserts in each a disembodied pair of legs dangling from the upper borders of the frame. One pair appears to be flying on a trapeze, and the other to be not standing on anything at all. Manet introduced with great subtlety violations of the conventions concerning gravity that had guided artists since the Renaissance.

Manet's gravity-defying suspension in midair is most pronounced in *The Dead Toreador* (1864) (Figure 21.2). The subject, a toreador, is lying horizontally. The minimal clue of bloodstains suggests he is not sleeping but dead, though even this point is inconclusive. And since the painting lacks perspectivist clues regarding foreground, background, or horizon, the subject appears to be floating in space like a levitating corpse. The visual tension created by this ambiguity is reminiscent of much late medieval and early Renaissance art, in which death, resurrection, and ascension were central themes.

The Dead Christ with Angels (1864) (Figure 21.3) complements Manet's *Dead Toreador*. It was an oddity that in the late nineteenth century a modernist like Manet would revive religious themes and handle them in such a peculiar fashion. He portrayed the moment in the sepulcher before Christ arises from the dead. Though the theme had been depicted in a thousand other paintings, Manet's version of Christ was unique. In all previous paintings, artists rendered Christ as a thin, ectomorphic man-god, suggesting that His ascension to heaven would be assisted by His ethereal lightness of being. Manet's was a very muscular, slightly portly Christ, whose deadweight in the painting does not suggest He is about to come back to life, much less defy the force of gravity and ascend to heaven. Manet's sortie into religious art provoked a storm of criticism in which he was excoriated for being sacrilegious and committing the sin of blasphemy. Manet's Christ, who does not appear ready to rise, contrasts with his dead toreador, who already has accomplished the feat.

Manet's contemporary Claude Monet also introduced some novel ideas about mass, density, and solidity. A constant feature of Monet's Impres-

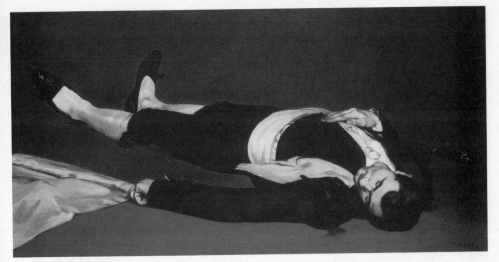

Figure 21.2. *Édouard Manet,* The Dead Toreador *(1864)* NATIONAL GALLERY
OF ART, WASHINGTON, D.C., WIDENER COLLECTION

sionist style was the absence of crisp boundaries between his objects and
the negative space surrounding them. By blending the mass of his objects
into that adjacent space, Monet diminished their substantiality. When
"light" is the adjective repeatedly applied to Monet's work, it refers not
only to his choice of bright colors, but also to the way his subjects are
invested with weightlessness and a certain sense of airiness.

In 1899 Monet began painting the Japanese bridge over his garden pool
at Giverny (Figure 21.4), a subject he returned to repeatedly in the ensuing
twenty years. But in his works there is no information about where the
bridge rests. No pylons or footings are visible; instead, the viewer confronts
a span that seems to float in midair. As Monet's bridge series progressed,
even the bridge's substance began to fuse into the shimmering space sur-
rounding it, and its weight and very mass appear to be subverted.

If Manet and Monet reopened the question about gravity, it was Paul
Cézanne who addressed it in earnest. We have seen how Cézanne devoted
his life to trying to understand the interrelationship of mass, space, and
light. He advised younger painters to "paint as if you held, rather than if
you saw objects,"[4] and his interest in the fundamentals of space led him
to reduce all natural forms to three basic shapes: the cylinder, the sphere,
and the cone. Interestingly, Cézanne does not include the cube in his
dictum on basic shapes even though he probably used it as much as any
other form. After declaring that geometry is the basis of all form, Cézanne

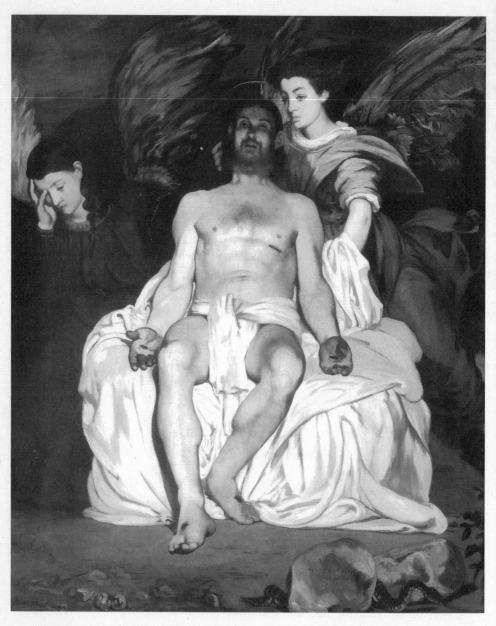

Figure 21.3. *Édouard Manet,* The Dead Christ with Angels *(1864)* THE
METROPOLITAN MUSEUM OF ART, BEQUEST OF MRS. H. O. HAVEMEYER, 1929, THE H. O.
HAVEMEYER COLLECTION (29.100.51)

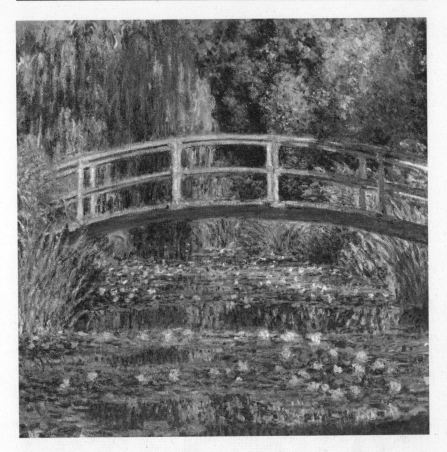

Figure 21.4. *Claude Monet,* Waterlilies and Japanese Bridge *(1915)* THE ART MUSEUM, PRINCETON UNIVERSITY, COLLECTION OF WILLIAM CHURCH OSBORN

distorted these very forms in order to satisfy the forms' interaction with his composition's geometrical demands. For previous Western artists it was the hierarchy of objects in a composition that was supposed to create the positive value of a painting. But Cézanne, despite his apparent endorsement of basic Euclidean solid geometry, seriously questioned its assumptions and endowed apparently empty space with an architectonic quality capable of affecting the objects it surrounded.

What image represents massiveness, solidity, and density better than a mountain? The Rock of Gibraltar and El Capitan symbolize the essence of substantiality. Yet as Cézanne's Mont Sainte Victoire series evolved, the

mountain began to dematerialize: It began to soften and seemed to lose rigidity, as if it were becoming ever more molten. In Cézanne's hands, the formidable massif became more like lava than rock, interacting with the space about it. Conversely, the space surrounding the mountain seemed to thicken, like gruel, acquiring an almost palpable quality. Cézanne compressed space itself, squeezing and reshaping it so that it became a reciprocal of the mass of the mountain. In the later works of the series, space acquires mass, as the mountain loses it (*Mont Sainte Victoire* ([1904–06]) (See Figure 8.9).

Newton discovered his laws of gravity because of a falling apple; Cézanne in *Apples and Biscuits* (1882) (Figure 21.5) introduced the possibility that Newton's conception was incomplete by painting apples that should fall but did not. More than any other artist, Cézanne exhaustively studied the

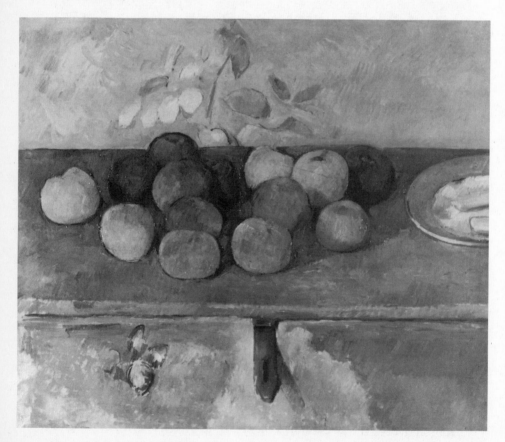

Figure 21.5. *Paul Cézanne,* Apples and Biscuits *(1882)* MUSÉE D'ORSAY, PARIS

essence of "apple." It has been said that he painted more apples than he could ever have consumed in a lifetime. Cézanne's representations of apples surreptitiously repealed Newton's laws of gravity. Many of his still lifes contain a table full of apples, the fruit precariously perched on a surface that is obviously tilted. Why don't the apples roll off? By insinuating into his canvases mountains that lose mass and apples that do not fall, Cézanne undermined the classical concepts of mass and space. And he did so a full generation before the scientific community discovered that the paradigm of mass, space, and gravity had to be revised.

Cézanne can be credited with changing the way the artist envisioned the relationship of space and mass. His accumulated insights departed radically from the precepts of the academic tradition. Space, no longer an empty stage upon which an artist merely presented objects, was now affected by the mass of those objects, which in turn were altered by the space in their vicinity. Many of Cézanne's works do not sharply delineate a boundary between space and mass because the boundary is an interactive tensile interface.

To understand better the subversive images of Manet, Monet, and Cézanne regarding gravity, it is necessary to jump ahead in time to the revolution that occurred in physics in the beginning of the twentieth century. These artists had initiated an inquiry in the late nineteenth century about the relationship of space and mass. This same question now consumed Albert Einstein, the *Homo mirabilis* of the twentieth century.

> There is nothing in the world except empty curved space. Matter, charge, electromagnetism, and other fields are only manifestations of the bending of space. *Physics is geometry*.
>
> <div align="right">John Archibald Wheeler</div>

> We will twist the tail of the cosmos 'till it squeaks.
>
> <div align="right">Oliver Wendell Holmes</div>

<div align="center">

C H A P T E R 2 2

SPACETIME / MASS - ENERGY

</div>

I
n the Newtonian paradigm, space and time are two of the four cornerstones of physical reality. Energy and mass are the others. Of the four, space and time are dimensions that locate the positions of things and actions. In speech they constitute the adverbs and adjectives, prepositions and qualifiers—"always," "earlier," "over there," "later," "underneath." Mass and energy are what is located and what does the locating in time and space. They are a sentence's subject and verb; the principal characters and their actions. These four play out the drama of daily existence.

The law of the conservation of energy and its companion, the law of the conservation of mass, were the two immense, sturdy legs that supported the Colossus of classical physics. These two verities were supposedly immutable. The best colloquial expression of the law of conservation is the

French aphorism *Plus ça change, plus c'est la même chose* ("The more things change, the more they remain the same"). The first law states that energy cannot be created or destroyed in any given system. No matter how many transformations it undergoes—kinetic to electrical to light to heat —the total amount of energy present at the outset must always and exactly equal the total amount present at the end.

The same green-eye-shaded accountant's law applied to the conservation of mass. Any substance can be subjected to transmutation so that its form and chemical makeup change dramatically. But after hammering, fire, pressure, and explosion, the books always had to balance. The same amount of matter will exist as existed before the earliest change was wrought.

Einstein said in effect yes, yes, that is all true, but suppose energy and mass can be expressed as an equivalence; suppose they are interchangeable entities. According to Einstein, matter is just a neatly packaged repository of energy. He immortalized this energy-mass equivalence in the elegantly simple formula $E = mc^2$. This tiny but mighty equation, a direct extension of his special relativity equations, blurred the distinction between a field of energy (the verb) and the mass of an object in that field (the noun). As the key to relativity had been the constant of the speed of light, so too the fiber binding mass and energy is light's velocity. The speed of light squared is, of course, a very large number. $E = mc^2$ actually states that the amount of energy stored within a lump of quiescent matter is equal to 186,000 miles per second raised to the second power. The explosive force of the sudden conversion of matter into energy is the source of our sun's life-sustaining outpourings.

Equally dramatic, when this equation is reversed and energy is converted into mass, then we must accept that pure energy can wring matter from out of the nothingness of the void. Elemental particles can literally appear out of nowhere: a true *creatio ex nihilo* that makes incorporeal fields of energy the progenitors of mass. This principle of something out of nothing resembles the appearance from out of nowhere of the biblical precipitation of manna on which the Hebrews sustained themselves while wandering in the desert with Moses. Manna from heaven and matter from energy may be the closest we will ever come to a free lunch in the universe. (Scientists have estimated that in the course of a year all the energy expended by the sum total of all human physical endeavors, along with nuclear power plants and coal-consuming furnaces, when heaped together, would equal only a few tons of matter.[1] The mental energy expended in the form of electro-magnetic and electrochemical processes in the brains of all human beings alive amounts to less than one billionth of a gram per second![2])

By the end of 1905 Einstein had laid the basis of two totally new entities: the spacetime continuum and the energy-mass equivalence. Within a few months he had linked space to time and yoked energy to matter. Thus the original four corners of the impregnable fortress of Newtonian physical reality—space, time, mass, and energy—were now combined into two new binary Einsteinian entities, spacetime and mass-energy, each linked together by the paradoxical glue of the speed of a beam of light.

Beginning in 1907 Einstein began to toy with the possibility that these two newly conjoined entities of his—spacetime and mass-energy—were also reciprocal, complementary aspects of each other. He had an intuitive feeling that the spacetime continuum and the mass-energy equivalence were somehow related, but he could not find a means to express their relationship in mathematical terms. He said at this time,

> Nature shows us only the tail of the lion. But I do not doubt that the lion belongs to it even though he cannot at once reveal himself because of his enormous size.[3]

When Einstein told Max Planck what he was trying to accomplish, Planck replied,

> As an older friend I must advise you against it for in the first place you will not succeed; and even if you succeed, no one will believe you.[4]

Despite Planck's advice Einstein attempted unsuccessfully to link the two entities for nearly a decade. In frustration, he turned to his boyhood friend Marcel Grossmann, a knowledgeable mathematician. In their long conversations on the subject, Grossmann told Einstein about a weird kind of non-Euclidean geometry that was the brainchild of Bernhard Riemann. As I described in Chapter 8, Riemann was one of a small group of nineteenth-century mathematicians who had had the temerity to question the assumptions of Euclid's geometry. As it happened, his equations exactly fit Einstein's conception of the fundamental shape of spacetime. Riemann's abstract, highly theoretical concept of space, believed to have no application in the real world, turned out to be very real indeed.

In November 1915, using Riemann's tensor field equations, Einstein finally succeeded in expressing the interconnectedness of spacetime and mass-energy in the general theory of relativity. To repeat, light, or more correctly the speed of light, became the Krazy Glue that bound together

first space and time and then energy and matter (Figure 22.1). Once he had joined the four corners of reality into new dual pairs, he was able to fuse these two combinations into his most majestic relationship. What Einstein brought forth in his general theory and its fallout—star death, warped spacetime, black holes—is a description of reality that is achingly beautiful and profoundly important. Nigel Calder, a science writer, put it thus, "If you have not yet felt the ground move under your feet while contemplating his ideas, you have missed the *frisson* of the century."[5]

Although the general theory radically changed previous conceptions of gravity, it is so simple it can be expressed in a single, one-line equation: Space *is* time equals matter *is* energy. This abbreviated haiku poem is like a Zen koan inviting reflection and meditation.

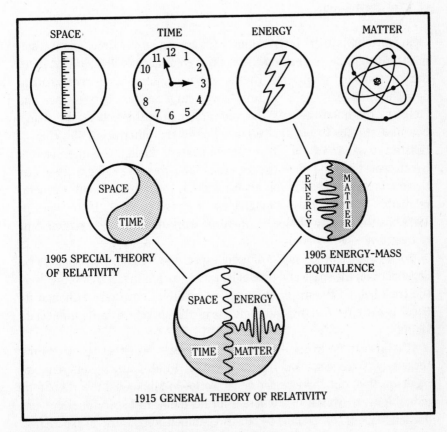

Figure 22.1. *The mandala of general relativity*

By combining all the four constructs of reality into a pair of tightly interconnected fascicles, Einstein unlocked the door leading to the inner sanctum that guarded the great secret of gravity. In the process, he explained something that is so inextricably a part of human existence that it is taken for granted. The essential fact that we are stuck to the surface of the earth like flies to flypaper without any visible glue is a subconscious ponderous truth rarely given much thought.

Einstein said in his biography that the moment in which all these connections coalesced in his mind "was the happiest thought of my life." In a lecture given many years later he recounted how this happened:

> I was sitting in a chair in the patent office at Bern when all of a sudden a thought occurred to me: If a person falls freely he will not feel his own weight. I was startled. This simple thought made a deep impression on me. It impelled me toward a theory of gravitation.[6]

In working out the interrelationships among space, time, energy, and mass, Einstein peered behind the multifaceted mask of illusion that hides the true unity of the universe. The general theory describes in mathematical detail how matter "tells" spacetime how to curve and how curved spacetime "tells" matter how to behave. The reciprocal relationship between Einstein's two new entities meant that each *informed* the other about the characteristics it was to exhibit. This complementary duality, the interplay between spacetime and mass-energy, results in a force we call gravity in our three-dimensional world. This amazing idea is the heart and soul of general relativity. Abraham Pais, a biographer of Einstein, said, "If the work of 1905 has the quality of Mozart, then the work of 1907–15 is reminiscent of Beethoven."[7]

For example, we do not ordinarily expect the weight of an apple to be dependent on the space and time of its existence, but in fact that is precisely the trick behind the magic show we call reality. Conversely, although its effect is extremely slight, the apple *warps* the spacetime in its immediate vicinity.

It is inaccurate to speak of the effect of mass on either space or time separately, since space and time only *appear* to be distinctly different elements in this, our three-dimensional world. In Minkowski's world of four dimensions, they exist in a different form we now call spacetime. Because our language is constrained by our three-dimensional world of experience,

there is, as yet, no common language in which to speak about the general theory and the reality it explains. The images in avant-garde art and the insights of physics have to a large extent outstripped the ability of ordinary words to express these ideas. As Henri Bergson said, after attending a meeting where he heard for the first time about the general theory, "I see in this work not only a new physics, but also, in certain respects, a new way of thinking."[8]

To describe the general theory of relativity, it is necessary to speak of space, time, energy, and mass as if each were separate from the others even though they are not. In these conventional terms, space compresses near the surface of any body's mass. It is a similar idea to the contraction that squeezes space for observers traveling at high relativistic speeds which was discussed in Chapter 9. In the general theory, it is the mass of the object that creates the compression of space, however, not the speed of the observer (as in the special theory). The closer space is to the surface of the mass in question, the more elastically compacted and curved it is in relationship to the surface of that object (Figure 22.2).

This effect of mass compressing the space around it has a bizarre corollary, which is that time dilates in the vicinity of mass. A clock on the ground floor of a tall building will lag behind a clock on the top floor of

Figure 22.2. *(left) Space contracts near mass and dilates away from it.* *(right) Time dilates near mass and contracts away from it.*

the same structure, farther from the density of the earth (see Figure 22.2 and Figure 22.3).

Time distant from objects of mass speeds up (compresses) just as space expands (dilates). Near the mass of the earth, time dilates and space contracts. This strange idea at the heart of the general theory has been experimentally proven by placing a very accurate atomic clock inside an airplane and having the plane fly at a high altitude. When the plane lands, its clock is running ahead of an identically synchronized clock that stayed behind on the surface of the earth.

Einstein used a variation on his famous twins paradox to illustrate this peculiarity. If one twin takes a trip aboard a spaceship that leaves Earth and stays away from objects of mass, when the spaceship returns to Earth, the peripatetic twin, reunited with his stay-at-home brother, would note

Figure 22.3. *Clocks positioned farther away from the mass of the earth run faster than clocks closer to the earth.*

a bizarre difference. The earthbound twin would be younger than the twin who spent time aboard a spaceship in a condition of zero gravity.*

A beam of light is the one thing in the universe that does not warp, melt, or change. The constancy of both its direction and its speed is an absolute invariant, a true Polaris of constancy. In our world of three dimensions, the speed of light in a vacuum is *always* 186,000 miles per second, and its path is *always* absolutely ruler-straight. When light passes through an area of warped spacetime, however, it appears to bend and shorten. I say "appears," because it is not the path of the light that undergoes a change; it is the shape of spacetime itself. Light always remains straight and steady. Spacetime that is not in the vicinity of any mass can be described in one context as flat, straight, and rectilinear and has all the characteristics of Euclidean space. Spacetime in proximity to an object of mass, however, is bent out of shape and assumes a warped contour. According to the field equations of general relativity, mass "tells" spacetime what shape to assume. Spacetime is molded by the presence of a massive object, and conversely, mass is the manifestation of intensely curved spacetime. The force we call gravity in our three-dimensional world is really due to the interplay of warped spacetime near an object of mass in the fourth dimension.

To use Arthur Eddington's explanation of why light rays seem to bend near objects of mass, let us suppose we are in a glass-bottom boat observing the motions of sunfish who are swimming along near the bottom of a lake. We can clearly see the sunfish moving in generally straight lines, but there is one spot the fish inevitably seem to swerve around. We deduce from our observation that some repellent force keeps the fish away from that place.

On closer investigation, however, we discover that there is no "force" repelling the fish, but rather that a mound of sand rises from the lake's bottom at this exact spot. The fish, swimming close to the lake's bottom, are simply following the easiest course available to them, which is *around* the mound rather than *over* it. Our misperception derived from our vantage, which is two-dimensional. The invisible "force" turns out to be a very visible object in the three-dimensional world. In the same way, light appears to bend as it passes through a zone of warped spacetime near an object of mass, but like the fish in the example, it is just following the path of least resistance.[9]

*In the more familiar twin paradox concerning special relativity, one twin flies away from Earth at near the speed of light. Upon his return after his high-speed journey, he is *younger* than his stay-at-home brother due to the dilation of time that occurs at high speeds.

Another extraordinary effect of the general theory is that mass affects color. Light in proximity to a massive object becomes blue-shifted; with increasing distance light becomes red-shifted. This principle transposed to art implies that objects affect the color of space around them and the colors of space in juxtaposition to objects of mass are a relative value.

In the years between the publication of Einstein's special theory of relativity in 1905 and his grand connections late in 1915, there had been considerable consternation in the physics community. The ubiquitous luminiferous ether was no more. The invisible substance that according to nineteenth-century physicists was supposed to fill the spaces between the stars was also the carrier of light waves. Now it had evaporated with the publication of Einstein's special theory of relativity. Since the force of gravity also depended on the ether and the ether now did not exist, then on what principle, scientists asked, could action-at-a-distance, mass-affecting-distant-mass, operate? The mystery of how a chunk of matter could affect another far-off mass with nothing in between remained as perplexing as ever. If there was no ether, physicists pondered, how does the earth act on the moon and why does an apple fall from a tree?

The answer to these questions was forthcoming when Einstein prepared himself for his grand insight by first overcoming the natural fear of falling. In a *gedankenexperiment*, he let himself imagine what he would *see* if he fell off the top of a very tall building. As the plummeting yet relaxed Einstein fell, he had time to take out his pen and pad in order to write a few notes. But he noticed that if he let go of the pen and pad, they appeared to be stationary because they were hurtling along with him at—as Galileo proved—the same speed (neglecting wind resistance, of course). In other words, Einstein could only know that he was accelerating downward by observing the building rushing past him in the opposite direction with increasing speed. He *needed to see* another frame of reference in order to determine whether he was accelerating or standing still in space. Without the stationary building to use as a point of reference relative to his acceleration, Einstein would have no way to verify his state of motion until he hit the ground. In Einstein's *gedanken* fall, his first insight was that acceleration, like uniform speed, also needs an outside reference point in order for him to mark his motion.

Einstein next imagined an elevator-sized, windowless box far out in space, sufficiently distant from large celestial bodies that any gravitational pull upon it would be negligible. A passenger in this box would be in a state of zero gravity or "free fall," familiar at the end of the twentieth

century as it was not at the beginning because of the many photos we have seen from space exploration programs. Without any outside gravitational forces operating upon the passenger in the box, he would simply float about within its walls as the box itself floated in space, because both the passenger and walls of the box would be moving at an identical, constant, steady speed, free of the influence of the force of gravity (Figure 22.4).

Einstein's simple second insight was that if the box were suddenly to accelerate, the passenger would immediately "fall": He would experience a pressure forcing his feet against one wall of the box; he would then feel oriented to "up" and "down" and perceive that wall as a "floor" (Figure 22.5). (In Einstein's experiment, acceleration produced the same effect as deceleration. In order to simplify this discussion, I will only refer to acceleration.) It would seem to the passenger far out in space that he was now "standing up." Anyone who has stood in a rapidly accelerating elevator has experienced this pressure as similar to gravity. In physics this force is called g. But if the elevator box in this example happened to accelerate at

Figure 22.4. *A passenger will float in a windowless box in outer space away from objects of mass.*

Figure 22.5. *If a force is applied to the box, accelerating it to 32 feet per second per second, the passenger will experience one wall as a "floor."*

precisely 32 feet per second per second, the passenger could not tell whether he was standing still in a box on Earth, or accelerating in a box in space. Without a window to look through to check his frame of reference, he would find the two possibilities absolutely indistinguishable from each other because 32 feet per second per second is the exact gravitational force exerted on each of us at the surface of the earth (Figure 22.6).

Einstein wondered why we should distinguish gravity from acceleration by giving it a special name. In his *gedankenexperiment*, the only difference between them is that gravity occurs near *objects of mass*. Einstein concluded that the force of gravity is no different from the force exerted by acceleration. Again Einstein, as he did in 1905, with the clarity of a naïve child, proclaimed that what is, is.

But if gravity is just acceleration, then what is accelerating when we stand still on the surface of the earth with our feet pressed firmly to the ground? Einstein proposed that the mass of the earth has warped the spacetime surrounding it. This wrinkled four-dimensional stuff creates

Figure 22.6. *If the same windowless box is resting on the surface of the earth, the passenger will not be able to distinguish between his situation of acceleration in Figure 22.5 or his one here of rest. He would need to see through a window in order to compare his situation against another frame of reference.*

the illusion of a specific force in three dimensions that does not actually exist in spacetime. His answer to Newton's question of what exactly constitutes the force of gravity is that gravity appears to be a force in three-dimensional space, but it is really acceleration in an intensely curved spacetime interacting with a mass-energy equivalence in four dimensions.

Einstein's 1915 pronouncement that what appeared to be a force called gravity was only an illusion due to warped spacetime wrapping about dense matter was the first new idea about this basic fact of everyday experience to occur to anyone since Newton. Einstein's theory was so revolutionary that he also overturned sacred Western assumptions about space, time, and mass that had been postulated by Aristotle and Euclid, and reinforced by Galileo, Newton, and Kant. Implicit in all their writings had been the ideas that space was separate from time, and that neither had anything to do with matter. The a priori underpinning for all their systems was that space

was as substantial as a shadow. When Einstein showed that space could be wrinkled and distorted by mass and further profoundly influence the substance of mass, however, he demonstrated that space was something. As in his 1905 special theory, once again in the general theory Einstein had revealed that it was the mistaken idea of sequential time that was the laughing poltergeist haunting the illusory three-dimensional world of experience.

Einstein had in effect thrown down a gauntlet that did not fall, but rather wormed its way through warped spacetime. If mass warps spacetime as Einstein proposed, then light beams should appear to bend as they passed near objects of mass. The pragmatic community of experimental physicists had to devise an experiment to prove or disprove this outrageously original theory. They rose to the challenge and devised one that required the entire solar system as well as the universe to serve as the laboratory.

In 1919 Arthur Eddington led an expedition laden with astronomical instruments deep into Príncipe Island off the coast of Africa because on a certain day there would occur in a certain location a total solar eclipse. For a few moments, as the sun's brilliance was blotted out by the moon's passage across its surface, the sky would darken and the stars would appear in the middle of the day.

According to Einstein's theory, those stars' light beams that happen to pass close to the sun's edge should bend as they travel through the area of warped spacetime surrounding the sun. If he was right, the stars would appear to be in a position in the darkened daytime sky different from the position they would occupy later at night, because at night there would be no object as massive as the sun to compress the spacetime between the stars' light and the observer's eye (Figure 22.7).

Eddington took pictures of the stars' positions in the sun's region of the sky during the eclipse in order to compare them with their nighttime locations. While waiting for the film to be developed, he knew his findings would either confirm or destroy Einstein's revolutionary theory. As it turned out, there among the mosquitoes and monkeys, at the approximate site where the ancestors of the human race first climbed down out of the trees and stopped trying to defy gravity, Eddington's data confirmed that Einstein was correct. Einstein, of course, was never in doubt. When one of his students asked him how he would feel if Eddington's results failed to confirm his theory, Einstein replied, "I would have been sorry for God—the theory *is* correct."[10]

This confirmation by an Englishman of a German's theory acted like a

Figure 22.7. *Light rays moving through curved spacetime near an object of mass are deflected from their usual straight paths.*

balm on the isolated, postwar nationalist scientific communities. Einstein's name would henceforth be synonymous with the brilliant radiance of the human mind.

> And when I saw my devil, I found him serious, thorough, profound and solemn: It was the spirit of gravity. Through him all things fall. Thus Spake Zarathustra.
>
> <div align="right">Friedrich Nietzsche</div>

> . . . Einstein's space is no closer to reality than van Gogh's sky. The glory of science is not in a truth more absolute than the truth of Bach or Tolstoy, but in the act of creation itself. The scientist's discoveries impose his own order on chaos, as the composer or painter imposes his; an order that always refers to limited aspects of reality, and is based on the observer's frame of reference, which differs from period to period as a Rembrandt nude differs from a nude by Manet.
>
> <div align="right">Arthur Koestler</div>

CHAPTER 23

WEIGHTLESS FORMS / GRAVITATIONAL FORCES

Sensing, somehow, the illusion of gravity, modern artists began to examine themes of antigravity in the late nineteenth century long before Einstein revised our ideas about the relationship between mass and space. The unconventional ideas that rippled through both paint-

ing and sculpture can be recognized, when viewed in retrospect, as heralds of change.

Acrobats are the one highly specialized group within a society who routinely defy the laws of gravity. While acrobats have been part of Western culture since antiquity, they had not been the subject of art for two thousand years except on rare occasions. Yet, they appeared in art in abundance shortly before the physicists revealed the illusory nature of the acrobats' unseen foil—gravity.

Manet became interested in acrobats, making them the subject of pen and ink drawings executed in 1862. Edgar Degas's 1867 *La La at the Cirque Fernando, Paris* (Figure 23.1) featured a Paris high-wire acrobat suspended in midair. Not only does his La La challenge the law of gravity, Degas has scrambled other conventional orientation clues as well: There is no horizon line evident in the painting, and by design, the ceiling struts and the angle of vision unsettle the viewer because of the composition's unusual perspective. In sharp contrast to the static, architectonic schema of most of his compositions, Georges Seurat also used an acrobat motif in his *Le Cirque* (1891) (Figure 23.2) by balancing a dancer on the back of a galloping horse so precariously that it seems nearly impossible that she will not be pulled off the horse by the force of gravity. Between 1903 and 1904 the young Picasso portrayed, almost exclusively, a circus family of saltimbanques. In the few years immediately before Einstein revolutionized the question of gravity's nature, these jugglers and acrobats, for example in *Young Acrobat on a Ball* (1905) (Figure 23.3), became the principal subjects of his rose period.

In 1907–12, as I discussed in Chapter 14, Pablo Picasso and Georges Braque carried Cézanne's insight about the relationship between space and mass to its logical extreme, creating in the process a whole new way to represent visual reality. Cubism fractured the mass of objects into pieces. Cubist artists rearranged these cracked shards so that they appear out of the linear sequence of time against a background of fractured Euclidean space. Like jagged pieces of a disintegrating ice floe, the fragments ride up while grinding against one another, impaling the space surrounding them. In Cubist art, as in the general theory of relativity, spacetime is inextricably enmeshed in mass-energy. Cubism can be viewed as the artist's way to penetrate an object's mass into the spacetime continuum.

Van Gogh had marveled at "the gravity of great sunlight's effects."[1] In both this statement and in his art, van Gogh communicated the weight of light. No other artist converted the sun's energy into such a palpable pastiche. But van Gogh could not have known that sunlight would soon

Figure 23.1. *Edgar Degas,* La La at the Cirque Fernando, Paris *(1867)*
LONDON NATIONAL GALLERY

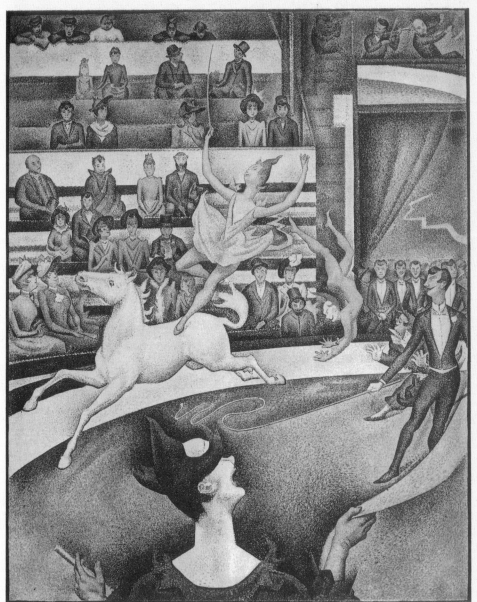

Figure 23.2. *Georges Seurat,* Le Cirque *(1891)* MUSÉE D'ORSAY, PARIS

actually be expressed as a weight through Einstein's famous formula, $E = mc^2$. The energy contained within a beam of light expressed in tons per second now can be converted into pounds of solid matter, and the "weight" of light can be calculated. Astrophysicists estimate that the equivalent of 160 tons of sunlight fall upon the surface of the earth in one year.[2]

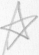

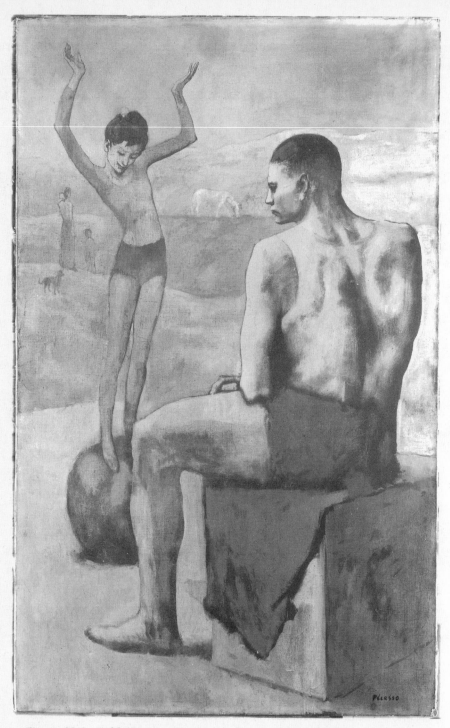

Figure 23.3. *Pablo Picasso,* Young Acrobat on a Ball *(1905)* PUSHKIN STATE MUSEUM OF FINE ARTS, MOSCOW

Soon, other artists introduced styles that resonated with the distant sounds of a fast-approaching new physical theory about the world. Beginning in 1910, the French artist Robert Delaunay chose the Eiffel Tower as the subject of over thirty paintings. Because in this unique structure space actually intercolates the mass, and light penetrates through its interstices so as to be seen from the other side, the Eiffel Tower was unlike any previous conventional structure. Delaunay did not portray the Eiffel Tower realistically; instead, as in *Red Eiffel Tower* (1910) (Figure 23.4), he dematerialized it. Believing that no one view could encompass the essence of the tower, he disintegrated it by embedding isolated chunks amidst the matrix of spacetime. In the late 1920s Lyonel Feininger created images consonant with Einstein's blurred interrelationship between space and mass by continuing the planes of his solid objects into the space around them. For Feininger, the boundary between clear space and material objects, which once had been sharp, became indistinct.

The scientific community was struck speechless when first confronted in 1915 by Einstein's integrated energy-mass and warped spacetime equations. Pressed to create a visual metaphor to help his audience understand his insight, Einstein replied, in effect, that "there is none." In trying to explain the difficulty, even Einstein could not express in language what he had envisioned.

> We cannot use in the general relativity theory the mechanical scaffolding of parallel and perpendicular rods and synchronized clocks. . . . Our world is not Euclidean. The geometrical nature of our world is shaped by masses and their velocities.[3]

As if to emphasize his unusual thought processes and lack of reliance on language, Einstein, in reply to a query about his manner of thinking posed by the French mathematician Jacques Hadamard, wrote, "The words or the language, as they are written or spoken, do not seem to play any role in my mechanism of thought."[4]

Spacetime, quantum jumping, and spacetime warped by mass-energy were so far from ordinary experience that the ordinary human mind, with very few exceptions, could not conceive of them. For the first time since natural philosophers began to inquire into the nature of the universe, scientists had created models of reality that humans, the most visual of animals, could not visualize. The concepts of general relativity, it seemed, could be precisely expressed only by the use of abstract mathematical symbols.

Figure 23.4. *Robert Delaunay,* Red Eiffel Tower *(1910)* SOLOMON R.
GUGGENHEIM MUSEUM, NEW YORK, PHOTOGRAPH BY ROBERT E. MATES

Readers who have come this far with me on the journey to understand the complementarity of art and physics will not be surprised to recognize that the failure of language to explicate the new paradigm of physics coincided with the introduction of a completely new, nonrepresentational form of art. Nor will they be surprised that abstract art, like the abstract mathematics upon which the new physics depended, could not be translated into an easily understandable visual model. Non-Euclidean geometry, the unimaginable arcane space supposedly confined to mathematics, became the new basis of physical reality and art without an image became a major new style in art.

Forty years before Einstein demonstrated that empty space was not nothingness but had real characteristics that could be expressed as geometry, Cézanne was already basing his art in geometry. Not only did he insist on simplifying shapes into the cone, the cylinder, and the sphere, as we have already seen; in addition, he began to treat the space in his art as a geometry with tensile characteristics.

During the second decade of the twentieth century Kandinsky, the first abstract painter, assumed that space had an inherent geometry and organized many of his later abstract works geometrically. Coincidentally the Russian suprematists, headed by Malevich, and the Dutch De Stijl school embraced this geometrical motif enthusiastically. Mondrian, an outspoken proponent of De Stijl, asserted as a basic principle of his art that "force is geometry," about the same time Einstein's equations declared that space is geometry and the force of gravity is due to the shape of spacetime. A leading avant-garde artist and the most prominent physicist both concluded at the same time that space was in fact a geometry and force was due to this feature of space. A representative example of Mondrian's work is his *Composition* (1933) (Figure 23.5). Much later, in the 1960s, the minimalist artist Frank Stella created a series of paintings known as his "Protractor" series in which the space of the canvas is converted literally into a geometry—precisely as Einstein declared that it is.

Modern art also anticipated Einstein's discovery that gravitational force is an illusion. After Manet's disembodied pairs of legs, painters began to portray people flying about, freed from the cloying hold of the earth's gravitational pull. Marc Chagall, in particular, went beyond painting acrobats and jugglers as his immediate predecessors had done and made floating, flying, and levitation common sights in his art. In *I and the Village* (1911) (Figure 23.6), Chagall introduced an image consistent with the concept of zero gravity. The two figures in the painting are not only flying about but one is "upside down." The words "up," "down," "over," "under,"

Figure 23.5. *Piet Mondrian,* Composition *(1933)* THE MUSEUM OF MODERN ART,
NEW YORK, THE SIDNEY AND HARRIET JANIS COLLECTION

"above," "below," "top," and "bottom" are not really vectors of Euclidean
space, but are ideas related to gravity: Things that are "up" are away from
the center of gravity and things closer to the center are "down." We cannot
see up and down; instead we *feel* up and down. But if the force of gravity
is a fiction of the three-dimensional universe, then these words would have

Figure 23.6. *Marc Chagall,* I and the Village *(1911)* THE MUSEUM OF MODERN
ART, NEW YORK, MRS. SIMON GUGGENHEIM FUND

no meaning in the language of four dimensions. For the artist, directions
like "up" and "down" had already lost their Newtonian significance and
been supplanted by the Einsteinian revolution just around the three-
dimensional corner.

Newton's system, including his laws of universal gravitation, came to be known as classical physics, probably in deference to Plato's classical truths which were considered ideal. In much the same way, Newton's system of mechanics was believed to be an ideal beyond dispute. Before Einstein's revelations about gravity introduced exceptions to classical physics, Picasso created a series of paintings using classical themes full of conspicuously gross and heavy Greco-Romanesque figures, for example in *Three Women at the Spring* (1921) (Figure 23.7). As if Picasso intuited that the classical notions of mass and density were about to be transformed, these neoclassical figures contrast sharply with the attenuated figures from his earlier blue and rose periods. If his saltimbanques were a metaphor for the relativistic elongation of form, the fun-house mirror was the appropriate metaphor for warped spacetime. Picasso depicted its distortions freely in his figurative painting.

Dali expressed with uncanny accuracy how a beam of light would appear passing through the warped spacetime near an object of mass in *Agnostic Symbol* (1932) (Figure 23.8). In this work, an enormously elongated silver spoon resembling nothing so much as a beam of light enters the picture from the upper right-hand corner. The spoon *qua* light beam then passes through a hermetic dark space containing only a small ambiguous object of mass; the thin spoon's straight shaft bends around the object's mass, then straightens out again. The tiny scoop of the spoon carries an infinitesimally small, realistically drawn clock upon whose face time has stopped forever at 6:04. Dali expresses in one surrealist painting the idea of bent light, warped space, and arrested time. It would be hard to find an image in all of art that more inventively portrays the effect of mass upon spacetime in its immediate vicinity than *Agnostic Symbol*.

The model we all use to think about the so-called real world is made up of certain fundamental beliefs, one of which is the bedrock, consensual agreement concerning the reality of Newtonian gravity. In several surrealist works, such as *Le Château des Pyrénées* (1959) (Figure 23.9), René Magritte singled out for reexamination one particular supposedly solid belief. There are few symbols in the psyche that are more massive than a mountain or a fortress. Magritte conjoined these two symbols. He went further than Cézanne's experiments concerning the relationship between space and mountain. His levitating mountain crowned with a fortress brazenly violated Newton's basic law of gravitation. In *The Sense of Reality* (1939), a boulder the size of a mountain floats free above an undisturbed landscape. Magritte's mute disregard for the "force" of gravity complements the nonverbal, obscure formulas of the new physics, and confronts the viewer with

Figure 23.7. *Pablo Picasso,* Three Women at the Spring *(1921)* THE MUSEUM OF MODERN ART, NEW YORK, GIFT OF MR. AND MRS. ALLAN D. EMIL

the possibility that alternate explanations exist regarding the interaction of space and mass.

Escher also challenged traditional beliefs regarding gravity. In a clever cardboard cutout entitled *Three Spheres I* (1945) (Figure 23.10), he demonstrated, using projective geometrical lines, the effect of gravity crushing and distorting mass. From the traditional perspectivist point of view, three

Figure 23.8. *Salvador Dali,* Agnostic Symbol *(1932)* PHILADELPHIA MUSEUM OF
ART, LOUISE AND WALTER ARENSBERG COLLECTION

spheres appear to be piled upon one another. The weight of the top two
spheres appears to flatten the one below, graphically showing the distorting
effects of gravity. When the viewer shifts perspective, however, and con-
siders *Three Spheres I* from another angle, what was perceived to be mass
distorted by gravity turns out to be nothing but three-dimensional illusion
made from a two-dimensional cardboard cutout. By simply adding another
dimension to the monolinear view imposed by perspective, he takes the
viewer behind the façade of three-dimensional gravity.

Soon after the general theory of relativity was published in 1915, the
mathematically inclined astronomer Karl Schwarzschild began to play with
Einstein's equations. He speculated about the possibility of an imaginary,
super-dense object that would so distort the spacetime in its vicinity that

Figure 23.9. *René Magritte,* Le Château des Pyrénées *(1959)* ISRAEL MUSEUM, JERUSALEM. COPYRIGHT © 1991 BY C. HERSCOVICI/ARS NEW YORK

Figure 23.10. *M. C. Escher,* Three Spheres I *(1945)* COLLECTION HAAGS
GEMEENTMUSEUM—THE HAGUE

light would not merely be bent in passing near it but would actually be captured, never again to escape from the object's surface. Because light could never be generated by it or reflected from it, the superdense object would in this special case be invisible. Light, the airy quintessence of the universe, the speeding Hermes of the cosmos, would in this special case be incarcerated by the dark warden of gravity. Speculation about such a fantastically dense object was so outlandish that physicists believed it could exist only in theory. Nothing was known to exist in the universe that was even remotely dense enough to produce this anomalous effect. Even Einstein, the originator of the field equations upon which these speculations were founded, never mentioned the possibility of the existence of a real black hole.

At the outset of rational doubt twenty-five hundred years ago, Plato suggested that there was little difference between imagination and reality. He observed that anything that one could reasonably imagine was eventually possible. The plenum of the mind, according to Plato, is actually the cornucopia of reality. In agreement, William Blake penned, "Everything possible to be believ'd is an image of truth."[5] The later discovery by astronomers of a "real" black hole in 1971 in the constellation Cygnus corroborated the validity of these philosophical and poetic views.

Black holes result from a giant star's death. Star death was a cosmic discovery. For millennia people from all civilizations looked up into the nighttime sky and saw what appeared to be the unchanging nature of the constellations. Aristotle's quintessence was supposed to be the one element that was eternal. In 1927, as a result of Edwin Hubble's interpretation of the galactic red shift discussed in Chapter 13, astronomers discovered with a jolt of excitement that the universe was not only evolving but it was expanding as well. A total reversal of previous beliefs occurred as a result. There was no such thing as a stellar, static, eternal quintessence.

Astronomers pieced together the events in a star's life by patiently peering into the nighttime sky. The faint starlight filtering through the dust and gases of distant nebulae that found its way into the barrel of their telescopes was then subjected to spectroscopic analysis. The alternating bands of different colors held the key to unlocking the makeup and the events in a star's life. The stars, the sun, and even the moon consisted of the ordinary atoms that are all present here on Earth. Astrophysicists could find nothing exotic. The distant galaxies contain all the building blocks that make up butterflies and buttercups here on our planet. Hydrogen, carbon, nitrogen, oxygen—the four basic ingredients responsible for life as we know it—are sprinkled all across the Milky Way. Each of us is made

out of the stuff of stars. At first glance nothing would seem to be more different than a human being and a star. Yet the similarities between the life cycles of each member of this unusual coupling are striking.

The genesis of a star begins in those regions of space where undifferentiated clouds of hydrogen atoms exist. Imperceptibly, because of the infinitesimally small gravitational pull* of each tiny atom upon its neighbor, these atoms begin to coalesce. Some unseen organizing principle, much like the ephemeral force of life, gathers the eddies and wisps together into an elegant slowly spinning spiral. The vortex continually winds inward in ever-tightening circles, as in a galactic whirling dervish's dance, and similarly the tempo increases over millions of years. Gradually, the intense jostling caused by each new excited atomic arrival raises the temperature at the spiral's core, as more hydrogen atoms are relentlessly pulled into the continued winding of this growing whirlpool of hot matter.

As yet, it produces no light. The star is in its gestational period. It resembles the embryonic stage of human life, which, like this phase of a star's growth, cannot be seen but is there, quietly growing in the darkness. As this vortex constricts, the temperature at its center rises to 10,000,000 degrees Celsius. Then, having accumulated a critical mass of hydrogen atoms, the star initiates a nuclear chain reaction. The frisible ignition of this thermonuclear flame, comparable to the first cry of a newborn baby, heralds the birth of the newborn star. The period during which the star lived in darkness, just like the human intrauterine existence, is over. Interested parties can see what these newborns look like.

Freud, in *Beyond the Pleasure Principle* (1920), theorized that the process of life results from a taut balance between two opposing forces, Eros, the urge to live, and Thanatos, the drive to die. These two engage in what amounts to a three-score-and-ten-year arm wrestling match. In youth, Eros is triumphant; inevitably, in old age, Thanatos gains the upper hand. It is the same with stars.

The growing young star's life depends upon its nuclear furnace to convert its substance into energy. Eros, through its outpouring of radiant energy, pulls the star's atoms apart and counteracts the deadly entreaties of Thanatos. Thanatos, on the other hand, controls the youthfully exuberant but potentially equally destructive wild outward urges of Eros by keeping the atoms together through the pull of gravity. The resulting balance of this struggle determines a star's form.

*To avoid added complexity, in this discussion of stars I will speak of gravity as the familiar force as it exists in our three-dimensional world.

Astronomers identify a star because it gives off a distinctive light that is its essence. Each star's unique flame will burn for millions of years, constantly fed by hydrogen atoms that give up their substance, disappearing into space in pulsing waves of electromagnetic light. This metamorphosis is the life-force of a star. While the star is young, it is light and airy, deriving its energy from its abundant hydrogen stores. During a period of childhood lasting billions of years, it uses nimble hydrogen as its only source of fuel. Its appearance, just like an adolescent's, changes as it begins to transubstantiate the simple hydrogen atom into heavier elements in order to continue its existence. The star begins to mature, and like humans, appears more substantial as its density increases. Then the adulthood of a star begins.

It is to this stage of a star's life cycle that we each owe our own individual existence. During this period the thermonuclear reaction burning at the star's center takes on the persona of the Roman god Vulcan who begins to forge most of the other atoms. Slowly the process of nuclear fusion converts hydrogen into helium, then helium to carbon, then carbon to nitrogen, then nitrogen to oxygen, then oxygen to silicon, and so on up the periodic table as far as iron. The Tinkertoys to build all life as we know it derive from this star stuff.

Charles Darwin in 1859 published his monumental *On the Origin of Species* in which he proposed that the process of evolution was due to the interaction between environmental challenge and an organism's adaptation to it. What he could not determine was the mechanism for life-forms' response to change. How does an animal evolve with a thicker fur coat as the temperature drops due to glaciation? Darwin would have been amazed to learn that the directive comes from the stars. The driving force behind the evolution of all life on this planet is the process of random mutation occurring within each molecule of DNA in sperm or ovum. These mutations are mainly the result of bombardment of DNA's atomic structure by cosmic radiation. From out of the depths of outer space, crossing billions of light-years, these directives from distant stars find a gene strand, bend it, and thus reshape the future forms of life. Not only are we made out of the stuff of stars but life itself could not evolve without the intercession of these distant stellar messengers. Evolution, which is another name for *all* life, takes its cue from the stars.

In the human life cycle, usually the most productive period in a person's life is the middle years of adulthood. If a person is to leave a distinct legacy for future generations, it is in these years that the creative and procreative flames must be ignited; so too with stars. The creation of the elements,

fired into existence in the kiln of the star's center, is the crucial antecedent step necessary for the evolution of the species here on earth. Stars are the primordial parents of all life-forms. Consciousness, emanating from our gray, moist, three-pound brain, is composed of their minute children. The skein of the genealogy of thought can be traced back to the galaxies. Upon the death of some stars, their ashes are spewed into the darkness to become the seeds of you and me.

When all the star's available hydrogen has been converted, a middle-age spread sets in and the star's light dims as the supply of fuel available to throw into its furnace steadily dwindles. The star literally gains weight. The balance between the life and death force of the star begins to shift. Gravity, the force of Thanatos, imperceptibly begins to overcome energy, the force of Eros. The star becomes a dying red giant and enters a period of senescence and quietude that lasts millions of years. Its source of power exhausted, the star's temperature begins to fall. Starlight, like the light of a guttering candle, metaphorically begins to flicker, signaling that the star is nearing its end.

Stars, like human beings, can die in many different ways. For some, death comes as a violent explosion called a supernova: a cataclysmic, cosmic event that shreds and rends a colossal star scattering its pieces across the sky. Supernovas are responsible for the creation of all elements heavier than iron. For most stars and people, however, death is a relatively quiet event.

When the average star's energy output falls too low to keep all its stellar atoms apart, gravity begins to gather them in toward its center. This crowding continues until the star becomes a tightly packed, glowing ember. The electrons of each individual atom so abhor sharing their space with other electrons of identical negative charge that at some point they cry, "Enough!" As a result, the squashed, cooling atoms cease their inward involution and reach a steady state. The star consists of such compressed matter and immense density that it "dents" the region of spacetime that surrounds it. Astronomers call these stars "white dwarfs." Their diameters measure in thousands of miles instead of billions or trillions, and their densities are in the range of a thousand tons per cubic inch. They remain in their glowing state indefinitely.

If the mass of the star is 1.4 times more massive than the sun, even the xenophobic aversion of the negative electrons cannot hold back the inexorable, crushing grip of gravity. Thanatos slowly and relentlessly squeezes the electrons into a forced mating with the protons in the nuclei, resulting in an increase in neutrons. The neutrons, like electrons, resist sharing

their cramped space with others of the same ilk. These crowds resemble nothing so much as the sullen inmates in an overcrowded jail, condemned to confinement in a space never intended to hold so many. This particular kind of star death creates a superdense, burned-out cinder astrophysicists call a "neutron star." In this case, the remains of a once-proud star may be squeezed into a coffin whose diameter may be only twenty miles; its density can be so great that a matchbox containing its substance would weigh forty billion tons.

The death of a star that happens to be 2.5 times larger than our sun (which incidentally is about average size) is attended by a monstrous grinding and crushing of burned-out matter into an ever smaller space. What began as an enormous celestial body whose diameter was measured in miles raised to the sixth or seventh power of ten will end as a corpse no more than a few miles across. With nothing to stand in its way, Thanatos, in a final relentless bear hug, grunts and heaves and literally chokes a giant star out of existence. The spacetime in its vicinity enfolds the dead star in a warped shroud. The density of these dead stars' matter is so great that their light disappears forever.

Death is the perfect metaphor in this last special case. The dying of the light occurs because the dark, unseen force of gravity strangles a great star. Both the star's light, the constant of the universe, and its stellar substance vanish, and the residue of their disappearance remains like the chalk outline of a corpse that has been removed from the scene of a murder. Astrophysicists have named the residue of this ghostlike entity a "black hole."

John Wheeler coined the name "black hole" in 1967 and astronomers located the first superdense star corpse in 1971. Black holes have captured the public's imagination ever since. The biologist J.B.S. Haldane once remarked, "The universe is not only queerer than we imagine, but it is queerer than we *can* imagine."[6] Edward Harrison poetically described black holes as "monsters of the deep."[7] The poet Jonathan Swift much earlier presciently might have been describing a black hole when he wrote:

> All-devouring, all-destroying,
> Never finding full repast,
> Till I eat the world at last.[8]

Despite its strangeness, a black hole consists of only two parts: the event horizon and the singularity (Figure 23.11). The event horizon is an invisible border that surrounds the black hole, inside which the gravitational pull

Figure 23.11 *A black hole*

is so great that any light that crosses into its confines disappears forever. If you direct a beam of light on to a black hole, no reflection will ever come back, nor will any light generated from inside the event horizon ever escape. Consequently, a black hole should be totally invisible.*

In order to illustrate the peculiar landscape of a black hole, let us take an imaginary spaceship tour to one of these cosmic Stygian islands. As we approach the outer vicinity of the black hole's event horizon, we are buffeted by the powerful effects of warped spacetime as space becomes compressed and squeezed by the vise of gravity. We know in advance that we cannot observe any "event" that occurs behind this opaque curtain, which is the reason why it is called the event horizon. During the star's collapse, any space that gets caught inside the barrier of the event horizon ceases to exist in our universe. Einstein's general theory of relativity demonstrates that mass slows time. At the event horizon of a black hole, the effect is so great that time literally stops.

Let us fantasize that one intrepid volunteer, magically protected, agrees

*Stephen Hawking has raised the possibility, however, that due to quantum fluctuations a negligible amount of light would escape.

to try to enter the black hole. In reality nothing of substance could exist on the other side of the event horizon because the gravity would crush the entity's atoms like so many grapes at harvest time. Our explorer takes with him a very large clock and a yardstick which he carries pointed toward the center of the black hole. Parked in our spaceship outside the event horizon, we observe that the ticking of his clock slows down the closer he approaches to the event horizon. When the clock reaches the edge of this invisible barrier, we see that its hands stop moving. This instant is preserved forever. As time becomes infinitely dilated, the image of the clock and our spacemate becomes perpetually frozen for us who have remained aboard the spaceship. Further, our explorer seems to us to flatten like a cardboard cutout, and the yardstick he carries, pointed at the black hole's center, contracts, becoming infinitely squeezed at the event horizon until there remains, finally, no length at all.

While from our perspective on the spaceship, our flattened explorer appears in a state of suspended animation, a different set of perceptions prevails for him. As he approaches the event horizon, the clock accompanying him steadfastly keeps ticking at an even rate. But though he does not notice anything unusual about his timepiece, he can see that he and his ruler are elongating, both becoming hundreds of miles long as they pass through the event horizon. His distortion is the exact opposite of what we observe from the spaceship. This is due to the effect of gravity on the parts of both ruler and explorer that are closest to the black hole. Gravity pulls the mass of each into relativistically attenuated lengths of taffylike substance.

Our courageous explorer experiences his greatest shock when he turns and looks back at our spaceship, however. Just as he is about to wave and step across the threshold of the event horizon, he sees the entire history of the universe fast-forward at an incredible speed. The whole life cycle of the universe, from big bang to the end, flits past in an instant and then is snuffed out![9]

At the event horizon there are three types of time. The first is the frozen eternal moment for us, the observers, in the spaceship watching our comrade trying to cross the event horizon (which he never does). The second is the time kept by the clock accompanying the explorer, which, to the explorer, is unaffected by all this gravitational pull. The third is the simultaneous history the adventurer experiences, looking back as he attempts to cross the event horizon: the entire time of the cosmos—past, present, and future—contained in an instant.

We cannot be sure what actually occurs inside a black hole because

relativity predicts that the five essences—space, time, energy, matter, and light—are forced together there and must converge into one geometrical point: the singularity. All world-lines from Minkowski's hourglass spacetime diagram, discussed in Chapter 17, meet and then stop at that point. There are no physical laws applicable in our world that can describe exactly what happens next. Entities "having not the law," St. Paul wrote in another context, "are a law unto themselves."[10]

Inside the event horizon, time, like space, ceases to exist in the sense that we know it. Instead, mathematicians have speculated that another type of time exists there: *imaginary time*. They propose that this mental construct is positioned at right angles to the rectilinear arrow of proper time. If time can indeed have another direction that is at right angles to linear time, then time is implicitly spacelike. Furthermore, a two-dimensional, timelike world in space implies a third perpendicular to the right angle of time. Minkowski's fusion of space and time into spacetime can be more graphically rendered in the context of imaginary time inter-secting proper time than it can by thinking only of monolinear time.[11]

As time *gains* dimensions on the far side of the event horizon, so, too, space by contrast *loses* them. Inside the event horizon there are limits on breadth and depth, but none on length. Movement sideways or back and forth is restricted: All movement must go inevitably forward toward the singularity. Outside there are three vectors of space and only one relentless direction of time. Inside the event horizon, time opens like an umbrella to contain other vectors while space inexorably is reduced to one, funneling into the singularity.

The dead center of a black hole does not really exist as a location in space and time as shown in the diagram in Figure 23.11 because the black hole does not really contain space, time, or light in the conventional sense. The singularity is the bottomless sink into which everything spirals and then disappears. Matter, energy, space, time, and light are all sucked into this celestial vacuum cleaner and vanish from our universe. There exists no everyday language to describe exactly what happens inside the singularity. A black hole is an idea that brings us face-to-face with the implacable limits of our mammalian three-dimensional perceptual equipment.

The mystery surrounding the fate of everything that vanishes into a black hole has led physicists to speculate that perhaps all these components of our reality may reemerge in another, parallel universe. An alternate conjecture is that they return in a different region of our own universe at a different time. According to these theories, the black hole produces a

worm tunnel in spacetime, and whatever disappears down its singularity exits somewhere else at another time through a reciprocal "white" hole (Figure 23.12 and Figure 23.13).

The theory of worm tunnels in spacetime was attractive to astrophysicists because it seemed to complement another bizarre fact of the universe, the quasar. Quasars (*quasi*-stell*ar* objects) are mysterious celestial objects that eject such prodigious amounts of energy that presently there is no known process in the universe that could account for them. While most astrophysicists believe quasars to be the active cores of massive protogalaxies, some astrophysicists have proposed that quasars may be "white holes" at the other end of the singularity of black holes that exist in either this universe in another region of space and time or even, more amazingly, from another universe. Perhaps in its churning and mincing of space, time,

Figure 23.12. *An embedding diagram of a black hole and its obverse, a white hole*

Figure 23.13. *A wormhole in spacetime: The other end of a black hole in our universe may open out on a different time and location.*

energy, and mass the singularity could be the celestial appliance which is the puzzling source of energy pouring forth from quasars. If this were to be true, then what we have perceived as a frightening image—the black hole—would turn out to be but one half of a complementary cosmic pairing. Yin and Yang would be a graphically real metaphor for this unity.

> Both science and art form in the course of the centuries a human language by which we can speak about the more remote parts of reality, and the coherent sets of concepts as well as the different styles of art are different words or groups of words in this language.
>
> Werner Heisenberg

> After this, we will all have to live a little differently.
>
> Rainer Maria Rilke, upon seeing Constantin Brancusi's
> 1919 sculpture *Bird in Space*

CHAPTER 24

SCULPTURAL MASS / CURVED SPACETIME

Before the physicists completely accepted the notion that a black hole could actually exist, an eclectic group of artists including Kazimir Malevich, Pierre Soulages, Franz Kline, Robert Motherwell, Yves Klein, and Robert Rauschenberg had begun to explore the possibility of creating abstract paintings devoid of image, color, and even light. Each of these artists created at least one all-black canvas. Ad Reinhardt, a New York artist of the 1960s and the bête noire of modern art, found in the all-black painting the perfect metaphor for the ultimate statement about reality. He never deviated from this style thereafter, executing the same

painting repetitiously for the rest of his life. For Reinhardt, the all-black canvas said everything there was to say because it said nothing. As he wrote in his book *Art as Art*:

> "A square *(neutral, shapeless)* canvas, five feet wide, five feet high, as high as a man, as wide as a man's outstretched arms *(not large, not small, sizeless)*, trisected *(no composition)*, one horizontal form negating one vertical form *(formless, no top, no bottom, directionless)*, three *(more or less)* dark *(lightless)* no-contrasting *(colorless)* colors, brushwork brushed out to remove brushwork, a matte, flat, free-hand painted surface *(glossless, textureless, non-linear, no hard edge, no soft edge)* which does not reflect its surroundings—a pure, abstract, non-objective, timeless, spaceless, changeless, relationless, dis-interested painting—an object that is self-conscious *(no un-consciousness)* ideal, transcendent, aware of no thing but art *(absolutely no anti-art)*."[1]

Reinhardt's paintings negated Leonardo's famous drawing illuminating the credo that man was the measure of all things (Figure 4.4). The sides of the square and the diameter of the circle in Leonardo's version were also exactly five feet. Reinhardt described his progression toward black squares as a search for an image like that of the Buddha, which he once called "breathless, timeless, styleless, lifeless, deathless, endless."[2]

The early-twentieth-century English writer G. K. Chesterton critiqued the art of his era by lamenting, "In the beginning there was art for God's sake, then in the Renaissance there was art for man's sake. Beginning with Impressionism there was art for art's sake. Now, unfortunately, we have no art for God's sake!"[3] One can only surmise Chesterton's reaction had he lived long enough to attend a Reinhardt gallery opening. There, hung on every wall, were identical all-black paintings. Reinhardt, used to critics' barbs, answered them enigmatically, "Looking is not as simple as it looks."[4]

Like black holes, Reinhardt's all-black paintings contained everything —space, time, energy, mass, light—yet they contained nothing. Despite the brutal negation of any image inherent in Reinhardt's work, this artist unerringly found a way to express a bizarre idea that later would be an object of physical reality described by astrophysicists. The black hole, a thing without any image, would capture the imagination of the public.

Mark Rothko, a contemporary of Pollock and Newman, painted enormous canvases that contained soft, glowing clouds of color reminiscent of the

star clouds that yielded the secrets of the universe to the astronomers. Thoughtful critics have likened Rothko's work to the light emanating from nebulae. His large canvases have a mysterious, spiritual effect on the viewer. The circular wall of a nondenominational chapel in Houston, Texas, contains his large brooding canvases, which are said to stir feelings of awe and reverence similar to those described by poetically inclined astronomers after spending a night observing the luminous lights of the nebulae.

Through their prescient imagery, painters often have captured features of Einstein's new conception of gravity. Sculpture, however, is the art form that best defines the changing relationship between mass and space. For thousands of years, embodying the essence of Newtonian gravity, statuary was massive, monolithic, heavy, and stationary. To enhance the effect of density, it was fashioned out of marble or bronze.

Until the close of the nineteenth century, the center of gravity for virtually all sculpture was located deep within the work itself. The mass, in turn, sharply displaced and delineated the empty space surrounding it. The distinction between what was empty space and hard mass was therefore clear. A spectator could walk around a sculpture and view it from multiple vantages. Lines of sight always passed through empty space to reach the mass, which led the great Renaissance sculptor Benvenuto Cellini to boast, "The art of sculpture is eight times as great as any other art based on drawing, because a statue has eight views and they must all be equally good."[5] A viewer usually could estimate where within a work lay the approximate center of gravity. These characteristics of statuary were so fundamental that it was difficult for anyone before the modern era to imagine this art form without them.

But decades before Einstein published his general theory of relativity, sculptors began to eliminate the preconceived confines that delimited sculpture. Using hammer and chisel, Auguste Rodin began to flake away the first chips that would transform these conventional ideas of mass, space, and gravity in sculpture. In 1886 he unveiled *The Burghers of Calais* (Figure 24.1), whose center was in space, not mass. The figures grouped about the empty center of the work seemed to be leaning away from it. Rodin's work suggested that the centrifugal force pulling the elements apart diminished the center's hold.

Similarly, as we have seen, the Cubists had begun to break apart compact mass into fragmented volumes a few years before Einstein's transcendent insight that space was a geometry. In painting, the volumes could only be suggested. In 1912 the futurist sculptor Umberto Boccioni wrote that modern sculpture must transcend traditional statuary whose mass was arranged

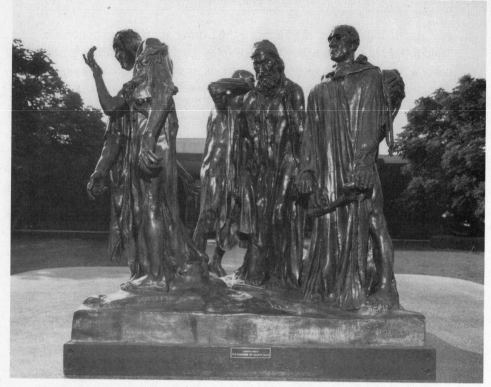

Figure 24.1. *Auguste Rodin,* The Burghers of Calais *(1884–85)* NORTON
SIMON ART FOUNDATION

about a central axis. Sculpture, he said, must be the art of "transposing
into material forms the spatial planes that enclose and traverse an object."[6]
Not necessarily influenced by Boccioni, in 1913 Picasso and Braque enlarged
the two dimensions of the planar veneer of canvas by introducing a com-
pletely new art form that was neither painting (space) nor sculpture (mass).
What they called *collage* was an ingenious mixture of the two. Collage
hung on walls, like paintings, but was composed of pieces of material glued
together to build up a construction that could protrude toward the viewer,
like sculpture. Whereas the key to all perspectivist painting was the illusion
of a receding third dimension, Cubist collage presented a *real* projected
third dimension, for example, Picasso's *Guitar* (1913) (Figure 24.2). This
was the first new dimensional concept in art since Giotto, as Einstein would
soon offer an entirely new dimensional concept in physics.

As if aware that the meaning of the word "weight" would have to be
reexamined, early Cubists used materials never before seen in sculpture.
They utilized wood, rope, paper, and cardboard instead of stone and metal,

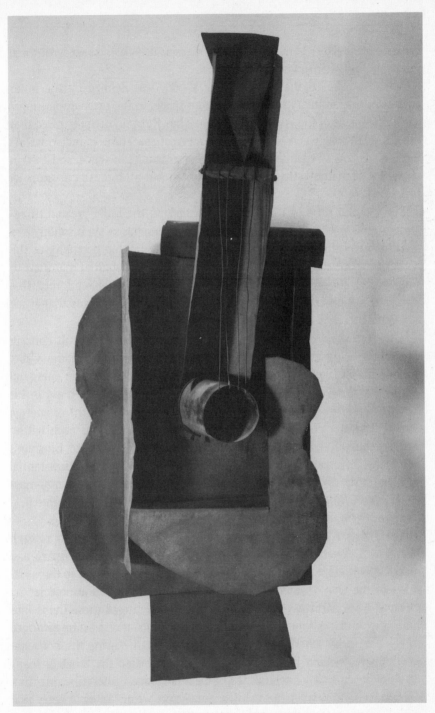

Figure 24.2. *Pablo Picasso,* Guitar *(1913)* THE MUSEUM OF MODERN ART, NEW YORK, GIFT OF THE ARTIST

yet they managed to convey the idea of mass or density in space with these relatively insubstantial components.

Aristotle believed that the *place* of a body was defined by the inner surface of the boundary separating it from space. In the three-dimensional world this piece of information is obvious; but Einstein demonstrated that the distinction between mass and the curve of spacetime is indistinct. As Picasso's collages redefined the location of a "thing" in space, so Einstein showed that matter—the place of a body—is but an intense curvature of spacetime.

For the first time in the history of sculpture, the artist created three-dimensional objects whose purpose was not to emphasize their solidity and density, but rather the tension generated by the unseen geometry at the border of space and mass. The use of ultralight, insubstantial materials to suggest the illusion of volume and density, subliminally reinforced this idea. The notion expressed in Cubist collages and sculptures is that space is a geometry that interacts with mass.

Although the mass-energy equivalence would seem a difficult concept to express using a visual model, in 1920 a Finnish artist, Naum Gabo, created the illusion of volume and mass using only the kinetic energy of a thin vibrating motor-driven wire. The apparent solidity of mass in his *Kinetic Sculpture* (Figure 24.3) is caused by vibrating patterns of energy. Since all matter consists of widely spaced oscillating atoms each within vast reaches of empty space, this work provides an image of Einstein's equations. By creating a visual volume out of something as insubstantial as a vibrating wire, Gabo was expressing metaphorically the energy-mass equivalence. *Kinetic Sculpture* is a transparent, incorporeal, dynamic field of force that manifests the appearance of substance.

The artists Kurt Schwitters, Alexander Calder, and Henry Moore each in his own way redefined the sculptural relationship between space and mass. Schwitters, a contemporary of Picasso and not a sculptor in the usual sense of the word, pasted together bits and pieces of "found objects" he salvaged from garbage cans and junkyards. He arranged these items into innovative collages that resembled Cubist paintings, though if he belonged to any particular school, it would be the Dadaist. Inventing the nonsense word "merz," which had no meaning, he anticipated the tenet of many new physicists that we would need a new language to describe quantum mechanical and relativistic realities. Schwitters wrote "merz" poetry that did not contain a single recognizable word.

For Schwitters, "merz" could be applied to anything. In 1923 he began to convert several rooms of his house in Hanover, Germany, into a "Merz-

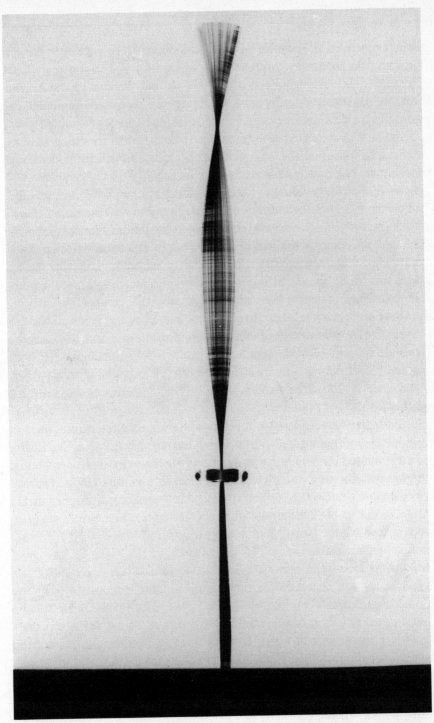

Figure 24.3. *Naum Gabo,* Kinetic Sculpture *(1920)* THE TATE GALLERY, LONDON, AND ART RESOURCE, NEW YORK

bau" (Figure 24.4). The original architect intended this structure to provide privacy and shelter by the time-honored means of enclosing space with mass. But Schwitters subverted this scheme and changed the house into an internal construction by gradually filling each room with nonfunctional structural elements. He called it a cathedral for things made out of things. Using large, painted, wooden trapezoids, triangles, and parallelograms, he gradually converted the interior of each room into a three-dimensional sculpture, emphasizing for visitors the invisible quality of geometry that *is* space. Schwitters always started by adding abstract forms to the walls, and then filling in the room from the perimeter toward the center. Eventually Schwitters could barely move about in the limited space of the room. In time his whole house had become a sculpture: a collage turned inside out. But unlike any sculpture before it, this collage encompassed the viewer, who was on the *inside*, at its core, at its very center of gravity, the point in space surrounded by the sculpture's mass.

Spacetime has rarely been so eloquently expressed as it is in Schwitters's work. This totally novel point of view from *inside* the sculpture was the complete antithesis of the traditional manner in which sculpture had been presented in the past. By inverting the usual conception of mass, space, and gravity, Schwitters expressed in art what Einstein proposed in his general theory of relativity.

Alexander Calder, like Rodin before him, broke up the central mass of sculpture and fragmented it into many different pieces. Also, like Rodin, he eliminated the visible center of gravity rooted in mass. Calder's initial forays into the field of sculpture in 1926 were miniature circus acrobats. His small figures crafted out of wire stood in stark contrast to the Carrara marble statues of Michelangelo and embodied an idea that challenged gravity, just as Manet, Degas, Seurat, and Picasso had done in their rendering of painted acrobats.

But in 1932, with his first mobile Calder lifted sculpture right off the floor, defying gravity and deemphasizing weight. Motion and sculpture (energy and mass) had hitherto seemed antithetical; now Calder found a way to express their binary relationship. Further, he suspended the mass of his work in space in a permanent free-fall. By literally hanging mass in space, for the first time ever, Calder disconnected sculpture from its pedestal. By meticulously balancing the density and mass of his mobiles so that they could be affected by something as insubstantial as a breeze, Calder made sculptures like his *Lobster Trap and Fish Tail* (1939) (Figure 24.5) that were more like particles responding in a field of force than like mass dominating empty space.

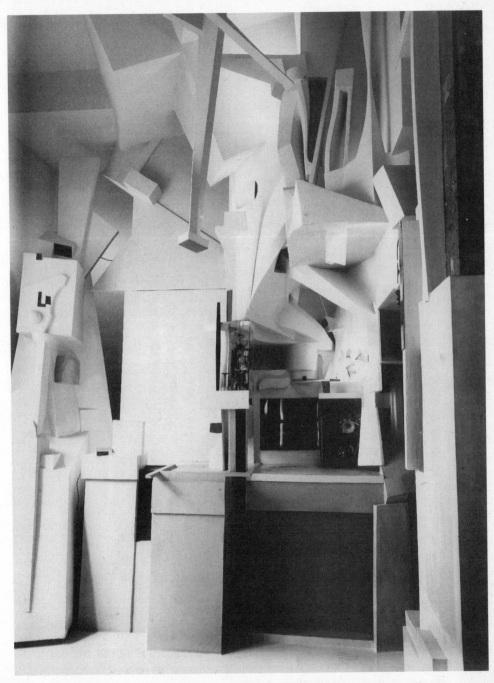

Figure 24.4. *Kurt Schwitters,* Photograph of Merzbau SPRENGEL MUSEUM, HANNOVER. COPYRIGHT © 1991 BY ARS NEW YORK/COSMOPRESS

Figure 24.5. *Alexander Calder,* Lobster Trap and Fish Tail *(1939)* THE
MUSEUM OF MODERN ART, NEW YORK. COMMISSIONED BY THE ADVISORY COMMITTEE
FOR THE STAIRWELL OF THE MUSEUM

In the fifteenth century Leonardo proposed that the boundary of a body is neither a part of the enclosed body nor a part of the surrounding atmosphere. Yet despite his observation, sculptors and viewers alike remained sure that the boundary did lie on this crisp margin. Five hundred years later, Henry Moore understood that the sharp boundary between the mass of an object and the negative space around it was an illusion, and he expressed this difficult idea with smooth-flowing statues such as *Internal and External Forms* (1953–54) (Figure 24.6), in which the space pours into the mass and conversely the mass surrounds empty space so the distinction between *inside* mass and *outside* space is blurred. Moore required that the viewer at some level integrate the notion that space admixes with mass; both affect each other and seem to inform each other. The rare physicist who could understand Einstein would have to have reached the same conclusion.

Picasso, Gabo, Schwitters, Moore, and Calder did not intersect the world of Albert Einstein, yet their sculptural metaphors are consonant with his radical, abstruse theory of physics. In their hands, sculpture, the art form of gravity, lost its borders, had its center turned inside out, and its solidity transformed into transparent planes and mobile intricacies. These artists literally and figuratively knocked statuary off its pedestal.

During the last forty years, unconsciously and consciously, sculptors seem to have thoroughly integrated Einstein's insights and worldview. One dominant trend in contemporary sculpture is the representation of geometrical mass interlocking with a negative reciprocal geometrical volume, giving concrete expression to Einstein's proclamation that spacetime is a geometry and in four-dimensional manifold it expresses mass. David Smith, for instance, in his *Cubi XVI* (1964) (Figure 24.7), has provided many examples of this kind of Euclidean inspired sculpture. In the twentieth century, in many civic plazas, the hero on the horse has been replaced by unique combinations of children's building blocks projected into space. Space-mass geometry has superseded the historical monument.

In a unique evolution of Karl Schwitters's *Merzbau*, contemporary sculptor Sol LeWitt designs sculptural constructions that literally engulf the space of the room, rather than being its focal point. The skein of his sculptures, which he calls "environments," creates webs consisting of structural elements that trap space so that space and mass are not separate entities but rather interact with each other behaving as an ecologically dependent pair. A representative example of his work is *Steel Structure* (1975–76) (Figure 24.8).

Many of the works of Carl Andre, another contemporary sculptor, employ

Figure 24.6. *Henry Moore,* Internal and External Forms *(1953–54)*
ALBRIGHT-KNOX ART GALLERY, BUFFALO, NEW YORK

Figure 24.7. *David Smith,* Cubi XVI *(1963)* ALBRIGHT-KNOX ART GALLERY, BUFFALO, NEW YORK

Figure 24.8. *Sol LeWitt,* Steel Structure *(1975–76)* SAN FRANCISCO MUSEUM
OF MODERN ART, T. B. WALKER FOUNDATION FUND

a similar principle. At many of his installations, Andre places only one work
in the entire gallery room. He requests that works by other artists be
removed so that the viewer can contemplate without distraction how the
mass of his art interacts with the room's empty volume—the only other
feature complementing his installation. For Andre, mass and space resonate
with each other to form one inseparable complementarity as in his *Zinc-
Zinc Plain* (1969) (Figure 24.9). The physicist de Broglie referred to our
three-dimensional world as a cross-sectional slice of four-dimensional real-
ity; Andre reflected this understanding when he referred to his own works
as "a cut in space."[7]

Coincident with the physicists' excitement over black holes, sculptor
Robert Morris created their perfect metaphor. In *Untitled* (1968), four large
cubes whose sides are covered with mirrors rest upon a slatted wood floor.
The viewer cannot actually see any of the cubes because their mass is

Figure 24.9. *Carl Andre,* Zinc-Zinc Plain (*1969*) PAULA COOPER GALLERY, NEW YORK. PHOTOGRAPH BY BEVAN DAVIES

hidden by a clever artistic "event horizon," yet their presence can be inferred by the effect they have upon the surrounding space.

The sculptor's fascination with gravity is further expressed in Earthworks, an art in which the sculptor manipulates the very repository of gravity, the earth itself. Walter De Maria was responsible for the first Earthwork, *Art Yard* (1961), which was really more of a "happening" than an object d'art. Spectators stood by and watched a large hole being dug in the ground. Such an activity focused attention on the interrelationship of space, mass, and gravity. One of his most celebrated exhibits took place in Munich in 1968 where he filled a gallery with sixteen hundred cubic feet of level dirt. Dirt, the chthonic symbol of the earth, is the ultimate source of gravity.

After geo-sculptor Robert Smithson became intrigued with the idea of using the earth as an artistic medium, he built *Spiral Jetty* (1970) (Figure 24.10) out into the Great Salt Lake in Utah, coaxing inert solid rock into the unique signature of galaxies. By conflating earth and star, he expressed the inexorable winding force of stellar gravity using the more familiar earth's solid rock.

Like Smithson, Michael Heizer uses the earth on a scale so grand that his art must be made away from cities' confines. Despite or because of the physical isolation of his projects, they have the ability to enthrall simply by their sheer magnitude. In *Double Negative* (1969), Heizer dug two cuts

Figure 24.10. *Smithson,* Spiral Jetty *(1970)* GREAT SALT LAKE, UTAH.
PHOTOGRAPH BY GIANFRANCO GORGONI/CONTACT

in the desert thirty feet deep and fifty feet wide, replacing the mass of the earth with negative interlocking space. This grand yet minimalist statement is congruent with Einstein's complementarity of spacetime and mass-energy.

Albert Einstein's radical revision of our understanding of gravity has enabled modern astrophysicists to gain a deeper understanding of the working of our universe. It has had little if any noticeable effect on our daily lives. Apples still fall from orchard trees and lovers still marvel at the moonrise. Yet Einstein's insight has led us to the threshold of another dimension as well as understanding the life and death of stars. Gravity is the force that shaped the chromosomes of life. It crushed our ancestors,

the primates, pulling them to their graves. Gravity has profoundly affected our species' functioning because we are descendants of mammals that flew through the air without wings. The reality of gravity has insinuated itself into the religion, philosophy, art, and science of all peoples. This force is so much a part of our existence that our response to it is autonomic. And yet, humankind's attempts to decipher the cryptic nature of gravity have allowed us to illuminate and begin to resolve the mystery of our world. Art and physics have been the pathfinders.

Humanity has just entered what is probably the greatest transformation it has ever known. . . . Something is happening in the structure of human consciousness. It is another species of life that is just beginning.

Pierre Teilhard de Chardin

I am, as it were, an eye that the cosmos uses to look at itself. The Mind is not mine alone; the Mind is everywhere.

Rudy Rucker

CHAPTER 25

I / WE

In the preceding chapters I proposed that revolutionary artists' imagery contains crucial insights that underlie the conceptual framework of how society sees the world. Later, these insights most often shine through visionary physicists' equations and subsequently change the way the rest of us think about the world. But if art embodies these concepts before their formulations filter down from scholarly physics journals, then the artists who give them form cannot possibly have had any conscious knowledge of their development—a proposition artists' writings, lectures, letters, and documented conversations overwhelmingly support. If the numerous examples of the concordance between art and physics that I have presented in this book give credence to my theory, then we must next ask how this is possible. How could so many diverse artists

throughout different centuries, virtually all of them unaware of what was about to happen in the field of physics, manage to bring forth so many innovative styles of art that spoke directly to the imminent re-visioning of physical reality in their times?

Confronted by this baffling phenomenon, most commentators have invoked the condition of a woolly surmise, a *zeitgeist*, claiming that some ill-defined quickening in the air precipitates change not just in one field, but across the whole range of human endeavor. They see societies as something like schools of fish that suddenly, all at once, change direction. The manner in which these grand, coordinated movements are choreographed rules out the possibility that one lead fish gives one signal with all the others following. Similarly, no single determinant can be identified as having sparked the complex network of events that led to the artistic and scientific glories of Periclean Athens, the Florence of the Medici, and multiple European capitals around the turn of the twentieth century. Unfortunately, the concept of a *zeitgeist* does not explain how this force that precipitates action-at-a-distance originates and propagates. How do the central principles of a new style in art segue across the spectrum of culture, like ripples on a pond, eventually to resonate in the equations of visionary physicists?

To consider this question, we must roam farther afield, venturing into evolutionary theory, brain lateralization, and mythology. Let us begin by examining our beliefs about the structure of consciousness. To an observer, an animal is conscious if it is moved by moods and feelings and is capable of assessing its present situation in the light of past experience, enabling it to arrive at a response that is more than an instinctive behavior pattern. Somewhere on the evolutionary trail leading from the primate brain, the self-reflective mind emerged in our species. Mind, a striking new development in the history of the planet, is a *self*-conscious reflective epiphenomenon that *knows* that it *knows*. Materialists have claimed that mind is the product of the electromagnetic and electrochemical energy expressed by a complex mechanism they identify as the brain, but our understanding of the connection between mind and brain has always been tenuous. Wilder Penfield, the great neurosurgeon, spent the 1940s and 1950s mapping the regions of the brain, and he was constantly on the lookout for the hiding place of the mind, trying to identify the precise anatomical location that wills action. He never did discover it and was forced to conclude that he could not be sure if brain and mind were as intimately attached as the materialists would have had him believe.

The search for the interface between mind and brain continues to occupy

present-day physiologists and philosophers. To date, no satisfactory explanation has been forthcoming for the essential question: What mechanism allows matter to act on mind or—even more troubling—mind on matter?

Most people in Western culture believe that each individual's mind is a distinct, separate entity generated by a person's physical being. The neurologist Charles Sherrington has stated this position elegantly:

> The self is a unity . . . it regards itself as one, others treat it as one, it is addressed as one, by a name to which it answers. The Law and the State schedule it as one. It and they identify it with a body which is considered by it and them to belong to it integrally. In short, unchallenged and unargued conviction assumes it to be one. The logic of grammar endorses this by a pronoun in the singular. All its diversity is merged in oneness.[1]

The concept of "I" ends at our skin. Within this waterproof bag the human immune system has at its disposal extreme measures designed to isolate the "I" from its environment, which the system most emphatically perceives as "*not* I." Perhaps because the full panoply of defense mechanisms surrounding "I" stands guard against any possible encroachment, the "I" upholds its individuality devoutly. The sharp demarcation of our physical boundaries naturally reinforces the idea that the mind of each of us is inviolately separate and distinct from all other minds. However, as Sherrington warned, "The strength of this conviction (of unity) is not assurance of its truth."

Each person's staunchly held belief in the integrity of his or her private being stands in contrast with the more radical proposal for the existence of a *universal mind*. William James, the American philosopher, suggested that a border encircles each individual human mind and keeps it separate from others of its kind. This border permits thoughts and ruminations to which no one else has access, creating the illusion of separateness. He proposed, however, that one segment of the circle was broken, and that through this vent each solitary consciousness is connected with all others in a much larger, all-encompassing, transcendental mind. As he stated in his 1902 lectures in *The Varieties of Religious Experience:*

> The further limits of our being plunge, it seems to me, into an altogether other dimension of existence from the sensible and merely "understandable" world. Name it the mystical region, or the supernatural region, whichever you choose.[2]

James advanced the concept of a "continuum of cosmic consciousness"[3] that existed in a higher dimension and subsumed individual minds. He proposed that this entity was ultimately God. Unfortunately, attaching the word "God" to an idea tends to still discussion among those who are uncomfortable linking religion to philosophy. Therefore, when the Catholic theologian Pierre Teilhard de Chardin proposed a similar theory in the 1940s, he posited the existence of a membrane of consciousness girdling the globe which he was careful *not* to call God.*

In Teilhard de Chardin's scheme, anytime the consciousness of any one individual in the world is raised, the general quality and quantity of *mind* in the world is enhanced. He called this invisible component of the atmosphere the "noosphere," after the archaic Greek word *noos*, which means "mind." Each person, upon becoming more aware of his or her life, adds to an ectoplasmic pool of awareness, thus ever so slightly raising its level. In his own words:

> But today, as a result of a better survey of Time and Space, another idea is about to dawn in our mind. Namely, we begin to realize that, under the veil of human socialization, there may be the same basic and universal force operating which, since the dawn of the world, has constantly striven towards an ever-growing organization of Matter. We must no longer think of this force as a mere spatial motion of the Earth (Galileo), but as the tightening, beyond ourselves and above our heads, of a sort of cosmic vortex, which, after generating each one of us individually, pushes further, through the building of collective units, on its steady course towards a continuous and simultaneous increase of complexity and consciousness.[4]

While Teilhard de Chardin envisioned a global mind attached to this planet, I would use the term *universal mind* in a less restrictive spatial sense. By *universal mind*, I mean an overarching, disembodied universal consciousness that binds and organizes the power generated by every person's thoughts. I shall use such a model of a human superconsciousness arising from the joining together of individual minds as the framework to explain how an artist can incorporate ideas into his or her work that have not as yet been discovered by physicists and that are certainly unknown to the general public.

*In retaliation for Teilhard de Chardin's failure to accord godliness to his global consciousness, the Catholic Church placed all of his works on its proscription index during his life.

To explore this idea a return to E. A. Abbott's book *Flatland* would be helpful. As we saw in Chapter 14, when the idea of a fourth dimension began to float about in the late nineteenth century, Abbott made the concept comprehensible by writing a novel based on analogy. To his two-dimensional Flatlanders the third dimension was as strange and incomprehensible a concept as the fourth dimension was to his three-dimensional readers. Abbott's novel concerns only the spatial vectors of geometry and does not take into account the coordinate of time, but his analogy suggests how *universal mind* could exist in the four dimensions of the spacetime continuum and be missed or misperceived by three-dimensional humans.

We can conceive of such a higher dimension in which there is a linking of human thoughts best by models and analogies. For the sake of conjecture, let us interject ourselves into the mental existence of a life-form that antedated Homo sapiens. For the purpose of our analogy, the ideal form would be one that lived in space but not in time. A social insect like the ant provides just such an example because, while individual ants maneuver through the three dimensions of space, they apparently have little or no temporal perception. Like Abbott's Flatlanders, they provide a convenient model that allows us to step down one dimensional level so that we can better envision the nature of *universal mind* as perceived from our limited three vectors of space and three durational states of time.

Ants cannot be self-conscious, because no self-referential thought is possible without the ability to exist in time. An essential prerequisite of self-consciousness is the presence of memory, a sophisticated neurological apparatus capable of holding the idea of the past so that it can be compared to the present. For all intents and purposes ants do not possess this attribute—they cannot be aware that they are aware.

Ants cannot be taught to run complex mazes because their memory is extremely limited. Their amazing feats of patience, endurance, and industry are due to an innate behavior program precoded into their nervous systems. They have a very restricted ability to learn from past mistakes and for the most part ants are ruled by instinct which forbids any variation in response to a particular environmental stimulus. Any specific provocation to an ant will elicit a repetition in its pattern of behavior. Individual insects cannot escape from the brutish totalitarian grip of instinct.

Despite this severe limitation upon each individual ant, a curious phenomenon occurs when ants join together in a group. If a few ants are placed in a sandbox, they wander about without apparent purpose, except to engage in a peculiar activity—upon meeting one another, they vigorously rub one another's antennae. If more ants are added to the box, this fraternal

activity increases in both its intensity and its frequency. Finally, when their sheer numbers reach a critical mass and a queen is present, the milling, chaotic group becomes a single organism with an obvious higher purpose. The ants cease their frenzied socializing and split into specialized groups committed to the task of building a cooperative community. From out of this heap of crawling insects begins to rise a structure of enormous complexity—the mound nest, or as it is more commonly known, the anthill.

All anthills are marvels, but the home of the Brazilian species *Atta* is a veritable Knossos. This structure burrows down into the soil over eighteen feet and contains underground chambers for food storage, tunnels whose sole purpose is the air-conditioning of the interior, and complex pathways for soldier ants to quickly come to the defense of the hill. There are sub-terranean fungus farms and an elaborate queen's throne room.

Sometime during the laborious construction of an anthill, the complex takes on a life of its own, superseding the life of any individual ant. While the average life span of an individual ant can be measured in months some anthills achieve fifteen years. If a person kicks in the side of the mound, more ants will be born in successive generations that specialize in repairing the damage, and fewer born to farm, soldier, or explore.

The hill's self-healing reconstructive capability gradually diminishes, however, and toward the end of its years, it mysteriously begins to decay. The final generations of ants seem dispirited, tired, and disoriented. They no longer show the industriousness and common purpose that character-ized ants in the early phase of the hill's development. Tunnels cave in from neglected maintenance, and the complex slowly decays and crumbles during a period of senescence culminating in death. This event goes unnoticed by any individual ant, however, because to notice an "event" taking place over time a creature must have memory—that is, a basis for comparison. Ants, unaware of their hill's long existence in time, are part of a larger entity whose purpose seems to have been to knit them into a higher level of organization.

But what of the guiding force that organized the ants in the first place? The anthill, created by these individual social insects, seems to have a synergetic "life-force" that permeates the hill and is its true essence. In Chapter 17, we saw how physicists came to believe that the incorporeal force field is a more essential component of reality than the particulate things suspended in it; so, too, there seems to exist an incorporeal "soul" of the anthill directing the detached particulate ants in stages of its de-velopment. Where then does this "soul" reside? The ants are obviously separated by physical distance and so it would be a tenuous presumption

to propose that the life-force of the hill existed in the limited ganglionic neurons of each ant. Scientific materialists will quickly point out that the soul is a mirage, and the plan for the hill is encoded in the DNA of each individual ant. While this is the correct scientific answer, is it the complete answer or even the right answer? Can a living organism (one anthill) of fifteen years' life span, existing without any physical connection between its parts (the individual ants), be the exclusive product of protein synthesis?

Using this example from an insect's world that lacks the coordinate of time—that is, memory—as a departure point, we can extrapolate into the human sphere where reality includes both space and time, but only as separate coordinates. We humans evolved long after the insects and can perceive another dimension in addition to the three vectors of space. We know what an ant does not: We know our existence in time. Our individual minds can roam leisurely back and forth along a temporal line that includes all three durational states of past, present, and future. Yet, we are in a quandary similar to that of the individual ant. Because of Einstein's and Minkowski's insights, we have learned that there exists another dimension to which we are not privy because it lies tantalizingly just beyond our perceptual capabilities. As the individual ant is unaware of its existence in time despite belonging to a community that lives on for years after its death, so may we be part of a much larger entity existing in the spacetime continuum with an agenda of which we are not aware. The proof that higher dimensions exist has been traced out in the arachnid formulas of the physicist as it was explained in the Flatland fiction of the novelist. In the evolutionary process, when the coordinate of time was added to the vectors of space, mind entered the world. There is nothing to preclude the possibility that something exists in a higher fourth dimension as well.

In *Tertium Organum* (1911), P. D. Ouspensky, a Russian mathematician and philosopher, describes how circumscribed entities existing in two dimensions can be part of a unity in the third dimension. Observe from one side of a pane of frosted glass the prints left by the tips of someone's fingers touching the opposite side. A two-dimensional investigator, counting five separate circles, would conclude that each fingerprint is a separate entity. But we who can appreciate the third dimension of depth, know that the five separate fingerprints belong to one unified object in three dimensions: a hand. We also know that the three-dimensional hand is attached to a being that generates mind when time is added to the vectors of space. By extrapolation, this is exactly the example that illustrates how our separate, individual minds, existing in our limited perceptual apparatus using two

coordinates, space and time, could also be part of a *universal mind* that is a unified entity in the higher dimension of the spacetime continuum.

Classical nineteenth-century physics described a physical world bounded by the distinct, contrasting coordinates of space and time, consisting of combinations of energy and matter. These four cornerstones now stand revealed by relativity and quantum mechanics to be inextricably enmeshed with one another as a unity in the matrix of the spacetime continuum.

The one phenomenon that cannot be categorized within Newton's classical framework is mind, yet we know it exists because each of us is aware that someone in there is reading this page. By emphasizing the *relative* frame of reference of the observer, relativity introduced into physics the idea that the position and speed of the mind that is observing and measuring had to be taken into account in the measurement. Quantum mechanical theory went even further and made mind an actual component of the objective world's physical processes by acknowledging the reciprocal nature of observer and observed. Space/time, mass/energy, spacetime/mass-energy, and observer/observed are all complementary reciprocal dualities. If the physicist John Wheeler is correct and *mind* and *universe* are but another binary pair that appear in this dimension as separate entities, then most likely they are unified in the spacetime continuum. Such a unity would be most appropriately named *universal mind*. A *zeitgeist* might be a space-and-time manifestation in these artificially limited coordinates of a space-time *universal mind*.

In our world of divided space and time, the only clues that such a schema existed would be occurrences that cannot be explained by the rules of causality. One such clue would be the puzzling way artists' images seem to anticipate new discoveries about reality. If artists' intuitions are the first intimations of movement in the larger entity of *universal mind*, artists themselves can be seen to serve the unique function of seers through whom the *zeitgeist* appears. Visionary artists, able to discern what the rest of us still cannot, embrace and announce through their art the principles emanating from this *spiritus mundi*. It does not matter if the critics and even the artists themselves are unaware of their singular purpose: If the artists' work is truly the apparition of the *zeitgeist*, it can become evident only in retrospect, as society matures and its members achieve the same vantage point visionary artists occupied decades earlier. As Teilhard de Chardin put it:

> In short, art represents the area of furthest advance around man's growing energy, the area in which nascent truths con-

dense, take on their first form, and become animate, before they are definitively formulated and assimilated.

This is the effective function and role of art in the general economy of evolution.[5]

Art is the singular harbinger of *universal mind*.

Throughout every historical age the perception of space and time has exerted a strong influence on culture. But ultimately it is the very origin of these perceptions that has created the separation of art and physics. An exploration into those origins is now in order. In the nervous system, the smallest unit is the neuron. When many neurons congregated into an entity as advanced as a mammalian brain, the conditions were present for the first thought. As mammalian brains became increasingly sophisticated, a critical number of thoughts accumulated in Homo sapiens' brains, from which there emerged the fantastic, self-reflective mind. (Some researchers suggest that other mammals, such as porpoises, whales, and higher apes, might also be capable of self-reflection.) Observing this inexorable progression, the next obvious step up the evolutionary scale would seem to be the integration of individual minds to create a giant, towering ectoplasmic brain capable of generating *universal mind*. Since it is problematical to speak of a mind without reference to a physical brain, perhaps an analogy rooted in experience can be made to conceptualize the *universal mind*.

The human brain consists of a large number of individual neurons. These neurons cluster together in groupings that perform specialized functions. Each separate region and pathway of the brain is responsible for specific tasks. For example, Broca's area is responsible for language; the visual cortex processes the impulses arriving from the eyes' retinas. Mind seems to emerge from the knitting together of the information gleaned from many of these discretely organized cognitive modules.

When superimposing the template of a single brain that generates a solitary mind upon a hypothetical universal brain, each member of our entire species can be seen as if each plays the role of an individual neuron building the larger brain, much as every ant contributes to the hill. As each neuron is a separate world unto itself, so too is each person, and the physical space between individuals is like the synapses within a colossal brain. In this enlarged model specialized groups of people in a society perform specific functions as do neuron clusters within a single human brain.

The features of brain lateralization are the loom upon which to weave

these theories. The strands of argument I have presented are strengthened by the passage of the shuttle back and forth, intertwining the warp and woof of right and left, space and time, art and physics. The pattern that emerges from the fabric will enhance the connections between *universal mind* and the fourth dimensional manifold as well as illuminate the peculiar congruence between artist and physicist.

Now mark what I say. The Right Eye looketh forward in thee into Eternity. The Left Eye looketh backward into Time. If thou now sufferest thyself to be always looking into Nature, and the Things of Time, it will be impossible for thee ever to arrive at the Unity which thou wishest for.

Jakob Böhme

Nothing that is vast enters into the life of mortals without a curse.

Sophocles

CHAPTER 26

RIGHT / LEFT

In the late seventeenth century, the mathematician Blaise Pascal distinguished between two different mental operations. One he characterized as the sudden grasp of knowledge leading to a total comprehension of all facets of a concept simultaneously; the other he described as patient analytic reasoning, proceeding in a sequential fashion. Although poets, artists, and mystics had long embraced it, Pascal was the first scientist to conceptualize this duality of the mind. It was another century before this dichotomy in mental processes was deemed to have a basis in anatomy, when in 1864 John Hughlings Jackson, the great neurologist, surmised that the two cerebral hemispheres of the brain performed different functions.

Using Jackson's observations, astute physicians gradually detailed asymmetry in the two hemispheres by recording different manifestations of injury to the brain's various regions. Extrapolating from these collections of symptoms, or syndromes, they pieced together the puzzle of a normal brain's organization.

In the late 1950s, Nobel Laureate Roger Sperry performed surgery on cats and monkeys, dividing the corpus callosum, the broad band of neurons that connects the brain's two hemispheres. Not only did his commissurotomized animals survive, but there was little adverse effect upon their observable behavior.

Emboldened by Sperry's work, two neurosurgeons, Joseph Bogen and Philip Vogel, performed the same radical surgery on humans for the first time in 1961, selecting only patients who were severely incapacitated by recurrent epileptic seizures and were refractory to all medication. Bogen and Vogel hypothesized that by surgically dividing the corpus callosum they could prevent seizures from spreading across it from one cerebral hemisphere to the other, thereby hindering the attack in its advance and making it more amenable to control.

Their patients experienced a marked diminution in the severity of their epileptic attacks. At the same time, they provided an unprecedented opportunity for scientists to study each cerebral hemisphere's function in isolation. After these patients had recovered, Sperry and Michael Gazzaniga studied them by asking them to perform various tasks combining perception and hand motor skills. Their results convincingly revealed the very different responses of each cortex.

The essential features of right/left brain asymmetry are fairly well known today because they have been popularly disseminated. It is generally understood, for example, that each side of the brain controls the functions of the body's opposite side: that the left brain controls the right hand, and the right brain controls the left hand. It is also known that each hemisphere normally works in close cooperation with the other; and that they cannot fully be divided according to their discrete functions. Nevertheless, brain commissurotomy has dramatically highlighted those tasks that are best carried out by each side.

In order to construct an analogy between the brain organization of a single individual and the global consciousness of the entire planet, I shall use as my model the brain organization of someone who is right-handed and left-brain dominant. I do not intend by this method to dismiss the 8 to 9 percent of the population who are left-handed and right-brain dominant. Rather, I wish to use the commonest mode and thereby avoid bogging

my discussion down in disclaimers and qualifiers. In fact, most of what follows is true for left-handers in reverse. However, the analogy is not complete because left-handers are not simply right-handers' mirror image. The dysfunction that occurs as a result of left-brain injury in right-handers is so great in terms of human interaction that the left cerebral hemisphere has come to be known as the dominant lobe. Therefore, I shall refer to the left brain in this chapter in its conventional manner, as the dominant hemisphere.*

While there have been many objections to the oversimplification of the brain lateralization scheme in recent years, certain straightforward facts cannot be dismissed. If a right-handed person has a major stroke in the controlling left hemisphere, a catastrophic dysfunction of speech, motor activity, or abstract thinking will occur. Conversely, a significant stroke in the right brain will impair an individual's ability to solve spatial problems, recognize faces, or appreciate music.

The place to begin is on the right side, since, from an evolutionary point of view, it is the older: It begins to develop and mature sooner than the left in the first fetal months. In addition, the right side of the brain is older than the left because it is closer to the earlier evolutionary patterns of behavior.

The neuroscientist Paul MacLean proposed in 1977 that each person has a three-layered brain corresponding to the history of all brains' evolutionary development; he calls this unit the triune brain.[1] In MacLean's scheme, the reptilian is the oldest layer, buried deepest in the brain and capable only of instinctual responses. The reptilian brain is overlaid by a paleo-mammalian brain which generates our basic emotions. Growing atop the other two, the imaginative and intelligent human cerebral neocortex is divided into right and left hemispheres capable of creating art and physics. According to MacLean, these three brains in one operate like "three interconnected biological computers, [each] with its own special intelligence, its own subjectivity, and its own sense of time and space. . . ."[2] The atavistic human reptilian brain, which he calls the R-complex, contains programs of behavior that are rigid, obsessive, compulsive, ritualistic, and paranoid. The old mammalian brain, anatomically known as the limbic system, is the seat of archaic emotions that drive feeding, fleeing, fighting, and sex,

*Right-handed left-brain-dominant readers should not feel too smug, however. Without reading further in this footnote, please perform a simple exercise with me. First, fold your hands and interdigitate your fingers. Now, please observe which thumb is on top. If you have placed your left thumb over your right, as many right-handers do, the nondominant right side of your brain plays a larger role in your psychic makeup than you may have previously believed.

and thus ensure survival. Since all emotions are either disagreeable or pleasant, pleasure and pain are the two criteria by which the limbic system judges all experience. Of the two cortical hemispheres, the right is in more direct communication with archaic reptilian instincts and primitive mammalian emotions.

An instinct permits no variation in an organism's response to a specific stimulus. Instincts are "hard-wired" into the brains of lizards and snakes, forcing them to respond repetitiously to any particular stimulus. In mammals, emotions may be thought of as instinct's truncated remnants. They differ from the reptiles' autonomic mechanical responses in that they are only one half of an instinct. A specific stimulus impinging upon the mammalian sensory apparatus always activates the same release of complex chains of neurotransmitters and hormones. Emotions impel mammals and their descendants, primates, to commit repetitive instinctual behavior patterns. Fear impels them to run away. Hate, anger, and jealousy impel them to kill. Envy and greed impel them to steal, lust to put aside caution and act in a manner that may even be dangerous for their safety. However, mammals have more complex brains than reptiles and can make decisions; they are therefore capable of choosing among different responses. For instance, lust may impel a young male elephant seal to want to copulate with a female, but fear of the alpha male seal's strength makes him hesitate. There is a choice the mammal makes, to challenge the older bull or to restrain his desire.

Humans, due to the gift of the cerebral cortex, have free will, which enables us to override our emotions and modify our response to environmental provocations. A human has many choices; horses very few; small lizards none at all. Anyone who is an astute observer of the human condition would agree that most of the time it is a very fuzzy distinction. The veneer of civilization is like the thin outer layer of the cerebral cortex: Both are the only barriers against primeval urgings thumping up from below, demanding release from their subterranean limbic passages. Since the right hemisphere is older than the left, it is the one that responds to these atavistic holdovers—instincts and emotions—from an earlier stage of evolution.

In the following discussion, I have categorized each hemisphere as having four major characteristics. The first characteristic of the right brain is pure *being*. Because it is closer to our atavistic heritage, the right brain is better able than the left to appreciate the feeling states that are complex expressions of our emotions, such as laughter, faith, patriotism, ecstasy, love, aesthetic appreciation, and harmony.

There is not a crisp nomenclature for feeling states. Each renders the reporter relatively inarticulate; none can be precisely or adequately enunciated in scientific language and they remain ambiguous whenever anyone tries to pin them down. They are *nondiscursive*.

Further, feeling states are *nonlogical*, and defy the rules of conventional reasoning. One cannot be argued into or out of a feeling state. When Blaise Pascal commented, *"Le coeur a ses raisons que la raison ne connaît pas"* ("The heart has reasons that reason will never know"), he pointed out the difference between the kind of knowing that goes on in the emotional right brain in contrast to that in the cerebral left.

Feeling states are *authentic*; once a person has experienced love or ecstasy, he *knows* it with an internal authority and its authenticity is beyond debate.

The essence of a joke, faith in God, and patriotism are all *nondiscursive, nonlogical*, and *authentic*: so are the reasons you love someone, how you have a hunch, or why a particular painting, beautiful to another person, is not beautiful to you. These affective states, standing in the shadows of our ancient beginnings, overwhelm the brain's more recently evolved glib facility with words. Each feeling state lies beyond the tight circle of logic. When pressed to explain affective states, people usually fall back upon the tautology "It is because it is!"

Feeling states do not progress in a linear fashion, but rather occur *all-at-once*. "Getting" the punch line of a joke causes a sudden explosion of laughter. An intuitive insight seems to come out of nowhere. Love at first sight such as Dante's encounter with Beatrice happens all at once. Religious conversions can take place in a flash, like the epiphany Saul of Tarsus had on the road to Damascus that led him to become Paul.

After *being*, the second major characteristic of the brain's right side is its comprehension of images. The right hemisphere can take in an entire tableau at a glance and recognize the grand picture in a holistic manner. It can appreciate the relationship of parts to the whole and build up a complete picture from a few fragments. The right side assimilates images as gestalts, which means seeing *all-at-once*.

The image cognition of the right brain is best exemplified by the way people recognize faces. A person's face can be altered dramatically by wrinkles and baldness; yet we are still able to identify a childhood friend in a crowd decades after we last saw him. The astonishing ability to recognize faces is so innate that, for the most part, we take it for granted. But some unfortunate individuals, having suffered a stroke or other injury to their right brain, cannot recognize other people at all. Of even greater import,

they sometimes are unable to recognize themselves. Their own faces in the mirror are strangers' faces, demanding that they come to grips with who they are anew every day.

Metaphor, the third characteristic of the right hemisphere, is a mental innovation arising out of a unique combination of feeling states and images. While there are no neat ladders whose numbered rungs lead to the ledge upon which feeling states rest, they can be reached by the magic carpet of metaphor. Metaphor derives from two Greek words: *meta*, which means "over and above," and *pherein*, which means to "bear across." A metaphor allows a leap across a chasm from one thought to the next. Metaphors have several different levels of meaning simultaneously perceived and supply a plasticity to language without which communication would be less interesting in most cases, very difficult in some, and in a few, impossible. Communicating any emotion or affective state depends heavily on the use of metaphor, because while the so-called objective world can be described, measured, and catalogued with remarkable precision, the internal world of emotions and feeling states eludes such analysis.

The verbal art form of metaphor is poetry. Some interesting evidence for believing that metaphor is a function of the right brain is the finding by neurologists that a few right-handed left-brain-dominant patients who have suffered a major left-lobe trauma rendering them speechless can still recite poetry that they knew before their trauma. Philosopher Hannah Arendt agrees:

> The metaphor, bridging the abyss between inward and invisible mental activities and the world of appearances, was certainly the greatest gift that language could bestow on thinking, and hence on philosophy, but the metaphor itself is poetic rather than philosophical in origin.[3]

Metaphor's cousins—similes, analogies, allegories, proverbs, and parables—each in their own way allow multiple simultaneous means of interpreting one single set of words. Their use in dream interpretation, myths, and religions are well established in many cultures. There is evidence to suggest dreaming also occurs principally in the right hemisphere since split-brain patients who verbalize only what is going on in their left brain, which is essentially cut off from its right half, have reported a cessation of dreaming. Mythos and dreams, both closely linked to metaphors, reside principally on the right.

The most compelling combination of metaphor and image is art. Great

visual art is *nondiscursive, nonlogical, authentic*. The artist frequently uses visual metaphor to transport a viewer from a neutral affective state to complex feeling states, for example, awe. When art is successful in metaphorically "bearing" us "across and above," there are no transitions. It is an *all-at-once* quantum jump. When this happens, we somehow *know* we are in the presence of great art. Henri Matisse once wrote:

> The only valid thing in art is the one thing that cannot be explained, to explain away the mystery of a great painting would do irreplaceable harm, for whenever you explain or define something you substitute the explanation or the definition for the image of the thing.[4]

The same right hemispheric area that enables us to recognize faces helps us to appreciate the subtleties of portraiture. Not only are the characteristics of visual art responsive to the right hemisphere's abilities, but also the single most common image found in Western art is the representation of the human face. As further evidence for the placement of art to the right, T. Alajoanine, the neurologist, describes a prominent painter who suffered an extensive left-brained stroke rendering the artist aphasic:

> His artistic activity remains undisturbed; indeed he has even accentuated the intensity and sharpness of his artistic realization and it seems that in him the aphasic and the artist have lived together.[5]

The fourth and last major feature of the right brain is its ability to appreciate *music*. This attribute shares with emotions that it, too, is a primitive response present in many other animals. Music differs from mere sound in that while both proceed in time, the right lobe can integrate multiple simultaneous sounds issuing forth from different sources into an *all-at-once* harmonious feeling state we perceive different from other sounds. We call this music. Extremely difficult to define, the difference between noise and music is something each of us is quite sure we can distinguish. Music demonstrates again the ability of the right brain to process information in an *all-at-once* manner.

Damage to the dominant left hemisphere usually stills the voice of language, but the musical ability to sing frequently remains. Perhaps the earliest recorded observation of this split was this description of a patient, recorded by Dalin in 1745, who

... had an attack of a violent illness which resulted in a paralysis of the entire right side of the body and complete loss of speech. . . . He can sing certain hymns, which he had learned before he became ill, as clearly and distinctly as any healthy person. However, it should be noted that at the beginning of the hymn he has to be helped a little by some other person singing with him. Similarly, with the same type of help, he can recite certain prayers without singing, but with a certain rhythm and in a highpitched, shouting tone. Yet this man is dumb, cannot say a single word except "yes" and has to communicate by making signs with his hand.[6]

Doctors continued to record similar observations during World War I, working with soldiers who had sustained traumatic injuries to their dominant hemispheres and become mute, but who could sing many songs they had learned before they were injured. Other instances of this split included the French composer Maurice Ravel, who suffered a stroke in his left hemisphere which left him unable to speak, write, or read musical notation.[7] Yet, he could sing and play on the piano from memory any piece he knew before his stroke. Alexander Luria, the Russian neurologist, reported a case of a composer who created his best work after he was rendered speechless by a massive stroke in his left hemisphere.[8]

These case histories lend credence to the tale that Mozart asked his wife to read stories to him while he composed. By distracting his left brain with spoken language, his music-oriented right brain would have been freer to compose unimpeded. Carl Orff, the choirmaster of the famed Vienna Boys Choir, seems to have understood this dichotomy in brain function intuitively, because he would not accept a child into his choir who had already learned to read and write.[9]

The separation of music and speech centers in the brain was convincingly demonstrated in experiments with commissurotomy patients. Neuroscientists, knowing that sound entering either ear goes to both sides of the brain, played a recording of a song into the ears of these split-brain patients. Then, using a specially designed screen that could flash questions to each hemisphere individually without showing them to the other one, they asked each hemisphere to repeat what it had heard. When the question was put to the right brain, the patients hummed the song's melody but were unable to enunciate the words. When the left brain was asked what it had heard, the patients could flatly repeat the lyrics of the song but could not hum its melody.[10] The conclusion to be drawn from all this evidence is quite

clear. Music is a function that resides principally in the right hemisphere. Orpheus, the poet-musician, holds court in the nondominant right side.

We can see that the right hemisphere processes information as an *all-at-once* holistic gestalt by using multiple incoming, converging determinants and integrating them synthetically. Simultaneity, the opposite of sequential time, is unique to the right brain which functions best in a visio-spatial context, correlating parts to a whole while intuiting diverse relationships among them. Since multiple determinants, multiple emotions, multiple meanings, multiple images, and multiple sounds converging into one state are expressed most easily through the metaphor of space, the right side is the better side for appreciating dimensions and judging distances. Driving, skiing, and dancing are the right side's province. Complex images, such as the human face filled with the subtle, constantly fluctuating expressions of varied emotions, are also best appreciated by the right brain. Indeed, all the right brain's principal attributes—*being, images, metaphors*, and *music*—are echoes of evolutionary techniques used by our recent zoological ancestors to comprehend reality, and are perceived holistically.

In contrast, the newer, left cerebral hemisphere controls the dominant right hand and is concerned with *doing* rather than being. Since the act of willing most often originates from the left brain, the right hand usually picks berries, throws spears, and fashions tools. Instead of simultaneity, the quality that makes us Homo faber, the toolmaker, depends on a sequence of steps that exist in time.

I suspect that the reason the left brain usurped the sovereignty of the mind from its elder twin is that uniquely human sounds—*words*—are generated there. As befits the myth of the origin of the alphabet—King Cadmus sowed serpents' teeth and the letters that sprang from the soil appeared as armed warriors—language, too, is action-oriented. Words are the very essence of the action mode; with them, we abstract, discriminate, analyze, and dissect the world into pieces, objects, and categories that we can then grasp metaphorically and literally. A vocabulary is a set of tools we use to act on the environment.

The left hemisphere is the seat of 90 percent of all language centers that exist in the brains of right-handed people. From the left brain comes the generation and comprehension of speech with all its intricacies of grammar, syntax, and semantics. Speech allows us not only to communicate with each other, speech also allows us to talk within ourselves only to ourselves. Lower creatures can *signal* and advanced animals can *inform*, but only

human beings can *question* and, further, *dispute* the answer. *Words* are the second major attribute of the left lobe.

The development of a language with which to question and dispute went hand in hand with the third feature of the left lobe—*abstract thinking*—which is the ability to process information *without* the use of images and is the opposite of metaphorical thinking. Words are image substitutes the mind uses in building concepts. The mind can then use language alone to rearrange these concepts and solve problems. When humans went beyond thinking in pictures, they made a transformative evolutionary leap. Meaningless phonemes generated by the early humans' larynx became the words of speech and the tools of abstract thought. Later, when they combined the meaningless letters of an arbitrary alphabet to form visual words to represent the world, they created the very first abstract art form: written alphabet language. The human species has combined meaningless sounds with meaningless symbols and created civilization.

Abstract thinking is, for the most part, performed within the context of causality. It most probably evolved from early hominids' categorizing the world into spatial events occurring in time. The mental grid work that resulted from the human brain's conception of the intersection of space and time could then have created the conditions to recognize causality and formulate logic. As a result, the primary benefit our species derived from the use of abstract thinking was the enhancement of foresight.

Logic depends upon the proposition if-then. A hypothetical "if" scene or idea is worked out in the mind and then held to the left of *now*, that is, in the past. Next, the mind proposes an equally hypothetical "then" scene or idea, and places it to the right of *now*, that is, in the future. One may then mentally deduce the likelihood of the "if" proposition leading to the "then" proposition, and initiate or withhold appropriate action. Clearly, logic is not holistic, nor is it conceived as a gestalt. It depends mainly on the notion of sequence.

If-then syllogisms have become the most reliable means to foretell the future, replacing omens, portents, and oracles. The rules of logic form the foundation of science, education, business, and military strategy. Logical thinking differs from the other common mental activities such as imagining, intuiting, reflecting, reminiscing, ruminating, or daydreaming in that it alone depends on the belief in a rigid coordinate system of absolute space and invariant time.

The fourth characteristic unique to the left hemisphere is *number sense*. Although the ability to count began in the visio-spatial right brain, and all

higher animals can separate the concept of "oneness" from "twoness" or "manyness," the human ability to permutate larger numbers was something radically new in the animal world. Calculation requires a level of abstraction that goes beyond the concrete workings of the right brain. Besides the language of speech, the left hemisphere also developed a language of number. Through mathematics, the left brain can rearrange meaningless symbols that stand for numerals into simple arithmetic, or it can work them into the intricate infinitesimal calculus. The critical significance of number sense is evident when small children learn the alphabet, they also learn to count.

All the innovative features of the left hemisphere—*doing, words, abstract thinking*, and *number sense*—are principally processed in *time*. To develop craft, strategy, language, logic, and arithmetic the mind must range back and forth along the line of past, present, and future. The ability to fashion a tool with the right hand issues out of the left brain and depends heavily on the ability to memorize a series of steps in sequence.* The dominant hand is a specialized limb that is an extension of the sequential left hemisphere.

Time's function in speech is evident because language can be understood only if one person is talking at a time. It is very difficult for a person to follow two different conversations simultaneously. By contrast, we can listen to all the instruments of a seventy-piece orchestra's simultaneous sounds and hear them holistically, *all-at-once*. Unlike music, we experience language one word at a time, one sentence at a time, and one thought at a time.

Logic, algebra, and physics equations all proceed in time; line-by-line proofs are their essence. Sequence is also the very crux of the language of numbers; it is impossible to think of arithmetic without the framework of time. Indeed, a series of numbers *is* a sequence.

Brain lateralization research has confirmed that there are indeed two different kinds of cognition. One is the old phylogenetic learning rooted in the right hemisphere, vision-based and dependent on space. The newer left side learns information by rote in sequence. We act when an interhemispheric consensus is reached between our two minds. The four key features of the right brain are its holistic, synthetic integration of *being, images, metaphor*, and *music*. It functions in an *all-at-once* mode. The right hemisphere's topography can be mapped for the most part using the

*While birds and beavers engage in a similar complex activity, they do not "learn" how to build nests or dams, nor must they remember the exact sequence of steps in their construction; theirs is instinctual behavior.

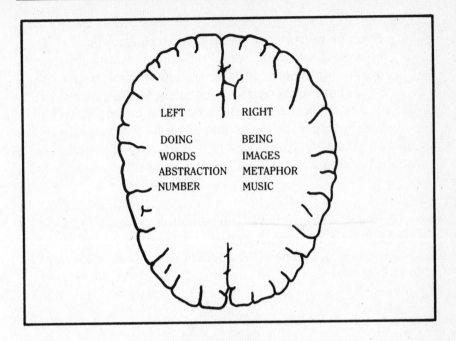

Figure 26.1. *The chief characteristics of each hemisphere*

vectors of *space*. In contrast, the left brain excels in *doing, words, abstract thinking,* and *number sense* (Figure 26.1). It functions in *one-at-a-time* sequence, and its faculties depend upon the durations of *time*. Being, metaphor, image, and music are the essence of art. Doing, reason, abstract thinking, and number are the crux of physics. Art lives principally to the right; physics resides mainly to the left.

From the point of view of evolutionary epistemology, the principal lesson of both special and general relativity theories is this: Human beings are organisms capable of manipulating internal representations of the world by means of concrete operations and can transcend the bounds of their biologically given perception. They can liberate themselves and construct a view of reality that conflicts with intuition, yet gives a truer, more encompassing view.

Max Delbrück, Nobel Laureate

Time & Space are Real Beings, a Male & a Female. Time is a Man, Space is a Woman.

William Blake

CHAPTER 27

SPACE / TIME

I ssuing as they do from different hemispheres of the human brain, the coordinates space and time are bound up in the separation of art and physics. The history of life on this planet can be expressed in terms of a gradually enhanced apprehension of the three vectors of Euclidean space and the three durational states of time. Homo sapiens, one of the latest arrivals, is the one species that can conceptualize all six subdimensions of the two coordinates completely because we alone can fully conceive of the future. Only after Einstein can we now appreciate the

existence of a seventh: the spacetime continuum. An overview of the climb up from no dimensions to six will help us to understand the significance of his insight more fully and to assimilate the accompanying revolution in art more thoroughly. Then we will be able to see how the sharp division between space and time that resulted from this evolution fits with the dichotomy between the right and left hemispheres of the brain.

The contemporary essayist Lewis Thomas points out that at the beginning of the universe there was neither space nor time, therefore the opening silent event should more appropriately be referred to not as the "big bang" but rather the "big light." From out of this explosion of pure energy, both space and time were born. Within billionths of a second after the flash, scintillating elementary particles of matter precipitated out of the glare, creating a hot, restless primordial soup. In the next three hundred thousand years these tiny motes coalesced into simple atoms, which we might think of as infinitesimally small "Legos." From that moment forward, atoms, the smallest functional units in the universe, slowly began to accrete into objects of tremendous size and power. Atoms formed the stars and provided the source for their prodigious energy. Stars joined together to form galaxies and galaxies conglomerated into clusters.

Approximately fourteen billion years later, on the fourth planet circling an ordinary star at the outer edge of our galaxy, carbon-based molecules began to aggregate into forms that would eventually writhe into the branches of the tree of life.

After another three billion years, what had been Earth's primordial slime glimmered with sentience. At first there was merely a dull awareness of the environment on the part of simple organisms. Later, with the increasing complexity of the nervous systems through successively more sophisticated phyla of animals, consciousness supplanted sentience. And somewhere in the last three million years of this long progression, the self-reflective conscious mind emerged, only fully developed in the human species.

If an observer had been present at any of the earlier stages in this evolutionary progression he would have found it impossible to anticipate, guess, or surmise the step that was to follow. Which is the more incredible leap: the emergence from out of nowhere of particulate matter precipitating out of sheer plasmic energy, or the smallest atom arrogating unto itself the power of stars? Neither event could have been more astonishing than the advent of self-replicating molecules, or the staggering momentousness of *mind* arising from the primeval swamp. Each of these steps along evolution's way was made essentially without transition; each appears to have been a quantum leap without antecedents. The new form at every new

plateau was like a butterfly emerging from its chrysalis, completely metamorphosed from something entirely different.

The evolution of life-forms on Earth seems to move in the direction of organisms that are increasingly cognizant of the subdimensions of space and time. A short excursion through the phyla will establish the hierarchy of this imperative. Plants, the planet's earliest biological adventure, cannot perceive any dimensions because they do not have nervous systems. It must be a given that the appreciation of space and time requires some kind of apparatus with which to do so. Plants represent the "point" of Euclidean geometry. The first animal organisms, denied the use of the sun as a primary energy source, ate the plants as a substitute. But to consume the algae, the single-celled herbivores had to find them. A paramecium or amoeba, propelling itself toward nutritional stimulae and recoiling from noxious ones, lives out its life in a one-dimensional tunnel. Its sentience is so rudimentary that one can say it exists only in the first dimension of space: a "line."

Not until the advent of flatworms does a nervous system appear that is elongated into a neural tube with a protuberance at the front end that branches into two lateral lobes. It is probably here that an organism begins to appreciate space from side to side, as well as to and fro. Because it has developed right and left symmetry, the elemental worm-brain is the likely candidate first to have apprehended the second spatial dimension, breadth. Existence for this organism is played out upon a geometrical "plane." Planaria, the flatworm, is the original "Flatlander."

When Devonian fish evolved with an eye and a cerebellum, they achieved the capacity for a full appreciation of the third spatial dimension, depth. From the vertebrates onward, all life-forms had the neurological equipment necessary to apprehend all three vectors of Euclidean space: length, breadth, and depth. Their world was contained within Euclid's solid geometrical shape: a cube.

Still missing from our story of evolution is a sense of time. None of the aforementioned organisms experiences duration. They need no awareness of time because their internal clocks are set by genetics and instinct alone. Programmed into their behavior pattern are the earth's daily revolution, the lunar periodicity, and the yearly equinoxes. Instead of a sense of time, they have what biologists call circadian rhythms. All organisms up to and including reptiles live in the thin slice of the present. To a fish, to a flatworm, to an amoeba, there is no past, and there is no future. Since it lacks the power of recollection, it is not possible for a crocodile to remember who or what it ate for lunch. All animals up the evolutionary chain

through reptiles are prisoners locked in the solitary confinement of the flickering *now*.

If we define intelligence as the ability to respond flexibly to environmental provocations, then intelligence had not yet appeared upon the earth's evolutionary stage at the time that dinosaurs reigned. The dinosaurs and their descendants, the reptiles, had hard-wired brains with mental programs probably limited to: *See! Act!*[1] Their most complex behaviors, as best we know, were instinctual. Dinosaurs responded mechanically to the same stimulae. Without a memory to hold the past for comparison to the present, there could be no thought. Without a memory there could be no mind because its necessary prerequisite, an appreciation of the coordinate of time, had not yet evolved.*

The appearance of mammals two hundred million years ago marks a sharp division in evolutionary history. Mammals descended from a transitional group of mammallike reptiles paleontologists have named *therapsids*. Dinosaurs, which were true reptiles, dined heartily upon the therapsids and, it is generally believed, brought about their extinction. The therapsids' last gesture, however, was to spawn the tiny progenitors of the mammals.[3]

In order to survive, these animals became progressively smaller and more inconspicuous. Tyrannosaurus rex could hardly have taken notice of the minute malanodon shrew. But the huge dinosaurs were cold-blooded and depended upon the heat of the day to be active. Because they were daytime creatures, vision was their most important sense. They needed the light from the sun to see what was going on about them. The warm-blooded mammalian line adopted the opposite approach, becoming active at night when the dinosaurs slept. Under the cover of darkness, mammals needed a primary sense other than sight to inform them about the world. To this end they evolved a keen sense of smell.

Whereas sight is largely a holistic *all-at-once* sense, the nose must process smells *one-at-a-time*. The ability to recall odors in sequence gave mammals the skill necessary to sally forth successfully in their nightly foraging for food. A place was established in their developing brains to hold the first memory on the planet thus creating the first epiphenomenon of thought. In contrast to perceiving visual information *all-at-once*, the reptilian method, the mechanism by which the mammalian cerebral cortex re-created the past was its invention of sequence.[4] Odors arranged in a

*While most reptiles lack a time sense there are exceptions. The giant Komodo lizards, which can grow to ten feet in length and weigh two hundred pounds, can stalk a deer relentlessly for days, an activity that could imply the possession of a sense of time.[2]

distinct order were the key to memory, initiating one-at-a-time thinking. For instance, a small mammal's chances for survival were enhanced if, when venturing forth in the nocturnal primeval forest, it could remember the location of last night's dining spot. The animal had to hold constant in its memory a specific smell sequence something like this: first, twenty feet to a decaying log's odor, then turn left thirty feet past the dinosaur scat's pungent scent, proceed for ten feet to the right and finally arrive at the termite nest that provided the previous night's sustenance.

In such a rudimentary state, only the dimmest glimmer could exist of the possibilities inherent in thinking about what had not yet happened. Although it is impossible to know with certainty, most likely early mammals had a very limited ability to manipulate the past and project it into the future. Nonetheless, they were capable of having a thought. Thinking is the formulation in mental terms of a segment of reality that is no longer before the senses. Every thought is an *after*thought. Despite its primitive nature, a single thought is the first, smallest unit of the grand edifice later to emerge in humans: the self-reflective mind.

Once mammals could conjure up purely mental pictures of earlier experiences, they could escape the narrow confines of the present. Then, for the very first time, a life-form could live not only in space but also in time. The proto-memory laid the groundwork for planning, choices, and learning by trial and error. Smells also enhanced mammals' identification of their offspring, and bonding between members of a species began. For purposes of species survival, bonding was a considerable improvement over the habits of reptiles, some of whom will eat their hatchlings if they happen to slither by as the eggs crack open.[5] With the debut of memory, the heavy hand of instinct began to lift and intelligence tentatively and shyly appeared on the planet.

The olfactory lobes of the emerging mammalian brain contributed to the rapidly enlarging cerebral cortex, whose first major innovation was to stretch the dimension of *now* backward in time. The past found a place there as a memorized sequence of smells. In other words, the cortex, the crowning achievement of evolution thus far and the prerequisite for mind, had its roots in odors. As testimony to its humble origin, the neurons from the nose, unique among the senses, connect directly to the higher cortical centers.

Traces of the connection between smell, sequence, and memory remain. For example, until the missionaries introduced mechanical clocks in the seventeenth century, the Chinese and Japanese had for thousands of years measured time by graduations of incense.[6] Not only the hours and days,

but the seasons and zodiacal signs were sequentially indicated by a succession of carefully ordered scents. In the 1930s, Wilder Penfield conducted a series of experiments upon his neurosurgical patients, in which he stimulated certain areas of the exposed brain with a tiny electrode and thereby evoked long-lost childhood memories that reappeared to his patients with vivid clarity. These visual memories were inevitably associated with deeply experienced smells that accompanied the memories.

As mammals developed, the cerebral cortex continued to expand so vigorously that eventually it had to start folding in upon itself in order to remain inside the confines of the skull. The bilobed, wrinkled brain of the early mammals is much smaller than ours but it has the same essential format. Despite this similarity, there is little brain lateralization in mammals.[7]

No one knows how or why the mammalian—and particularly the primate—brain developed a future sense. A number of hypotheses exist; what follows is mine. As we have seen, the nose played a decisive role in the brain's invention of the past. The progenitor of the future, however, was the eye. Although the early mammals developed amazing night vision because of their nocturnal habits, these adaptations diminished the value of daylight sight and retarded the overall development of this vital sense. For the mammal's survival purposes, hearing was a more accurate warning system than vision. The ear provided a twenty-four-hour, 360-degree trip wire alert. Smell, too, required no light and could serve as a Distant Early Warning system. Another important factor diminishing sight's value was that most nocturnal mammals were vegetarian and in the dark smell was far superior to vision when it came to locating a stationary delectation.

As the dinosaurs became extinct, however, mammals began to move out of the night into the bright noontime sun and take possession of the day.[8] The eye developed into a spectacular sensory organ in only two very different creatures: birds and primates. Birds and mammalian primates both lived too high off the ground for smell to be useful in finding food. Further, for primates especially, seeing clearly and judging distances was a matter of life and death. Shaped by these environmental pressures, sight in these two forms reasserted its earlier hegemony. In order to accommodate the primates' need to see by both day and by night, as well as their need to see both near and far, their eye's retina increased in complexity building upon the specialization that had begun in earlier animals. Two entirely different functional areas characterized by two contrasting types of cells populated the retina: rods in the periphery, and cones in its center.

Rods, named for their cylindrical shape, are extremely light-sensitive.

Originally evolved during the long night of the mammals to detect the presence of even minimal light, they permitted mammals to see in the dark. Their function in sunshine enlarged so as to give each organism an overall picture of the world before it. Since the rods were evenly spaced throughout the retina's periphery, birds and primates now could take in everything in their visual field simultaneously, in one grand gestalt. By giving the brain the information necessary to integrate the visual relationship of the parts to the whole, rods gave to vision its simultaneous *all-at-once* quality.

In humans, this function of the retina is so important that the rods enlist the entire body to help them perform: The brow becomes unfurrowed and tension diminishes as the pupil dilates, letting in maximum light. The eyes become unfocused in order to see everything rather than one detail, and the skeletal muscles relax into a passive stance as consciousness, like the gears in a car, downshifts into idle. This visual, physical, and mental state is known as contemplation. The right hemisphere of the brain is best able to appreciate these states since the right *all-at-once* brain is older than the left *one-at-a-time* brain. From an evolutionary point of view, rods are much older than cones; all eyes have them.

The cones, the other component cells of the retina, are evolutionarily speaking, recent arrivals and their function is something new.* They congregate densely en masse in the central part of the eye called the *macula*, where the *fovea centralis* at the macula's center is vision's focal point. Cones allow a creature to see color and to see with great clarity. Because of the sophistication of their cones, birds and primates could not only identify one brightly colored seed or fruit among green foliage at great distances, they could also *abstract* a single detail from a wealth of visual data and scrutinize it separately from the rest by fixing it with the piercing gaze of the macula.

Instead of contemplation, which characterizes the rods' use in humans, concentration is associated with the visual state of scrutiny during which the entire body's sense of alertness is heightened. Skeletal muscles tense while the pupil constricts and the brow furrows, effectively reducing the amount of light entering the eye and shutting down the light-sensitive rods. Intense concentration upon a colored detail, the special gift of the cones, is very different from holistic contemplation, the relaxed, open-eyed

*As evidence of their newness, cone vision does not develop for many months after birth. Rod vision is present within days but the maturation of the macula is not completely functional until six months later.

activity of the rods. The left brain's discriminatory analytic mode is better suited than the right's for the concentrated vision of the macula.

According to my hypothesis, there was a significant price to pay for shutting out the rods' distracting visual information. The macula can concentrate on only one detail of the whole picture at any given moment. Its vision is tunnel vision, similar to looking out at the world through a cardboard tube. Therefore, examining an object with this part of the retina unwittingly creates the illusion of the passage of time. Because each section of visual reality is inspected in sequence, the focusing power of the macula, and specifically the fovea centralis, reinforces the mental conception of time because the pictures generated out of this small central area of the eye can be processed only in a *one-at-a-time* manner.

Because macular vision examined what was and then moves on to what is, it enabled the emerging brain to consider the possibility of what comes *next!* By demanding the conceptualization of *next!* the macula forced upon the brain that there could be a *next!*: that something follows from a series of events that marches out of the past. This process is called foresight— that is, a sense of the future.

The need for retinal cone specialization, with its concomitant increase in brain complexity, is particularly acute in predatory birds, predatory mammals, and the most predatory primate, the hominid. Because plants can't run away, a horse munching on some grass need not be mindful that his next mouthful will bolt for the barn. But a predator must focus its attention on its prey and observe not only where dinner is, but also where it might be going.

This feature of the cones can best be illustrated by example. Imagine walking into a dark theater, your eyes not yet adjusted to the dark. The usher leading you down the aisle stops, then turns on a flashlight. As the beam scans a row, one person after another appears within the flashlight's narrow circle. As the flashlight leaves one person, he disappears, while the next person magically emerges. The flashlight beam is like the tunnel vision of the macula. Although everyone in the theater row is already there, searchlight vision isolates them in a *one-at-a-time* manner creating the illusion that objects existing in relation to one another in three-dimensional space are now sliding by in an orderly sequence of time.

I propose that the highly evolved splitting of the visual functions within each human eye accelerated the division of the cerebral cortex into two different functional lobes, and that the unique requirements of tunnel vision created an evolutionary imperative that forced the brain to speed up the division of its perceptual assignments into two separate sides. This process,

which began when early mammals smelled sequence in order to remember the past, now accelerated because of the new directive from the primates' macular cones to imagine the future.

On casual examination, the human brain appears to be a symmetrical, bilobed structure. Neither macro- nor microscopic examination of the lobes reveals any significant difference between them. Yet each hemisphere is in charge of entirely different functions. Each eye, too, is a perfect mirror image of the other, yet each has within it a sharp division of function, and the contrast between the rods and the cones corresponds to the contrast between the right and the left brain. The rods and the right brain share the ability to see the holistic gestalt—to perceive reality *all-at-once*. The cones and the left brain, on the other hand, see the world in a *one-at-a-time* manner. To "abstract" something means to tear out of the whole one segment that can then be studied in isolation. Abstract thought, the highest cortical function of the left hemisphere, has much in common with the abstract visual capability of the cones.*

The sharp division of hemispheric attributes is unique in its extent only in humans. What evolutionary advantage could this new dual brain have conferred upon early humankind? It made our distant ancestors supremely intelligent among animals. The division of functions gave Homo sapiens two separate brains in one head. The right and left hemispheres are essentially two independent, conscious individuals each able to solve problems differently, each capable of independent decisions, memories, judgments, and actions. Since intelligence means a flexible response to environmental stimulae, the more flexible its response capabilities, the more intelligent an organism is. Splitting the brain of Homo sapiens into two separate functional units did not result simply in a near doubling of the potential number of responses; instead, the constant feedback between the lobes has led to an infinite variety of responses.

As we have seen, the right side of the brain specializes in the simultaneous coordination of information in *space*, while the left side collates data sequentially perceived in *time*. This arrangement forces on dual-brained humans the *illusion* that reality is a series of causal events that appear in

*Some support for this hypothesis of synchronous eye and brain specialization derives from the observation that songbirds, the only other species besides humans whose brain hemispheres are extensively lateralized, share with us the probing macula. In their incredible production of birdsong, songbirds are also capable of vocalization whose complexity is evocative of human speech, and which they generate principally from their brains' left hemispheres. Sequence, too, is a crucial characteristic of birdsong, since altering the order of a call changes its entire meaning. Moreover, a bird—the parrot—is the creature on earth that can most accurately memorize and mimic the sequences of human speech. Parrots generate mimicry from their left hemispheres, and are also endowed with sharp maculae.

three-dimensional spatial extensions in a specific sequence on a conveyor belt of time. Almost two centuries ago, Kant surmised that space and time were the two basic categories of appearance: Indeed, they are not only mere categories, but each has its own anatomical mailing address. Evolution has conferred dominance upon the new left brain, I suspect, because causal thinking, which can predict the future, depends on sequence.

The nose remembered the past and the eye envisioned the future. By dilating the limits of the present, mammals and especially one primate, Homo sapiens, extended the appreciation of time in both directions. For this development to occur, under the pressure of environmental change, the brain lateralized. Events and functions that took place largely in *space* were assigned to the older right hemisphere. All of the wondrously unique functions of the new left lobe—craft, speech, abstraction, logic, and arithmetic—are dependent on a sense of time. In the history of life on this planet, the left hemisphere is something new under the sun. It is not just a part of the brain. It is actually a sixth sensory organ encased within the skull, charged with the task of apprehending time.

There's a lot of prophecy in these Dionysian doings and in
their hysteria, and when that god gets deep in a man's
body, why he can make you tell the future.
Euripides

CHAPTER 28

DIONYSUS / APOLLO

Hypotheses about eyes and noses and space and time are difficult to corroborate using science's traditional investigative methods because there are no fossil records of the outline presented in the previous chapter. An intriguing confirmation appears, however, in a mythological context. Since art and myth are inextricably connected, and since the thesis of this book is that art precognitively anticipates science, I propose that myths contain scientific theories couched in allegorical and poetic terms. This idea has been eloquently expressed by Joseph Campbell who wrote:

It would not be too much to say that myth is the secret opening through which the inexhaustible energies of the cosmos pour into human cultural manifestation. Religions, philosophies, arts, the social forms of primitive and historic man, prime dis-

412

coveries in science and technology, the very dreams that blister
sleep, boil up from the basic, magic ring of myth.[1]

Myths tell the story of the mind's division of space and time, and the
subsequent separation of art and physics, by allegorically illuminating the
incremental steps on the road to the self-reflective mind.

Mythologists such as James Frazer and Joseph Campbell have revealed
a common thread running through diverse myths even though their origins
occurred in cultures separated by miles of space and centuries of time.
Three principal theories have addressed this extraordinary phenomenon.

The first is that travel in prehistoric times was much more extensive
than has been conjectured and broad contacts between populations diffused
and homogenized the myths. The second theory, as Freud proposed in
Totem and Taboo (1913) and *Civilization and Its Discontents* (1930), is
that myths are to society what dreams are to the individual and that the
source of both is individuals' childhood fantasies. According to Freud, the
primal drama played out in every generation among mother, father, and
child becomes the loom upon which diverse cultures weave the rich tapestry
of what is really a monomyth. Since the emotions evoked by Oedipal and
Electra feelings are universal, it is inevitable that every mythology partic-
ipates in them and shares certain common threads.

Carl Jung proposed the third and most radical hypothesis. He believed
that myths were the inherited memories of the race; he called these engrams
the *collective unconscious*. Jung suggested that we do not come into the
world as a tabula rasa devoid of any information, but rather, are born with
unconscious memories that embody the great events of our evolutionary
development. In effect, Jung extended Kant's proposal of a priori categories
to include knowledge of archaic events.*

But where, in Jung's scheme, would this information be stored? The
DNA molecule is a massive library that contains different blueprints for
everything from fingerprints to hair color. It is not inconceivable that
somewhere along its twisted, elongated shelves is a section for evolutionary
history. Genetic engineers have recently identified long stretches of human
DNA that do not contribute to the individual's physical attributes. Molecular
biologists have proposed that these silent sections are either "junk DNA"
or are available for some future purpose, as yet undiscernible. I would
proffer an additional hypothesis: Perhaps some of them are the depository
for the engrams of ancient memories.

*Noam Chomsky, the linguist, recently put forth the analogous idea that we are born with
the knowledge of the syntax of language before we learn any language itself.

The earlier events of evolution, transferred from DNA and encoded in the developing brain of a fetus, could become the basis for Jung's *collective unconscious*. If we consider his hypothesis a possibility, then it should be fruitful to search for parallels between myths and evolutionary events. Myth is an allegorical means of telling a complex story with many levels of meaning.

Throughout this book, I have taken the Greek heritage to be the dominant influence on Western civilization's conception of space and time, as well as providing the substrate for our art and physics. The ancient Greeks' Olympian creation myth recounts with uncanny accuracy the evolutionary separation of space and time. It also reveals the relationship between art and physics, and right and left hemispheres of the brain. As a fortuitous corroboration, the story is remarkably similar to the present scientific evolutionary hypothesis regarding human consciousness.

According to the Olympian myth of creation, in the beginning all was Chaos. In this state, there were no things, no forms, no substance, no events—nothing except pure turmoil, or as we would say today, pure energy. Because there was nowhere to stand, a god, who, in a cousinly echo from the Old Testament, did not have a name, split Chaos into sky and earth. The male sky god, Uranus, looked down upon the lovely earth goddess, Gaea, felt moved by passion, and impregnated her clefts and valleys with soft rain, producing vegetation and, later, simple animal life. In time, they successively brought forth more sophisticated races of living things until the penultimate race was born: the forerunners of the mortals' gods called Titans. Chief among them were the sons of Uranus: Kronos, Epimetheus, Prometheus, and their sister Mnemosyne.

The prologue to the story of the human race begins with patricide. Kronos, the strongest son of Uranus, chafed under his father's rule, impatient to appropriate his power. Gaea, angered by the cruel and arbitrary punishments her husband meted out to their children, conspired with her son Kronos. The first Oedipal drama unfolded when Kronos murdered the sleeping Uranus and then compounded the horror of his deed by castrating his father with a monstrous sickle. Kronos proclaimed himself king, usurping control over all other life-forms. He forced his two brothers, the slow-witted Epimetheus and the nimble-minded Prometheus, and his sister Mnemosyne, to pledge allegiance to him, thus acknowledging his power.

The story so far contains an accurate chronology of both cosmology and evolution. We can recognize the formless chaos of the early universe, the big bang, the beginning of space and time, the formation of matter, the intimate connection between life and water, and the creation of sequentially

more complex phyla of organisms culminating in the ancestors of human-kind by splitting off one primate from all the others of the species. The early distinguishing characteristic of this hominid primate was that he was a dangerous, meat-eating predator capable of murder. Of the over one hundred species of primates, only one, Homo sapiens, routinely derives most of its nutritional needs from eating prey. As an aside, it is compelling to note how often in creation myths, early on someone gets killed.

The eerie correspondence behind the story of Kronos as the precursor of Homo sapiens becomes even more provocative when his and his siblings' names are translated into English. *Kronos* means "time." His name is the source for "chronicle," "chronological," and "chronic." On New Year's Eve, Father Time is represented by an old man with a scythe, killing the decrepit year. This archetype is really Kronos with his sickle. In evolutionary terms, the older hominids' primitive notions of time were murdered to make way for a new time—literally. King Time became the ruler of the world when the ability to apprehend time became the critical precondition for human thought. The need to process time as a separate coordinate from space became the impetus for the left brain's temporal specialization, which succeeded when the cones and the left brain collaborated to invent the illusion of sequence.

Kronos' siblings' names are equally revealing. *Metheus* means "thought." The words "thesis," "theory," and "thinking" are derived from its root. *Epi* means "after," so *Epi-metheus* means "after-thought," that is, thinking about the past. His sister's name, *Mnemosyne*, is the root of the word "memory"; every student has used her name to create "mnemonics" to help memorize long sequences of facts. Mnemosyne was the mother of the Muses, because remembrance makes all the arts possible. *Pro-metheus* means "fore-thought," which is indispensable for anticipating the future. *Prometheus* is synonymous with "prediction." According to myth then, King *Time*, along with his brothers, *After-thought* and *Fore-thought*, and their sister *Memory*, are the ancestors once-removed of the human race. According to presently accepted neuroanthropological theory, they are also the necessary preconditions for all the critical faculties of the brain's emerging left hemisphere.

To continue the story, Kronos was warned by an oracle that one day one of his children would slay him in retaliation for the patricide he had committed. As a precaution against this prophecy, Kronos, who had married another of his sisters, Rhea, developed the inelegant habit of devouring each of his offspring immediately after their birth. He consumed in rapid succession Hades, Poseidon, Haephestus, Pan, and Hera before Rhea plotted

to put an end to this unseemly practice. When she gave birth to Zeus, she quickly hid the infant and substituted a nine-pound rock wrapped in swaddling clothes. It is no credit to the sensitivity of Kronos' palate that he failed to notice the difference. He consumed the rock, believing that once again he had outsmarted the oracle.

Spirited away by Rhea's servants, Zeus grew to manhood in hiding and when he was old enough, organized a rebel force to avenge his grandfather's death.* He killed Kronos in fierce combat and then, according to the myth, slit open his father's belly. To his surprise and delight, out sprang his siblings unharmed.

Two of Kronos' Titan brothers, Prometheus and Epimetheus, deserted their race to ally themselves with Zeus. Following this second patricide, Zeus and his small band took on the entire Titan race and, in the famous battle of the Titans immortalized on the pediment of the Parthenon, subjugated or killed all the remaining members of the hapless Titans.

Until this juncture in prehistory, there were still no mortals, only gods and goddesses. The human race began during Zeus' reign, and its creator was none other than Prometheus, who, according to the story, molded a composite of men and women out of rich loam and rainwater.† Few anthropologists would quarrel with the notion that the most extraordinary human attribute is forethought. Here, in this myth, the creator of our species is a god whose name literally means "prediction."

Because Prometheus paid obeisance to Zeus, Zeus was considered the father of mortals. But as humankind's favorite uncle, Prometheus continued to play an avuncular role in this new race's development. Students remember him as the god who risked the wrath of Zeus by stealing fire from Mount Olympus to give as a gift to mortals. Also of great significance, he is credited with teaching mortals the alphabet and numbers, and initiating the art of crafts—all gifts that require an appreciation of time because each is critically dependent upon sequence.

*The thread of this story is a monomyth. A son, raised in anonymity because of his father's fear or ire, who grows up to become king is the story of Moses in the bulrushes, Oedipus, Perseus, Theseus, Romulus, Cyrus, and many others.

†Plato, in the *Symposium*, reports the playwright Aristophanes' version of this important event. When Prometheus, proud of his new four-legged, four-armed, two-headed creation, presented it to Zeus, the chief god became alarmed. He feared the possible power of such a potent new race and told a crestfallen Prometheus that such a race could eventually challenge the hegemony of the gods. Zeus, however, proposed a solution. He told Prometheus to split his creation down the middle and call the halves "man" and "woman." Zeus cleverly pointed out to Prometheus that because of the cleavage each side would spend its life searching for its other half and this expenditure of energy would diminish their threat to the Olympian gods.

In his play *Prometheus Bound*, Aeschylus has Prometheus describe the gifts he gave to the human race:

> They were like the shapes we see in dreams and all through
> their long life, they mingled all things aimlessly . . . And then
> I found for them the art of using numbers, that master science,
> and the arrangement of letters, and a discursive memory, a skill
> to be mother of the Muses.[2]

The ability to use alphabets, abstract thinking, and numbers distinguishes our species from the higher apes. Our formidable memory allows us to impose order in a chronological sequence and not "mingle all things aimlessly."

Another Greek myth specifically immortalized the moment when the functions of the cerebral hemispheres were lateralized. This tale concerns Zeus, an amoral, amorous sort who mated with both goddesses and mortals depending upon whether they attracted his fancy. His sexual adventures produced many offspring who came to populate the pantheon.

This prosaic method of fathering various gods, goddesses, and god-mortals stands in striking contrast to the myth surrounding Athena, the goddess of wisdom. According to myth, Zeus had originally married Metis, the goddess of measure, mind, and wisdom; then he became envious of her powers, and so devoured her to consume her attributes. Unbeknownst to Zeus, Metis was pregnant at the time with their daughter Athena. Although Metis died, the embryonic Athena continued to grow to term in Zeus' head.

One morning Zeus complained of a throbbing headache. As the day wore on, it turned into excruciating agony. He howled in pain and dispatched Hermes, the messenger, to find someone who could give him relief. To help the ailing Zeus, Hermes brought another god, who placed a wedge on Zeus' brow and, with a sharp blow of a hammer, cleaved his forehead. From out of this central fissure sprang the goddess Athena, full-grown and dressed in armor, without infancy, childhood, or any rite of passage to adulthood.*

That Athena was the goddess of wisdom meant she was the goddess of learning from trial and error and combining past knowledge with intuition to predict future outcomes. Wisdom is synonymous with good judgment.

*The only other being in Greek mythology who appeared fully grown was Aphrodite, the goddess of erotic love. Since mature sexual desire does not begin until adolescence, it was mythologically appropriate that Aphrodite emerge as a nubile young adult.

It is based on experience that integrates information from both the right and left hemispheres. Most people consider the attainment of wisdom to be the highest goal of life. According to Greek myth, wisdom, in the form of Athena, came into the world because of the mythological hemispheric lateralization of the single most potent god. And who among all the gods and goddesses did Hermes summon to wield the wedge and hammer that split Zeus' brow? None other than Prometheus, the god of forethought, the only god capable of such radical neurosurgery. What Greek mythology tells us, then, is that wisdom came into being when the brain was split by forethought so that time could be extended into the future. Henceforth, one half of the cerebral cortex would process information in space and the other half in time; under these conditions an individual could use past knowledge in order to anticipate the future. The god whose name means forethought midwifed the birth of wisdom.

Athena's arrival, full-grown, follows fairly close to the conjectures of modern science about the specialization of the human brain into two functionally different hemispheres. Higher apes demonstrate some hemispheric lateralization, but the epitome of this cerebral arrangement is found in humans. Furthermore, this division apparently occurred with astonishing rapidity and remains one of the most tantalizing anthropological puzzles unexplained to date.*

Three million years ago, the advanced hominids' brain weighed approximately 900 grams, or two pounds. Within the space of a scant one million years, this critical organ grew by one third its weight to add an entire pound of gray matter. Its present weight is approximately 1,400 grams, and it seems to have stopped growing. Virtually all the growth occurred in the cerebral cortex, enlarging both hemispheres. Immediately after this development, the attributes we consider uniquely human appeared: Promethean forethought, speech, control of fire, toolmaking, and clear evidence of preferential handedness. In this century, paleontologist Raymond Dart observed that excavated antelope skulls in South Africa that had been crushed by a blow from a weapon were more commonly found broken on the left side, suggesting that the Paleolithic hominid wielding the club was preferentially right-handed.[3]

It is not too removed from scientific hypotheses based in documented fact to speculate that the birth of wisdom occurred simultaneously with this radical enlargement of the two cerebral cortices and their split into

*Unlike previous beliefs that evolution occurred in a slow steady progression, Stephen Jay Gould, the evolutionist, has proposed that there have been occasions when evolution suddenly accelerated in a veritable quantum leap.

separate functions. Athena emerged fully grown from the godhead without any transition; the fossil records of the brain cases of earlier hominids suggest a similar sudden leap in brain size.

Both Prometheus and Athena were major benefactors of the human race, and there is a considerable overlap between their gifts. By mythical account, Athena also taught mortals the art of letters and numbers. She was skilled in the military arts and rarely lost a match. Even Ares, the violent and truculent god of war, was not able to defeat her because she won by superior strategy—forethought and wisdom—rather than mere force. She taught women the practical crafts of weaving, pottery, and fashioning utensils, all of which depend on learning a series of steps that must be carried out in precise sequence. She also taught them how to design artfully.

Although a woman, Athena was asexual. She was androgynous, combining important characteristics of both male and female. According to the myth, she never desired or mated with anyone, which is another way of saying that she rarely let her right-brained emotions influence her rational judgments. When Pallas, a Titan, made the mistake of making a sexual overture to Athena, she killed him for his temerity and then usurped his name as a warning to others. Pallas Athena was not a woman a male could trifle with.

The creature that came under Athena's aegis was the owl. This bird of prey is known for its remarkable visual acuity, even in darkness. The eye of the owl contains the best of the functions of both the rods and the cones, and, parenthetically, those of the right and the left hemispheres. The owl is one of the few creatures in the entire animal kingdom capable of swiveling its head in such a manner as to see a complete 360-degree circle: It can look behind to see what is past, as well as ahead to see what is coming. As such, the wise old owl is the perfect totemic creature for Athena.

After his brain had been split in two, creating wisdom in the process, Zeus sired two more gods who came to represent the two very different aspects of the human psyche—Dionysus and Apollo. Although Dionysus was the last god to gain the status of an Olympian, he will be considered first because his outlook is more primitive. As befits Dionysus' close association with the archaic limbic system of the brain, he, like Athena, was born from a body part. But whereas Athena came from Zeus' brain, Dionysus originated from his loin.

In this story, Zeus much desired the beautiful mortal Semele, who acceded to his lust on the condition that he grant her one wish. In the heat of desire, Zeus agreed, and Semele became pregnant with Dionysus. In her seventh month of pregnancy, Zeus visited and Semele asked him to

fulfill his promise. At first he assented, but when she told him that her wish was to see him not as a man, but as a god, Zeus scowled and then pleaded with her to wish for something else. He explained that no mortal could look upon his god-form dressed in full regalia and survive. Semele stubbornly refused and demanded that Zeus keep his promise.

Reluctantly, Zeus reverted to his awesome god-form, complete with flashing thunderbolts, and Semele was burned to death consumed in his white-hot radiance. Remorseful over her terrible end, Zeus snatched the premature Dionysus from her womb and had Hermes sew the fetus into his, Zeus', own loin, where Dionysus was carried for the final two months. His gestational proximity to the kingly genitals shaped the essential nature of Dionysus' character. He is the god of ecstasy, of orgiastic celebrations using intoxicants and dance. His mystic cult is the antithesis of intellectual cerebrations. Dionysus is the paradoxical master magician of pleasure and pain, beauty and cruelty, genius and madness, ecstasy and terror.

The figures that appear in our dreams and nightmares—satyrs, nymphs, and chimeras—could all be found at a Dionysian ritual. He was intimately connected with procreation, and the serpent and the ram, both phallic symbols, are under his aegis. According to the ancient Greeks, life's regeneration each spring was due to his spirit. Dionysus introduced mortals to altered states of consciousness by teaching them the cultivation of the vine. Included in his retinue were the Muses of all the arts. Dionysus was irrational and nonverbal. Associated with the moon and symbolized by the mask, he was a lover, not a fighter, attracting women devotees just by being instead of by the more conventional masculine mode of doing. Although not intellectual, he was clairvoyant: The hunch, the lucky guess, and intuitive knowledge are all part of his domain. The attributes of Dionysus are the characteristics of the right brain.

Zeus' favorite son, the cool and unflappable Apollo, was the polar opposite of his brother Dionysus. Apollo, "the shining one," the sun-god, was the god of reason, science, medicine, law, and philosophy. A serious, humorless warrior, Apollo acquired his most important attribute when he stole the gift of prophecy by capturing the shrine at Delphi from Pan, a precursor god who strikingly resembles Dionysus.

The sacred shrine at Delphi invested virgin priestesses with the all-important power to see the future. In order for Apollo to gain control of the oracle, he had to slay the mighty serpent, Python, a creature sacred to Dionysus. He accomplished this deed with a new weapon he had invented—the bow and arrow. Not only does this tale present a subtle allegory of how the aggressive left brain gained dominance over its older

and more primitive opposite; it also echoes the story of Adam, Eve, and the serpent. The Old Testament implies that knowledge, apple, and serpent are connected. In Greek, one derivation of Apollo's name is "apple."

Predicting the future, the raison d'être of an oracle, is crucial to science, industry, and the military. A scientific theory becomes a law only if it can correctly predict an experiment's outcome. Wall Street is awash with soothsayers who forecast future trends—with less than Delphic success. A successful military strategist accurately anticipates what the other side will do in combat. Therefore, having wrested control of Delphi from Pan and his double, Dionysus, it is not at all surprising that Apollo became the patron of these three branches of human endeavor.

Greek philosophers, charged with separating human thought from its entanglements with irrational beliefs, felt a kinship with Apollo because he was a god who thought things through. Reason, logic, and considered discourse were characteristic of his nature. Throughout his writings, Plato, more than any other philosopher, extolled the Apollonian virtues. Western physicians begin the Hippocratic oath with the phrase "I swear by Apollo . . ." Because Apollo gave laws to mortals, he is the patron of all lawyers and judges. After Prometheus introduced the alphabet to mortals, Apollo became its protector. The Greeks revered this simple code, which became the key to converting invisible speech into a silent, visual mode.

This serious god epitomizes the masculine principle out of touch with its feminine counterpart. Love and romance seemed to elude Apollo. For example, when he tried to woo the lovely Daphne, he literally could not touch her: She was so repulsed by his advances she transformed herself into a laurel tree and escaped forever. Similarly, Dionysus does not have access to rational discrimination, without which he is condemned to commit egregious sensual and amoral excesses.

The dark sides of Dionysus and Apollo symbolize respectively the danger and sterility of one-sided hemispheric specialization. These two incompatible brothers did not have much to do with each other in their mythical exploits, yet the Greeks recognized their complementarity. According to myth, Apollo was in residence at Delphi for nine months of the year. Then he left and Dionysus ruled for the other three. Further, Dionysus' bones are buried at the foot of Apollo's shrine at Delphi. Despite their veiled antipathy toward each other, they shared one major dominion: Both were principal patron gods of music.

The Greeks recognized two different kinds of music, for just as rational philosophy and rational art arose in classical Greece, splitting off from superstition and primitivism, so music too lateralized. Erotic desire was

the impetus for the first musical instrument. Pan, the goat-god and proto-Dionysus, was particularly attracted by the singing voice and charms of one of the maenads, Syrinx. He became enthralled by her but she did not reciprocate his feelings and fled from his attention, hiding among some water reeds. Just as Pan was about to discover her hiding place, she magically transformed herself into one of the water reeds and disappeared forever. When Pan realized what had happened, he was overcome with the sadness of unrequited love. Disconsolate, he sat beside the bank and cut a series of different-sized reeds, combining these into the first panpipe, and played the first of what was to become a long line of mournful love songs. The haunting origin of Pan's songs will always be remembered: the anatomical name for the vocal mechanism of birds, the counterpart to the human larynx, is syrinx. Dionysus inherited Pan's pipe, and the wind instrument became the symbol of Dionysian music.

Dionysian music has a spellbinding quality. Its primitive rhythms could incite the female maenads, priestesses of Dionysus, into a frenzy—a midnight madness of music and dance that ended with the violent dismemberment of a live sacrificial victim which could be animal or man. After tearing their sacrifice into pieces, the devotees would smear their bodies with its blood. The witches' Sabbath and Walpurgisnacht have their origins in this Dionysian ritual.

Apollo abhorred Dionysian music, preferring instead a serious and contemplative style. His instrument was the lyre, the precursor of today's harp, violin, and viola. Apollo's lyre always had seven strings, representing the alphabet's seven vowels. Apollonian music created the proper environment for thinking, in that it was soothing, ordered, and antidotal to the stirring rhythms of Dionysus. Plato, a chief proponent of Apollonian music, understood the destabilizing influence of the Dionysian wind instruments and decreed that in his Republic only the strings of Apollo would be allowed. Plato believed Dionysian flutes, reeds, and horns were seditious instruments.

Two opposite musical modes representing Apollo and Dionysus are present even today. It is no accident that in all symphony orchestras the string instruments, descendants of the lyre, are accorded the dignity and respect of being seated in the front, while the woodwinds and horns are positioned behind them. The reverse, however, holds true for jazz, a Dionysian form where the clarinet, saxophone, and trumpet are proudly out in front, and the bass, usually the lone string instrument, takes the background in both position and role.

Apollo represents all the attributes that modern neuroscientists have attributed to the left hemisphere. Dionysus, on the other hand, is the perfect

embodiment of all characteristics of the right side. Dionysus' retinue includes music, drama, dance, poetry, painting, and sculpture. Apollo presides over science, the military, industry, education, medicine, law, and philosophy. Dionysus is the exemplar of the artist, as Apollo is of the physicist.

Without the benefit of modern science, the ancient Greeks attributed to these two very different gods the characteristic features of the two separate hemispheres of the brain. The revelation by modern neuroscientists that the cerebral hemispheres had asymmetrical functions confirmed the mythic Greek division of human brain function. The dual nature of the human brain-psyche-mind lies barely concealed in ancient myth. The opposing personalities of Dionysus and Apollo, with sibylline prescience, define the differences between the right and left sides of the brain, as well as those between art and physics and space and time.

> More primordial than any idea, beauty will be manifest as the herald and generator of ideas.
>
> Teilhard de Chardin

> The artist is the man in any field, scientific or humanistic, who grasps the implications of his actions and of new knowledge in his own time. He is the man of integral awareness.
>
> Marshall McLuhan

CHAPTER 29

ART / PHYSICS

Before the rise of reason began to suppress the hegemony of myth in classical Greece, the patron goddess of practical knowledge was Techne, from whose name we derive our word "technique," carrying within it the idea of step-by-step scientific investigation. Yet one of the Greek words for art is *techne*, for she was also its goddess, and the Greek verb *tikein* ("to create") is derived from her name. Techne served as the inspiration for science as well as for art.

Science, custom, and intuition all acknowledge that the right brain is the artistic side. Right-art-*space* belongs principally in one hemisphere. Yet, though art is contemplated and even inspired in a synthetic, holistic, *all-at-once* manner, the actual task of composing music, painting a picture,

or casting a statue is left-brain work: It takes place *one-step-at-a-time* and depends on a sequential technique. The studio for the fabrication of art is located somewhere in the left brain, but the design center's headquarters and creative offices are within the right.

Left-physics-*time* resides chiefly in one hemisphere. Just as art needs left-sided sequence, so physics depends upon right-sided inspiration. Visionary physicists frequently report that their insights occur in a flash of intuition: an epiphany that is at once *nondiscursive, nonlogical,* and *authentic.* In these cases, the painstaking labor necessary to shape each intuition into the language of mathematical proofs occurs *after* the insight. Einstein expressed this when he said, "Invention is not the product of logical thought, even though the final product is tied to a logical structure."[1] Despite these crossovers, the framework of physics consists of sequential, abstract, algebraic equations. Its infrastructure is that of logic and number, and its essence is that of a time line. Although one cannot completely assign something as broad and creative as the field of physics to only one side of the brain, nevertheless the intricate equation-driven work of physics proceeds for the most part in the time-dependent, science-oriented left hemisphere.

Throughout this book, I have provided many illustrations of art's precognitive power, showing how artists repeatedly conjured up revolutionary images before physicists formulated visionary new configurations of the world. Even when artists and physicists arrived at their formulations coincidentally, or when physicists' explanations preceded artists' images, the artists were, and continued to be, generally unaware of the physicists' discoveries. As we have seen, some of the most stunning examples of deeply revolutionary art in Western history were made at the turn of the twentieth century, when two thought-changing branches of physics were emerging: relativity and quantum theory. Our present world full of computers, lasers, space probes, transistors, and nuclear energy attests to the great power of prediction implicit in these two theories. Most members of contemporary society still have not processed the profound implications these two hold for their belief in commonsense reality. The new physics presently rests like a pea under the collective mattress of humankind, disturbing tranquil sleep just enough to begin to change how people think about the world. Art was there before to sound the clarion warning of the technostress to come.

A feature of the right hemisphere that has been greatly denigrated is its ability to foresee the future. The Newtonian paradigm exalted the ability

of Promethean and Apollonian logic to predict, and overlooked, ignored, and even belittled the Dionysian means of forecasting that takes the form of hunch, intuition, and clairvoyance. Now, from what once would have seemed the unlikeliest corner, physics has verified a hypothetical place from which this could be possible—the spacetime continuum. As has been reiterated throughout this book, nothing of physical mass can travel at the speed of light, which, of course, would be the prerequisite in order to "see" the spacetime continuum. Yet, the repeated inability of science to pin down the mind's nature rests on the excuse that mind is not a physical form, substance, object, force, field, or thing and as such rests outside the pale of science. In our limited three-dimensional mammalian brain we do not have a framework for conceptualizing either mind or the spacetime continuum. But this may be the very clue pointing to their connection.

Someone who can glimpse spacetime would see that all events that in our prosaic three-dimensional world appear in linear fashion occur simultaneously, that is, *all-at-once*. Physicists begin to sound like mystics when they discuss relativity. Louis de Broglie wrote:

> In space-time, everything which for each of us constitutes the past, the present and the future is given in block, and the entire collection of events, successive for each of us which forms the existence of a material particle is represented by a line, the world line of the particle . . . Each observer, as his time passes, discovers, so to speak, new slices of space-time which appear to him as successive aspects of the material world, though in reality the ensemble of events constituting space-time exist prior to his knowledge of them.[2]

When vision is truly *all-at-once*, that is, when it can see the spacetime condition, it can perceive all the durations simultaneously and can, therefore, foretell the future.

The Russian philosopher P. D. Ouspensky wrote:

> Only that fine apparatus which is called *the soul of the artist* can understand and feel the reflection of the noumenon in the phenomenon. In art it is necessary to study "occultism"—the hidden side of life. The artist must be a clairvoyant: he must see that which others do not see; he must be a magician: must possess the power to make others see that which they do not themselves see, but which he does see.[3]

And here the thesis of this book—that revolutionary art anticipates visionary physics—lies revealed. *When the vision of the revolutionary artist, rooted in the Dionysian right hemisphere, combines with precognition, art will prophesy the future conception of reality*. The artist introduces a new way to see the world, then the physicist formulates a new way to think about the world. Only later do the other members of the civilization incorporate this novel view into all aspects of the culture. The view sitting astride a light beam is *all here* and *ever now*. Spacetime consciousness must be holistic, merging as it does all space's vectors with all time's durations. It most likely issues forth from the right hemisphere, since the artists and mystics, expressing themselves in images and poetry, are more attuned to this type of consciousness.*

Because precognition violates causality, there are many who refuse to even entertain the possibility, even though both relativity and quantum mechanics both propose hypothetical circumstances where precognition would be possible. Further, despite the many advances of neuroscientists, there remain mental functions for which there are no satisfactory explanations. Earlier, I put forth the analogy between a single brain and the collective mind. Perhaps returning to this comparison again will help us understand the artists' clairvoyance.

Lawrence Weizkrantz, a neuroscientist, has observed a peculiar phenomenon in individuals who are blind because of defects in their visual cortex. Writing in 1974 he noted the following: When a light is directed toward their eyes from a distance far enough away that the heat of the light cannot be a factor, the blind subjects are asked if they can see anything. Of course, they all reply that indeed they cannot. They are then told that a light is being shone in their direction. When the investigators ask them to guess from which direction the light beam is coming, the subjects again protest, replying that they do not have the slightest idea. The investigators again urge them to point with their finger where they guess the light originates. With an uncanny degree of accuracy that far exceeds probability, these subjects, devoid of sight, are often able to identify the light source correctly.[5]

Weizkrantz named this ability to respond to visual stimulae without

*Another suggestion that the right hemisphere/artistic sensibility precedes the left/scientific one is the cognitive model for infants recently proposed by two neuroscientists, Marshall Gladstone and Catherine T. Best:

> The right hemisphere would serve to code novel information, while the left hemisphere would be best suited for reporting *already acquired, compactly coded information*, the sequence of knowledge acquisition following a shift from right to left hemispheres.[4]

conscious awareness *blindsight:* the ability to see that which is physically impossible to see. At present this phenomenon is poorly understood.

The ability to see that which cannot be seen, present in the individual, can be extrapolated to the society at large. Revolutionary artists are endowed with blindsight. Time and again they have glimpsed a reality not visible to the rest of us. Artists, when asked, are unable to articulate their prescience. That blindsight exists has been well documented; perhaps it is not too much to believe that some seers, like the mythical blind Greek prophet, Tiresias, can see that which is not visible. Artists are nonverbal prophets who translate their visions into symbols before there are words: Artistic precognition is civilization's blindsight.

Prophets are those who speak of things before they come into being. To do this, they must possess a kind of spacetime consciousness that is not merely momentary awareness of passing experience, or just the ability to predict events within a scientific framework. Rather, spacetime consciousness—knowing *all-at-once*—is the fundamental ground of being unrestricted by the cultural limitations of three Euclidean vectors of space or Aristotelian notions of linear time.

Artistic creations that issue from this level of being appear prophetic only because they occur within the context of a culture that denies the open timeless conditions of being itself. A prophet, then, does not look forward in time so much as expresses the condition of the spacetime continuum: that which is timeless. In spacetime the most ancient is intermingled with the most futuristic. For the prophet these two are one, since in the unified mythic realm of spacetime such distinctions as "past" and "future" are meaningless.

We eventually revere our prophets. While the Age of Reason glorified Kant, who correctly surmised that space and time were separate and distinct categories of experience, recently we have rediscovered the work of William Blake, who more prophetically than Kant, saw both as components of a unity. For Blake, time and space have no absolute existence: They are twin aspects of what he called "Eternity." In *Jerusalem* 49:21 he wrote that "the Visions of Eternity, by reason of narrowed perceptions, are become weak Visions of Time & Space." Einstein and Minkowski would wholeheartedly have agreed.

Relativity is such a radical idea that to understand its importance we have to blend phylogenetic evolution into the historical record of humankind. For the past three million years, right up to 1905, the right brain mapped space's three vectors and the left brain manipulated time's three states. Particularly in Western culture, time was distinct from space: New-

ton declared it so and Kant even proposed that both were "organs of perception." Kant could not have known in the late eighteenth century that mid-twentieth-century neuroscientists would confirm that, indeed, one hemisphere of the brain was better suited to handle the concept of space and the other the concept of time. When Einstein published his revolutionary special theory, he revealed the reciprocal relationship of these two coordinates. Minkowski then went on to merge space and time into the spacetime continuum. Einstein's and Minkowski's great revelations changed our world forever. According to Einstein and Minkowski, space and time are fused aspects of a higher unity that lies just beyond the reach of human perception. Confirming what the mystics had said for centuries, Einstein pole-vaulted us beyond a doubt into the next higher dimension. The belief in the separation of space and time is counterproductive if we are to assimilate his profound insight.

Three million years ago the human brain organized itself into a functional bicameral organ, whose purpose seems to have been to enhance the use of causality by keeping space and time strictly separate. In our era we have witnessed these two diametrically opposed coordinates merge. Einstein's revolutionary pronouncement was not only a triumph in the history of ideas: It also marked a crucial watershed on the much larger scale of biological evolution.

It has now been more than eighty years since Einstein and Minkowski revealed the interrelationships among space, time, and light. Despite indisputable proof of the existence of the spacetime continuum, there has been a dearth of speculations concerning what could possibly exist on this new plane, apart from Einstein's discovery that gravity is due to the curvature of spacetime in the fourth dimension. To revert to the anthill analogy once more, a creature that can perceive only space but not time lives in a severely constricted world. The addition of linear time to mammals' mental operations resulted in unique thoughts; and when a critical number of thoughts accumulated in this one species, Homo sapiens, something even more ephemeral emerged: the self-reflective mind, capable of comprehending both infinite space and eternal time. The discovery of a fourth dimension should be as momentous for our species as the introduction of the coordinate of time was to lower animals. By extrapolation, I propose that spacetime generates *universal mind*.

If the individual self-reflective mind *knows* that it *knows, universal mind* not only knows that it knows, but it also *knows everything, everywhere and anytime*. It is in a dimension where all durational stages merge so that they can be appreciated simultaneously, and at the speed of light,

separate locations in front and back fuse. *Universal mind* most likely manifests itself in our coordinate system as clairvoyance, and is known by the presence of certain individuals whom the rest of us, still bound by history, would dismiss as cranks and mountebanks. *Universal mind* would be the moving force behind our *zeitgeist*, speaking through the works of revolutionary, right-brained, intuitive artists first, and later through left-brained, visionary, rational physicists.

In 1926 Niels Bohr, a pioneer in quantum mechanics, proposed the theory of complementarity, a theory that could be used to fuse together some of the fractious elements of the new physics. His grand conception, ironically, had more to do with philosophy than with science. His original paper contained not a single equation and was published in a journal of philosophy. The broad, inviting arms of his concept allowed physicists as well as nonphysicists to begin to integrate the paradoxes of relativity and quantum mechanics. Bohr specifically addressed the paradox that light appears to be both wave and particle, but his theory can be applied equally well to the dichotomies of space/time, right/left, and art/physics. He appreciated that observer and observed are also a reciprocal indivisible pair, and proposed that there can be no such thing as objective reality. Combining any of these pairs creates a reciprocal duality that together form a seamless unity. According to Bohr, opposites are not always contradictions; rather, they may be complementary aspects of a higher truth. "The opposite of a correct statement is an incorrect one," Bohr once said, "but the opposite of a profound truth is another profound truth."[6]

One of Western civilization's most important accomplishments has been to separate the *out there* of objective reality from the *in here* of reflective thought. At the outset of the scientific method, Descartes declared that these two were disconnected and distinct phenomena, and in the ensuing centuries, science, the left brain's most aggressive agent, clarified the confusion that had been wrought by mingling them. The theory of complementarity, however, fuses the *out there* back together with the *in here*. Not only are the observer and the observed connected, but the connection is *not* classically causal: It is part of the new quantum thinking. In the words of another physicist, Erwin Schrödinger,

> . . . the reason why our sentient, percipient, and thinking ego is met nowhere in our world picture can easily be indicated in seven words: because it is ITSELF that world picture. It is identical with the whole and therefore cannot be contained in it as part of it.[7]

John Wheeler, Bohr's student, echoing this sentiment, proposed that *mind* and *universe* are also a complementary pair; since neither could exist without the other.

Einstein's union of space and time and Bohr's theory of complementarity have brought humans to the brink of a new way to think. Homo sapiens, the wise hominid with the split brain, will have to assimilate this new way of thinking in order to cross the threshold. Brain lateralization, which for three million years conveniently divided space from time, right from left, and more recently, art from physics, is no longer an effective way to deal with a world changed by Einstein's insight. As the mathematician Henri Poincaré wrote in 1914:

> Modern man has used cause-and-effect as ancient man used the
> gods to give order to the Universe. This is not because it was
> the truest system, but because it was the most convenient.[8]

To incorporate relativity and quantum mechanics into our mind-sets seems at first inconvenient but it has become imperative if we are to continue to evolve consciously. In order to take advantage of the new discoveries in the field of physics, we will have to begin integrating the two hemispheric functions. It will be a prodigious task: The gulf that divides the right hemisphere from the left in Western culture is very wide.

To illustrate the chasm separating the two, suppose that in every year of human history a Nobel Prize committee had granted an award for the outstanding artistic achievement as well as for the most meritorious scientific one. Since physics is derived from the Greek word for "nature," let us broaden the scope of the word "physicist" to include everyone who ever pondered the nature of *nature*, including Pythagoras, Plato, St. Augustine, Aquinas, Kant, Dalton, Darwin, and Freud.

Despite the numerous artistic titans and the many giants of science, the fact that leaps out of the historical record is how rarely anyone would have ever qualified for *both* awards. While there have been artists who dabbled in science and physicists who displayed an artistic bent, there are very few who were able to make an outstanding contribution to both fields.

Upon reflection, one name stands out high above all the others: Leonardo da Vinci. His many inventions and investigations in diverse areas of science would guarantee him not one but several nominations for the prize. At the same time, his artistic legacy is such that he would doubtless have become a Nobel Laureate in this category as well. How odd that in all of recorded civilization only one person could lay clear-cut claim to both prizes. It

speaks to the sharp divisions in our culture between art and physics, contemplation and concentration, right and left hemispheres, space and time, and Dionysus and Apollo that we have produced only this one indisputable example of the total integration of creativity's dual aspects at such exemplary levels. The existence of even this one individual, however, points the way to the possibility and the importance of healing the artificial rift between these two sides. Somehow Leonardo merged the processes of seeing and thinking, and the profusion of images and insights that emerged from that cross-fertilization was cornucopian.

Leonardo must have been born with some very peculiar wiring in his brain. We know several startling things about his mental faculties, the most striking of which was that he was ambidextrous and could write with equal facility forward and backward (mirror writing). These same features are found in people with dyslexia, a cognitive syndrome in which the letters *b* and *d* and *p* and *q* are frequently transposed. Neuroscientists now theorize that dyslexia may be due to a failure of brain dominance.[9] In the dyslexic child, both hemispheres have nearly equal responsibility for the generation and understanding of speech, written language, and hand dominance, instead of the conventional arrangement in which hand preference and the preponderance of speech centers lie in the dominant lobe. Although today dyslexia is generally considered a learning disability, Leonardo apparently used it to range back and forth between two different mental processes, one rooted in space, the other in time. In this way he achieved a depth of understanding about this world that has rarely, if ever, been equaled.

I propose it was the equality of Leonardo's hemispheres that enabled this dual man to perceive space and time differently from any artist before him. As we saw in Chapter 4, Leonardo elevated the artistic practice of sfumato to its apogee. It was his vision of deep space and the way atmospheric conditions changed distant light that revealed the subtleties of *depth* to all viewers of his art. This feature of reality had previously gone unnoticed by artists or anybody else.

In the most famous painting in the world, his *Mona Lisa*, Leonardo imbued this obscure young woman with an eternal aura of mystery. A significant part of her inscrutable countenance lies just at the edges of the viewer's perception, for on either side of her head Leonardo created different distant landscapes that do not coincide: One is painted in a perspective that makes it closer than the other. While few people are consciously aware of this slight difference in the third dimension of depth, it is not unperceived by the viewer's eye, and this paradox of space heightens the enigmatic quality of the *Mona Lisa*'s smile.

Leonardo's ability to perceive time was also most unusual. He observed and recorded in his drawings the complex sequence of pigeons' wings fluttering in flight, as well as the patterns made by fast-flowing water. It was not until time-lapse photography was invented three hundred years after he worked that anyone else could slow down these visual blurs, and then the studies photographers made confirmed what Leonardo had seen. He alone, among all the world's artists, was able to see time in slow motion, to delay its passage so as to observe the sequence of flight or the pattern of rivulets, and capture in a still frame these incredibly complex whorls and eddies. This trait is so unique that I surmise it is also related to the nondominance of his hemispheres, which allowed him to envision time as an *all-at-once* phenomenon, rather than perceive it in the conventional *one-at-a-time* sequence.

Further evidence that Leonardo's time sense was different from other people's is his reputation for procrastination. In one case, Leonardo set an all-time record for time elapsed between accepting a commission and delivering the finished painting—twenty-three years![10] In another, Pope Leo X commissioned Leonardo to paint any subject he wished. Absorbed as always in technical matters, Leonardo started to compound a special varnish for the finish of the unpainted picture. The pope, checking on the progress of his commission, threw up his hands in disgust and exploded, "This man will never accomplish anything! He thinks about finishing the work before he even starts it!"[11] If Leonardo did not envision time as a linear sequence running from beginning to end, perhaps for him the end was the same as the beginning. Aware of his unusual ability to see time *all-at-once*, he once remarked,

> We know well that sight, through rapid observation, discovers in one glance an infinity of forms; nonetheless, it can only take in one thing at a time.[12]

Although he lived more than four hundred years ago, the achievements of Leonardo continue to fascinate a populace that still operates primarily out of either one or the other side of the psyche. In *The Innocent Eye*, Roger Shattuck reports that for a stretch of fifty years—from 1869 to 1919, a time characterized by a burst of artistic and scientific creativity in the West—there was an average of one full-length book per year published on the subject of Leonardo—more than about any other individual.[13] This literary outpouring came from such diverse authors as Bernard Berenson, Jakob Burckhardt, Sigmund Freud, and Paul Valéry, to mention but a few.

The number of books still being published about the life and work of this phenomenal artist/scientist suggests that his combination of artistic humanism and scientific curiosity continues to hold us in a riveting awe.

If Leonardo could integrate the two halves of his divided psyche, then how might the rest of us learn to do so? Perhaps the answer lies with the synthesis of art and physics. Once these two endeavors can be seen as being inextricably linked, the ensuing reinforcement across the corpus callosum between the right and left hemispheres will enrich all who are able to see one in the terms of the other. To appreciate more fully why the full integration of the views from each hemisphere will enhance a new way to see and think, I offer the following analogy.

One of the most compelling features of our sensory apparatus occurs as the result of the quirk of overlapping fields. When a paired sense such as vision or hearing appreciates the same perception from two slightly different positions in space, something unique emerges. For instance, since both our eyes face forward, we see essentially the same picture with each eye at any given moment, but because the distance between the skeletal orbits of the two eyeballs is minimal, each retina registers its impression from a slightly offset point of view.

When we view an object with one eye, we perceive only two vectors of space: perpendicular height and horizontal length. However, when we open our second eye, we provide our brain with information from a slightly different angle. Somewhere within the matrix of the visual cortex, the brain overlaps the information from these two angles to create, almost magically, the third dimension of depth.

Our brains operate in the same sort of way with our hearing. Each of our ears listens to the same sounds; however, each takes in auditory information from a different point in space. Again, this distance between our ears, though small, is enough to create a third dimension of sound that we perceive as depth. Everyone knows this who has listened to music through a pair of stereophonic earphones and heard the sound as if it emanated from a point directly above the head. This occurs even though the listener *knows* that the sound from each speaker is entering each ear on the head's opposite sides.

We can also discover a new dimension when we attempt to understand art and physics in terms of each other. Our language certainly recognizes this, which is why, when we say a person is "well-rounded," or that he "has depth," we commonly mean he can see the world through the different lenses of art and science and, by integrating these perspectives, arrive at a *deeper* understanding of reality. These colloquial expressions indicate

that, unconsciously, we realize that someone who has the ability to knit together two basically different hemispheric points of view is richer for it. We refer to them in words evocative of depth—"multifaceted" or "multi-dimensional." Art and physics also offer overlapping viewpoints of the same thing: Some call it nature; others call it reality. It is the milieu within which we exist. Adopting a stance in *both* art and physics allows us to see it in the full glory of three dimensions and understand its existence in an extended *now*. The synthesis will produce a heightened awareness and appreciation of the world we live in. Meister Eckhardt, the medieval mystic, wrote:

"When is a man in mere understanding?" I answer, "When he sees one thing separate from another." And when is a man above mere understanding? That I can tell you: "When a man sees All in all, then a man stands beyond mere understanding."[14]

In *A Bar at the Folies-Bergère* (1882) (Figure 29.1), Édouard Manet captured the essence of the complementarity of space and time. The painting was Manet's final statement, executed when he was sick and often suffering from pain and exhaustion. Because he was ill and the critics by then were accustomed to his enigmatic paintings, much of the strangeness of this work has been attributed to his elegiac mood. However, this work anticipated the future. Manet, the artist who heralded the arrival of modern art, introduced into one canvas the theory of complementarity—forty-five years before Bohr—and the key features of the special theory of relativity twenty-four years before Einstein.

In this painting, an unemotional young barmaid stands before a mirror that reflects the world Manet knew so well—the ebullient crowd at the Folies-Bergère. Although Manet is remembered as the artist who introduced flattening of perspective, this particular painting impresses the viewer with its sense of deep space. To peer into Manet's mirror is to look through the window of the universe. Reflected in it is a distant crowd that becomes less and less distinct as it shades off into the distance. There appears to be no limiting back wall at this Folies, but rather a horizon line composed of humanity merging with a hazy, infinite space, creating a profound sense of depth. A chandelier of sparkling lights hovers above the heads of the crowd, seemingly unattached to any ceiling and resembling nothing so much as a galaxy of stars. The chandelier, in conjunction with the other twinkling dots and circular orbs of white light of various sizes, equally without apparent connection to the ceiling, contributes to the disturbing

Figure 29.1. *Édouard Manet,* A Bar at the Folies-Bergère *(1882)* COURTAULD
INSTITUTE GALLERIES, LONDON, COURTAULD COLLECTION

impression that we, the viewers, are not looking through a mirror at all,
but are gazing instead out into a clear nighttime sky.

To add to this illusion, Manet has pulled the rug out from under the
viewer, for there does not appear to be any floor under or in front of the
bar. With emptiness above them as well as below them, the sea of people
reflected in the mirror appear suspended in space. The pair of disembodied
legs dangling from what appears to be a trapeze in the upper left-hand
corner adds to the painting's sense of zero gravity's weightlessness. To look
beyond the barmaid is to see into the vistas of the cosmos.

Further study of his work reveals another very strange construction. In
the mirror, the barmaid's back can be seen reflected off to the right, where
she is engaged in conversation with a patron. Furthermore, where we see
the barmaid off to the right side, she is leaning forward as if engaging the
patron, whereas in the main frontal view she is erect. Yet, we should not
be able to have any full, unobstructed architectonic frontal view of the
barmaid if there is a man standing in front of her. Since in one view he

is absent, and in the second he is present, the painting has the appearance of a double exposure.

In fact, Manet represented the bar at the Folies-Bergère from two different angles. Each view contains information that cannot be found in the alternative view. Manet introduces the notion of the same scene as seen from two separated points in space, and also the same scene as imagined in two different moments in time. This profound artistic insight prefigures Einstein's and Bohr's imperative: that we will have to combine two opposing aspects of reality in order to go forward with our understanding of the universe.

The evolutionary consequences of splitting the brain into two separate minds were manifold. First, the division gave us access to the twin coordinates of space and time. This led to a heightened intuitive and intellectual capacity that enabled Einstein, three million years later, to discover that space and time are not really separate, but are, in fact, at a higher level of abstraction—one. To understand his insight we must reunite the two hemispheric viewpoints in a unity as well. One place to begin this process is at the junction of art and physics. The right and left hemispheres, the rods and cones, and art and physics all provide complementary views of reality. Our synthesis of these pairs not only deepens our understanding of each and both, but also adds a new dimension to the mind generating energy for *universal mind*.

The Romans introduced a male god, Janus, who had no Greek antecedent. I suspect that Techne and Janus are closely related. In mythology, Janus is the two-faced god. I propose that we, each of us, must become like Janus. He occupies the space of a threshold and looks both forward and back in a single moment in time, noting what has passed, and what is becoming. From the core of the past to the edge of the future, Janus scans two views in space and time simultaneously. If we think of one face as art and the other as physics, these two perspectives invite us to change the way we see and consider the world. Seemingly divergent in the direction of their visions, the artist and the physicist limn for us revisions of reality.

NOTES

CHAPTER 1

Epigraph 1. James Baldwin, *Creative Process* (New York: Ridge Press, 1962), p. 17.

Epigraph 2. P. Buckley and F. D. Peat, eds., *A Question of Physics: Conversations in Physics and Biology* (New York: Routledge & Kegan Paul, 1979), p. 129.

1. David Piper, ed., *Random House History of Painting and Sculpture* (New York: Random House, 1981), p. 95.
2. James Gibbons Huneker, *Pathos of Distance* (New York: Scribners, 1913), p. 33.
3. Rainer Maria Rilke, *Letters of Cézanne* (New York: Fromm International, 1985), p. vii.
4. Émile Zola, *Mes Haines* (1701; reprint, Paris and Geneva: Slatkin Reprint, 1979).
5. Alfred Appel, "An Interview with Nabokov," *Wisconsin Studies in Contemporary Literature* 8 (Spring 1967): 140–41.
6. John Russell, *The Meanings of Modern Art* (New York: Harper & Row, 1974), p. 271.
7. Robert Hughes, *The Shock of the New* (New York: Alfred A. Knopf, 1980), p. 366.
8. Marshall McLuhan, *Understanding Media: The Extensions of Man* (New York: New American Library, 1964), p. 71.
9. Werner Heisenberg, *Physics and Beyond* (New York: Harper & Brothers, 1958), p. 130.
10. Russell, *Meanings of Modern Art*, p. 371.
11. Alfred North Whitehead, *Adventures of Ideas* (London: Collier Macmillan, 1933), p. 241.
12. Paul Davies, *God and the New Physics* (New York: Simon & Schuster, 1983), p. 112.
13. Werner Heisenberg, *Physics and Philosophy* (New York: Harper & Brothers, 1958), p. 102.

CHAPTER 2

Epigraph 1. Euclid, *The Thirteen Books of the Elements* (New York: Dover, 1956), p. 153.

Epigraph 2. Aristotle, *The Pocket Aristotle*, ed. Justin D. Kaplan (New York: Simon & Schuster, 1958), p. 23.

1. Harold Innis, *Empire and Communications* (Oxford: Clarendon Press, 1950), pp. 25, 50, 115.

2. Marshall McLuhan and Quentin Fiore, *The Medium Is the Massage* (New York: Bantam, 1967), p. 160.
3. Marshall McLuhan, *The Gutenberg Galaxy* (Toronto: University of Toronto Press, 1965), p. 58.
4. Jan Lukasiegiez, *Aristotle's Syllogistic* (Oxford: Oxford University Press, 1928), p. 15.
5. John White, *The Birth and Rebirth of Pictorial Space* (Cambridge: Belknap Press, 1987), p. 237.
6. José Argüelles, *The Transformative Vision* (Boulder: Shambhala, 1975), p. 51.
7. Paul C. Vitz and Arnold B. Glimcher, *Modern Art and Modern Science* (New York: Praeger, 1984), p. 183.
8. John Onians, *Art and Thought in the Hellenistic Age* (London: Thames & Hudson, 1979), p. 115.
9. Aristotle, *Pocket Aristotle*, p. 92.
10. Onians, *Art and Thought*, p. 115.

CHAPTER 3

Epigraph. Stephen Toulmin and June Goodfield, *The Fabric of the Heavens* (New York: Harper & Row, 1961), p. 148.
1. Thomas Goldstein, *Dawn of Modern Science* (Boston: Houghton Mifflin, 1988), p. 57.
2. Mircea Eliade, *The Sacred and the Profane: The Nature of Religion*, trans. Willard Ropes Trask (New York: Harcourt Brace, and World, 1959), p. 51.
3. Kenneth Clark, *Civilisation* (New York: Harper & Row, 1969), p. 17.
4. José Argüelles, *The Transformative Vision* (Boulder: Shambhala, 1975), p. 53.
5. Giorgio Vasari, *Lives of the Artists*, trans. George Bull (Middlesex, Eng.: Penguin, 1965). pp. 36–37.
6. Gyorgy Kepes, *Language of Vision* (Chicago: Paul Theobalk, 1939), p. 96.
7. Georges Poulet, *Studies in Human Time*, trans. E. Coleman (Baltimore: Johns Hopkins University Press, 1956), p. 7.
8. Marshall McLuhan, *The Gutenberg Galaxy* (Toronto: University of Toronto Press, 1962), p. 105.
9. Otto von Simson, *The Gothic Cathedral* (London: Routledge & Kegan Paul, 1956), pp. 3–4.

CHAPTER 4

Epigraph 1. Ernst H. Gombrich, *Art and Illusion* (Princeton: Princeton University Press, 1956), p. 61.
Epigraph 2. Jefferson Hane Weaver, *Physics* (New York: Simon & Schuster, 1987), vol. 1, p. 455.
1. Giorgio Vasari, *Lives of the Artists*, trans. George Bull (Middlesex, Eng.: Penguin, 1965), p. 57.
2. Ibid., pp. 64–65.
3. Stephen Toulmin and June Goodfield, *The Architecture of Matter* (Chicago: University of Chicago Press, 1962), p. 215.

4. William M. Ivins, Jr., *Art and Geometry: A Study in Space Intuitions* (New York: Dover, 1946), p. 41.

5. John Russell, *The Meanings of Modern Art* (New York: Harper & Row, 1974), p. 31.

6. José Argüelles, *The Transformative Vision* (Boulder: Shambhala, 1975), p. 34.

7. Ernst H. Gombrich, *The Story of Art* (Oxford: Phaidon, 1972), p. 195.

8. Kenneth Clark, *Civilisation* (New York: Harper & Row, 1969), p. 87.

9. Timothy Ferris, *Coming of Age in the Milky Way* (New York: William Morrow, 1988), p. 43.

10. Jacob Bronowski, *The Ascent of Man* (Boston: Little, Brown, 1973), p. 197.

11. Will and Ariel Durant, *The Age of Reason* (New York: Simon & Schuster, 1961), p. 612.

CHAPTER 5

Epigraph 1. Leon Battista Alberti, *On Painting*, trans. John R. Spencer (New Haven: Yale University Press, 1956), p. 1.
Epigraph 2. Timothy Ferris, *Coming of Age in the Milky Way* (New York: William Morrow, 1988), p. 79.

1. Stephen Toulmin and June Goodfield, *The Fabric of the Heavens* (New York: Harper & Row, 1961), p. 247.

2. Edgar Allan Poe, "Eureka: An Essay on the Material and Spiritual Universe" in *Eureka: A Prose Poem,* ed. Richard P. Benton (Hartford: Transcendental Books, 1973), p. 48.

CHAPTER 6

Epigraph 1. Robert Wallace, *The World of Leonardo* (New York: Times Books, 1966), p. 104.
Epigraph 2. Sir Isaac Newton, *Principia: The System of the World*, trans. Andrew Motte (Berkeley: University of California Press, 1934), vol. 2, p. 398.

1. Alexander Pope, *The Complete Poetical Works of Alexander Pope*, ed. Aubrey Williams (Boston: Houghton Mifflin, 1969), p. 135.

2. Newton, *Principia*, vol. 2, p. 419.

3. Ibid., vol. 1, p. 6.

4. Ibid.

5. Timothy Ferris, *Coming of Age in the Milky Way* (New York: William Morrow, 1988), p. 107.

6. Wallace, *World of Leonardo*, p. 12.

7. Ibid., p. 58.

8. Newton, *Principia*, vol. 1, p. xvii.

9. Wallace, *World of Leonardo*, p. 107.

10. Newton, *Principia*, vol. 1, p. 13.

11. Wallace, *World of Leonardo*, p. 107.

12. Ibid., p. 175.

13. Newton, *Principia*, vol. 1, p. xvii.

14. Domenico Argentieri, *Leonardo Da Vinci* (New York: Reynal & Company/William Morrow), p. 405.

15. José Argüelles, *The Transformative Vision* (Boulder: Shambhala, 1975), p. 22.
16. Ernst Gombrich, *Art and Illusion* (Princeton: Princeton University Press, 1956), p. 188.
17. John Maynard Keynes, "Newton, the Man" in *Newton Tercentenary Celebrations* (Cambridge: Cambridge University Press, 1947), p. 5.
18. Wallace, *World of Leonardo*, p. 101.
19. Richard J. Westfall, *Never at Rest: A Biography of Isaac Newton* (Cambridge: Cambridge University Press, 1980), p. 764.
20. Wallace, *World of Leonardo*, p. 76.
21. Ibid., p. 11.
22. Ferris, *Coming of Age in the Milky Way*, p. 119.
23. Jefferson Hane Weaver, *The World of Physics* (New York: Simon & Schuster, 1987), vol. 1, p. 482.

CHAPTER 7

Epigraph 1. Max Jammer, *Concepts of Space* (New York: Harper & Row, 1960), p. 136.
Epigraph 2. José Argüelles, *The Transformative Vision* (Boulder: Shambhala, 1975), p. 83.
1. Stephen Toulmin and June Goodfield, *The Architecture of Matter* (Chicago: University of Chicago Press, 1962), p. 166.
2. Pierre Descargues, *Perspective* (New York: Harry N. Abrams, 1976), p. 19.
3. Ernst H. Gombrich, *Art and Illusion* (Princeton: Princeton University Press, 1956), p. 33.
4. Sir Isaac Newton, *Principia: The System of the World*, trans. Andrew Motte (Berkeley: University of California Press, 1934), vol. 2, p. 547.
5. Jefferson Hane Weaver, *Physics* (New York: Simon & Schuster, 1987), vol. 2, p. 807.
6. Stephen Toulmin and June Goodfield, *The Discovery of Time* (Chicago: University of Chicago Press, 1965), p. 83.
7. Will Durant and Ariel Durant, *The Story of Philosophy* (New York: Simon & Schuster, 1926), p. 201.
8. John Locke, *An Essay Concerning Human Understanding* (abridged) in *Classics of Western Philosophy*, ed. Stephen M. Cahn (Indianapolis: Hackett, 1977).
9. Nick Herbert, *Quantum Reality* (Garden City, N.Y.: Anchor/Doubleday, 1985), p. 193.
10. Edward Harrison, *Masks of the Universe* (New York: Macmillan, 1985), p. 12.
11. David Hume, *A Treatise of Human Nature*, ed. Peter H. Nidditch (London: Oxford University Press, 1978), p. 252.
12. Durant and Durant, *Story of Philosophy*, p. 257.
13. Hume, *Treatise of Human Nature*, p. 282.
14. Bertrand Russell, *The ABC of Relativity* (New York: Mentor, 1985), p. 141.
15. David Hume, *An Enquiry Concerning Human Understanding*, ed. Eugene Freeman (La Salle, Ill.: Open Court, 1966), p. 184.
16. Durant and Durant, *Story of Philosophy*, p. 202.
17. Ibid., p. 201.
18. Hannah Arendt, *The Life of the Mind* (New York: Harcourt Brace Jovanovich, 1978), p. 201.

19. John Donne, *The Poems of John Donne*, ed. Herbert J. C. Grierson (Oxford: Oxford University Press, 1912), vol. 1, p. 237.
20. Alexander Pope, *Poetry and Prose of Alexander Pope*, ed. Aubrey William (Boston: Houghton Mifflin, 1969), p. 377.
21. Kenneth Clark, *Civilisation* (New York: Harper & Row, 1969), p. 274.
22. Timothy Ferris, *Coming of Age in the Milky Way* (New York: William Morrow, 1988), p. 122.
23. Harrison, *Masks of the Universe*, p. 154.
24. John Milton, *Paradise Lost and Selected Poetry and Prose*, ed. Northrop Frye (Toronto: Rinehart and Co., 1955), p. 207.
25. Stanley Kunitz, ed., *The Essential Blake* (New York: Ecco, 1987), p. 9.
26. Geoffrey Keynes, ed., *The Complete Writings of William Blake* (Oxford: Oxford University Press, 1966), pp. 150–52.
27. Ibid., p. 777.
28. Ibid., p. 150.
29. Ibid., p. 714.
30. Ibid., p. 776.
31. Ibid., p. 674.
32. Northrop Frye, *Fearful Symmetry* (Boston: Beacon, 1958), p. 411.
33. Keynes, *William Blake*, p. 431.
34. Frye, *Fearful Symmetry*, p. 46.
35. Keynes, *William Blake*, p. 154.
36. Frye, *Fearful Symmetry*, p. 50.
37. Keynes, *William Blake*, p. 445.
38. Ibid., p. 776.
39. Ibid., p. 621.

CHAPTER 8

Epigraph 1. T. S. Eliot, "Dante," 1929, paraphrased by George Steiner in an interview with Bill Moyers in the P.B.S. series *Bill Moyers' Journals*.
Epigraph 2. Marshall McLuhan, *Understanding Media: The Extensions of Man* (New York: New American Library, 1964), p.70.
1. José Argüelles, *The Transformative Vision* (Boulder: Shambhala, 1975), p. 117.
2. Robert Hughes, *The Shock of the New* (New York: Alfred A. Knopf, 1982), p. 399.
3. Georges Bataille, *Manet* (New York: Skira/Rizzoli, 1983), p. 64.
4. Paul C. Vitz and Arnold B. Glimcher, *Modern Art and Modern Science* (New York: Praeger, 1984), p. 49.
5. H. G. Wells, *The Time Machine and The Invisible Man* (New York: Signet, 1984), pp. 1–2.
6. Werner Haftmann, *On Painting in the Twentieth Century* (New York: Praeger, 1965), p. 35.
7. John Berger, *Ways of Seeing* (London: BBC, 1972), p. 31.
8. John Canaday, *Mainstreams of Modern Art* (New York: Simon & Schuster, 1959), p. 341.

CHAPTER 9

Epigraph 1. Jefferson Hane Weaver, *Physics* (New York: Simon & Schuster, 1987), vol. 1, p. 807.

Epigraph 2. Ibid., p. 78.

1. Abraham Pais, *Subtle Is the Lord: The Science and the Life of Albert Einstein* (Oxford: Oxford University Press, 1982), p. 113.
2. Timothy Ferris, *Coming of Age in the Milky Way* (New York: William Morrow, 1988), p. 190.
3. Paul Davies, *God and the New Physics* (New York: Simon & Schuster, 1983), p. 128.
4. Pais, *Subtle Is the Lord*, p. 152.
5. Edward Harrison, *Masks of the Universe* (New York: Macmillan, 1985), p. 150.
6. Alan J. Friedman and Carol C. Donley, *Einstein as Myth and Muse* (Cambridge: Cambridge University Press, 1985), p. 11.
7. Ibid., p. 59.
8. Pais, *Subtle Is the Lord*, p. 144.

CHAPTER 10

Epigraph 1. Max Delbrück, *Mind from Matter* (Palo Alto: Blackwell Scientific, 1986), p. 125.

Epigraph 2. Marshall McLuhan, *The Gutenberg Galaxy* (Toronto: University of Toronto Press, 1962), p. 23.

1. Jean Piaget, *Le Développement de la notion de temps chez l'enfant* (Paris: Presse Universitaire de France, 1946), pref.
2. José Argüelles, *The Transformative Vision* (Boulder: Shambhala, 1975), p. 167.
3. Ibid., p. 167.
4. Roger Shattuck, *The Innocent Eye* (New York: Washington Square Press, 1960), p. 345.
5. Marshall McLuhan, *Understanding Media: The Extensions of Man* (New York: New American Library, 1964), p. 216.
6. Jefferson Hane Weaver, *Physics* (New York: Simon & Schuster, 1987), vol. 3, p. 815.
7. Jacob Bronowski, *The Ascent of Man* (Boston: Little, Brown, 1973), p. 236.
8. Werner Haftmann, *On Painting in the Twentieth Century* (New York: Praeger, 1965), pp. 169–70.
9. Ibid., p. 169.
10. Ibid., p. 170.
11. Alexandrian, *Marcel Duchamp* (New York: Crown Publishers, 1977), p. 13.
12. Haftmann, *Painting in the Twentieth Century*, p. 244.
13. Anthony Phillip French, ed., *Einstein Centennial* (Cambridge: Harvard University Press, 1979), p. 143.

CHAPTER 11

Epigraph. John Canaday, *Mainstreams of Modern Art* (New York: Simon & Schuster, 1959), p. 340.

1. Edmund Snow Carpenter, *Eskimo* (Toronto: University of Toronto Press, 1960), pp. 66–67.
2. Marshall McLuhan, *Understanding Media: The Extensions of Man* (New York: New American Library, 1964), p. 251.

3. Ibid., p. 149.
4. Benjamin Lee Whorf, "An American Indian Model of the Universe," in *The Philosophy of Time*, ed. Richard M. Gale (Garden City, N.Y.: Doubleday, 1967), p. 378.
5. Robert Hughes, *The Shock of the New* (New York: Alfred A. Knopf, 1980), p. 24.
6. McLuhan, *Understanding Media*, p. 140.
7. Waldeman Bogoras, "Ideas of Space and Time in the Conception of Primitive Religion," *American Anthropologist* 27, no. 2 (April 1925): 205.

CHAPTER 12

Epigraph 1. Jefferson Hane Weaver, *The World of Physics* (New York: Simon & Schuster, 1987), Vol. 2, p. 197.
Epigraph 2. Carl G. Jung, "Psychological Commentary," in *The Tibetan Book of the Dead*, ed. W. Y. Evans-Wentz (London: Penguin, 1954), p. xxxviii.
1. H. W. Janson, *History of Art* (New York: Prentice-Hall and Harry N. Abrams, 1960), p. 546.
2. Ernst M. Gombrich, *The Story of Art* (Oxford: Phaidon Press, 1972), p. 108
3. Michael Crichton, *Jasper Johns* (New York: Harry N. Abrams, 1977), p. 91.

CHAPTER 13

Epigraph 1. Werner Haftmann, *On Painting in the Twentieth Century* (New York: Praeger, 1965), p. 78.
Epigraph 2. John Russell, *The Meanings of Modern Art* (New York: Harper & Row, 1974), p. 42.
1. John Canaday, *Mainstreams of Modern Art* (New York: Simon & Schuster, 1959), p. 405.
2. Barbara W. Tuchman, *A Distant Mirror* (New York: Alfred A. Knopf, 1978), p. 207.
3. Immanuel Kant, *The Critique of Judgment*, trans. James Creed Meredith (Oxford: Clarendon Press, 1952), p. 67.
4. Russell, *Meanings of Modern Art*, p. 46.
5. Ibid., p. 46.
6. Ernst H. Gombrich, *Art and Illusion: A Study in the Psychology of Pictorial Representation* (Princeton: Princeton University Press, 1960), p. 53.
7. Paul C. Vitz and Arnold B. Glimcher, *Modern Art and Modern Science* (New York: Praeger, 1984), p. 79.
8. Robert Hughes, *The Shock of the New* (New York: Alfred A. Knopf, 1980), p. 129.
9. Haftmann, *Painting in the Twentieth Century*, p. 39.
10. Ibid., p. 74.
11. Russell, *Meanings of Modern Art*, p. 39.
12. Canaday, *Mainstreams of Modern Art*, p. 353.
13. Haftmann, *Painting in the Twentieth Century*, p. 34.
14. Ibid., p. 71.
15. Timothy Ferris, *Coming of Age in the Milky Way* (New York: William Morrow, 1988), p. 164.
16. Ronald W. Clark, *Einstein: The Life and Times* (New York: Avon, 1971), p. 252.
17. Ernst H. Gombrich, *The Story of Art* (Oxford: Phaidon, 1972), p. 17
18. Haftmann, *Painting in the Twentieth Century*, p. 121.

19. Ibid., p. 136.

20. Abraham Pais, *Subtle Is the Lord: The Science and the Life of Albert Einstein* (Oxford: Oxford University Press, 1982), p. 103.

CHAPTER 14

Epigraph 1. José Argüelles, *The Transformative Vision* (Boulder: Shambhala, 1975), p. 181.

Epigraph 2. Norman Cousins, *The Human Adventure*, (Dallas: Saybrook, 1986), p. 98.

1. Georges Poulet, *Studies in Human Time*, trans. E. Coleman (Baltimore: Johns Hopkins University Press, 1956), p. 85.

2. Calvin Tomkins, *Off the Wall* (Middlesex, Eng.: Penguin, 1962), p. 118.

3. John Russell, *The Meanings of Modern Art* (New York: Harper & Row, 1974), p. 105.

4. Delo E. Mook and Thomas Vargish, *Inside Relativity* (Princeton: Princeton University Press, 1987), p. 123.

5. Hermann Weyl, *Philosophy of Mathematics and Natural Sciences* (New York: Atheneum, 1963), p. 116.

6. Paul C. Vitz and Arnold B. Glimcher, *Modern Art and Modern Science* (New York: Praeger, 1984), p. 73.

7. Russell, *Meanings of Modern Art*, p. 37.

8. Linda Dalrymple Henderson, *The Fourth Dimension and Non-Euclidian Geometry in Modern Art* (Princeton: Princeton University Press, 1983), p. 97.

9. E. A. Abbott, *Flatland: A Romance of Many Dimensions* (New York: Dover, 1952), p. 88.

10. Henderson, *Fourth Dimension*, p. 364.

11. Linda Dalrymple Henderson, "A New Facet of Cubism: 'The Fourth-Dimension' and 'Non-Euclidean Geometry' Reinterpreted," *Art Quarterly* 34 (1971): 417.

12. Sigfried Gideon, *Space, Time and Architecture: The Growth of a New Tradition* (Cambridge: Harvard University Press, 1941), p. 436.

13. Géza Szamosi, *The Twin Dimensions: Inventing Time and Space* (New York: McGraw-Hill, 1986), p. 227.

14. John Adkins Richardson, *Modern Art and Scientific Thought* (Urbana: University of Illinois Press, 1971), pp. 111–13.

15. Paul M. Laporte, "Cubism and Relativity (With a Letter of Albert Einstein)," *Art Journal* 25 (1966): 246.

16. Albert Einstein, *The World as I See It* (Secaucus, N.J.: Citadel, 1979), p. 10.

17. Abraham Pais, *Subtle Is the Lord: The Science and the Life of Albert Einstein* (Oxford: Oxford University Press, 1982), p. 16.

18. Alexander Pope, "An Essay on Criticism," in *The Complete Poetical Works of Alexander Pope*, ed. Aubrey Williams (Boston: Houghton Mifflin, 1969), p. 39.

CHAPTER 15

Epigraph 1. Linda Dalrymple Henderson, *The Fourth Dimension and Non-Euclidian Geometry in Modern Art* (Princeton: Princeton University Press, 1983), p. 284.

Epigraph 2. Calvin Tomkins, *The Bride and the Bachelors* (Middlesex, Eng.: Penguin, 1962), p. 31.

1. Robert Hughes, *The Shock of the New* (New York: Alfred A. Knopf, 1980), p. 43.
2. Ibid., p. 391.
3. John Russell, *The Meanings of Modern Art* (New York: Harper & Row, 1974), p. 149.
4. Werner Haftmann, *On Painting in the Twentieth Century* (New York: Praeger, 1965), p. 106.
5. John Canaday, *Mainstreams of Modern Art* (New York: Simon & Schuster, 1959), p. 471.
6. Haftmann, *Painting in the Twentieth Century*, p. 106.
7. Calvin Tomkins, *Bride and the Bachelors*, p. 22.
8. Ibid., p. 30.
9. Peter Selz, *Art in Our Times* (New York: E. P. Dutton, 1986), p. 141.
10. Rudy Rucker, *The Fourth Dimension* (Boston: Houghton Mifflin, 1984), p. 45.
11. Henderson, *Fourth Dimension*, p. 162.
12. Tomkins, *Bride and the Bachelors*, p. 48.
13. Ibid., p. 49.
14. Ibid., p. 44.
15. Ibid., p. 51.
16. Ibid., p. 51.
17. Henderson, *Fourth Dimension*, p. 150.

CHAPTER 16

Epigraph 1. Roger Shattuck, *The Innocent Eye* (New York: Washington Square Press, 1960), p. 335.
Epigraph 2. Robert Hughes, *The Shock of the New* (New York: Alfred A. Knopf, 1980), p. 221.
1. Subrahmanyan Chandrasekhar, *Eddington, The Most Distinguished Astrophysicist of His Time* (Cambridge: Cambridge University Press, 1983), p. 30.
2. David Piper, *The Random House Library of Painting and Sculpture* (New York: Random House, 1981), vol. 3, p. 174.
3. Hughes, *Shock of the New*, p. 192.
4. Shattuck, *Innocent Eye*, p. 64.
5. Marshall McLuhan, *Understanding Media: The Extensions of Man* (New York: New American Library, 1964), p. 46.
6. Hughes, *Shock of the New*, p. 69.
7. Harry Torczyner, *Magritte: Ideas and Images* (New York: Harry N. Abrams, 1977), p. 93.
8. Hughes, *Shock of the New*, p. 237.
9. Torczyner, *Magritte*, p. 81.
10. Ibid., p. 84.
11. Michel Foucault, *This Is Not a Pipe* (Berkeley: University of California Press, 1983), p. 9.
12. José Argüelles, *The Transformative Vision* (Boulder: Shambhala, 1975), p. 90.

CHAPTER 17

Epigraph 1. Calvin Tomkins, *Off the Wall* (Middlesex, Eng.: Penguin, 1962), p. 156.
Epigrpah 2. Gary Zukav, *The Dancing Wu Li Masters* (New York: William Morrow, 1979), p. 156.

1. Fritjof Capra, *The Tao of Physics* (Berkeley: Shambhala, 1975), p. 214.
2. José Argüelles, *The Transformative Vision* (Boulder: Shambhala, 1975), p. 253.
3. Peter Selz, *Art in Our Times* (New York: E. P. Dutton, 1986), p. 406.
4. Harold Rosenberg, *Barnett Newman: Broken Obelisk and Other Sculptures* (Seattle: University of Washington Press, 1971), p. 18.

CHAPTER 18

Epigraph 1. Jefferson Hane Weaver, *Physics* (New York: Simon & Schuster, 1987), vol 2, p. 804.
Epigraph 2. John Russell, *The Meanings of Modern Art* (New York: Harper & Row, 1974), p. 382.
1. Michael Crichton, *Jasper Johns* (New York: Harry N. Abrams, 1977), p. 28.
2. Ibid., p. 91.
3. Ibid., p. 19.
4. Ibid., p. 18.
5. Willoughby Sharp, "Luminism and Kineticism," in *Minimal Art: A Critical Anthology*, ed. Gregory Battcock (New York: E. P. Dutton, 1968), p. 321.
6. Calvin Tomkins, *Off the Wall* (Middlesex, Eng.: Penguin, 1962), p. 71.
7. Ibid.
8. Ibid., p. 86.
9. Tomkins, *Off the Wall*, p. 95.
10. Raymond Bernard Blakney, *Meister Eckhardt: A Modern Translation* (New York: Harper & Row, 1941), p. 76.
11. Tomkins, *Off the Wall*, p. 153.
12. Ibid.
13. Crichton, *Jasper Johns*, p. 46.

CHAPTER 19

Epigraph 1. Géza Szamosi, *The Twin Dimensions: Inventing Time and Space* (New York: McGraw-Hill, 1986), p. 232.
Epigraph 2. Will Durant and Ariel Durant, *The Story of Philosophy* (New York: Simon & Schuster, 1926), p. 304.
1. Lewis Thomas, *The Lives of a Cell* (New York: Viking Penguin, 1978), p. 25.
2. H. W. Janson and Joseph Kerman, *A History of Art and Music* (Englewood Cliffs, N.J.: Prentice-Hall, 1960), p. 214.
3. Carter Harman, *A Popular History of Music*, (New York: Dell, 1956), p. 198.
4. Janson and Kerman, *A History of Art and Music*, p. 219.
5. Ibid., p. 19.
6. Albert Einstein, *A Short History of Music* (New York: Vintage, 1954), p. 45.
7. Marshall McLuhan and Quentin Fiore, *The Medium Is the Massage* (New York: Bantam, 1967), p. 121.
8. Marshall McLuhan, *Understanding Media: The Extensions of Man* (New York: New American Library, 1964), p. 159.
9. Janson and Kerman, *A History of Art and Music*, p. 242.
10. Harman, *A Popular History of Music*, p. 198.
11. Ibid., p. 286.
12. Ibid., p. 293.

CHAPTER 20

Epigraph 1. Werner Heisenberg, *Physics and Philosophy* (New York: Harper & Brothers, 1958), p. 174.

Epigraph 2. e. e. cummings, *Selected Letters of e. e. cummings*, ed. Kenneth Burke (New York: Harcourt, Brace and World, 1969), p. 248.

1. Anthony Philip French, ed., *Einstein: A Centenary Volume* (Cambridge: Harvard University Press, 1979), p. 178.

2. Abraham Pais, *Subtle Is the Lord: The Science and the Life of Albert Einstein* (Oxford: Oxford University Press, 1982), p. 17.

3. Fyodor Dostoyevsky, *The Brothers Karamazov*, trans. Constance Garnett (New York: Vintage, 1955), p. 279.

4. Marshall McLuhan, *The Gutenberg Galaxy* (Toronto: University of Toronto Press, 1965), p. 61.

5. E. P. Goldschmidt, *Medieval Texts and Their First Appearance in Print* (Oxford: Oxford University Press, 1943), pp. 130–35.

6. McLuhan, *Gutenberg Galaxy*, p. 202.

7. Dom Jean Leclerq, *Love of Learning and the Desire for God*, trans. Catherine Misrahi (New York: Fordham University Press, 1961), p. 18.

8. McLuhan, *Gutenberg Galaxy*, p. 273.

9. Edgar Allan Poe, *Eureka: A Prose Poem*, ed. Richard P. Benton (Hartford: Transcendental Books, 1973), p. 117.

10. Jefferson Hane Weaver, *Physics* (New York: Simon & Schuster, 1987), vol. 1, p. 548.

11. Robert W. Weisberg, *Creativity: Genius and Other Myths* (New York: W. H. Freeman, 1986), p. 117.

12. Marcel Proust, *The Past Recaptured*, trans. Andreas Mayor (New York: Vintage, 1971), vol. 7, p. 272.

13. Gaston de Pawlowski, "Le Leviathan," *Comoedia*, 24 December 1909, p. 1.

14. Gaston de Pawlowski, "Voyage au pays de la quatrième dimension (1) L'Ame Silencieuse," *Comoedia*, 24 February 1912, p. 1.

15. James Joyce, *Finnegans Wake* (New York: Viking, 1939), p. 582.

16. Ibid.

CHAPTER 21

Epigraph 1. John Russell, *The Meanings of Modern Art* (New York: Harper & Row, 1974), p. 221.

Epigraph 2. Marshall McLuhan, *Understanding Media: The Extensions of Man* (New York: New American Library, 1964), p. xi.

1. Abraham Pais, *Subtle Is the Lord: The Science and the Life of Albert Einstein* (Oxford: Oxford University Press, 1982), pp. 14–15.

2. Robert Ardrey, *African Genesis* (New York: Bantam, 1961), p. 77.

3. Gary Zuckav, *The Dancing Wu Li Masters* (New York: William Morrow, 1979), p. 49.

4. Marshall McLuhan, *The Gutenberg Galaxy* (Toronto: University of Toronto Press, 1965), p. 42.

CHAPTER 22

Epigraph 1. Jefferson Hane Weaver, *Physics* (New York: Simon & Schuster, 1987), vol. 2, p. 263.

Epigraph 2. Lawrence Leshan, *The Medium, the Mystic and the Physicist* (New York: Viking, 1966), p. xix.

1. Nigel Calder, *Einstein's Universe* (New York: Penguin, 1980), p. 35.
2. Ibid.
3. Abraham Pais, *Subtle Is the Lord: The Science and the Life of Albert Einstein* (Oxford: Oxford University Press, 1982), p. 235.
4. Ibid., p. 239.
5. Calder, *Einstein's Universe*, p. 15.
6. Pais, *Subtle Is the Lord*, p. 179.
7. Ibid., p. 183.
8. Ibid., p. 163.
9. Gary Zuckav, *The Dancing Wu Li Masters* (New York: William Morrow, 1979), p. 49.
10. Ronald W. Clark, *Einstein: The Life and Times* (New York: Avon, 1971), p. 287.

CHAPTER 23

Epigraph 1. Friedrich Nietzsche, *The Portable Nietzsche*, ed. and trans. Walter Kaufmann (New York: Viking, 1982), p. 153.

Epigraph 2. Arthur Koestler, *The Act of Creation* (London: Pan, 1970), p. 253.

1. Robert Hughes, *The Shock of the New* (New York: Alfred A. Knopf, 1980), p. 273.
2. Nigel Calder, *Einstein's Universe* (New York: Penguin, 1980), p. 34.
3. Alan J. Friedman and Carol C. Donley, *Einstein as Myth and Muse* (Cambridge: Cambridge University Press, 1985), p. 63.
4. James Baldwin, *The Creative Process* (New York: Ridge Press, 1962), p. 32.
5. Stanley Kunitz, ed., *The Essential Blake* (New York: Ecco, 1987), p. 5.
6. Fred Wolf, *Taking the Quantum Leap* (San Francisco: Harper & Row, 1987), p. 100.
7. Edward Harrison, *Masks of the Universe* (New York: Macmillan, 1985), p. 167.
8. Ibid., p. 170.
9. Robert H. March, *Physics for Poets* (New York: McGraw-Hill, 1978), p. 149.
10. Harrison, *Masks of the Universe*, p. 167.
11. Stephen Hawking, *A Brief History of Time: From the Big Bang to Black Holes* (Toronto: Bantam, 1988), p. 143.

CHAPTER 24

Epigraph 1. Werner Heisenberg, *Physics and Philosophy* (New York: Harper & Brothers, 1958), p. 109.

1. Ad Reinhardt, *Art on Art*, ed. Barbara Rose (New York: Viking, 1975), pp. 82–83.
2. David Piper, *The Random House Library of Painting and Sculpture* (New York: Random House, 1981), vol. 1, p. 89.
3. Quote attributed by Rollo May, personal communication.
4. John Russell, *The Meanings of Modern Art* (New York: Harper & Row, 1974), p. 345.

5. Piper, *Random House Library*, vol. 1, p. 169.
6. Werner Haftmann, *On Painting in the Twentieth Century* (New York: Praeger, 1965), p. 195.
7. John Walker, *Art Since Pop* (Woodbury, N.Y.: Barrons, 1978), p. 25.

CHAPTER 25

Epigraph 1. Pierre Teilhard de Chardin, *Building the Earth* (New York: Discus Books, 1965), p. 23.
Epigraph 2. Rudy Rucker, *The Fourth Dimension* (Boston: Houghton Mifflin, 1984), p. 247.
1. Charles Sherrington, *The Integrative Action of the Nervous System* (Cambridge: Cambridge University Press, 1947), p. xvii.
2. William James, *The Varieties of Religious Experience: A Study in Human Nature* (London: Longmans, 1902), pp. 515–16.
3. William James, "The Confidences of a 'Psychical Researcher,' " *American Magazine* 68 (October 1909): 589.
4. Teilhard de Chardin, *Building the Earth*, p. 104.
5. Teilhard de Chardin, *Toward the Future*, trans. René Hague (New York: Harcourt Brace Jovanovich, 1975), pp. 90–91.

CHAPTER 26

Epigraph 1. Jakob Böehme, *Dialogue on the Supersensual Life*, trans. William Law et al. (New York: Ungar, 1957), p. 60.
Epigraph 2. Timothy Ferris, *Coming of Age in the Milky Way* (New York: William Morrow, 1988), p. 387.
1. Paul MacLean, "Brain Evolution Relating to Family, Play, and the Separation Call," *Archives of General Psychiatry* 42 (April 1985): 405–16.
2. Judith Hooper and Dick Teresi, *The 3-Pound Universe* (New York: Dell, 1986), p. 43.
3. Hannah Arendt, "On Thinking," *The New Yorker*, November 1977, p. 146.
4. John Russell, *The Meanings of Modern Art* (New York: Harper & Row, 1974), p. 287.
5. Robert E. Ornstein, *The Nature of Human Consciousness* (San Francisco: W. H. Freeman, 1968), p. 106.
6. Ibid., p. 104.
7. Ibid., p. 106.
8. Ibid.
9. Marshall McLuhan, *The Gutenberg Galaxy* (Toronto: University of Toronto Press, 1965), p. 40.
10. Doreen Kimura, "Cerebral Dominance and the Perception of Verbal Stimuli," *Canadian Journal of Psychology* 15, 3 (1961): 166–71.

CHAPTER 27

Epigraph 1. Max Delbrück, *Mind from Matter* (Palo Alto: Blackwell Scientific, 1986), p. 222.

Epigraph 2. William Blake, *The Complete Writings of William Blake*, ed. Geoffrey Keynes (Oxford: Oxford University Press, 1966), p. 614.

1. Robert Jastrow, *The Enchanted Loom*: *Mind in the Universe* (New York: Simon & Schuster, 1981), p. 53.
2. Paul MacLean, "Brain Evolution Relating to Family, Play, and the Separation Call," *Archives of General Psychiatry* 42 (April 1985): 411.
3. Ibid.
4. Jastrow, *The Enchanted Loom*, p. 54.
5. Ibid. p.33
6. Marshall McLuhan, *Understanding Media*: *The Extensions of Man* (New York: New American Library, 1964), p. 136.
7. Bruce Bowen, "A 'Handy' Guide to Primate Evolution," *Science News*, 7 January 1989, p. 10.
8. Jastrow, *The Enchanted Loom*, p. 61.

CHAPTER 28

Epigraph 1. Will Durant and Ariel Durant, *The Story of Philosophy* (New York: Simon & Schuster, 1926), p. 306.
Epigraph 2. Euripides, *Greek Tragedy: An Anthology*, ed. Albert Cook and Edwin Dolin (Dallas: Spring Publications, 1972), p. 364.

1. Joseph Campbell, *The Hero with a Thousand Faces* (Princeton: Princeton University Press, 1968), p. 3.
2. Aeschylus, *Prometheus Bound*, trans. Philip Vellacott (Middlesex, Eng.: Penguin, 1978), p. 34.
3. Robert Ardrey, *African Genesis* (New York: Bantam, 1961), p. 304.

CHAPTER 29

Epigraph 1. Pierre Teilhard de Chardin, *Toward the Future*, trans. René Hague (New York: Harcourt Brace Jovanovich, 1975), p. 90.
Epigraph 2. Marshall McLuhan, *Understanding Media*: *The Extensions of Man* (New York: New American Library, 1964), p. 71.

1. Abraham Pais, *Subtle Is the Lord*: *The Science and the Life of Albert Einstein* (Oxford: Oxford University Press, 1982), p. 131.
2. Lawrence Leshan, *The Medium, The Mystic and the Physicist* (New York: Viking, 1966), p. 70.
3. P. D. Ouspensky, *Tertium Organum*: *A Key to the Enigmas of the World* (New York: Vintage, 1970), pp. 161–62.
4. Lawrence Weizkrantz, ed., *Thought Without Language* (Oxford: Oxford University Press, 1988), p. 41.
5. Ibid., p. 73.
6. Werner Heisenberg, *Physics and Beyond*: *Encounters and Conversations* (New York: Harper & Row, 1971), p. 102.
7. R. Fischer, ed., *Interdisciplinary Perspectives on Time* (New York: New York Academy of Science, 1967), p. 16.
8. Leshan, *The Medium*, p. 85.
9. Frank R. Vellutino, "Dyslexia," *Scientific American* 256, 3 (March 1987): 34.

10. Douglas Mannering, *The Art of Leonardo da Vinci* (New York: Gallery Books, 1981), p. 32.
11. Giorgio Vasari, *Lives of the Artists*, ed. George Bull (Middlesex, Eng.: Penguin, 1965), p. 269.
12. Robert Wallace, *The World of Leonardo* (New York: Times Books, 1966), p. 171.
13. Roger Shattuck, *The Innocent Eye* (New York: Washington Square Press, 1960), p. 101.
14. Leshan, *The Medium*, p. 88.

BIBLIOGRAPHY

Abbott, E. A. *Flatland: A Romance of Many Dimensions*. New York: Dover, 1952.

Ades, Dawn. *Dali*. London: Thames & Hudson, 1982.

Aeschylus, *Prometheus Bound*, trans. Philip Vellacott, Middlesex, Eng.: Penguin, 1978.

Alberti, Leon Battista. *On Painting*. Translated by John R. Spencer. New Haven: Yale University Press, 1956.

Alexandrian. *Marcel Duchamp*. New York: Crown, 1977.

Ardrey, Robert. *African Genesis*. New York: Bantam, 1961.

Arendt, Hannah. *The Life of the Mind*. New York: Harcourt Brace Jovanovich, 1978.

Argüelles, José. *The Transformative Vision*. Boulder: Shambhala, 1975.

Aristotle. *The Pocket Aristotle*. Edited by Justin D. Kaplan. New York: Simon & Schuster, 1958.

Arnheim, Rudolph. *Art and Visual Perception*. Berkeley: University of California Press, 1954.

Baldwin, James. *The Creative Process*. New York: Ridge Press, 1962.

Bataille, Georges. *Manet*. New York: Skira/Rizzoli, 1983.

Battcock, Gregory, ed. *Minimal Art: A Critical Anthology*. New York: E. P. Dutton, 1968.

Berger, John. *Ways of Seeing*. London: BBC, 1972.

Bergson, Henri. *Creative Evolution*. Translated by E. Mitchell. New York: Macmillan, 1911.

Berkeley, George. *Three Dialogues Between Hylas and Philonous*. La Salle, Ill.: Open Court, 1959.

Berlin, Brant, and Paul Kay. *Basic Color Terms: Their Universality and Evolution*. Berkeley: University of California Press, 1969.

Blake, William. *The Selected Poetry of Blake*. Edited by David V. Erdman. New York: Meridian, 1976.

Blakney, Raymond Bernard. *Meister Eckhardt: A Modern Translation*. New York: Harper & Row, 1941.

Bool, F H. et al. *M. C. Escher: His Life and Graphic Works*. New York: Harry N. Abrams, 1981.

Boorstin, Daniel J. *The Discoverers: A History of Man's Search to Know His World and Himself*. New York: Random House, 1983.

Bowra, C. M. *The Greek Experience*. New York: World, 1959.

Brecht, Bertolt. *Galileo: A Play by Bertolt Brecht*. New York: Grove, 1966.

Bronowski, Jacob. *The Ascent of Man*. Boston: Little, Brown, 1973.

————. *The Visionary Eye: Essays in the Arts, Literature, and Science*. Cambridge, Mass: MIT, 1978.

Cachin, Françoise, and Charles Moffett. *Manet*. New York: Metropolitan Museum of Art and Harry N. Abrams, 1983.

Calder, Nigel. *Einstein's Universe*. New York: Penguin, 1980.

Campbell, Joseph. *The Hero with a Thousand Faces*. Princeton: Princeton University Press, 1949.

Canaday, John. *Mainstreams of Modern Art*. New York: Simon & Schuster, 1959.

Capra, Fritjof. *The Tao of Physics*. Berkeley: Shambhala, 1975.

Carpenter, Edmund Snow. *Eskimo*. Toronto: Toronto University Press, 1960.

Carroll, Lewis. *Alice's Adventures in Wonderland and Through the Looking Glass*. New York: Bantam, 1981.

Casmir, Hendrick B. G. *Haphazard Reality*. New York: Harper & Row, 1963.

Chandrasekhar, Subrahmanyan. *Eddington, The Most Distinguished Astrophysicist of His Time*. Cambridge: Cambridge University Press, 1983.

Chaucer, Geoffrey. *The Works of Geoffrey Chaucer*. Edited by I. N. Robinson. Boston: Houghton Mifflin, 1957.

Cherry, Colin. *On Human Communication: Review, a Survey, and a Criticism*. Cambridge, Mass.: MIT, 1957.

Chomsky, Noam. *Reflections on Language*. New York: Pantheon, 1975.

Clark, Kenneth. *Civilisation*. New York: Harper & Row, 1969.

————. *Leonardo da Vinci*. New York: Viking, 1980.

Clark, Ronald W. *Einstein: The Life and Times*. New York: Avon, 1971.

Cogniat, Raymond. *Braque*. New York: Crown, 1978.

Cook, Albert, and Edwin Dolin. *An Anthology of Greek Tragedy*. Dallas: Spring Publications, 1972.

Cousins, Norman. *The Human Adventure*. Dallas: Saybrook, 1986.

Crichton, Michael. *Jasper Johns*. New York: Harry N. Abrams, 1977.

cummings, e. e. "Letter to Kenneth Burke." In *Selected Letters of e. e. cummings*. Edited by F. W. Dupee and George Stade. New York: Harcourt, Brace & World, 1969.

Dampier, William Cecil. *A History of Science and Its Relations with Philosophy and Religion*. London: Cambridge University Press, 1949.

Dantzig, Tobias. *Number: The Language of Science*. New York: Free Press, 1930.

Davies, Paul. *God and the New Physics*. New York: Simon & Schuster, 1983.

Delbrück, Max. *Mind from Matter*. Palo Alto: Blackwell Scientific, 1986.

Descargues, Pierre. *Perspective*. New York: Harry N. Abrams, 1976.

Diehl, Gaston. *Picasso*. New York: Crown, 1977.

Donne, John. *The Poems of John Donne*. Edited by Herbert J. C. Grierson. Oxford: Oxford University Press, 1912.

Dorival, Bernard. *Cézanne*. Translated by H. H. A. Thackwaite. Boston: Boston Book and Art Shop, 1949.

Dostoyevsky, Fyodor. *The Brothers Karamazov*. Translated by Constance Garnett. New York: Vintage, 1955.

Drake, Stillman. *Galileo*. New York: Hill & Wang, 1980.

Durant, Will, and Ariel Durant. *The Story of Philosophy*. New York: Simon & Schuster, 1926.

————. *The Renaissance*. New York: Simon & Schuster, 1953.

Eddington, Sir Arthur. *Space, Time and Gravitation*. Cambridge: Cambridge University Press, 1920.

Einstein, Albert. *Short History of Music*. New York: Vintage, 1954.

————. *The World as I See It*. Secaucus, N.J.: Citadel, 1979.

————. *Sidelights on Relativity*. New York: Dover, 1983.

————, and Leopold Infeld. *The Evolution of Physics*. New York: Simon & Schuster, 1938.

Eliade, Mircea. *Myths, Dreams, and Mysteries*. New York: Harper & Row, 1957.

————. *The Sacred and the Profane: The Nature of Religion*. Translated by Willard Ropes Trask. New York: Harcourt, Brace & World, 1959.

Epstein, Lewis Carroll. *Relativity Visualized*. San Francisco: Insight Press, 1981.

Euclid. *The Thirteen Books of the Elements*. New York: Dover, 1956.

Ferris, Timothy. *Coming of Age in the Milky Way*. New York: William Morrow, 1988.

Fischer, R., ed. *Interdisciplinary Perspectives on Time*. New York: New York Academy of Science, 1967.

Flam, Jack D. *Matisse on Art*. New York: E.P. Dutton, 1973.

Foucault, Michel. *This Is Not a Pipe*. Berkeley: University of California Press, 1983.

Francis, Richard. *Jasper Johns*. New York: Abbeville, 1984.

Fraser, Julius Thomas, ed. *The Voices of Time*. Amherst: University of Massachusetts Press, 1981.

Frazer, Sir James George. *The Golden Bough*. London: Macmillan, 1960.

French, Anthony Philip, ed. *Einstein: A Centenary Volume*. Cambridge: Harvard University Press, 1979.

Freud, Sigmund. *Interpretation of Dreams*. New York: Macmillan, 1913.

————. *Leonardo da Vinci: A Study in Psychosexuality*. New York: Random House, 1947.

————. *Totem and Taboo*. London: Hogarth Press, 1953.

————. *Civilization and Its Discontents*. New York: Norton, 1984.

Friedman, Alan J., and Carol C. Donley. *Einstein as Myth and Muse*. Cambridge: Cambridge University Press, 1985.

Fry, Roger. *Vision and Design*. New York: Meridian, 1920.

Frye, Northrop. *Fearful Symmetry: A Study of William Blake*. Princeton: Princeton University Press, 1947

Galilei, Galileo. *Dialogue Concerning the Two Chief Systems of the World*. Translated by Stillman Drake. Berkeley: University of California Press, 1967.

Gazzaniga, Michael S. *The Social Brain*. New York: Basic Books, 1985.

————. *Mind Matters*. Boston: Houghton Mifflin, 1988.

Gerard, Max, ed. *Dali*. New York: Harry N. Abrams, 1968.

Gideon, Sigfried. *Space, Time and Architecture: The Growth of a New Tradition*. Cambridge: Harvard University Press, 1941.

Goldberg, Stanley. *Understanding Relativity: Origin and Impact of a Scientific Revolution*. Boston: Birkhäuser, 1984.

Goldschmidt, Ernst Philip. *Medieval Texts and Their First Appearance in Print*. Oxford: Oxford University Press, 1943.

Goldstein, Thomas. *Dawn of Modern Science*. Boston: Houghton Mifflin, 1988.

Gombrich, Ernest H. *Art and Illusion: A Study in the Psychology of Pictorial Representation*. Princeton: Princeton University Press, 1960.

————. *The Story of Art*. Oxford: Phaidon, 1972.

————, Julian Hochberg, and Max Black. *Art, Perception, and Reality*. Baltimore: Johns Hopkins University Press, 1972.

Haftmann, Werner. *On Painting in the Twentieth Century*. New York: Praeger, 1965.

Hamilton, Edith, *Mythology: Timeless Tales of Gods and Heroes*. New York: Mentor, 1940.

Harman, Carter. *A Popular History of Music*. New York: Dell, 1956.

Harmon, Peter Michael. *Energy, Force, and Matter: The Conceptual Development of Nineteenth-Century Physics*. Cambridge: Cambridge University Press, 1982.

Harris, Nathaniel. *The Art of Cézanne*. New York: Excalibur, 1982.

————. *The Art of Manet*. New York: Excalibur, 1982.

Harrison, Edward. *Masks of the Universe*. New York: Macmillan, 1985.

Hawking, Stephen W. *A Brief History of Time: From the Big Bang to Black Holes*. Toronto: Bantam, 1988.

Heisenberg, Werner, *Physics and Philosophy*. New York: Harper & Brothers, 1958.

————. *Physics and Beyond: Encounters and Conversations*. New York: Harper & Row, 1971.

Henderson, Linda Dalrymple. *The Fourth Dimension: Non-Euclidian Geometry in Modern Art*. Princeton: Princeton University Press, 1983.

Herbert, Nick. *Quantum Reality*. Garden City, N.Y.: Anchor/Doubleday, 1985.

Hilton, Timothy. *Picasso*. New York: Praeger, 1975.

Hofstadter, Douglas R. *Gödel, Escher, Bach: An Eternal Golden Braid*. New York: Basic Books, 1979.

Holldöbler, Bert, and Edward O. Wilson. *The Ants*. Cambridge: Harvard University Press, 1990.

Hooper, Judith, and Dick Teresi. *The 3-Pound Universe*. New York: Dell, 1986.

Hughes, Robert. *The Shock of the New*. New York: Alfred A. Knopf, 1980.

Hume, David. *An Enquiry Concerning Human Understanding*. Edited by Eugene Freeman. La Salle, Ill.: Open Court, 1966.

————. *A Treatise of Human Nature*. Edited by Peter H. Nidditch. London: Oxford University Press, 1978.

Huneker, James Gibbons. *Pathos of Distance*. New York: Scribner's, 1913.

Huyghe, René. *Van Gogh*. New York: Crown, 1979.

Innis, Harold. *Empire and Communications*. Oxford: Clarendon Press, 1950.

Ivins, William M., Jr. *Art and Geometry: A Study in Space Intuitions*. New York: Dover, 1946.

James, William. *The Varieties of Religious Experience: A Study in Human Nature*. London: Longmans, 1902.

————. *Pragmatism*. New York: World, 1907.

Janik, Allan, and Stephen Toulmin. *Wittgenstein's Vienna*. New York: Simon & Schuster, 1973.

Janson, H. W. *History of Art*. New York: Prentice-Hall and Harry N. Abrams, 1960.

————, and Joseph Denman. *A History of Art and Music*. New York: Prentice-Hall, 1960.

Jastrow, Robert. *The Enchanted Loom: Mind in the Universe*. New York: Simon & Schuster, 1981.

Jaynes, Julian. *The Origin of Consciousness in the Breakdown of the Bicameral Mind*. Boston: Houghton Mifflin, 1977.

Jones, Robert S. *Physics As Metaphor*. New York: Meridian, 1982.

Joyce, James. *Finnegans Wake*. New York: Viking, 1939.

Kandinsky, Wassily. *Point and Line to Plane*. New York: Dover, 1979.

Kant, Immanuel. *The Philosophy of Kant*. Edited and translated by Carl Joachim Friedrich. New York: Modern Library, 1949.

———. *The Critique of Judgment*. Translated by James Creed Meredith. Oxford: Clarendon Press, 1952.

———. *Prolegomena to any Future Metaphysics*. Translated by James W. Ellington. Indianapolis: Hackett, 1977.

Kaufmann, William J. III. *Stars and Nebulas*. San Francisco: W. H. Freeman, 1973.

———. *The Cosmic Frontiers of General Relativity*. Boston: Little, Brown, 1977.

———. *Black Holes and Warped Spacetime*. New York: W. H. Freeman, 1979.

Kepes, Gyorgy. *Language of Vision*. Chicago: Paul Theobalk, 1939.

Keynes, Geoffrey, ed. *Complete Writings of William Blake*. New York: Oxford University Press, 1989.

Keynes, John Maynard. "Newton, the Man." In *Newton Tercentenary Celebrations*. New York: Cambridge University Press, 1947.

Koestler, Arthur. *The Act of Creation*. London: Pan, 1970.

Komoda, Shusui, and Horst Pointer. *Ikebana Spirit and Technique*. London: Blanford, 1987.

Kuhn, Thomas S. *The Structure of Scientific Revolutions*. Chicago: University of Chicago Press, 1962.

Kunitz, Stanley. *The Essential Blake*. New York: Ecco, 1987.

Leshan, Lawrence. *The Medium, the Mystic and the Physicist*. New York: Viking, 1966.

Levey, Michael. *From Giotto to Cézanne: A Concise History of Painting*. London: Thames & Hudson, 1962.

Liaño, Ignacia Goméz de. *Dali*. New York: Rizzoli, 1984.

Lippard, Lucy R. *Pop Art*. New York: Praeger, 1966.

Locke, John. *An Essay Concerning Human Understanding*. Indianapolis: Hackett, 1977.

Lucie-Smith, Edward. *Art Now*. New York: William Morrow, 1981.

Lukasiegiez, Jan. *Aristotle's Syllogistic*. Oxford: Oxford University Press, 1928.

McLuhan, Marshall. *The Gutenberg Galaxy*. Toronto: University of Toronto Press, 1962.

———. *Understanding Media: The Extensions of Man*. New York: New American Library, 1964.

———, and Quentin Fiore. *The Medium Is the Massage*. New York: Bantam, 1967.

Mannering, Douglas. *The Art of Leonardo da Vinci*. New York: Gallery Books, 1981.

March, Robert. H. *Physics for Poets*. New York: McGraw-Hill, 1978.

Masanobu, Kudo. *The History of Ikebana*. Tokyo: Shufunotuma, 1986.

Miller, George A. *Language and Speech*. San Francisco: W. H. Freeman, 1981.

Milton, John. *Paradise Lost and Selected Poetry and Prose*. Edited by Northrop Frye. Toronto: Rinehart & Co., 1955.

Mook, Delo E., and Thomas Vargish. *Inside Relativity*. Princeton: Princeton University Press, 1987.

Newton, Sir Isaac. *Principia: The System of the World*. Translated by Andrew Motte. Berkeley: University of California Press, 1934.

———. *Opticks*. New York: Dover, 1952.

Nietzsche, Friedrich Wilhelm. *The Portable Nietzsche*. Edited and translated by Walter Kaufmann. New York: Viking, 1982.

Onians, John. *Art and Thought in the Hellenistic Age*. London: Thames & Hudson, 1979.

Ornstein, Robert E. *The Nature of Human Consciousness*. San Francisco: W. H. Freeman, 1968.

Otto, Walter F. *Dionysus: Myth and Cult*. Dallas: Spring Publications, 1965.

Ouspensky, P. D. *Tertium Organum: A Key to the Enigmas of the World*. New York: Vintage, 1970.

Pagels, Heinz R. *The Cosmic Code*. Toronto: Bantam, 1982.

Pais, Abraham. *Subtle Is the Lord: The Science and the Life of Albert Einstein*. Oxford: Oxford University Press, 1982.

Palmer, Donald. *Looking at Philosophy: The Unbearable Heaviness of Philosophy Made Light*. Mountain View, Calif.: Mayfield, 1988.

Panofsky, Erwin. *Meaning in the Visual Arts*. New York: Harper & Row, 1962.

Penfield, Wilder. *The Mystery of the Mind*. Princeton: Princeton University Press, 1971.

Piaget, Jean. *Le Dévloppement de la notion de temps chez l'enfant*. Paris: Presse Universitaire de France, 1946.

Piper, David, ed. *Random House History of Painting and Sculpture*. New York: Random House, 1981.

Plato. *The Republic*. Translated by Desmond Lee. London: Penguin, 1987.

Poe, Edgar Allan. *Eureka: A Prose Poem*. Edited by Richard P. Benton. Hartford: Transcendental Books, 1973.

Pope, Alexander. *The Complete Poetical Works of Pope*, edited by Aubrey Williams Cambridge: Houghton Mifflin, 1931.

———. *Poetry and Prose of Alexander Pope*. Edited by Aubrey Williams. Boston: Houghton Mifflin, 1969.

Poulet, Georges. *Studies in Human Time*. Translated by E. Coleman. Baltimore: Johns Hopkins University Press, 1956.

Proust, Marcel. *The Past Recaptured*. Translated by Andreas Mayor. New York: Vintage, 1971.

Raine, Kathleen. *William Blake*. New York: Oxford University Press, 1970.

Read, Herbert. *Modern Sculpture*. London: Thames & Hudson, 1964.

———. *Icon and Idea*. New York: Schocken, 1965.

Reinhardt, Ad. *Art on Art*. Edited by Barbara Rose. New York: Viking, 1975.

Richardson, John Adkins. *Modern Art and Scientific Thought*. Urbana: University of Illinois Press, 1971.

Richter, Hans. *Dada Art and Anti-Art*. New York: Oxford University Press, 1965.

Rilke, Rainer Maria. *Letters on Cézanne*. Translated by Joel Agee. New York: Fromm International, 1985.

Rodin, Auguste. *Rodin on Art and Artists*. Translated by Mrs. Romilly Fedden. New York: Dover, 1983.

Rosenberg, Harold. *Barnett Newman: Broken Obelisk and Other Sculptures*. Seattle: University of Washington Press, 1971.

———. *The Definition of Art*. Chicago: University of Chicago Press, 1972.

Rossotti, Hazel. *Colour: Why the World Isn't Grey*. Princeton: Princeton University Press, 1983.

Roth, John K. *The Moral Philosophy of William James*. New York: Thomas Y. Crowell, 1969.

Rubin, William, ed. *Pablo Picasso: A Retrospective*. New York: The Museum of Modern Art, 1980.

Rucker, Rudy. *The Fourth Dimension*. Boston: Houghton Mifflin, 1984.

Russell, Bertrand. *The ABC of Relativity*. New York: Merton, 1985.

Russell, John. *The Meanings of Modern Art*. New York: Harper & Row, 1974.

St. Augustine. *City of God*. Garden City, N.Y.: Anchor/Doubleday, 1958.

Sapir, Edward. *Selected Writings in Language, Culture and Personality*. Berkeley: University of California Press, 1958.

Schwartz, Joseph, and Michael McGuinness. *Einstein for Beginners*. New York: Pantheon, 1979.

Selz, Peter. *Art in Our Times*. New York: Harcourt Brace Jovanovich, 1981.

Shattuck, Roger. *The Innocent Eye*. New York: Washington Square Press, 1960.

Shone, Richard. *Manet*. New York: Park South Books, 1978.

Stace, Walter Terence. *The Teachings of the Mystics*. New York: Mentor, 1969.

Szamosi, Géza. *The Twin Dimensions: Inventing Time and Space*. New York: McGraw-Hill, 1986.

Taillandier, Yvon. *Cézanne*. New York: Crown, 1979.

———. *Claude Monet*. New York: Crown, 1982.

Teilhard de Chardin, Pierre. *The Phenomenon of Man*. New York: Harper & Row, 1959.

———. *Building the Earth*. New York: Discus Books, 1965.

———. *Toward the Future*. Translated by Réne Hague. New York: Harcourt Brace Jovanovich, 1975.

Thomas, Lewis. *The Lives of a Cell*. New York: Viking Penguin, 1978.

Tomkins, Calvin. *The Bride and the Bachelors*. Middlesex, Eng.: Penguin, 1962.

———. *Off the Wall*. Middlesex, Eng.: Penguin, 1980.

Torczyner, Harry. *Magritte: Ideas and Images*. New York: Harry N. Abrams, 1977.

Toulmin, Stephen, and June Goodfield. *The Fabric of the Heavens*. New York: Harper & Row, 1961.

———. *The Architecture of Matter*. Chicago: University of Chicago Press, 1962.

———. *The Discovery of Time*. Chicago: University of Chicago Press, 1965.

Tuchman, Barbara W. *A Distant Mirror*. New York: Alfred A. Knopf, 1978.

Vasari, Giorgio. *Lives of the Artists*. Translated by George Bull. Middlesex, Eng.: Penguin, 1965.

Vitruvius, Marcus. *Ten Books on Architecture*. London: Dover, 1986.

Vitz, Paul C., and Arnold B. Glimcher. *Modern Art and Modern Science*. New York: Praeger, 1984.

Von Simson, Otto. *The Gothic Cathedral*. London: Routledge & Kegan Paul, 1956.

Walker, John A. *Art Since Pop*. Woodbury, N.Y.: Barrons, 1978.

Wallace, Robert. *The World of Leonardo*. New York: Times Books, 1966.

Warhol, Andy. *The Philosophy of Andy Warhol*. New York: Harcourt Brace Jovanovich, 1975.

Weaver, Jefferson Hane. *The World of Physics*. New York: Simon & Schuster, 1987.

Weinberg, Steven. *The First Three Minutes*. New York: Basic Books, 1977.

Weisberg, Robert W. *Creativity: Genius and Other Myths*. New York: W. H. Freeman, 1986.

Weizkrantz, Lawrence, ed. *Thought Without Language*. Oxford: Oxford University Press, 1988.

Wells, H. G. *The Time Machine and The Invisible Man*. New York: Signet, 1984.

Westfall, Richard J. *Never at Rest: A Biography of Isaac Newton*. Cambridge: Cambridge University Press, 1980.

Weyl, Hermann. *Philosophy of Mathematics and Natural Sciences*. New York: Atheneum, 1963.

White, John. *The Birth and Rebirth of Pictorial Space*. Cambridge: Belknap Press, 1987.

Whitehead, Alfred North. *Adventures of Ideas*. London: Collier Macmillan, 1933.

Whorf, Benjamin Lee. *Language, Thought and Reality*. John Wiley & Sons, 1959.

———. "An American Indian Model of the Universe." In *The Philosophy of Time*. Edited by Richard M. Gale. Garden City, N.Y.: Doubleday, 1967.

Wilber, Ken. *Quantum Questions*. Boulder: Shambhala, 1984.

Wilson, Edward O. *On Human Nature*. Toronto: Bantam, 1978.

———. *The Insect Societies*. Cambridge: Belnap Press, 1979.

Wittkower, Rudolf, and Margot Wittkower. *Born Under Saturn*. New York: Norton, 1963.

Wolf, Fred Allan. *Taking the Quantum Leap*. San Francisco: Harper & Row, 1987.

Wölfflin, Heinrich. *Principles of Art History*. New York: Dover, 1950.

Wordsworth, William. *The Complete Poetical Works of William Wordsworth*, edited by Andrew Jackson Genge. Boston: Houghton Mifflin, 1904.

Young, John Zachary. *Introduction to the Study of Man*. London: Penguin, 1971.

Zola, Émile. *Mes Haines*. 1701. Reprint. Paris and Geneva: Slatkine, 1979.

Zuckav, Gary. *The Dancing Wu Li Masters*. New York: William Morrow, 1979.

INDEX

Page numbers in *italics* refer to illustrations.